N O
RESPECT

N O
RESPECT

.

Intellectuals
& Popular
Culture

.

Andrew Ross

ROUTLEDGE
New York & London

First published in 1989 by

Routledge an imprint of
Routledge, Chapman and Hall, Inc.
29 West 35 Street
New York, NY 10001

Published in Great Britain by

Routledge
11 New Fetter Lane
London EC4P4EE

Library of Congress Cataloging-in-Publication Data

Ross, Andrew, 1956–
 No respect: intellectuals and popular culture/Andrew Ross.
 p. cm.
 Bibliography: p.
 Includes index.
 ISBN 0–415–90036–0; ISBN 0–415–90037–9 (pbk.)
 1. United States—Civilization—1945– 2. United States—Popular
 culture. 3. United States—Intellectual life—20th century.
 4. Intellectuals—United States—History—20th century. I. Title.
 E169.12.R675 1989 89–5880
 973.9—dc19 CIP

British Library Cataloging Data also available

For Jean, my mother,
and in memory of Ben,
my father

Contents

Acknowledgments

Writing *No Respect* was not a lonely business. Help was everywhere at hand—from guardian angels, family, friends, colleagues, editors, correspondents, and a whole assortment of imaginary acquaintances and superegos.

Some of the book's materials were first presented as talks, and I'm grateful to those who invited me to lecture and to those in the audience who responded at the following universities: SUNY Buffalo, Cornell, Yale, York, Northwestern, Rochester, SUNY Stonybrook, Columbia and UMass Amherst.

First drafts of the whole book were treated to invaluable readings and critiques from Larry Grossberg, Paul Smith, Harvey Teres, and Constance Penley. In addition, individual chapters benefited no end from the comments of Paula Treichler, Linda Williams, David Bromwich, Sharon Willis, Alan Sinfield, Jan Radway, and Geoffrey Nowell-Smith. Thanks are also due to many others for help, advice, comments, and enlightenment: Steve Fagin, Dana Polan, Bill Warner, Anne Norton, Stanley Aronowitz, Lauren Berlant, Michael Rogin, Cary Nelson, Deborah Esch, Ian Balfour, Michael Cadden, Jonathan Arac, Alex Doty, Mary Caputi, Bruce Robbins, David Lloyd, Jules Law, Stuart Hall, Anne McClintock, Elaine Showalter, Mark Seltzer, Shirley Samuels, Danny Goldberg, Anders Stephanson, and all those on the *Social Text* collective.

A special note of gratitude to Eva and all the gang at Rush Rhees Library in Rochester for all the fabulous help they provided. My thanks, also, to students in my seminars at Princeton and Rochester from 1986–88 who were accomplices in the critique of taste—especially to Elana Sigall, almost a collaborator.

Earlier and shorter versions of some of the chapters were originally published in *Cultural Studies, Cultural Critique* and *The Yale Journal of Criticism*. Thanks to the editors and to Yale University Press for permission to reprint, and also, for their encouragement and understanding, to my editor, Bill Germano, and copy-editor, Diane Gibbons, at Routledge.

The credits close with Constance, who, I think, likes music a lot more than she lets on.

No Respect: An Introduction

In a solo stage appearance, Bill Cosby tells a story about how he and his wife, "because they were intellectuals," decided that she ought to have their child by way of natural childbirth. Nothing is more natural than giving birth; according to the movies, all you need is "hot water," and plenty of it! On the other hand, intellectuals, he points out, are those people "who go off to study things which other people do naturally," and so it seemed appropriate to them to attend exercise classes together, as they were advised to do, to prepare for the birth. In these classes, she practiced breathing, and he coached her, "macho-style" (both had university degrees in child psychology, but he had also majored in physical education). Come the big day, their nerve fails them, their newly acquired skills of breathing and coaching are found wanting, and, in the heat of the moment, more orthodox medical procedures are called for. The obstetrician who is "attending," rather than directing the childbirth, is seen as a passive incompetent. Unlike Cosby, the enthusiastic, agitating coach, this doctor sits and watches, "Johnny Bench"-like, while Cosby's wife, at the first peak of pain, dramatically renounces the ideology of the drugfree delivery by demanding her fair share of morphine. The rest of this very funny sketch describes the subsequent trials and tribulations of Cosby's paternity, augmented by comparisons with his father's competence at dealing with this role. Paternity, of course, turns out to be an endless condition of agonizing, about which Cosby, credentialed as a child psychologist and valorized as TV's most affable patriarch, is more than qualified to speak.

Where does this story come from? Perhaps it reflects a visible anxiety about the reproduction of a particular social class, that of the first-generation professionals to which Cosby and his wife belong. Too young and amorphous to have solidified its own interests, this social grouping still hangs on to its external, non-professional allegiances, especially those of its parents, and is unsure about the autonomy and power of its new social standing. Of course, this anxiety about social reproduction does not necessarily extend to other classes, and Cosby's caustic but nonetheless revealing proof of this is his example of "ladies picking rice" in "the 'deprived' countries of the world," who give birth in the fields to babies that immediately set to work at picking the rice themselves.

So too, his story betrays a suggestive anxiety about professionalism itself—if acquired skills and accredited knowledge are often seen to be worthless in the face of "natural" life, then the authority and privileges that come with them might also be unwarranted. This is an anxiety that speaks

to a general ambivalence about, if not distrust of, the authoritative role of experts in people's lives. Behind the perception that intellectuals acquire skills that are often superfluous lies an increasingly visible history of the expropriation, on the part of professionals, of the skilled "amateur" labor of working people. In the case of childbirth, for example, this history records the development of obstetric techniques which served to suppress the skills of midwives and to take childbirth out of homes and communities by placing it under institutional supervision. Consequently, childbirth became defined as a scientific, and not a natural event.[1] Generally speaking, it is a history that explains how the cultural authority of professionals arose from establishing responsibility for "what other people do naturally," and thus depriving them of control over their daily environments.

That Cosby's story is able to invoke these anxieties, fears, and resentments reflects in part the widespread expression of disrespect for authority which grew out of challenges to institutionalized expertise in the sixties and seventies. Such challenges to the perceived privileges and alienating practices of doctors, lawyers, professors, administrators, politicians, etc., resulted in the local popularity, for instance, of alternative health care for women and other "self-help" attempts to reappropriate skills and powers from the experts. Like many comedians, Cosby gets a lot of his laughs out of playing upon the distrust of experts (doctors and dentists and others), but it is important to recognize that there are always ideological limits to this disrespect, and it is here that the many facets of the Cosby "character" come into play as a way of managing this disrespect; he is a hip, successful, middle-class black male, a professional comedian, a celebrity who is "responsible" to certain liberal causes, and an actor whose earliest TV roles always emphasized an educated, professional training and who currently plays the role of a patriarch and doctor in the astonishingly popular *The Cosby Show*.[2]

After all, the educated plans for the natural childbirth end traumatically, almost in disaster, and so it's clearly implied that, when all is said and done, doctors do know best. So do fathers, at least after they have given up their immature attempts to demystify their authority; "my wife and I were intellectuals *before* we had children," after which experience, it is inferred, they learned, not through books, to behave like normal grown-ups with respect for authority. As the teller of this tale, the comedian speaks with double authority; with the authority of "experience," and with the legitimacy of his well-known roles as doctor and patriarch, competing first with the real doctor in the hospital, and then vying endlessly with his wife for his children's attention and respect in the home.

From the first, however, no one seems to take him very seriously (there are titters from the audience) when he announces that he used to be an "intellectual." No more do we take very seriously Rodney Dangerfield's

perennial complaint that he gets "no respect," not even when he dons academic robes as a middle-aged, self-made millionaire who decides to go to college in *Back To School* (1986), a film, which, in addition to its debunking of the pretensions of the professorial class, kicks around some home truths about the reliance of academic freedom upon the philanthropy of the business class. The Dangerfield character in the film pursues a successful and enormously popular, college career, not just by extravagantly paying his way, but also because of his down-to-earth attitude of "no respect" towards professors, whose otherworldly claims he contests on the basis of his own experience of the world. Although he earns a degree, however, he earns no abiding respect for himself, because the film clearly implies that, in a "real" educational environment, he would not be seen by professors and college officials as a legitimate student.

It is through Cosby's, and even Dangerfield's, pose as an intellectual, drawing upon the audience's suspension of disbelief in its deference towards the intellectual, that such stories manage to explain how popular disrespect for experts and intellectual authorities is somehow justified, while at the same time the narrative is intent on reinforcing their authority—in the end, doctors and professors and patriarchs know best. The narrative and the pose work hard to splice together what appears to be in contradiction: distrust and hostility, on the one hand, and deference and respect on the other.

I cite these stories because they contain exemplary parables about some of the main themes of this book: intellectuals and popular culture, authority and disrespect, hegemony and consent. When all is said and done, doctors, patriarchs, professors, and other experts are judged to know best. It is not by any guaranteed social contract, however, but in the saying and the doing, which is never "said and done," that cultural authority secures the power that it comes to both command and serve. The struggle to win popular respect and consent for authority is endlessly being waged, and most of it takes place in the realm of what we recognize as popular culture.

While it speaks enthusiastically to the feelings, desires, aspirations, and pleasures of ordinary people, popular culture is far from being a straightforward or unified expression of popular interests. It contains elements of disrespect, and even opposition to structures of authority, but it also contains "explanations," as I have suggested, for the maintenance of respect for those structures of authority. More often than not, it suppresses the most populist propositional truths—you don't, for example, have to think of yourself as an "intellectual" to consider taking activities like that of childbirth into your own hands, even though Cosby's story does not *include* that more radical suggestion. By that same token, the story excludes the most authoritarian truths—that the function of experts, for example, is precisely to discourage participation and self-determination, because

experts tend to serve interests which depend upon maintaining control over the means of social reproduction. So too, by invoking the value of the "natural" (even as it is debunked) in matters relating to familial reproduction, the story underscores a deeply conservative perspective about the "natural" status of the nuclear family.

Just as with Cosby's family, a similar case could be made for *Back To School*'s representation of the educational system. What, for example, is so threatening about the prospect of a "Rodney Dangerfield" (or others of his age and "unlikely" background) becoming a college freshman, and *participating* in the educational process by challenging professorial claims on the basis of his own experience? It isn't so much that it undermines the individual education of "legitimate" students, but that it undermines the way in which education, posed as a "natural" system or process of socialization, helps to ensure that those who have the power that comes with accredited knowledge are properly situated by age and class.

In spite of what they neglect to say, Cosby's story and Dangerfield's film include a contradictory array of values and viewpoints and suggestions that do not add up to a unified point of view, ideologically speaking. Above all, neither tells the audience what to think about these contradictions: some of the audience may, in fact, take to heart the discourse of disrespect, take it home and *apply* it in confronting or negotiating with figures of authority, while, for others, it may only cement their respect for the naturalized authority of experts. But the stories won't do any of these things if they don't provide the pleasure of recognition and identification, *of knowing one's place*: in this case, identification with the pleasure that arises from imagining oneself in control of one's environment and contesting others' usurpation of that control, even as that fantasy is devalorized, leaving the world as it is, except (and there's the rub) for the addition of this new fantasy. Accordingly, we could take the voices of "Cosby" and "Rodney" here as representative of what popular culture constantly works to do, not always wholly successfully, in incorporating popular perceptions, aspirations, and resentments that are reshaped and reaffiliated in the course of its appeals, however contradictory, to legitimate cultural authorities like doctors and professors. Without that all-round, dialectical appeal, to ordinary self-respect as well as to cultural authority, most people would not *believe in* "Cosby," or "Rodney," let alone *love* them, as audiences clearly do.

To accept this description of what popular culture does as dialectical in its appeal to authority and self-respect alike is of course to reject the more well-known, conspiratorial view of "mass culture" as imposed upon a passive populace like so much standardized fodder, doled out to quell unrest and to fuel massive profits. So too, it is to cast suspicion upon the enthusiastic, and often uncritical, populist appraisal of popular culture as an authentic expression of the interests of the people. Most important, however, it

helps to explain why a history of popular culture cannot simply be a history of producers—artists, the culture industries, the impersonal narrative of technological "progress"—and/or a history of consumers—audiences, taste markets, subcultures. It must also be a history of intellectuals—in particular, those experts in culture whose traditional business is to define what is popular and what is legitimate, who patrol the ever shifting borders of popular and legitimate taste, who supervise the passports, the temporary visas, the cultural identities, the threatening "alien" elements, and the deportation orders, and who occasionally make their own adventurist forays across the border.

To be truthful, we ought to admit that there is no such thing as a history from above, of intellectuals, or a history from below, of popular culture, although many such histories, of either kind, have been and will continue to be written. On the contrary, it is increasingly important (especially today, when the once politicized divisions between high and low culture make less and less sense in a culture that ignores these divisions with official impunity) to consider what is dialectical about the historically fractious relationship between intellectuals and popular culture. Only then can we expect to make proper sense of the linked material power, in our culture, of elitism and anti-intellectualism, vanguardism and populism, paternalism and delinquency. Only then can we see how categories of taste, which police the differentiated middle ground, are also categories of cultural power which play upon every suggestive trace of difference in order to tap the sources of indignity, on the one hand, and *hauteur*, on the other.

Just as popular culture includes elements of disrespect and opposition, however incorporated or contained, so too, the culture of the highly educated carries insurance for their own safe conduct when they go slumming. This *cordon sanitaire* is evident in categories of intellectual taste like "hip," "camp," "bad," or "sick" taste, and, most recently, postmodernist "fun," each of which are described in this book as secure opportunities for intellectuals to sample the emotional charge of popular culture while guaranteeing their immunity from its power to constitute social identities that are in some way marked as subordinate. At some level, these categories are also strategies of containment, converting anti-intellectualism into new forms of respect for the creative taste of intellectuals. On the other hand, these categories have also served as initially powerful conduits for expressions of social desire that would otherwise be considered illegitimate: "hip" and "camp," for example, are essential historical components of the respective cultural politics that preceded and helped to usher in the civil rights and the gay liberation movements.

At the heart of the story about intellectuals and popular culture is a structural interrelatedness between knowledge and power. In recent years, it has become a commonplace to concede that knowledge is power, but how

do we recognize the full social and cultural effects of that equation, unless by expressions of taste? While relations of disrespect/deference/contempt/ paternalism are always felt and expressed subjectively, there is no point in ignoring that some form of objective antagonism is at stake here, even if that antagonism cannot be reduced simply to relations of class. Insofar as that antagonism can be thought of, for the sake of shorthand, as an abstractly objective relation between "intellectuals" and "ordinary people," it is fractionated, in reality, into countless arrangements of minute differences of taste and consumption, each governed by the authority of cultural competence, whether inherited or else *explained* by reference to an occupational hierarchy based on education and training.

Education (which covers much more than formal schooling), and not material prosperity, is our culture's way of "earning" respect. Yet the authority and privileges that come with this respect are also deeply resented by those who recognize and aspire to the potential freedom, dignity, and self-determination that is promised by the acquisition of knowledge. In particular, this is the stock narrative of the immigrant American family. Its second- or third-generation children will earn respect through schooling, but their subsequent, perk-ridden, white-collar lifestyles will turn out to be too easy to sustain their parents' and grandparents' innate respect for an honest hard-working life. Rodney Dangerfield's pancultural character act is a brilliant interpretation of many of the secondary characteristics of this narrative. His belligerent air of thwarted entitlement expresses a kind of divided loyalty toward the institutions of respect that reproduces in his every gesture what Richard Sennett and Jonathan Cobb have, in another context, called "the hidden injuries of class."[3]

For blacks and native Americans, on the other hand, the right to earn respect is something other than an opportunity to be "thankful" for, as it is in the semi-mythical instance of the immigrant narrative; it is more likely to be seen as a common right that has been denied out of gross historical injustices. In this context, Dangerfield's self-deprecating complaint about "no respect" could be contrasted with the assertive cultural strength of Aretha Franklin's famous version of "Respect," which transformed Otis Redding's song about traditional conjugal rights into an anthem of black self-determination, shot through with female potency.

Ever more proficient in its capacity to mediate the hidden injuries of class, professionalism has the task, today, of managing the antagonisms that are bound up with the cultural institution of "respect." It works at this task with resources that range from naked apologism to professional self-loathing; from providing eminently "rational" explanations for the natural "justice" of inequalities and differences, to taking on for itself, like a kind of elaborate blackface, the discourse of anti-intellectualism. It is in a similar accommodating spirit that postmodernist culture, if far from being the

"common culture" that radicals once dreamed of, seeks to present itself at least as a universal *passe-partout*, with no regrets for the past and no more borders to cross.

Before we accept, at face-value, the delirious claim of postmodernism to have transcended the problem of elitism or paternalism, it would be best to examine the historical grounds for such a lack of conscience. That, at least, is one of the working claims of this book, and I have chosen to locate its premises in the history, since the thirties, of taste and intellectual authority within the national-popular culture. If we want to deepen the current debate about postmodernism and popular culture, we ought to be able to draw some lessons from the historical spectacle of intellectuals who have addressed these issues from both the vanguardist standpoint—What is to be done?—and from a Pop perspective—Everybody join in! Such lessons and such a history are essential, right now, to American cultural studies if, having abandoned the prestigious but undemocratic, Europeanized contempt for "mass culture," and rejected the more celebratory, native tradition of gee-whizzery, it is now to avoid falling entirely under the sway of the established British tradition of Cultural Studies, which, for all its virtues and insights (this book would not have been written without them) has its own national specificity.[4]

However much the intellectuals' debate about national culture has been governed, at least until the early sixties, by the influence of European categories of taste and value, saturated with a precapitalist prestige that is "foreign" but essential nonetheless to the American cultural apparatus, it is probably fair to say that popular culture has been socially and institutionally central in America for longer and in a more significant way than in Europe. The historical role, for example, of popular commercial culture in the "Americanization" of immigrants can be contrasted with the role of high bourgeois culture in "Europeanizing" colonial populations. European cultural institutions have enjoyed a relative autonomy from the institutions of government and business which the American equivalents, infused with the respective cults of democracy and profit, do not historically share. By that same token, the shape of American national-popular culture has been determined much less than elsewhere by the directive influence, judgment, and "standards" of intellectuals and much more by the way in which the culture industries have responded to the changing organization of popular taste. In fact, this is so much the case that it is popular culture, and not the work of "serious" American writers, artists, musicians, and thinkers, that is often, and increasingly, heralded as the nation's central and lasting cultural achievement, at home and abroad.

Take, for example, a recent issue of *Time* magazine, devoted to "What America Does Best," in which popular culture (hard-boiled fiction, the musical, the Hollywood epic, and grass-roots journalism are all covered,

but not a single mention of high culture) is given pride of place along with venture capitalism, freedom, the consumer ethic, philanthropy, sportswear, and high technology. As it so often does, *Time* journalism provides the kind of astonishingly brazen analysis that demonstrates the links between all of these top achievements. "Only capitalists," in "a wildly unregulated society," it is pointed out, "have the necessary cash and the eagerness to please," qualities which the mass production of culture requires; only capitalism can ensure the "elaborate system of distribution and promotion, the pop equivalent of military command-and-control, and here the U.S. is absolutely without peer." The case for American pop's global mission to combat feudalism and to assuage political sectarianism is openly flaunted: "The *Rambo* look is all the rage among guerrillas in Beirut"; "A Tina Turner song playing on the transistor can mitigate (even as it fosters) a Third Worlder's sense of backwater isolation"; "The irreverent interplay between Heathcliff Huxtable and his children on *The Cosby Show* is unthinkable and exciting to young Singaporeans"; "You see Marxist-Leninists [in Peru] with T-Shirts that say COCA-COLA" (in fact, it is shrewdly acknowledged that "foreigners turn to the left precisely because they like American pop so much"); while the bottom line is left to Charles Wick, director of the USIA—"I would hope that American pop culture would penetrate into other societies, acting as a pilot parachute for the rest of American values." The article even presents a brief historical overview (briefer than that offered in this book, but along similar lines) of the changing attitudes of American intellectuals towards popular culture, from the killjoy days of the Cold War liberal mandarin to the ironic, pop quotationalism of the postmodern yuppie.[5] In short, what is on sale here is a consensus "idea of America," a theme park view of the national essence, hopelessly in love with the cultural classlessness in whose republicanist name it conquers internal and external resistance the world over. It is the *multinational-popular* in action.

No savvy culture critic can afford to disagree outright with the assertions and observations presented in the *Time* article. Even though it does not tell the whole story, and strategically shrinks from giving the "big" political picture to which socially minded critics are accustomed, the article contains many elements that have the ring of truth, and, more important, that bear the mark of common sense. To contest that "common sense"—with its exhilarating language of consensus, its fast and loose logic, its rhetoric of comfort—always involves taking it seriously in the first place, and then learning how to fit in what it does not say, without pricing one's discourse out of the market of popular meanings. And that often means putting aside the big social picture, forsaking polemical purity, speaking out of character, taking the messy part of consumption at the cost of a neat, critical analysis of production; in short, all of the

occupational hazards and heresies of a cultural criticism that eschews the intellectual option of hectoring from on high.[6] Committing critical speech to common, vernacular ground doesn't mean giving up politics, only a sacred, theoretical attachment to political essences.

In fact, the *Time* article hardly goes out of its way to hide the immense political stakes of popular culture. While it ends with a tranquil vignette of a yuppie, cocktail in hand, listening to a Buddy Holly record on a breezy summer evening, there is more than enough talk of naked capitalist and militaristic values (they are more or less frankly espoused and admired in the article), foreigners turning to the left, guerrillas in Beirut, ad agency semioticians in the developing countries, and so on, to assure even the most tireless critic of "power" that there is a lot more going on here than vacuously beating a drum for the American way of life.

The language of common sense is not a whitewash. It works to incorporate and rearticulate the most uncommonly critical ideas and perceptions as part of its explanatory presentation of the values that survive—the values that endure—in a world whose volatility is depicted as potentially hostile to the stability of all values. This is how the "folklore of capitalism" comes to preside over the popular memory, by way of a constantly changing repertoire of perceptions and maxims of value—American values— that are presented as unchanging, as outlasting all rivals and competitors in the field of lived experience. Nothing is more crucial to the maintenance of the idea of the sovereignty of "we, the people" in America; nothing is more crucial to the maintenance of ideological stability, even as capitalism's voracious need for change and innovation insists, not just on constantly shuffling the cards and raising the stakes, but also on continually changing the rules, and replacing the scenery.

The *Time* article is exclusively about the "American century," in which consumerism, driven along by the heady dream of Fordist production and mass consumption of culture, was established as the organizing feature of advanced capitalism. Popular culture, as it is described in this book, is understood within this socio-economic context; the term covers a vast range of technologically advanced cultural products, industrially produced for profit, and consumed and used for a variety of purposes by a broad range of audiences. But the status of popular culture—what is popular and what is not—is also an unstable political definition, variably fixed from moment to moment by intellectuals and tastemakers, and in this respect, is often seen as constituting, if not representing, a political identity for the "popular classes."

This is as true for preindustrial folk culture as for the currently advanced age of consumerism, in which, it is often claimed, the logic of the commodity form has finally annexed all areas of cultural experience. In a brief discussion of popular songs, for example, Gramsci considers the

following categories: "1) songs composed by the people and for the people 2) those composed for the people but not by the people 3) those written neither by the people nor for the people, but which the people adopt because they conform to their way of thinking and feeling."[7] Gramsci concludes that "all songs can and must be reduced to the third category," a conclusion, of course, that rejects the enduring assumption that "folk culture," usually identified with the first category, is somehow more authentically popular than commercial popular culture. In fact, the historical or class or industrial origin of the song is no more important than its claim to high, low, or middling artistic worth. Rather, what counts for Gramsci is that the song is identified as popular because it *contains* a conception of the world that contrasts with what he calls the "official" conception of the world at any one time, and is therefore identified as representing the people's conception of the world. But this conception of the world does not correspond directly to any group that could be identified as the "people," no more than it corresponds to anything like a purely "oppositional" point of view. In short, we cannot attribute any purity of political expression to popular culture, although we can locate its power to identify ideas and desires that are relatively opposed, alongside those that are clearly complicit, to the official culture.

While refusing the legacy of contempt for popular culture, many critical intellectuals today have nonetheless learned to be wary of locating *pure* political value in popular culture, even as it becomes rote for yuppie baby boomers to rebaptize themselves, Achilles heel and all, in the nostalgic waters of their media-saturated youth. But if this critical wariness has been reinforced by the gaudy spectacle of the new hip wave of "born again" popism (a profound displacement of contemporary energies and cultural politics, since its generational locus of "fun" often tends to be the prelapsarian, "prepolitical" age before the mid-sixties) then the tolerance for *impure* criticism is equally a result of the lessons learned from the past fifty years, and it is in that critical spirit, I hope, that the book presents itself.

Just as the claim for any purity in cultural politics is suspect, so my own history of intellectuals is methodologically governed by no strict or absolute definitions of the role or function of intellectuals. It includes, among others, Lenny Bruce, Ethel Rosenberg, Andy Warhol, John Waters, and Grace Jones, just as it includes Dwight MacDonald, Susan Sontag, Marshall McLuhan, Amiri Baraka, and Andrea Dworkin. The diversity of this gathering is hardly surprising if one acknowledges the enormous difference in style between intellectuals of the Old Left, bohemian intellectuals of the Underground subcultures, the counterculture and the New Left, Pop intellectuals and celebrities, and, lastly, intellectuals of the liberation movements—the four, primarily generational, cul-

tural moments with which I deal. To do justice to the respective spirit of each, it seemed necessary at times to refuse any high theoretical ground or vantage point from which an entire historical trajectory could be summed up, and to enter the fray.

After all, *No Respect* spans a history that includes the last generation of American intellectuals to swear unswerving allegiance to the printed word and the dictates of European taste, and the first generations to *use* their involvement with popular culture as a site of contestation in itself, rather than view it as a objective tool with which to raise or improve political consciousness; the last generation to view culture in the polarized marxist terms of a universal class struggle, and the first to accept the uneven development, across a diverse range of social groups and interests, of the contradictions of living within a capitalist culture; the last generation for whom the heroic mythologies of the unattached, dissident intellectual could still be acted out, and the first to insist that the institutionalizing or the commercializing of knowledge does not seal the fate of political criticism; the last to devolve its politics solely upon the mind, and the labor of production, the first to appeal to the liberatory body, and the creativity of consumption. Not surprisingly, the shifts in cultural taste and value that accompanied these generational revolutions are often so sweeping as to militate against any attempt to make any ultimately systematic sense of their meanings.

On the other hand, there are particular intellectuals' traditions (summarized in the last chapter), as well as certain theoretical accounts of the role of intellectuals that consistently provide the framework for my readings and arguments. For example, Gramsci's distinction between organic (affiliated) and traditional (independent) intellectuals is much too useful to ignore, although the reader is warned that this distinction is loosely employed (i.e. in a non-class reductionist way), and enjoys an unorthodox mobility, throughout the course of the book. So too, Gramsci's account of the role of intellectuals in bridging political and civil society, and in securing/contesting hegemonic consent is broadly applied. Pierre Bourdieu's description of the social and symbolic use of cultural capital provides an important, if far from systematic, explanation for the "powerless power" of intellectuals over "ordinary people." More generally, the spirit of resistance on the part of the civil rights, the women's and the gay liberation movements to *vertical* forms of left organization and to centralizing explanations of power, has quite clearly shaped my often unfavorable treatment of the vanguardist intellectual tradition. Thus, in contrast to my discussion of the predominantly class-oriented concerns of the pre-war and Cold War debates about popular culture, the later chapters are organized around topics—Afro-American music, media imperialism, camp, and pornography—which specifically focus

upon the inflection of gender, sexuality, nationality, race, and color within popular culture.

Above all, the abiding "problem" of the political significance of popular culture is one that has been most seriously and consistently addressed from the historical perspective of an aspiring socialism, or radical democracy, wherein the orthodox relation between committed intellectuals and popular consciousness has most clearly been seen as dialectical. It is towards that tradition of cultural thought that this book is primarily addressed. The history of this "problem" does not begin with Marx's elegant suspicion, in *The Holy Family*, of the tendentious populism of Eugene Sue's novels. But it is a suspicion, as I show, whose contradictions are borne out in the attempts of American intellectuals, in the thirties, to generate alternative cultures—a hard-boiled "proletarian culture," first, then the *volkisch* "people's culture" of the Popular Front—in order to *compete* for "the masses" with commercial popular culture. Thirty years later, when popular culture was no longer being viewed as a potential medium for mass recruitment, it was worn instead as a badge of disaffiliation, as the sixties counterculture fashioned its own alternative culture for its own middle-class constituency in articulate defiance of the daily culture of others. Nor does this history end (with the problem resolved) where this book ends, with the recent anti-antiporn movement against state censorship of sexually explicit material, a movement which contests the antiporn critique of popular pornographic culture on the part of feminist intellectuals, and seeks to protect and advance sexual rights in doing so. Nonetheless, my case, for the sake of the book, rests there, in the contrast between the tradition of suspicion, recruitism, and disaffiliation on the one hand, and what I take to be a more exemplary model of intellectual engagement and activism on the other.

In fact, what the anti-antiporn position embodies could be read as a bill of rights for a new social contract between intellectuals and popular culture, or, conversely, as an epitaph for older ones. It demands: a) a recognition that the popularity of cultural forms (like pornography) depends upon none too resolvable contradictions, arising out of desires and fantasies that do not always "obey" politically conscious ideas about correctness; b) that any critique of these forms as channels of subordination must be accompanied by a frank estimation of the liberatory uses that might also be derived from the personal pleasure and significance invested in them; c) that the use of such forms be considered as a basis for inventing new and popular relations to the body—the source of all experience of power—and to social institutions, like the family, which regulate the behavior of bodies; d) an extended tolerance for and solidarity with the pleasure of other users, not always shared, especially if the pleasure is associated with marginal, persecuted constituencies; e) the

protection of freedoms and also the advancement, through the cultural marketplace and the laws of civil society, of sexual rights, especially those of sexual minorities, not yet fully achieved; f) radical attention to the voices of the exploited or unheard, in this case, sex workers and nonintellectual (non-passive and non-brutal/ brutalized) consumers; g) strong opposition to moral vigilantism, state interventionism and censorship of popular cultural materials; and h) the need for self-criticism, which includes the historically proven need to question the privileged voice of the universal, vanguardist intellectual in hot pursuit of his or her own model reforms. A good deal is no doubt missing from this list, and, in addition, it is addressed primarily to the issues raised by the pornography debate, but I submit that it contains a few useful rules of thumb for constructing a more popular, less guilt-ridden, cultural politics for our time.

Finally, a word from myself as an erstwhile Scot, whose first national-popular culture is an immensely fabricated skein of folk myths and *havers*, stitched up by monarchical and crypto-nationalist ceremony into the most fantastical mummery of tartan shapes and guises—a folk-royal culture that is a colorful but irritating and mostly alien presence, with which an increasingly deindustrialized people has learned to peacefully coexist, not, however, without some degree of cynical endurance and verbally armed resistance. Starting out from such an eccentric place, as an unwilling casualty of such an invented tradition, there is not much more that one could expect to learn about the cultural power of "popular" tradition, and the uses made of tradition by the powerful. Eight years of living now in a republic with no such official folkloric tradition to speak of has meant coming to terms with the quite different ways in which the overlap between culture and authority establishes its sense of popular sovereignty within everyday life, and reshapes, molecule by molecule, one's identity and subjectivity. If, in this new country, the popular sovereign goes forth in more modest, republican garb, and drinks a less expensive, carbonated version of the water of life, perhaps it is only because it has learned, taking its weird cue from Marx, to protect itself against ending in a tragedy that may be repeated throughout history as farce.

If my own fraught experience of "cultural republicanism" provided much of the inspiration to write this book, I have, of course, relied almost entirely upon "secondhand" sources to write it. Even those who live intimately with a particular history depend largely upon secondhand records of that history, whether in print, oral, sonic, or visual media, to supplement their memories or support their arguments. On the other hand, and perhaps at the cost of a more unified set of memories and

arguments, I have tried not to overlook my own prejudices, tastes, and affections for this or that idea, image, film, music, writer, critic, or artist. Although it may not always be evident, research is always autobiographical, and in this case, was bound up with the larger project of self-criticism that the book encourages on behalf of intellectuals engaged with the popular. Best of all, however, the course of this research led me inevitably to rediscover much of what had already been familiar, by the same name but with different meanings, in another country and in another kind of culture. Perhaps, finally, it is only in the course of writing about American pop culture that one is obliged to discover that Americans themselves no more have unmediated access to this history than the somewhat un-American body, however visible or invisible, that was behind the writing of a book like this. But maybe this is just a way of also saying (and hoping) that writing about American culture can still amount to what used to be called an un-American activity.

1

Reading the Rosenberg Letters

The Isaacsons are arrested for conspiring to give the secret of television to the Soviet Union. (E.L. Doctorow, *The Book of Daniel*)

Under what circumstances could the unpretentious dwelling units of a low-rent housing project on New York's Lower East Side come to be accusingly characterized as the "visible manifestation of the Stalinized petty-bourgeois mind"?[1] In the tradition of establishing "guilt by housing," it has long been a commonplace to see the "petty-bourgeois mind" and its place of residence being pilloried for their respective lack of distinction, their failure of imagination, or their ready embrace of convention. But the addition of "Stalinized" to the "petty-bourgeois mind" suggests something quite different from the usual impeachment of the lower middle class on the grounds of its sorry failure of taste. In fact, it attributes sinister, menacing qualities to a social stratum whose taste in culture and politics is ordinarily viewed as respectably conformist. At best, petty-bourgeois "respectability" rests upon its claim to common and not elite authority, earned through its capacity for self-sufficiency in regard to both popular and highbrow taste; in other words, it can inhabit its own cultural house with dignity. However, when this claim to dignity and respect takes on a self-grounded political authority of its own, it is always likely to be seen as compromising the higher legitimacy of intellectual authority.

Consequently, for postwar liberal intellectuals like Leslie Fielder, the author of this critique of the housing project, the politicized petty-bourgeois mind was filled with a "sentimental egalitarianism" that dreamed of a "universal literacy leading to a universal culture." This dream on the part of a middling culture characterized as "the middle against both ends," would come to be demonized by Fiedler and others as a leveling threat to the class hierarchies of the national culture; hence the epithet of "Stalinized," with its connotation of rigid standardization and homogeneity. But this demonized petty-bourgeois mind is also a haunted house. For the ghostly presence of Stalin, as we will see, is a real reminder of a pre-war cultural radicalism that Cold War intellectuals like Fiedler hastened to exorcise from their own histories or else pass off as a political apparition with no popular substance.

The intellectual charge of "Stalinization," belongs to a specific historical context in America. It was born in the thirties as a dissenting, left response to the Moscow treason trials (1936-38), the Nazi-Soviet Pact (1939), and the earlier Communist International policy of assailing all non-Communists as "social fascists," and it achieved mainstream maturity amid the Cold War hysteria fomented by the U.S. foreign policy established under the Truman Doctrine and legislatively enforced at home in a whole series of repressive acts aimed at eliminating left-wing activity in labor organizations, government administration, and public culture: the Smith Act (1940), the Taft-Hartley Act (1947), the McCarran Internal Security Act (1950), the McCarran-Walter Act (1952), the Communist Control Act (1954).[2] Critics and historians have explained the most hysterical features of this postwar "age of suspicion" in terms of the political need for a domestic climate of fear that would facilitate a foreign policy promoting military-backed expansion of U.S. interests abroad: the Cold War redefinition of the world balance of power, the policy of containment, the Marshall Plan, and the revival and extension of open door policies. It remains, however, to show to what extent the domestic Cold War climate was also shaped by intellectuals' contradictory responses to the domestic development of mass-produced popular culture. Cold War culture, as I will discuss in the next chapter, was crucially organized around the interplay between what was foreign, and outside, and what was domestic, and inside. Surely nothing could seem more perfectly at home in the new "prosperity state" of postwar consumer capitalism than the domestic forms of the popular culture industries. And yet, these were the same cultural forms which bore all the "foreign" traces, for Cold War liberals, of an achievement of Stalinized taste.

Spies Like Us

The strangest fruit born of this contradiction was the case of the Rosenbergs, occupants of Knickerbocker Village, the housing project that had evoked such a carping response from Fiedler. As most people know, the Rosenbergs were tried and convicted on charges of espionage in 1951, and then executed in 1953 after numerous appeals to the judiciary and a worldwide campaign for clemency that had failed to budge the presidential resolve of, first, Truman, and then Eisenhower. In his sentencing speech, Judge Irving Kaufman opined that the Rosenbergs had "altered the course of history to the disadvantage of our country." Invoking the spirit of Cold War antagonism—"this country is engaged in a life and death struggle with a completely different system"—he concluded that the Rosenbergs' alleged crime of atom espionage was

"worse then murder." In fact, he held them directly responsible for "the Communist aggression in Korea with the resultant casualties exceeding 50,000 and who knows but what that millions more innocent people may pay the price of [their] treason," a conclusion with which Eisenhower was soon to concur when he refused to grant clemency on the grounds that the Rosenbergs "may have condemned to death tens of millions of innocent people all over the world."

Most commentators have agreed that neither the megadeath scale of these accusations nor the severity of a death sentence (for espionage) seem to fit well with the flimsy allegations produced at the trial of *U.S. vs. Rosenbergs and Sobell.* To this day, no hard evidence of the Rosenbergs' guilt has ever been produced, in spite of the long and exhaustive FBI investigation of an alleged espionage ring for which Julius Rosenberg was the alleged master spy. The release of thousands of FBI files on the case under the Freedom of Information Act (1974) helped to reaffirm what had long been an article of faith for the American left—that the Rosenberg trial was a rather awkward frame-up, staged by J. Edgar Hoover and President Truman because such a trial was needed to "explain" the Soviet possession of an atomic bomb.[3] While scientists had publicly made it clear, from the mid-forties on, that there was no atom bomb "secret," and that the Manhattan Project had made no significant discoveries in the course of its development of the bomb, the assumption that a "secret" existed and had been passed on to Soviet Russia nonetheless formed the basic premise of the Cold War and, consequently, set the agenda for future U.S. foreign policy.

Unlike other famous defendants in the "trials" of this period—blue-chip liberals in the State Department like Alger Hiss and Owen Lattimore, hard-core intellectuals like J. Robert Oppenheimer, or committed cultural workers like the Hollywood Ten—the Rosenbergs appeared to be "just folks." In fact, official calculations of the enormity of their alleged crime seemed to escalate in direct proportion to the increasingly mundane revelations of their everyday middle-of-the-roadness. While their "guilt" was being measured against the average mean of their very ordinary lives, their "innocence," for a while, seemed to rest upon the disparity between these prosaic lives and the fantastic figures cut by spies and foreign agents in the pages of detective novels and in crime melodramas on radio and television. Michael Meeropol, one of the Rosenberg sons, recalls how the family was listening to *The Lone Ranger* at the time of his father's arrest by the FBI in 1950: "The radio episode concerned bandits trying to frame the Lone Ranger by committing crimes with 'silver-looking' bullets. Just as someone was exposing the fraud by scraping the bullets to show they were softer than silver and only silver-colored, an FBI man turned off the radio. I turned it on: he turned it off again."[4] As things got worse for the family, no

one could be sure whether the radio had in fact been figuratively turned off, or whether the "case" was being constructed out of the generic formulae of a broadcast spy fiction. This, at any rate, was his father, Julius's, response to the FBI charges; he said they were "fantastic—something like kids hear over the television on the Lone Ranger program."[5] As for Michael, for whom the primal scene of his future political life had been the *coitus interruptus* of a radio program, his visits to his parents in Sing Sing prison were all confusingly experienced through the imaginative filter of "private detective radio shows" in which the FBI tended to be the unquestioned heroes. Television, of course, was the harder drug, and Meeropol remembers that many of the auto and beer commercials that first captured his fancy were actually the scene of a second birth; they were written by the man who was to adopt the Rosenberg children after their parents' death.[6]

Meeropol's reconstruction of these mass-mediated infantile memories is more evocative of the fantasmatic milieu of the whole affair than is the more objective research of those who have tried to distinguish between fact and fiction in the case. From as early as 1947, sensationalist reports about atom espionage had begun to dominate newspaper headlines. The initial tongue-in-cheek tone of *New York Times* editorials like "Mystery of the Stolen Atom," gave way to a more responsible and authoritative tone as the FBI kept reporters busy with dozens and dozens of "atom spy" arrests over the next three years.[7] In his own account of the case, published and widely read in *Reader's Digest* under the title, "The Crime of the Century," Hoover, or his ghost writer, showed that he had a shrewd eye for pulp fiction. Here, for example, is his description of the confession of government witness Harry Gold:

> A startled gleam flashed through his eyes, his mouth fell open and he seemed momentarily to freeze. The map he had obtained in the Santa Fe museum, so that he could find the way to the bridge without asking questions! The shock of seeing the Chamber of Commerce folder was profound; it unmanned him, shattered the habitual, impregnable poise of an accomplished deceiver.
>
> In a sleepwalker's voice, Gold finally asked, "Where does that thing come from?"
>
> An agent intoned: "You said you never had been west of the Mississippi. Or have you?"
>
> The question seemed to pound with resistless force upon the stunned mind of Harry Gold, a man who had lived for years behind a front of lies and fantasy. There was a pause. Gold said nothing. Then the other agent prodded: "About this map, Mr. Gold. Would you like to tell the whole truth?"
>
> Then, abruptly, Gold blurted out, "I . . . I am the man to whom Klaus Fuchs gave his information."

> With these words the mysterious shadow we had been seeking became
> a living, breathing person—Harry Gold . . .[8]

The "red spy" was a new villain hastily constructed for the readers of comic books, popular fiction, and media folklore. In the postwar years, there were numerous confessors and informers (about eighty ex-Communists in all) who were willing to supplement the popular image-repertoire of the spy with fanciful embellishments of their own; the most notorious being the desperate Whittaker Chambers and the loquacious Elizabeth Bentley, "The Red Spy Queen." When the atom espionage story finally broke, however (*Spies Do Exist!*), a new kind of spy was called for, partly because of the enormity and the politically inflected nature of the charges. Despite, or perhaps because of the fact that there was no real "secret" to give away—the bomb had been produced from a fund of international wartime knowledge—the cultural construction of the A-spy required a personality that was distinct from the gentlemanly stereotype of the espionage agent usually found in popular spy fiction. A more sinister espionage psychology conveniently emerged in the case of Klaus Fuchs, the British spy scientist arrested and convicted in 1950. In his confession, Fuchs described his attitude towards spying as one of "controlled schizophrenia," a result, he claimed, of the dialectical separation of his life into dual worlds, which his "Marxian philosophy" had facilitated. The prosecuting counsel subsequently attributed to him a "Jekyll and Hyde" dual personality that may "be a unique . . . new precedent in the field of psychiatry," but he might just as well have been describing the new spy formula demanded by the political moment: a treasonable, though "ordinary," personality for whom the world of fact had to be shown to be more perverse than the world of fiction.

Signs of normality and of social conformity could now be regarded, by alert neighbors and friends, as the most insidious signs of treachery, since, in the Jekyll and Hyde spy syndrome, they are the most telling symptoms of deception. Accordingly, each of the main characters in the Rosenberg drama was distinguished, it seems, only by his or her lack of social distinction. Harry Gold, the informer, a "pudgy, stoop-shouldered chemist"[9] from the "false fronts and dirty, narrow backyards" of a "grimy" Philadelphia neighborhood,[10] who nonetheless was credited, by his detractors, as being a "Walter Mitty," with an active imagination that thrived upon its exotic distance from his everyday life. David Greenglass, the conspiracy case witness, described by his own lawyer as a "slob," (and as a "slovenly, shifty-eyed machinist" by a former client);[11] he was given to reading science fiction rather than "science," and was thus to draw the disdain of distinguished scientists all over the world for his obvious lack of scientific and technical intelligence, a fact that undermined the court's

assumption that he had understood enough about the Los Alamos bomb to be able to pass on the secrets of its sophisticated construction.

As for the striking normality of the Rosenbergs themselves, Ethel is described as a "plain," "slightly dumpy," and generally dowdy working-class housewife: "it is hard to believe that someone who chose to wear hats with six-inch high artificial flowers sticking straight out from them—as Ethel did the day she was arrested—could fully represent the international Communist menace."[12] And the unbohemian Julius is remembered as a serious and humane fellow, struggling ignominiously to make ends meet with his small, failing machine-shop business, while allegedly running an extensive spy ring. Gold's passion for baseball appeared to sustain his interest during the trial. Greenglass claimed that his love of popular culture like "Li'l Abner" prevented him from defecting at Julius's entreaty. In the trial itself, judgments of great importance came to rest upon the most insignificant commodity items: the famous, torn Jello box, allegedly used to identify Gold to Greenglass, and the inexpensive, mass-produced console table from Macy's that allegedly concealed a micro-filmmaking unit. Every further revelation about the humdrum petty-bourgeois reality of their lives served not to dull but to heighten the already "monstrous" status of the Rosenbergs' alleged crime, and, in the absence of any "real" evidence, the defendants were made to take on the spy's shadowy inventory of effects precisely *because* they themselves were all too normal—and thus boring.[13]

At the dead center of this farrago of fictions something only slightly more palpable was at stake. The question—What is a spy?—was one thing. Just as important was the question—What is a Communist?—or even—Are Communists real people?; questions that would trouble the representation of "aliens" in the science-fiction films of Cold War Hollywood. If the Rosenbergs were Communists (and there is no question that Julius, at least, had graduated from the Young Communist League to full Party membership in 1939—as a student, he was a regular of the famous Alcove 2 at City College and he later became the chairman of his CP unit, branch 16–B of the Party's industrial division), then Communists could not be "crazy Reds." In fact, if the Rosenbergs were Communists, then Communists were barely distinguishable from any ordinary American couple, and certainly far removed from the image of Communists as "a lot of whacked-up Bohemians" that Harry Gold presented in his trial testimony.[14] On the contrary, the Cold War climate was such that the Rosenbergs could be presented as a social threat, not because they harbored subversive, or violently revolutionary views (as Popular Fronters, they did not), but because they were *so* much like an ordinary, patriotic American couple. The exception to this, of course, was their Jewishness, still massively identified in the public mind with unpatriotic behavior and

opinions. And yet, like so many of the overwhelmingly Jewish hard-core membership of the CPUSA in the thirties and forties, the Rosenbergs' allegiance to religious traditions, however orthodox (Julius had once been a very devout Talmudic scholar, the Greenglass family was very Orthodox), had long since been rearticulated in politically secular, and Americanized, terms.

Among their predominantly Jewish anti-Stalinist detractors, however, the question of the Rosenbergs' Jewishness was much less of an issue. For them, the more specific political deception that the Rosenbergs came to represent was the apparent *indifference* of "Americanist" Communism not only to its parental Bolshevik origins, but also to its alleged Fifth Columnist role during the years of the Nazi-Soviet pact. The historical reasons for this seeming indifference are bound up with the vacillating policies, over twenty years, of the Communist International.

In the days of ultra-leftism, in the early thirties, *real* Communists were easy to distinguish. Sherwood Anderson had this to say about the difference between a Communist and a Socialist: "I guess the Communists mean it!" And John Dos Passos supposed that becoming a Socialist would be like "drinking a bottle of near-beer."[15] Fellow travelers, while welcomed if they were famous intellectuals or writers, also ran the risk of being branded as "social fascists" for their lack of real commitment to the movement. The change in Comintern policy that ushered in the anti-fascist Popular Front in 1935 could hardly have been more dramatic: the "people" replaced the "workers"; nationalism replaced international socialism; reformism replaced revolution; cooperation replaced class conflict; the defense of democracy replaced the assault on capitalism. The new "classless" rhetoric against fascism was an open appeal to all Americans, of all classes and walks of life, to loosely congregate in patriotic fraternity under Earl Browder's slogan: "Communism is Twentieth Century Americanism." As the process of Americanization took hold, the innumerable front organizations took on a native hue: the Descendants of the American Revolution, the American Committee for Democracy and International Freedom, the League of Women Shoppers, among hundreds of others. At the fifth and largest congress of the American League Against War and Fascism, in 1939, greetings were sent from such unlikely quarters as The Improved Benevolent and Protective Order of the Elks, the YWCA, Young Judea, and the National Intercollegiate Christian Council.[16] In 1938, the Preamble to the CPUSA's Constitution was amended by Browder to read that the CP simply "carried forward the traditions of Washington, Jefferson, Paine, Jackson and Lincoln under the changed conditions of today."[17] Bohemianism, proletarianism, and asceticism were abandoned. Party members became neighbor- and family-oriented in their social activities, party officials were seen in public

in tuxedos, while Manhattan's "penthouse Bolsheviks" were united with Hollywood's "swimming pool proletariat" in raising money for anti-fascist causes. By now, the question—What is a Communist?—was less easy to answer.

A similar transformation took place in the cultural organizations affiliated with the new united front. Hitherto figureheaded by those in the John Reed Clubs whom he considered to be "bona fide" intellectuals, Irving Howe disparagingly describes the shape of the renovated League of American Writers after 1935: there was a group of stars—Hemingway, Dreiser, Sinclair, Steinbeck, MacLeish, Wolfe—in its firmament, but "beneath the upper echelon of praised and petty celebrities, there milled about a horde of second rank intellectuals, Hollywood scripters, radio hacks, popular novelists, English professors, actors, dancers, newspapermen, and publicity agents for whom the *Schwärmerei* and political baby talk of the Popular Front were exactly right."[18] Donald Ogden Stewart, the Hollywood comic writer, had replaced the highbrow Waldo Frank as the president of the Congress. If Howe lamented, along with Murray Kempton, that "the poets were gone . . . the journalists remained," then he concurred with the generation of anti-Stalinists with whom he has traveled intellectually, if not always politically, ever since. Trotskyism— home of left dissent and "intellectual independence"—was to be the immediate haven of the *bona fide* intellectuals like Howe, protective of what they saw as the privileges of artistic "freedom" over and against political "discipline," and temperamentally unsuited to the steadily committed life of the organized "professional revolutionary," whether that meant fund-raising and working within the culture industries, or, for the rank-and-file, selling the *Daily Worker*, or going "into industry" as a full-time labor organizer.

As a consequence of this studied aloofness, the anti-Stalinist intellectuals' attacks on popular culture from the late thirties on were almost coterminous with attacks on the sub-intellectual lives and tastes of Communists themselves. This was not simply a response to an alleged "anti-intellectual" Party line, it was largely because the anti-Stalinists associated the new lower middle-class constituency of the Popular Front with a middlebrow culture that willfully eschewed the concentrated appeal of "serious" art. Writing long after the demise of the Popular Front, and ever alert to the symptoms of cultural compromise that were so heretical to his circle, Howe found vestiges of its style everywhere in the larger American culture:

> in the Hollywood and TV drama, where stress upon the amiable fumblings of "the little man" constituted a simple displacement of social consciousness; in musical comedies, where the exploitation of regional

"folk" quaintness replaced social satire; in the historical novel; in the cult of city-made folk dancing and singing; and perhaps most important, in a quivering, folksy, and insinuating style—*vibrato intime*—which came to favor in the Popular Front press . . . and has since become a national affliction.[19]

Ordinary People

For all the social and cultural eclecticism of the Popular Front organizations, the cultural interests and cultural institutions of its core CP subculture were quite closely circumscribed, if only because of the comprehensive range of social activities sponsored by the Party—art exhibitions, concerts, parties, plays, lectures, camps, etc. So too, the new ideology of "people's culture," was most visible in the realm of folk music, which had replaced the proletarian novel as the cultural form most privileged at social gatherings, while it shared honors in the pages of the *Daily Worker* and *New Masses* with "progressive" literature, theater, and even Hollywood films like *The Grapes of Wrath* (1940). The rural, nativist vernacular of the "minstrels in overalls"—Woody Guthrie, Aunt Molly Jackson, Leadbelly, Burl Ives, Earl Robinson, the Almanac Singers—was the expressive voice of the new populism, and provided the institutional form of the hootenanny, the most popular kind of social event for the rank and file.[20]

There is little evidence that a "people's culture," like the earlier proletarian version, was anything more than a Party fantasy of what a true image of the people ought to be. If that were all it was, then it would simply constitute another chapter in the history of intellectuals' constructions of the "imaginary American." But this people's culture was also the basis of an intense transference on to the idea of the national-popular, and thus a source of relief on the part of Party members and fellow travellers from the hard line of the international-proletarian. Even if its ruralism was often hopelessly at odds with the imagined daily life of urban workers, the native intonation of the people's culture was accompanied by the genuine enthusiasm of the cadres for the new Americanist line, and inflected the unpopularity of the old line—Towards a Soviet America!—among these same Party members. In short, it was all part of what Vivian Gornick has called "the romance of American Communism."[21]

The cultural feel of Popular Front life is well represented in the letters written to each other by the Rosenbergs while in prison awaiting the results of various appeals against their death sentence.[22] Edited and published before their execution by the National Committee to Secure Justice in the Rosenberg Case, they became a powerful propaganda

element in the worldwide clemency campaign, most active in France, where *l'affaire Rosenberg* took on all the scandalous dimensions of a second Dreyfus affair. In fact, the Rosenberg letters can be read as an expressive document of the disparate range of cultural references that had organized meaning for a lower middle-class Popular Front family. So too, in the picture they provide of the condemned couple trying to cope with the ascetic regimen of the prison day, we are given some sense of the continuity between the everyday regularity of prison life and the Party habits of *organization* and *self-criticism* with which they were now obliged to interpret their private family life in relation to a larger world of social and political meanings. Everything, in effect, was part of a plan; their release, if it were only left to the judgment of the people, was surely as inevitable as the coming of a people's state. All they needed was fortitude and faith, or in their own private motto, "courage, confidence and perspective," an outlook exactly reflected and voiced in the populist songs and literature to which they turned.

In his exercise periods, Julius was accustomed to sing "mostly folk music, worker's songs, people's songs, popular tunes, and excerpts from operas and symphonies": "I sing Peat Bog Soldiers, Kevin Barry, United Nations, Tennessee Waltz, Irene, Down in the Valley, Beethoven's Ninth Choral symphony and as many of the children's records as I can remember. In all frankness, I feel good and strong when I sing" (DHL,33). (After hearing their sentence in court, Ethel had sung an aria from *Madame Butterfly*—"Un bel dì, vedremo . . . " ["One fine day, we will see . . . "]—to which Julius, in an adjoining cell had responded, less appropriately, perhaps, with "The Battle Hymn of the Republic.") Ethel also records how she was heartened by broadcasts over the prison loudspeakers: Bob Hope (DHL,34), "Ballad for Americans" and Frank Sinatra's recording of "The House I Live In" (DHL,47). Their reading is eclectic: lots of Thomas Wolfe, biographies, the Beards' *The Rise of American Civilization* and other volumes of American history, and books about Jewish culture and history, while they recommend that their children read Robert Louis Stevenson. Ethel warns Judge Kaufman to take heed of the infernal punishment guaranteed the Rouen judges for martyring the Maid of Orleans in Shaw's *St Joan* (DHL,123–34). Baseball is a consistent presence, especially the Dodgers, who are praised for "their outstanding contribution to the eradication of racial prejudice" (DHL,67). They interpret their Jewish heritage in terms of their own immediate and continuing role in a historical struggle for freedom. On Passover, for example, Julius describes himself as imprisoned by "the modern Pharaohs," Chanukah signifies "the victory of our forefathers in a struggle for freedom from oppression and tyranny," while Ethel warns that they ought not to use "prayer to an Omnipotent Being as a pretext for

evading our responsibility to our fellow-beings in the daily struggle for the establishment of social justice" (DHL, 67).

Throughout the letters, this historical interpretation of their Jewishness is spliced with appraisals of the democratic solidity of an American heritage: "freedom, culture and human decency" (DHL,27), "faith in the principles of democracy and the dignity of the human being" (DHL,112). As "honest citizens taking part in mankind's progressive efforts," the politicization of their beliefs and opinions is everywhere *continuous* with an idealized Americanism. On July 4, 1951, Julius clips a copy of the Declaration of Independence from the *New York Times*, and compares the freedoms denied him as a political prisoner with the "rights our country's patriots died for" (DHL,46). A year later, he records how he has appended his own name to the list of signatories of the Declaration: "I take second place to no other American in my loyalty to my country," and points out to Ethel that "we are illustrating the fundamental tenets of our democracy . . . no amount of distortion and deliberate rewriting of American history can hide its progressive drive" (DHL,98). In this act of alignment, Julius was perhaps consciously imitating an earlier Popular Front attempt to symbolically cast Earl Browder's family as "among the founders of America":

> It was in the springtime of 1776 and Thomas Jefferson may well have been driving his one-horse shay . . . with a draft of the Declaration of Independence in his pocket, when a certain boy, just turned 21, stepped into a recruiting station in Dinwiddie County, Virginia. He gave his name as Littleberry Browder and was sworn in as a soldier of the Continental Army of General George Washington.[23]

The Rosenberg letters are otherwise interspersed with lively comments on current affairs: the Smith Acts, Korea, Franco, Israel's fourth birthday, Willie McGee, McCarthy, and, increasingly, the vigorous campaign waged in the press against their clemency appeals. So too, the letters increasingly incorporate addresses to "fellow," "brother," and "sister" Americans, especially "progressives," who are warned that the "legal lynching" of the Rosenbergs will not augur well for those "who don't conform": Ethel's last public comment immemorialized a common belief on the left at that time—"we are the first victims of American Fascism."

Julius's tendency to cast himself as the spokesman for the future of the left embarrassed the Committee members who were editing the letters for public consumption. But it was Ethel's literary skills that formed the basis of the appeal, both emotional and persuasive, of the letters. Encouragement and praise of these skills by Julius and others played to her long nurtured ambitions to be a professional artiste—an actress or

singer.[24] All the same, the editors felt it best to expurgate some of Ethel's "rhetorical excesses" from the second edition. As it was, the worked-up, self-consciously "literary" style of the letters has drawn more than its fair share of criticism, much of it abusively directed at the obviously literary (and specifically "feminine") pretensions of Ethel.

A comparison might be made between the laborious style of Ethel's commentary on nature and culture, and the very different prison letters of Rosa Luxemburg, whose "style," for the editors of *Partisan Review* at least (who published a selection of the letters in 1938), was that of the "pure" revolutionary: "the Luxemburg," they write, "whose human relationships are so warm, whose sympathy for animals, birds, even plants and insects, is so acute as to cause her constant pain." Moreover, the selection chosen by the editors deliberately showcases Luxemburg's impressively cultured European sensibility. It is full of discriminating comments about the novels of Galsworthy, Wilde, Mann, and Dostoevski, the poetry of Mörike, Hoffmannsthal, Goethe, Homer, and Arno Holz, the plays of Shaw and Johannes Schlaf, the music of Hugo Wolf, and the painting of Titian, Rembrandt; "What am I reading?" she writes to a correspondent, "Mostly books on natural sciences—geography, botany and zoology," she answers.[25]

This attractive display of legitimate cultural authority on the part of an independent female revolutionary is a far cry from the picture of Ethel, the imprisoned housewife and mother, scouring her dictionary for dramatic and sophisticated terms and phrases to use in her letters. Nonetheless, a less patronizing reading of her literary "excesses" might consider what it is that they do manage to communicate or signify, rather than, or in addition to, what they *fail* to achieve in terms of virtuoso literary skills. Ethel, for example, writes to her lawyer, Emmanuel Bloch, in ominous tones:

> (W)hile it is no easy matter to contemplate one's own imminent death, it is far more horrifying to watch the cauldron boiling and the plot thickening right out in broad daylight, while the people flee headlong down the path to their own destruction, and the liberals flounder about pathetically atop their synthetic fences! (DHL,113)

These are not choice words, and they will not be remembered as an especially fitting evocation of the rabid political hysteria of the day. They draw upon a number of available languages and metaphors—biblical, Party rhetoric, pulp novel, journalese—to summon up a pastiche of suggested apocalyptic effects. A knee-jerk formalist literary critic might have the following responses to this: her prose is either an embarrassing failure to produce a consummate image of apocalypse, or else (the re-

deemer's reading), this motley patchwork of styles *expresses* in itself the Babel-like confusion of apocalypse, or, more shrewd yet, that it suggests their author's discomfort with the circumstances under which the languages of discomfort are available to her.

But what is really in question is not Ethel's discomfort or her flawed penmanship. What is really at stake here is the literary critic's or intellectual's discomfort with a language that is not properly (or *literarily*) coded as either private or public. It is the language of "ordinary people" writing for literary effect. This language is no more "artificial" than that of professional poets or prophets, who, when they write letters with an eye to their publication, are nonetheless obliged to show in some way that their writing is both "natural" and indifferent to the public eye. When the Rosenbergs wrote, also for publication, the difference shows; they *are* writing for a public. But difference from what? The "real" Rosenbergs who do not write for a public? Clearly, there is no such thing. Take another example, Ethel's response to Julius's "brusque conduct" at one of their weekly meetings:

> Sweetheart, expect me to pull a few boners now and then. Not that your temporarily sharp reaction exactly cramped my style outwardly, or even caused me to lose any sleep; still, it does make me feel I haven't your genuine acceptance of my right to make, yes, an ass of myself, if you will. (DHL,85)

Nothing could be more "ordinary" than this awkward reminder of the agreed limits of a code of interpersonal tolerance between a married couple (in addition to being written for a public, it is important to remember that the letters were also very personal communications between people who knew they may not have much time left to communicate with each other). And yet nothing could better demonstrate the *unhappy* relationship of what Fiedler called the "petty-bourgeois mind" to the practiced forms of legitimate culture; an unhappiness that is a result of having little choice but to take "literature" and its signifying codes too seriously.

For the intellectual, "ordinary," like middlebrow, is not a code in itself; it is defined against, or is signified by its transgression or corruption of other codes like those of the "vernacular" or the "literary." Here, "ordinary" may indeed be signified by the absence of a polished and unlabored style that Ethel's prose aims at and yet inevitably fails to achieve, but it is also marked by the labored presence of emotions in which the reader is required to *participate*, beyond any question of style or literary competence. To be "ordinary" here is to be over-literary, because it reveals the labor involved in producing sentences which, if their author was truly

"literary," would be articulated as "naturally" as one breathes air. But the result, on the reader's part, is a difficult identification that does not invite a passive sense of admiration so much as it elicits an active form of empathy. The Rosenbergs' letters, described by the editors of the second edition as "world classics of democratic eloquence and inspiration" proved to be very effective propaganda; they helped to mobilize thousands of readers who responded to a discourse which they recognized as addressed to themselves. There is every reason to think that, for these readers, the language was not necessarily pretentious, and may have been more or less appropriate to the political sentiments expressed by the authors. In this respect, the Rosenberg letters challenge the assumption that effective political statements cannot be communicated in a language that lacks the ring of posterity, and therefore that political sentiments, to be persuasive, require trained intellectuals or populist rhetoricians.

In his introduction to George Jackson's *Soledad Brother*, another collection of prison letters, Jean Genet pays tribute to a discourse of authenticity that is to be distinguished from the ordinary or the common. Jackson's letters, he suggests, prove that "every authentic writer discovers not only a new style but a narrative form that is his alone, and which in most cases he uses up, exhausting its effects for his own purposes."[26] Jackson's letters, then, are a truly "natural" literary discourse; not only do they "perfectly articulate the road travelled by their author," but they are written under pain of death, and are not willed or composed "for the sake of a book." Confronting the white "syntax of his enemy," where he might otherwise "crave a separate language belonging only to his people," Jackson, in Genet's view, opts to "corrupt" white language so "skillfully that the white men are caught in his trap." Genet concludes that if the reader finds the "poetry" of this strategy "immoral," then it is because such a strategy both upholds *and* contradicts "revolutionary morality." It remains unclear whether Genet thinks it more "immoral" for Jackson to "skillfully" corrupt white language or whether it is more immoral to forge a path that is independent of "revolutionary" correctness. What is more important is the way in which Genet sanctions this immorality on both political and literary grounds.

Genet suggests that "a certain complicity links all works written in prisons or asylums," but that they share "common ground in the audacity of their undertaking." But would he have extended the same salute to the Rosenberg letters as he does to the prison literature of Jackson, Sade, and Artaud? If not, why not? Like Jackson's assault on white language, do they not also "corrupt" the coded literary discourse of their adversaries, those Cold War liberals who heaped such scorn on the "quasi-intellectual" life of the Popular Front? Like Jackson's letters, do they not also "crave" their own language, while being obliged to mouth the rhetoric

of political prisoners, Party martyrs, or scapegoat victims? Are they not as racially scandalous in their own way about the Rosenbergs' contradictory attitude towards Jewish identity? And do they not both uphold and contradict the traditionally "revolutionary morality" of the political movement with which they are associated?

The answers to these questions are neither simple nor timeless, although I am convinced, by the reactions of contemporary students to whom I have taught the materials of the case, of the continuing capacity of the Rosenberg letters to compromise every possible canon of "legitimate" taste. The problem of petty-bourgeois taste, culture, and expression remains to this day a largely neglected question for cultural studies and a formidable obstacle to a left cultural politics. For many Cold War liberals, this problem was not, and perhaps could not be directly confronted. The political climate was such that they could only identify the language of these ordinary people with a dying political discourse—that of cultural Stalinism. In so doing, the untidy problematic of lower middle-class culture was (conveniently) displaced. In the particular case of the Rosenbergs, as I will show, the peculiar reception by intellectuals that greeted the publication of their letters demonstrates why the "immorality" of the language in which they were written could not be viewed as a cultural expression in its own right, but had to be seen as the lingering symptom of a moribund political cause.

One . . . Two . . . Many Trials

One of the most effective and proven smear tactics in cultural criticism is to invoke the discourse of the "secondhand." In *Breaking Ranks* (1979), Norman Podhoretz writes, for example, of Lillian Hellman that "her prose style—an imitation of Hammett's imitation of Hemingway, and already so corrupted by affectation and falsity in the original that only a miracle could have rendered it capable of anything genuine at this third remove—was to [her admirers] the essence of honesty and distilled candor."[27] Only Podhoretz, perhaps, could have demonstrated so succinctly the core elements of anti-Stalinist criticism, whereby falsity is identified at various Platonic "removes" from an original that is itself always already corrupted. The context of Podhoretz's attack on the three H's of the Popular Front was a response to the controversial publication of Hellman's *Scoundrel Time* (1976), in which she indicted the silence of the liberal intellectuals who had failed to take a stand on McCarthyism and whose Cold War anti-communism, she argued, had helped to precipitate the climate of sympathy for U.S. intervention in Vietnam.

Hellman was passing judgment on an age of judgment-passing—the long season of show trials, heresy charges, investigations, witchhunts, inquisitions, defections, and deathbed conversions that ran its course from the end of the war to the ignominious conclusion of McCarthyism. "Truth made you a traitor as it often does in a time of scoundrels," Hellman wrote, while her evocation of the Red scare points to the tendentious role played by popular cultural forms:

> It was not the first time in history that the confusions of honest people were picked up in space by cheap baddies, who, hearing a few bars of popular notes, made them into an opera of public disorder, staged and sung, as much of the congressional testimony shows, in the wards of an insane asylum . . . The anti-Red theme was easily chosen . . . not alone because we were frightened of socialism, but chiefly, I think, to destroy the remains of Roosevelt and his sometimes advanced work.[28]

In this scoundrel time, to be associated with a "few bars of popular notes" was to be burdened by a very specific kind of ontological disadvantage. It was to be at a remove from one's "true self" (a violated essence, in any case), to simulate rather than practice one's beliefs, to live vicariously rather than directly; to be identified, in short, as a functionary form and not as a content.

This ontology pervaded the anti-Stalinist criticism of popular culture in exactly the same measure as it governed the defamation, both inside and outside the courts, of those who were judged to have defended to some degree either their own or another's Communist past. The most obvious targets, of course, were those from the communications and entertainment industries who had displaced the *bona fide* intellectuals from the mastheads of Popular Front organizations. Stalinized by Hollywood, whether they made "sympathetic" films or not, they were condemned, as Murray Kempton put it, to making "two-dimensional appeals to a two-dimensional community." It was not enough, however, to have been lobotomized by working within a spurious medium, for Kempton added that the Hollywood Communists were further dehumanized by the media need to publicize their own work: "they were entombed, most of them, not for being true to themselves but for sitting up too long with their own press releases."[29]

A more reasoned, but no less partisan, judgment from above irradiates Robert Warshow's response in 1953 to the opening night of Arthur Miller's play, *The Crucible*. Warshow compares the end of this performance—the shouts of "Bravo!" from the "liberal audience"—with the celebrated ending of Clifford Odets's *Waiting for Lefty* (1935), at which both cast and audience joined voices to shout "Strike!" (the consummation

of the "marriage of the liberal theater and the liberal audience"). Warshow is kinder to Odets than Kempton, who suggested that Odets had never been near a strike in his life.[30] In fact, Warshow argues that "Strike!" at least *meant* something. Odets had a message, while Miller has no message, and so the cry of "Bravo!" that greets his play is merely performative, a "cry of celebration with no content."[31] The path traveled from a play that has a meaningful message to a play that has neither message nor meaning, is, of course, the history-in-little of "the liberal conscience," that lives on now only in a community of the "elect," for whom grace, "like the grace of God," is given irrevocably, and who "no longer need to prove themselves in the world of experience" (IE,203). Here, Warshow takes on the incongruous role of confessor. But there is something no less denominational about his nostalgia for a time when radicalism was a "meaningful" activity.

Like many of his fellow anti-Stalinists, Warshow invokes a conventional narrative of decline which holds that there was once a prelapsarian correspondence between cultural politics and political experience that has long since been corrupted by the influence of pseudo-believers. Any attentive reader of his essay, "The Legacy of the Thirties," will see how this decline and fall of a radicalism once "uncorrupted" (the historical high water mark is Sacco-Vanzetti) is linked in every way to a progressive lowering of intellectual taste. "Stalinism," in fact, is a term that he defines there with some exactitude to mean the "degradation" and "conversion" of Communism "into a vehicle of mass culture" (IE,36). More importantly, Stalinism is indissociable from the intellectual fortunes of a middle class for whom "even political discussion becomes a form of entertainment," and whose middlebrow culture is a never-never land populated by bad imitations of genuine art. Warshow at least grants that Stalinism is not in itself *responsible* for the emergence of mass culture for the educated classes; the real causes lie "far back in the history of American culture . . . and industrial capitalism" (IE,35). But one senses that he would just as soon gloss over this history, for his real quarrel is with those second-rate intellectuals of the united front who aided and abetted the "Stalinist" estrangement of cultural life from direct experience.

While Warshow and others pursued their quarrel with popular culture in the pages of *Commentary, Dissent,* and *Partisan Review,* the "show trials" and confessions of the late forties and early fifties offered a public opportunity to stigmatize those who had been Stalinized both by popular culture and by an alleged Fifth Column which putatively used mass media for propaganda purposes. If there was a tendency among liberal intellectuals to go easy on professionals like the Hollywood Ten, an open season, by contrast, was declared on the Rosenberg case and the Death House Letters. The personal attacks on the Rosenbergs were clearly aimed at

the strict regimen of loyalty demanded by the Communist Party, but the critique was waged just as strongly on the grounds that the accused were irredeemably middlebrow and therefore dangerously oblivious to the self-corrupting influence of the *Kulturbolschewismus* (the Nazi term which the *Partisan Review* writers ironically applied to Popular Front culture) that they espoused.

Recent commentators have argued that the letters present a problem of *misrepresentation*. Ronald Radosh and Joyce Milton, for example, are outraged to find that the "personalities that emerge from the printed page bear little resemblance to the Rosenbergs as they were portrayed by their more ardent defenders."[32] The Meeropols, however, maintain exactly the opposite. When asked in an interview whether his mother was a "traditional woman who stands by her husband even if that means going to her death to support him," Robert replied: "Look at my parent's jailhouse letters and decide. I think those letters are a fairly accurate reflection of who my mother was."[33] Their parents' detractors, in 1953, would have agreed with the Meeropols, but they had a different conclusion to reach. They argued that the Rosenbergs were perfectly represented by the letters, and that the letters were as "false" as they were, because there was nothing *behind* the letters, except, of course, a chain of subterfuge and falsification that ended in Moscow. Two articles published within a month of each other, Fiedler's "Afterthoughts on the Rosenbergs," and Warshow's "The 'Idealism' of Julius and Ethel Rosenberg," have become infamous for pursuing this thesis.

Warshow's argument is a near replica of his critique of mass culture. While at times the Rosenbergs appear to "sound the authentic tone of parental love in the educated and conscientious middle class," Warshow claims that the letters, in fact, everywhere proclaim "the awkwardness and falsity of the Rosenbergs' relations to culture, sports and to themselves" (IE,76). The Rosenbergs actually saw themselves from "without," as the most devoted of all of the "sympathizers" of the constructed, cardboard personae they had fashioned for themselves. Warshow sees their "characters" as failures, in much the same way as literary critics were accustomed to speak of the "failure" of characters in a novel. The failure arises from the fact that "nothing really belonged to them, not even their own experience; they filled their lives with the secondhand." Nothing, not even the language they use, is immune to this contagion of the counterfeit. "Communism," for example, only ever appears in quotation marks in their letters; it no longer stands for anything in particular, a development that signifies the true material state of Communism—an idea without a content. And what do the Rosenbergs stand for? asks Warshow. Nothing in particular. It is as if their identity were in quotation marks, defined and handed down to them, at any moment, on Party directives.

Warshow's reasoning leads to its logical conclusion. Did the Rosenbergs actually write the letters? The question, of course, is academic. If they were not written by the Rosenbergs, these letters "are what the Rosenbergs would have written" (IE,81).[34]

The prototype for Fiedler's article was his earlier essay on "Hiss, Chambers and the End of Innocence," published in *Commentary* in 1950, in which he characterized Hiss as "the Popular Front mind at bay, incapable of honesty even when there is no hope of anything else" (EI,6). It is a heavily melodramatic account of the famous case, with Chambers cast as the old, Third Period kind of Communist, physically unappealing, rhetorically adept, and openly rebellious; and Hiss as the new kind of Popular Front apparatchik, a confusing hybrid of Communist gentility, clean-cut, impeccably connected, and working from within as an infiltrator, albeit in Earl Browder's spirit of "Jefferson, Lincoln and Jackson" (EI,19). Fiedler's larger purpose was to respond to the spectacle of what Alastair Cooke had called "a generation on trial." Hiss, in Fiedler's opinion, had indeed failed "all liberals" who had once shared his "illusions" by not honestly speaking aloud his supposed convictions. He concluded, however, by taking up the penitential cause of all the self-flagellating liberals who saw themselves at the dock alongside Hiss ("there but for the grace of God go I" was the *de rigeur* sentiment among many intellectuals of the day).[35] The age of innocence is dead, Fiedler announced, "we" must "move forward from a liberalism of innocence to a liberalism of responsibility" (EI,24). This show of communal repentance was inspired by a recognition of complicity between the critic, his readers, and the accused—all of whom were assumed to be articulate, bona fide intellectuals. No such common courtesy, however, was extended to the Rosenbergs.

Fiedler's essay on the Rosenbergs appeared, appropriately enough, in the inaugural 1953 issue of *Encounter*, the organ of the new Congress for Cultural Freedom, and a journal purposely based in London in order to offset creeping European neutralism.[36] Indeed, much of the weight of Fiedler's attack was directed at the massively sympathetic European response to the Rosenbergs' plight. Disgusted with Fiedler's trio of essays on Hiss, the Rosenbergs, and McCarthy, Harold Rosenberg, in turn, imagined the European response to Fiedler: "As one of our new cultural ambassadors 'explaining us' to the Europeans, Fiedler must have done as much as anyone to confirm the belief that everyone in America lives on a billboard."[37] Creeping billboardification was hardly Rosenberg's idea of a stiff remedy for creeping neutralism! But Rosenberg's response to Fiedler is also, in its own way, a response in kind, because it accuses Fiedler of depthlessness—exactly the same charge brought to bear on the Rosenbergs by Fiedler and Warshow (there is nothing "behind" the letters just as there are no "real" Rosenbergs). Rosenberg objects to

Fiedler's use of "we" to invoke a whole generation, and suggests that it is an empty "we," a made-up character with an attributably guilty past to which he and all other liberals must now confess. Rosenberg is puzzled (a favored rhetorical strategy of his) by this claim that "all liberals" are contaminated by the past, and he confesses: "I never shared anything with Mr. Hiss, including automobiles and typewriters."

But Rosenberg's critique comes home to roost when he suspects that, behind Fiedler's "I," there is no real political experience to speak of. More recently, Morris Dickstein has repeated this charge: "Fiedler's involvement in the political life of the thirties was practically nil"; instead of an activist past, all he had was "illusions," and they were the illusions of others, to boot.[38] The point I want to make here is that, although both Rosenberg and Dickstein draw attention to different "discontents" from those of Warshow and Fiedler, they tend to reproduce the critical strategy by which Warshow and Fiedler had stripped the Rosenbergs of all their "contents." Each, in turn, were being sentenced to political death by this same critical strategy: the Rosenbergs, by Warshow and Fiedler, and then Fiedler himself, by Rosenberg and Dickstein.

If Warshow's essay reads like a Metaphysical poem, in which the Rosenberg letters were "nothing," begot of "things which are not," Fiedler presents himself as a New Critic, reading the Rosenberg case *as if it were* a Metaphysical poem. This conceit could be supported by the preface to *The End of Innocence*, the 1955 volume in which his essay was published, rescued from the polemical fray of *Encounter* and *Commentary*, and offered up to the tweedy world of academic criticism. In fact, Fiedler, a literary man at heart, is worried that he may be "misrepresented" to academic critics by a first book that is so political.[39] *Because* he presents himself as a serious literary man, trained by the "newer critical methods," and thus immune to "journalistic platitudes," Fiedler feels that he should be trusted to produce a "close reading" of cultural events in the same way as a New Critic would read a poem with an eye to paradox and ambiguity. If Fiedler, in the mid-fifties, was clearly trying to salvage academic respectability for such a political book, it was quite obvious to any reader that the book was composed of essays originally written for nonacademic intellectuals who, unlike the New Critics, believed that art and politics were more than just a set of textual paradoxes.

In his essay, Fiedler recognizes two Rosenberg trials. The first was a "real" trial, based on real facts, and it produced a real verdict, with which he concurs. However, it is with the second, "symbolic" trial that he is concerned, a trial in which the Rosenbergs were judged innocent by "liberaloid" and "Stalinoid" sentimentalists all over the world. Between the first trial and the symbolic trial that was conducted through fiction and propaganda, the real Rosenbergs had disappeared as putative authors of

themselves and their acts; in disappearing, they became nothing more than an "all-purpose vocabulary" that could variously position them as victims, martyrs, Jews, Americans, dissidents, or rebels. *Real* martyrs, Fiedler grants, do exist. Sacco and Vanzetti, for example. But the Rosenbergs did not exist, inasmuch as their existence only had meaning for the Stalinized mind, for which events and persons do not *exist* until they appear in Party journals and newspapers. Fiedler imagines a small group of "conscious exploiters" in the Party, manipulating a "mass of naive communicants" who form a conveniently "prefabricated public," thereby "stalinized at second or third remove." But this stereotypical picture of American Communists as slavish automatons of foreign directives hardly does justice to the flourishing of a political community and subculture which, in the thirties and forties, had transformed so many thousands of its members' lives and which, in the Popular Front period, had tried to establish deep roots in American political institutions, cultural traditions, and popular structures of feeling. In fact, the inadequacy of this scenario makes it virtually indistinguishable from the conspiracy picture of American industrial mass culture, made familiar by Clement Greenberg, Dwight MacDonald, and other Cold War liberals—whereby the fat cat, capitalist "lords of kitsch" set about ventriloquizing an inert and prefabricated mass of consumers.

What does it take for a Communist to be human? This is the question, nevertheless, which Fiedler claims that he is addressing in his essay about the Rosenbergs. For Fiedler and other professional anti-communists, to be a Communist was to be *purely* political (just as, say, the homophobe's gay is someone who *only* commits homosexual acts). Whatever they were, Communists were no longer human because they had resigned their humanity. To say this of the Rosenbergs in 1953 was a way of blaming the victims without having to acknowledge them as real people. Rebecca West, for example, ends *The Meaning of Treason*, her book on spies, by musing over how "the photographs of the Rosenbergs show that their faces, formed by nature to express natural emotions, resigned the expressive function, and became blank as if they had made the final resignation of that function which is death."[40]

Harold Rosenberg, again, had an important point to make about this alleged "empty fictionality" of the Rosenbergs. In a letter of response to Fiedler's article, sent to *Encounter* but not printed by the editors of that journal, he pointed out that in cases of law "no defendant is a 'person'— *nor ought to be*. The law defines a man by his act. Justice requires only that he shall not be made to personify an act that he did not perform; and that the punishment shall not be cruel and inhuman and shall fit the crime."[41] The Rosenbergs were in fact made to personify much more than they could have possibly performed. In Rosenberg's view, they were

made to become individuals, rather than "subjects," before the law, firstly because of the absurd severity of their sentence, and secondly, because the government had to create a demonic "atom spy" to fit the bill (no *real* spy could exist, since there was no real secret to give away). The law was thus superseded by "the dramatic imagination *with its power of creating the person it judges*." Rosenberg's conclusion, then, is that there was too much humanity in the case, and that justice should have been left alone to pursue its more abstract ends. Fiedler had been wrong to suppose that there was *too little* humanity shown in the case.

The real difference, then, between the two critics is that Rosenberg thinks that politics, like art, is *too* humanizing, and ought to be more objective, while Fiedler thinks it is not humanizing *enough*, and sets about correcting the imbalance. If nothing else, this shows that Fiedler is much less of a New Critic than Rosenberg would care to be. Nonetheless, it has been argued, by Dickstein, that for Fiedler (and Warshow), the Rosenberg case and the Letters were "a godsend, a text, life in an orderly bundle," and were thus subject to the worst heresies of academic "textualism."[42] But it is clear that Fiedler, at least, was concerned with something more than the seamless charm of his own powers of interpretation. In fact, he insists that we should learn from the Rosenbergs' failure to distinguish between fact and fiction, from their "constitutional inability to be frank," and from their powerful belief in their own "unimpeachable innocence" (EI,41). The *lesson* of the Rosenbergs is that, unlike them, we must learn to tell the difference between a text and the real thing. If the Rosenbergs could not be called liars, since everything they touched, "including themselves," was false, they could perhaps be compared to the New Critical stereotype—the critic who does not see where art or politics ends and where the world begins.

To fall into the same trap of indifference as the Rosenbergs, will dehumanize "us" too, although, as non-Communists, Fiedler assumes that his readers have more to lose in the way of humanity. He thus appears to want to *rehumanize* the Rosenbergs, but he does so on his own terms, after having stripped them of any "humanity" they might otherwise have earned for themselves with dignity. But Fiedler's way of rehumanizing is perhaps worse than the FBI's ultimatum of "Confess or Die!" Fiedler's is the way of the Christian humanist tradition in which the heretic saves his soul, but not his earthly face, by confessing; he will be damned and burned anyway, but at least he will have died for something *real*. Fiedler undertakes to confess for the Rosenbergs by revealing the true referent of their sins. He reveals that they were not condemned for believing in "peace, bread and roses and the laughter of children"; these were only heretical codenames for something else: "one must look deeper, realize that a code is involved, a substitution of equivalents whose true meaning can be read off immedi-

ately by the insider. 'Peace, democracy and liberty,' like 'roses and the laughter of children,' are only conventional ciphers for the barely whispered word 'Communism' and Communism itself only a secondary encoding of the completely unmentioned 'Defense of the Soviet Union'" (EI,45). In the end, this confessor grants the Rosenbergs a limited kind of "grace" when he recognizes, on their behalf, the true, unspoken referent of their double talk. It is up to the reader to follow suit, granting them a higher humanity than they deserved, because the "suffering person is realer than the political moment that produces him or the political philosophy for which he stands" (EI,45).

Rosenberg points out that Fiedler's essay gruesomely restages each component—political, legal, and cultural—of the victims' ordeal. That, it seems, is the price to be paid for asserting the superiority of the liberal conscience in 1953. It was also a conscience, as I have suggested, that guaranteed immunity to the intellectual from all forms of quasi-intellectual contagion: from the "sublunary" judgments of the courts, from the "vulgar" political interests of the State, from the "sentimental" egalitarian imperative of the Popular Fronters, from the "academic" textualism of the New Critics, and from the "Stalinoid" dissimulations of mass culture. Here, then, was the caste-bound voice of the secular priesthood of intellectuals, exercising its special powers of redemption on behalf of even the most conscious of sinners: "it is our special duty to treat as persons, as real human beings, those who most blasphemously deny their own humanity" (EI,45).

The need to affirm the fierce independence and superiority of these powers of judgment made for political consequences often more bizarre than those found in the case of the Rosenbergs. Fiedler's essay on "McCarthy and the Intellectuals" is a case in point, if only because it makes exactly the same moves on McCarthy as had been made on the Rosenbergs—but with almost the opposite effects. There is a "real" and a "legendary" McCarthy, Fiedler suggests, but the former has long since disappeared. "McCarthy" only exists now (in 1954) as a surface, in the media, and he is as "vividly unreal as a political slogan" (EI,47). As a result, fighting him would be like fighting a windmill; he deals only with issues and not facts, and he no longer exists outside of his twin popular roles as "Captain America" and "The Witch Hunter." These might strike us today as flimsy, even shameful, grounds for the appeasement of McCarthy, but Fiedler's subsequent attempt to *rehumanize* McCarthy (just as he had burdened himself with rehumanizing the Rosenbergs) actually distributes the blame for the Senator's excesses upon his victims, and other unnamed innocents.

First, he displaces the fraudulence of McCarthy's methods onto McCarthy's target, by comparing them to the discursive moves by which Popular

Fronters had tried to Americanize Communism. Second, Fiedler discovers that McCarthy is not a reactionary, anti-intellectual stereotype, and that he is much closer to the popular will than were his Communist victims, because McCarthy himself is a victim of that will. If McCarthy *does* represent something, and if that something is brutal and nasty, it is because it "comes of something in the American people which grows impatient with law and order" (EI,81). McCarthy, then, is a "symptom" of this irrational, populist faith, a creature of the people's dark will, who, if it had not been for the demands of the moment, would otherwise be what he really is—a "hopelessly ordinary politician," corrupt in a small-time way like any "run-of-the-mill lawyer." He is the dupe of the masses, a sympathetic, even endearing "American instance," who happens to have been "the victim of almost as many frauds as he himself perpetrated" (EI,59). Not content yet with this rattlebrained image of McCarthy as *victim* of the masses, Fiedler goes on to suggest that he is equally a creation of left-wing "liberal mythology," a monstrous projection of "paranoia answering paranoia" (EI,75). Rehumanizing McCarthy, as we can see, has merely become Fiedler's vehicle for maligning those whom McCarthy persecuted—left liberals, radicals, and Communists—and also those— "the people"—who were quite incongruously held responsible for his excesses in office.[43]

If the Rosenberg case was haunted by the finality of the *electric chair*, the new technology of apocalypse revealed by McCarthyism was the *electronic chair*—the grisly spectacle, as Fiedler saw it, of a whole nation "transfixed for weeks before their television sets in a voyeuristic orgy" as the senator died a slow public death in the broadcast Army hearings. This, in fact, is Fiedler's final displacement of the blame; the contempt which ought, by right, to be forever associated with McCarthy's name, is attributed to those who watch the televised spectacle only to hate themselves for not having the courage to turn off their sets. All of the shame that is McCarthy's had become internalized in the obsessive sense of guilt with which people had begun to watch television, while being encouraged to forget that, somewhere else, other than on television, politics is required to be real.

Tomorrowland

Two years after the Rosenbergs were put to death, cultural "innocence" was to be offered its very own institution when Disneyland, the famous theme park, was opened in Anaheim, "a town," as E.L. Doctorow diagnostically puts it, "somewhere between Buchenwald and Belsen." It is fitting, then, that Doctorow's own novel about the Rosenbergs, *The Book of Daniel*

(1971), features a penultimate scenario set in Disneyland, where Danny, the Rosenberg-son character, who is now a feisty New Lefter, has sought out Selig Mindish, the Greenglass character, now very old and palsied. Tomorrowland, where they meet, is that section of the park, in contrast to Fantasyland, Adventureland, and Frontierland, where history, even in its most mythological Disney form, has been banished. There follows a moving scene between the wasted Mindish and the insistent youth; "for one moment of recognition he was restored to life," and he kisses Danny's head "in wonder." It is an all too brief appearance of the "real" in an environment that prohibits such "direct" living, and lives, instead, off vicariousness.

Doctorow's novel seems to need this conventional moment of truth in order to complete its litany of political horror, as alive for Danny in U.S. foreign policy of the late sixties as it was in the domestic persecutions of the fifties. But Doctorow just as surely *needs*, as a scourge, the shorthand of Disney history, reduced still further to the mindless "theme" of this monument to popular culture, for his politics to take on its fully humanist meanings. Disneyland, he writes, drawing upon a rhetoric that, ironically, echoes Fiedler, Warshow, and other Rosenberg detractors, "is only a sentimental compression of something that is itself already a lie."[44] The site of a monstrous confidence trick upon the American people, it becomes an appropriate backdrop for this encounter, because it evokes the stigma of falsity with which the Rosenberg case, it seems, will always be associated.

Because of this association, the Rosenbergs continue to exert a profound fascination not only for the political conscience of the left, but also for its conscience about popular culture. If Doctorow tries to redeem the Rosenberg past and present through his own critique of popular culture, that strategy is turned on its head in Robert Coover's *The Public Burning* (1977), a novel about a series of grotesque media entertainments staged around the public execution of the Rosenbergs in Times Square, where "all top box-office draws since the days of the Roman circus" have been officially celebrated.[45]

Here, the languages of the "secondhand" are excessively reproduced without any deference to an uncorrupted realm of truths, public or private. What happens to the Rosenbergs *happens* within the constructed popular culture at large, and is supervised, not by the J. Edgar Hoovers of a servile state apparatus, but by the Cecil B. De Milles and the Uncle Sams of a culture addicted to the commodification of history's myths and icons, among which are now counted the Rosenbergs themselves. Appointed to head up an Entertainment Committee, which includes Bernard Baruch, Walt Disney, Sam Goldwyn, Ed Sullivan, and others, De Mille is asked to stage an ambitiously eclectic pageant to precede the

execution. Oliver Allstorm and the Pentagon Patriots lead off a show that includes a Texas high-school marching band, the Singing Saints of the Mormon Tabernacle Choir, Harry James and his Orchestra, the Singing Cowboy Gene Autry, the Holy Six, a fifteen-round boxing championship bout, backup movies, pantomime, poetry, evangelist sermons, hymns, and many other popular sideshows. The frenzied audience is studded with personalities from Hollywood and Capitol Hill, and Betty Crocker serves as hostess for a VIP processional. When it is announced that prizes are to be awarded for skits or readings from the Death House Letters, the response is stupendous: Astaire and Rogers work up a dance routine around a single line from a letter by each of Julius and Ethel; Abbott and Costello act out a series of gags around the same theme; Boris Karloff and Elsa Lanchester do an "electrifying" Frankenstein-is-born act; Bob Hope, Bing Crosby, and Dorothy Lamour perform "Going My Way" on the electric chair; other acts include Dean Martin and Jerry Lewis, Amos 'n' Andy, Jimmy Durante and Garry Moore, Laurel and Hardy, Mickey Rooney and Judy Garland, Buster Keaton and Jack Benny. The Marx Brothers win the prize for their special understanding of the Rosenbergs' Jewishness. As for the Rosenbergs themselves, their eventual appearance and execution is merely the most poorly acted turn on stage.

While the entertainment world holds sway in Coover's novel, politics is no less present, and is represented, primarily, through the point of view of Richard Nixon, who is the unlikely narrator of large portions of *The Public Burning*. Presented as the "intellectual" of the Eisenhower administration, Coover's Nixon seeks to redeem the Rosenbergs in a more sympathetic way than Fiedler or Warshow had offered to do. He compares his own "Checkers" speech with the Death House Letters; his speech, he reckons, had more feeling, and, besides, he told the truth, didn't he? Social differences, however, get in the way; the Rosenbergs hung out with "people Pat and I wouldn't know how to talk to" (p. 158). Consequently, his only resort is to present himself as a *victim* on the same scale as the Rosenbergs. "We've both been victims of the same lie, Ethel!" he points out, as they botch a lovemaking attempt minutes before Ethel's scheduled execution. Nixon, backing on to the public stage, is revealed with his pants down, but there is no threat of *exposure*, only the occasion for this eternal opportunist to strike up yet another political slogan: *"Pants Down for God and Country! Pants Down for the Common Man! Pants Down for Dick!"*

Caught with his pants down, protesting "innocence," and getting away with it, Coover's Nixon could be interpreted as a cruel parody of the Rosenbergs' failure to do likewise. He is as much an ironic response, however, to those Cold War liberals who sought to exorcize their own pre-war political "innocence" by demonizing the untidy contradictions of

lower middle-class culture. If Coover's novel represents Nixon as the "intellectual" who *understood* the Rosenbergs, Nixon himself was to become a White House parody of the idea of an "intellectuals' President," after all the candidate-intellectuals like Henry Wallace, Adlai Stevenson, Eugene McCarthy, and George McGovern had failed. And when Hollywood itself began to produce presidents, the shoe was, finally, on the other foot. Ronald Reagan was not a simple return of the repressed. In fact, he came to represent one possible resolution, an alarming right-wing resolution, of the dialogue between culture and politics that Popular Fronters had first sought to establish in their broadly pitched search, from cocktail parties in Hollywood to hootenannies in Brooklyn, for a common vocabulary and a popular language for the left.

Although the Popular Front versions of this dialogue had often been awkward, and anachronistically based upon romantic, preindustrial notions of the "folk-popular," it was a dialogue that many Cold War liberals could not even begin to recognize, let alone develop, because it meant taking popular culture seriously. Not as a tool of enlightenment to be used for (good) education, or as a channel of subordination to be resisted for its (bad) domination: the positions of the liberal pluralist and the liberal dissenter respectively. But as a terrain on which political meanings could be won or lost.

2

Containing Culture in the Cold War

Ignorance of Communism, fascism, or any other po-
lice-state philosophy is far more dangerous than igno-
rance of the most virulent disease. (Dwight D. Eisen-
hower, at his inauguration as President of Columbia
University 1948)

Mass culture, mass society, the masses. They have all come to sound
"un-American," as if they suggested alarming foreign activities that surely
"can't happen here," to use Sinclair Lewis's ironic phrase. For terms
whose referents are held to lie outside of the national culture, however,
they still retain a good deal of currency today, not only in the lexicon of
intellectuals, but also in certain vernacular turns of phrase. In fact, these
terms often function either as external limits or boundaries against which
the official idea of a national democratic culture is defined, or, when
applied internally, to denote a critical, dystopian view of profoundly
undemocratic features within that culture. (A more or less neutral mean-
ing is assumed in quantitative usages that apply to technical communica-
tions, like "mass transit" or "mass media.") In short, "mass" is one of the
key terms that governs the official distinction between American/Un-
American, or inside/outside.

The history behind this official distinction is in many ways the history
of the formation of the modern national culture. It has its origins in the
postwar political and cultural settlement, often referred to as the age of
consensus, which established liberal pluralism as the ideal model of a
fully democratic, classless society. The temporary success of this postwar
settlement, at least until the late sixties, depended, to a degree hitherto
uncalled for, on the cultural authority of intellectuals. For perhaps the
first time in American history, intellectuals, as a social grouping, had the
opportunity to recognize themselves as national agents of cultural, moral,
and political leadership. In fact, many of them helped to underwrite and
legitimize the new rules of *consent*, which demanded—mostly in response
to the consolidations of the labor movement in the thirties and forties,
but also in embryonic recognition of the claims set in motion by the
wartime "contributions" of women and blacks—the containment, absorp-
tion, and enfranchisement in "power-sharing" of an expanded range of
social and cultural groups.

42

The conditions under which many intellectuals were "recruited" for this task were determined by the new exigencies of a *national* culture, defensively constructed against foreign threats and influences, and internally strengthened by the declaration of a consensus, posed in the form of a common and spontaneous agreement about fundamentals. As a result of this new consensus about things American, there was a price to pay for those whose intellectual interests and loyalties had been shaped by marxist thought and by the lively, if territorially divided, marxist culture that had flourished in the thirties and early forties. If the restorative properties of the new liberal pluralism were to take hold, terms like "class" and "mass," so redolent of that vestigial marxist culture, would have to be quarantined, if not entirely lobotomized from the national mind.

To explain how this *cordon sanitaire* was established, and to gauge the extent to which it was resisted, we need to examine the intense, and quite public, debate about "mass culture" that occupied intellectuals for almost fifteen years, until the late fifties. I do not invoke these metaphors about public health gratuitously. The debate about mass culture was conducted in a discursive climate that linked social, cultural, and political difference to disease. In this respect, I will show that the rhetoric of containment, established primarily in the area of U.S. foreign policy, was to have specific, if pervasive, uses for the domestic settlement that secured the Cold War consensus.

Kitsch, Containment, and Immunity

In a 1984 interview, Dwight MacDonald, who claims to have coined the term "mass culture" (at Meyer Schapiro's suggestion) recounts his memory of the origins of Clement Greenberg's famous essay "Avant-Garde and Kitsch." The essay, he claims, began as a letter written in response to MacDonald's own series of 1938 *Partisan Review* articles on the Soviet cinema, in which MacDonald had speculated that the post-revolutionary films were very popular with Russian peasants. MacDonald (erroneously) recalls how, in his article, he had praised other "primitives" as well: "look at what wonderful things the Africans do."[1] According to MacDonald, Greenberg's letter of reply pointed out that the "first thing these marvelous native tribesmen in Africa and Australia, who do such wonderful abstract work, demand of the explorer is not the works of Picasso but picture postcards, gaudy, horrible." As it happened, this stunningly absurd scenario (at least, in the way that MacDonald recalls it) did not survive wholly intact in "Avant-Garde and Kitsch." What Greenberg primarily discusses there is MacDonald's scenario in which an

"ignorant Russian peasant [not quite the same as a "marvelous native tribesman"] . . . stands with hypothetical freedom of choice between a painting by Picasso and a painting by Repin"; the peasant is reminded, in the Picasso, of the quaint domestic formalism of the village icon, but opts, finally, for the kitsch pleasures of the Repin because, as Greenberg suggests, the Repin spares him the effort of pure intellectual reflection and interpretation.[2]

This peasant's "hypothetical freedom of choice" could be read as a bitterly ironic prefiguring of the limited choices faced by cultures in the moment of decolonization, which is on the not so distant horizon in 1939. Indeed, Greenberg's advance warning about the spreading epidemic of kitsch looks forward to the postcolonial heyday of American pop cultural imperialism. He writes that kitsch has "gone on a triumphant tour of the world, crowding out and defacing native cultures in one colonial country after another." It shows no regard for "geographical and national-cultural boundaries" and will soon be a "universal" culture: "today the Chinaman, no less than the South American Indian, the Hindu no less than the Polynesian have come to prefer to the products of their native art, magazine covers, rotogravure sections, and calendar girls." Greenberg's explanation of why the native of these cultures is unable to resist, and in fact welcomes the oncoming tide of kitsch, is that kitsch is "essentially its own salesman," by virtue of its own formal properties and regardless of the success of its commercial distribution or the uses made of it. For Greenberg, it is thus an inherent *formal* quality of kitsch rather than an imposed cultural imperative which accounts for the peasant's capitulation before the irresistible charm of the kitsch object. Consequently it no more needs a critic to "explain" kitsch than it needs a competent audience to "appreciate" it.

It was this formal quality that MacDonald, drawing upon Greenberg's claim that kitsch "pre-digests" and "imitates the effects of art," came to call the "built-in reaction" of popular culture. In short, kitsch already *contains* our response to it. Avant-garde art, by contrast, *contains* only its own response to itself—the "imitation of imitating" which Greenberg designates as the essential component of abstract formalism. Because kitsch structurally contains some possible part of us, kitsch cannot be "contained," as a mass epidemic could be contained by quarantine or by administering the correct antidote or vaccine, whether social or medicinal.

In fact, when it comes to (what he referred to as) the "virulence" of kitsch, Greenberg was already suggesting that our immune system would be defenseless. What is really at stake, moreover, in the international battle of serious culture vs. kitsch, is the health of each national culture's lifeblood. His essay ends with a wary, if not ominous, nod in the direction

of Europe where, by 1939, it is in the name of "the blood's health" that the statue-smashing has begun. Why? Because fascism is a mass culture, and, for Greenberg, this seems to lead inevitably to "revolvers and torches" being "mentioned in the same breath as culture." And what is the underlying cause of this barbarism? An excess of democracy, welling up from the apocalyptic moment, as Greenberg describes it, when "every man, from the Tammany alderman to the Austrian house-painter, finds that he is entitled to his opinion."

Greenberg's premature anxiety about the "totalitarian" features of mass culture, spliced with his concern about the "excesses" of egalitarianism, looks forward to a long postwar debate among intellectuals about mass culture and mass society that is explicitly shot through with a rhetoric about containment. Harold Rosenberg, for example, would conclude that "there is only one way to quarantine kitsch: by being too busy with art."[3] Louis Kronenberger speculated about "how to avoid contamination without avoiding contact.[4] Irving Howe contended that "the vast culture industries are parasites on the body of art, letting it neither live nor die," and that "direct criticism [of them] . . . is a necessity of hygiene."[5] MacDonald was quite unequivocal about the need for "a staying power . . . against the spreading ooze of Mass Culture,"[6] and David Riesman declared his fellow intellectuals' reluctance to "give the patient a clean bill of health lest some other doctor find a hidden flaw."[7] In a telling phrase, Tom Hayden's original draft for the 1962 Port Huron Statement would speak of the "paranoid quest for decontamination" that had seized Cold War intellectuals.[8]

The widespread use of this rhetoric belongs, of course, to the chorus of similar hysterical discourses that contributed to the Cold War culture of germophobia, and the many fantasmatic health concerns directly linked to the Cold War—Is fluoridation a Communist plot? Is your washroom breeding Bolsheviks? Cold War culture is rich with the demonology of the "alien," especially in the genre of science fiction film,[9] where a pan-social fear of the Other—communism, feminism, and other egalitarianisms foreign to the American social body—is reproduced through images drawn from the popular fringe of biological or genetic engineering gone wrong.[10] Beneath the pervasive discourse of germophobia, fears about the failure of the national immune system ran strong. Most symptomatic of this was the film version of *War of the Worlds* (1953), where the alien invaders withstand every attack made by conventional weaponry but finally succumb to everyday American "germs." In a world that is divided between us and hostile, pathogenic "germs," the film demonstrates the problematic of containment from both sides.

How had the idea of containment come to be recognized as a matter of public, or official, concern? The standard sources for the Cold War

policy of containment are diplomat George Kennan's two documents: the "long telegram" from Moscow in 1946, and the 1947 article "The Sources of Soviet Conduct" (known as the "X article"). In what survives of Kennan's theories in the popular consciousness, most of us are aware of the emphasis placed on the inevitability of Soviet expansionism. We may even recognize his celebrated metaphors: Russia is "a toy automobile wound up and headed in a given direction"—mechanical inevitability; or, Russia is "a fluid stream that moves constantly, wherever it is permitted to move"—organic inevitability.[11] Consequently, we tend to think of "containment" in the sense of militarily keeping at bay or holding in check an aggressive *external* threat; in terms of the theory of superpowers, the world is thus seen as an arena in which two opposite and equal Newtonian forces are held in a delicate, coldwarring balance. Indeed, this was the standard militaristic interpretation of containment on the part of the U.S. foreign policy establishment, at least until Vietnam.

Kennan has long complained that this was a misconstrual of his own 1946 advice, which was not primarily intended to be militaristic but which was directed, instead, at the internal "political containment of a political threat."[12] In addition, he claims, he meant to "encourage other peoples . . . to defend the *integral* integrity of their countries," to discourage domestic coercion of the sort practiced in a police state, and not necessarily to support international coercive measures of the sort that have characterized subsequent Cold War interventionism. But what is actually in play here are two different meanings of containment. The first speaks to a threat *outside* of the social body, a threat that therefore has to be excluded, or isolated in quarantine, and kept at bay from the domestic body. The second meaning of containment, which speaks to the domestic *contents* of the social body, concerns a threat internal to the host which must then be neutralized by being fully absorbed and thereby neutralized.

These two meanings are often difficult to keep apart in Kennan's polemical reasoning, especially since his arguments proceed from a "psychological" explanation of Soviet hostility. In fact, his theory is almost wholly derived from an alleged Soviet *fear of being contained*, manifest, as Kennan sees it, in the historical insecurity of Russia about its borders, and reinforced now in the Stalinist fear of "capitalist encirclement." Containment, as a policy, then, might succeed by simply playing upon this Soviet fear of being contained. On the other hand, Kennan argues that the Soviet view of the capitalist world is that the West contains (the second, "domestic" meaning of containment), within its own internal, or domestic, contradictions, the reasons for its inevitable demise: the Soviet views the "outside world as . . . bearing within itself germs of creeping disease, and [is] destined to be wracked with growing internal convulsions

until it is given final *coup de grace* by rising power of socialism . . . "[sic].[13] In the "X article," however, Kennan proposes, in a further twist of his argument, that this may be no more than a Soviet self-projection: "Soviet power, like the capitalist world of its own conception, bears within it the seeds of its own decay, and . . . the sprouting of these seeds is well advanced."[14]

The lesson that Kennan draws from this series of mirror-images of decay begins to sound like a lesson in immunology, surely the most overdetermined of all the Cold War scientific discourses: "World communism is like a malignant parasite, which feeds only on diseased tissue." It is no surprise, then, to find Kennan prescribing that we ought to avoid hysteria and emotional provocation when dealing with this pathogenic threat to our political health, and that we ought, instead, to study Communism with the kind of detachment with which a "doctor studies an unruly and unreasonable individual." Everything finally depends upon the "health and vigor of our own society" in its ability to resist or contain the corrosive effects of Soviet attempts to "disrupt the internal harmony of our society" by penetrating what Kennan named as labor, youth and women's organizations, religious societies, cultural groups, liberal magazines, and publishing houses, among others. From this perspective, the great test of national integrity would not take place on the front line, but rather in the success of domestic policies of social and cultural containment.

Clearly, then, Kennan's analysis is much more like a prescription for domestic than foreign policy. In fact, it anticipates, if it does not exactly advocate, the Red scare that generated much of the postwar hysteria about aliens, bugs, pods, microbes, germs, and other demonologies of the Other that pervaded the culture and politics of the fifties. Within a year or so, J. Howard McGrath, the Attorney General, was describing how the Communist is "everywhere—in factories, offices, butcher shops [sic], on street corners, in private businesses—each carries with him the germs of death."[15] But Kennan (who left his government position in 1950), also spoke as one of a body of intellectuals who enjoyed a new cultural authority in the postwar years, and whose authoritative contributions to the new consensus in the national culture depended explicitly upon the containment of intellectual radicalism and cultural populism alike.

Classes or Masses?

To illustrate this point, we must briefly describe the shift in legitimacy that characterized the respective social position of American intellectuals

in the thirties and in the postwar settlement. Greenberg's 1939 essay, with its talk of "explorers" and "natives," suggestively evokes the ethnological feel of a decade when writers and artists had set out on exhaustive fact-finding travels all over the country, imbued with the documentary spirit of studying a hitherto "unseen" native culture that could be cast as either "folk" or "proletarian" in character. Edmund Wilson, Sherwood Anderson, James Rorty, Theodore Dreiser, John Dos Passos, Gilbert Seldes, James Agee, and, of course, the Farm Security Administration photographers were among the many who undertook this kind of field study. Documentary presentations focussed in different ways, in word and image, on popular experience: films like Pare Lorentz's *The Plow That Broke the Plains* (1936), or Robert Flaherty's *The Land* (1941), the Federal Writers Project's *These Are Our Lives* (1939), James Agee and Walker Evans's *Let Us Now Praise Famous Men* (1941), Erskine Caldwell and Margaret Bourke-White's *You Have Seen Their Faces* (1940), Richard Wright's *12 Million Black Voices* (1941), and countless others. So too, the search for a "usable past" meant the discovery of a homegrown social anthropology: Ruth Benedict's *Patterns of Culture* (1934), Stuart Chase's *Mexico: A Study of Two Americas* (1931), Constance Rourke's "The Roots of American Culture," and *American Humor* (1931), Thurmond Arnold's *The Folklore of Capitalism* (1937), alongside less legitimate ethnography like Henry Luce's immensely popular "March of Time" newsreels.

New and highly praised genres like the "worker narrative" and the "folk" or "vernacular" history drew upon heavily ideological notions of "authenticity," and there was often a very thin line drawn between what was praised as true documentary objectivity and what was disparaged as sweetened or sentimentalized presentations of everyday folk life. Such distinctions, between, for example, the truly original and untouched record of sharecropper life and the candid, journalistic exposé, are still to be found in critiques like that of William Stott, who contrasts the pristine *Let Us Now Praise Famous Men* with *You Have Seen Their Faces*, the authors of which, Stott claims, put words into their subject's mouths.[16] The montages of the latter, which match Margaret Bourke-White's photographs with Erskine Caldwell's folksy caption-quotations, suggest many of the elements of kitsch according to Greenberg's definition, because they contain, *a priori*, in the cloying fitness of word to image, the reader's ready-made reaction. There is only presentation, and no recorded awareness or analysis of the methods used to produce the powerful emotional effects of these captioned images.

By contrast, the preface to *Let Us Now Praise Famous Men* openly agonizes about the ethical propriety of Agee and Evans's documentary record of the daily life of tenant farmer families. Within the text proper, Agee and Evans take pains to disavow any pretensions to either scientific or

artistic interest in their subject. Recognizing their guilt in *appropriating* the images and integrity of an Other, they sought to justify themselves by recording that they were "curious," rather than "honest"; by claiming that they were "spies, guardians and cheats," and wouldn't pretend to be "journalists, sociologists, politicians, entertainers, humanitarians, priests or artists" (least of all the latter: "above all else, don't think of it as Art").[17] Aware of the contrast with Bourke-White and Caldwell, Agee and Evans vindictively included, in an appendix to their book, a series of news clippings about Bourke-White's success, which dwell (damningly when read in this context), upon her gay, upper-class lifestyle; a "tango expert," she loves theater, swimming, ice skating, and "adores" horseback riding.

Delmore Schwartz was certainly patronizing but not entirely amiss when he tells of a well-known critic, in the worst part of the Depression, who, having just arrived at the home of a Southern friend for a visit, had scarcely put down his suitcase when he asked his host: "Where are the sharecroppers?"[18] Schwartz's parody apart, what this scenario presents is an image of the intellectual in foreign parts, with a sense of mission at hand, and, for the first and possibly the last time in American cultural history, a universal politics of class (or class conflict), to think with.

With the Comintern announcement of the Popular Front in 1935, the abandonment of scientific socialism, and the new emphasis on solidarity with the American people as a whole, sharecropper and industrialist alike, such class antagonisms were played down. In response, anti-Stalinist intellectuals withdrew from the fray of American cultural politics, and took to celebrating the pantheon of European high modernist thinkers and writers. For a brief time, however, during the ultraleftism of the early thirties, class analysis was the privileged cultural outlook of American intellectuals, and popular culture was seen as a tool for educating and mobilizing popular opinion. Even in the broadened cultural base of the Popular Front period, intellectuals could still see themselves as missionaries, offering the masses an alternative folk culture (or, through the good agency of Hollywood Popular Fronters, a "progressive" film culture) that was more germane to their interests than what was seen as the debilitating political effects of commercial popular culture. Attempts to forge a proletarian culture (centered upon the notoriously hard-boiled "proletarian novel") or, after 1935, a peoples' culture, were posed as a way of competing with the rival attractions of industrial mass culture.[19]

Halfway through *Where Life is Better*, the 1936 documentary travelogue of James Rorty, advertising copywriter-turned-muckraker, there occurs a symptomatic meeting between the "missionary" of proletarian culture and the "slavetrader" in commercial popular culture. Driving between Toledo and Detroit, Rorty picks up a salesman of block subscriptions for

the mass market McFadden publications (satirized by Rorty as *"Blue Romances, Stewed Stories, Flicker Fancies* and *Fraternity* . . ."). Rorty interrogates the rival culture-bearer and is alarmed to learn how widely his wares are distributed among workers and their families. Repulsed by the salesman's reactionary politics and his cynicism about "serious" culture, Rorty aggressively abandons him in "the middle of a deserted stretch of scrubby pine land."[20] Rorty's lack of fraternity could be seen as a displacement of his own frustrated mission to convert the masses, a frustration that pervades his and many other likeminded narratives.

But the same ethnographic frame of reference—minus the missionary discourse—was adopted by those who never ventured into the hinterlands and who, on occasion, were obliged to be crudely honest about their metropolitan insularity. Dwight MacDonald, for example, wrote of *These Are Our Lives: As Told By the People and Written by Members of the Federal Writers Project*: "to one who like myself lives in a big city and has always had enough to eat, many of these stories seem as remote as tales of some tribe in Africa" (although MacDonald opines that the "African savages" have a much better time of it than these Southern sharecroppers did).[21]

If the dominant model of attention in the early thirties was that of a class society, then the appearance of fascism—characterized by a form of social and ideological organization that appeared to transform classes into "masses"—ensured that the social concern of American intellectuals would increasingly be with the model of a mass society and a mass culture. Although it had long been an article of faith among conservative thinkers like De Tocqueville, Nietzsche, F.R. Leavis, T.S. Eliot, and Ortega y Gasset, the mass society critique was first advanced on the left as an explanation for the failure of socialist movements, and the growing successes of fascism. The influence of cultural theories of totalitarianism, imported by German intellectuals in exile, like Hannah Arendt, Theodor Adorno, Max Horkheimer, and Leo Lowenthal was strong among intellectuals particularly attracted by the Frankfurt School's combination of a trenchant critique of capitalism with the traditionally mandarin prejudices of high Germanic culture. As a result, the picture of mass culture as a profitable opiate, synthetically prepared for consumption for a society of automatons, won favor among the anti-Stalinist, and mostly Trotskyist intellectuals grouped around the little magazines like *Partisan Review, Politics*, and *Dissent*, and emerged, in the postwar period, as a primary, conceptual object of intellectual attention.

More important to the hegemonic moment, however, was the opposition of Cold War liberalism to this "European" mass society model—it "can't happen here." In opposition to both the broad class analysis of the thirties and the radical elitism of the left analysis of mass society, a whole

group of influential sociologists and historians like Daniel Bell, David Riesman, Talcott Parsons, Edward Shils, Arthur Schlesinger, Joseph Schumpeter, John Kenneth Galbraith, and others favored a pluralistic model of status groups, interest groups, and veto groups, each claiming a potential share in power and influence over decision-making.[22] In such a model, the intellectual's voice was to be a fully integrated one, no longer that of the vanguard missionary or that of the saving remnant.

The classic demonstration of this shift in position is the *Partisan Review* symposium of 1952 on "Our Country and Our Culture," in which twenty-four leading intellectuals responded rather favorably to the editorial suggestion that they were exhibiting a more "affirmative" attitude towards American institutions and American culture, an attitude that was interpreted as signaling the end of a long phase of alienation on the part of intellectuals. The outcomes of this symposium were socratically shaped, in form and substance, by the editorial statement and by a series of questions posed to the contributors. Most of the respondents, with the exception of Norman Mailer and C. Wright Mills, saw fit to agree with the editorial assumption that, compared to the thirties and forties, intellectuals were now more centrally aligned, if not yet wholly identified, with American political, economic, and cultural institutions, while many expressed their anxiety about the likely erosion of their traditional critical and independent vantage point upon social and cultural affairs. Responses ranged from the observation that intellectuals had finally "arrived" to the suggestion that they had somehow been "contained" and thus neutralized as oppositional voices as a result. Mailer was quick to assault the voluntarist assumptions that lay at the heart of the editorial questions, rejecting the suggestion that intellectuals had the choice of remaining "outside" or stepping "inside." This "choice" looked less like a choice if one considered that there were always social forces at work upon the intellectual's willed independence, in other words, a dominant bloc of ideological interests which looks to the intellectual to provide moral and cultural legitimacy for these interests.[23]

From the editors' point of view, however, the chief obstacle to the new integration of the intellectual was what they saw as the monolithic presence of mass culture. "The intellectual," they wrote, "is faced with a mass culture which makes him feel that he is still outside looking in." If mass culture is what is "inside," and the intellectual is being assimilated from "outside," then clearly one of the roles for such intellectuals would be to issue the national culture with a clean bill of health by guaranteeing that the most pernicious effects of mass culture could be properly *contained*. This would be one of the intellectual's new "public" roles—as a inspector of the nation's cultural health. Hence, the following question posed by the editors:

Must the American intellectual and writer adapt himself to mass culture? If he must, what forms can his adaptation take? Or, do you believe that a democratic society necessarily leads to a leveling of culture, to a mass culture that will overrun intellectual and aesthetic values traditional to Western civilization?

The neo-aristocratic critique of mass culture (Eliot, Gasset) as an extension of hyperdemocracy—the "political domination of the masses" (from below)—had, by this time, lost most of its political validity, although it would retain its attractions for the new neoconservative critics who would see nothing but "dark" or "brutal populism" behind the appeal of figures from McCarthy to Rambo. Not too far removed in its lack of respect for the users of popular culture, however, was the neo-marxist critique of commodity production, which had informed the thinking of the Frankfurt School. Mailer, Mills, Howe, and others largely agreed with the picture which the Frankfurt School provided of a populace of dopes, dupes, and robots mechanically delivered into passivity and conformity by the monolithic channels of the mass media and the culture industries. With consumerism now almost fully in place, both as a discourse and a practice, and the mercurial creation of a National Security State almost complete, they and others feared that the overlap between culture and authority would lend itself to ever greater forms of social control and an increasing monopolization of all channels of opinion and information. By and large, these views were ostracized at the time as part of a general liberal crusade to jettison marxist ideas and terms. But while this position continues to command a strong following among left intellectuals today, it has long been challenged within the left as a one-sided and inadequate account not only of the contradictory power and significance of popular culture for its users and consumers, but also of the complex process by which popular culture actually creates political and social identities, by rearticulating desires that have a deep resonance in people's daily lives.

In the earlier essays of Greenberg and MacDonald, mass culture had been seen quite directly as an "instrument of social domination" imposed on an empty-headed populace from above by "technicians hired by the ruling class" in order to maintain and profitably exploit their class rule. Over the course of two decades, MacDonald's change of heart would be demonstrated by three different versions of his most famous essay: "A Theory of 'Popular Culture'" (1944), "A Theory of Mass Culture" (1953), and "Masscult & Midcult" (1962). By the time of the last version, he was more inclined to accept the liberal view that there was no single "mass" audience, but rather a "number of smaller, more specialized audiences," a fact that reduced the likelihood of cultural domination by "the principle of the lowest common denominator."[24] MacDonald's shift of opinion

reflected the growing pressure, not only to renounce marxist analysis, but also to depict American culture as one that did not conform in any way to the model of mass society that was supposed to dominate the so-called totalitarian states. But it had also become clear, from the attention increasingly devoted to analyses of consumption, and to the diversity of uses to which mass-produced culture was being put, that the critique of capitalist production which underpinned the manipulative "mass society" thesis was politically inadequate.

There were, and still are, two sides to the new liberal attention to consumption. When, in 1952, David Riesman rejected the notion of a "mass culture" in favor of a "class-mass culture," and pointed to a "series of audiences, stratified by taste and class, each large enough to constitute, in psychological terms, a 'mass,' " he was perhaps only recognizing what the advertising and culture industries and their research affiliates had known for almost two decades, or else wanted to know, about their target audiences. The perceived existence of "taste markets," in other words, was merely a tribute to the social engineering of consumer capitalism.

On the other hand, Riesman's concern with the way in which an audience negotiates the effects and meanings of the process of consumption leads in a potentially more interesting direction. "The various audiences," he wrote, "are not so manipulated as is often supposed; they fight back, by refusing to 'understand,' by selective interpretation, by apathy." "We need to know," he concludes, "how individuals and groups *interpret* the commodities and endow them with meanings."[25] Elsewhere, he judges that "the same or virtually the same popular culture materials are used by audiences in radically different ways and for radically different purposes; for example, a movie theater may be used to get warm, to sleep, to neck, to learn new styles, to expand one's imaginative understanding of people and places . . . "[26] And Henry Rabassiere drew out some of the oppositional consequences of this position when he suggested that "there is no conformistic material that cannot be turned into nonconformistic outcries."[27] These kinds of observation helped to prise open a gap between what would be thought of as the *mass* production of culture and the *popular* nature of its reception and uses by consumers. The liberal focus on consumption tended to emphasize popular culture's role in promoting "healthy" social adaptation, by educating a populace in the ways of consumption. More radical theories of "creative consumption" would later come to be posed as a way of explaining how people actually express their resistance, symbolically or otherwise, to everyday domination, by redefining the meanings of mass-produced objects and discourses in ways that go against the "dominant" messages in the text.[28]

In the fifties, however, two liberal positions had begun to dominate the debate about mass culture. There was the frustrated, or disappointed,

aesthetic-liberal position, much in evidence in the widespread complaint that the popular classes, relatively free from the nineteenth-century yoke of thankless labor and production, spent their newly won leisure time with second- and third-rate aesthetic gratifications, preferring the standardized products of the entertainment industries to the more enlightened liberal values of high culture. Increasingly favored among sociologists, however, was the corporate-liberal or progressive evolutionist position, which emphasized the benign function of popular culture in teaching individuals how to adjust, cope with, and enjoy the fruits of consumer society. Riesman observed that where once popular culture, in thrall to the Horatio Alger narrative, had trained the young for the frontiers of production and thus for successful adaptation to labor roles, now popular culture, in the Dale Carnegie mode, was training the young for life at the frontiers of consumption, and thus for success in adapting to personality roles.[29] From this perspective, popular culture was a socializer or "group-adjuster," and not a manipulator; it strengthened rather than weakened civil society. Rather than a form of social control, it was seen as an efficient servant of the new social psychology, tied to liberal-therapeutic values like diversity, personal fulfillment, and group loyalty.

With the new postwar ascendancy of "experts" in social psychology—psychiatrists, psychotherapists, sociologists, and other "physicians of society"—the therapeutic ethic that had earlier been central to proto-consumerist hopes for a populace given over to profitable forms of controlled hedonism, now became the legitimate criterion of "exposure" to commercial culture.[30] For intellectuals, this often meant accepting the function of cultural health professionals, and thus of determining acceptable levels of exposure to popular culture. Robert Warshow, for example, wrote about his son's enthusiasm for comic books in the light of a Congressional committee's investigation of the relation of children's comic books to juvenile delinquency. Inveighing against the testimony of Frederic Wertham, the author of the alarmist *Seduction of the Innocent*, who had warned about the violent and sadistic excesses of comic book culture, Warshow concluded that his son was not in danger of becoming a psychopath simply because he was a member of the E. C. Group's fan club. He decided that his son was not an "addict," but merely a "fan": his membership in the club was not "a serious problem in his life." In fact, Warshow would rather that his son had no access at all to popular culture, although, good liberal that he is, he adds: "I'd rather Paul didn't get the idea that I had anything to do with [denying him access to] it."[31]

Warshow's conclusions are symptomatic of the liberal concern for social adaptation and cultural maturity. But behind the concern about "arrested adolescence" associated with popular culture, there often lay a palpable reaction against the "infantile disorder" of thirties leftism that many of

the anti-Stalinist liberals had come to regard as an aberrance of their own youth. As I have suggested, there was considerable pressure to combat the vestigial marxist influences that were still evident in theories about the "totalitarian" nature of mass society/culture. Arthur Schlesinger puts the case quite unequivocally:

> The only answer to mass culture, of course, lies in the affirmation of America, not as a uniform society, but as a various and pluralistic society, made up of many groups with diverse interests. The immediate problem is to conserve cultural pluralism in the face of the threat of the mass media . . . [and its] policy of forcing the collective approach into the remotest corners of our intellectual life.[32]

The agenda was clearly to distinguish American social experience from what was lumped together as fascist and Soviet "totalitarianism." The response of many Cold War liberals was to give credence to a pluralistic model in which there was no direct class rule—no leader and no led—but rather a chorus of interested and participant group voices, more or less in common agreement.

Hegemony's Moment

David Riesman had speculated that "the bullet that killed McKinley marked the end of explicit class leadership" in America.[33] If explicit class leadership had died along with McKinley in 1896, the language of consensus that accompanied this idea had to wait for its legitimate "moment" until the Cold War years, when it was posed in a form that successfully excluded a theory of ruling groups while implying the spontaneous consent of all social groups and classes. Never had there been a moment in American history when such a large body of prominent intellectuals could be so identifiably linked to the process of cultural legitimation that is central to Gramsci's concept of hegemony. According to Gramsci, a social formation becomes profoundly hegemonic when the balance between political society and civil society is consolidated in favor of a particular historic bloc (rather than a single ruling class) that has succeeded not only in containing and incorporating the interests of a whole range of subordinate groups but also in articulating these interests *along with* its own in the form of a popular and seemingly unified collective will. Traditional intellectuals, who were once organically tied to rising classes or groups but who are now "independent," come to serve, not always consciously, as functionaries or cultural deputies of this dominant group, by lending their cultural authority to the process of eliciting

"spontaneous" or popular consent for the ideas and authority of this group. Their role is therefore central to the process of legitimation—to serve, again not always consciously, as bearers and shapers of a language that makes some forms of discursive experience available while it ignores, excludes, or suppresses others. A certain vocabulary is presented as permissible, not all of it hegemonic (some counterhegemonic ideas are contained within it), and not in any way unified, but which nonetheless marks the temporarily legitimate boundaries of consciousness. This vocabulary marks the unstable limits of popular or "common sense" that unconsciously saturates the social order from moment to moment.

The Gramscian emphasis on hegemony stands in corrective opposition to the more orthodox marxist emphasis upon class domination. While his theory of hegemony has an obvious resonance for this period, known as the age of consensus, we can also see how the hegemonic process of winning consent crucially involves the operation of containment. If the postwar settlement was indeed a profoundly hegemonic moment, then we ought to be able to see how the Cold War intellectuals' liberal pluralist model of checks and balances and veto powers is also a discourse about containing conflicts and differences. For the easiest way to contain potential antagonisms in society and legitimize the maintenance of existing inequalities is to construct or create differences, in order to *signify* pluralism, and thereby advertize social diversity.

To see how this model of containment further describes and explains the postwar culture of consensus, we must look more closely at how this model came to win over the participants in the mass culture debates, even those who espoused an independent socialist viewpoint like MacDonald. In the 1962 preface to his book *Against the American Grain*, MacDonald reflects on how he had once been one of the "earliest settlers in the wilderness of masscult," and, expanding on this image of the ethnographer as folk pioneer, claims that he now feels like the "ageing Daniel Boone when the plowed fields began to surround him in Kentucky." Over the course of his two decades of writing about popular culture, MacDonald had abandoned the civilizing mission of his frontier days to educate and integrate the masses, as he put it, into high culture, and has ended up insisting on separate class cultures. This latter position, he recognized, was unabashedly elitist, but it was the only way of saving "culture" as a meaningful term, at least from the threatening tide of what he had famously come to call "midcult."

Earlier metaphors of contagion about the "spreading ooze" of popular culture—"the infection cannot be localized"[34]—were now simply displaced onto the growing threat of midcult, demonized as a parasitical culture that threatens the authenticity of high and popular culture alike. "Midcult" had grown out of the cultural populist movements of the twenties and thirties,

aimed at popularizing and democratizing the high arts for the benefit of the "average man," who was neither patrician nor plebeian. Midcult's institutions included the Book-Of-the-Month Club, NBC radio's "music appreciation" hours, the Great Books series, and many other self-educational programs that MacDonald satirized as Howtoism.[35]

While this new "democratic culture" was a result of a shift in cultural production to reflect and accommodate the new middle classes of the pre-war and postwar periods, the liberal foray against midcult, as I suggested in the first chapter, had its partial origin in the anti-Stalinist reaction to the predominantly lower middle-class values of Popular Front culture, values which MacDonald and many of the intellectuals who wrote for the little magazines pilloried as an expression of hopelessly mainstream, sentimental egalitarianism—in short, a dilution of true radicalism. In this respect, the midcult "episode" is not just another reactionary quarrel about the lowering of cultural quality, it must also be seen in the context of the postwar Red scare. The campaign against the "threat" posed by midcult was heightened by linking it to a political tendency. Under cover of this smear tactic, highbrow began to nostalgically patronize lowbrow for the first time; earlier commercial culture, in retrospect, was seen as a kind of Golden Age of Folk Art—Krazy Kat, jazz, Chaplin, "the gay, inventive early Mickey Mouse and Silly Symphony cartoons"[36]— while the saving remnant of modernist high culture, always the intellectual altarpiece of Trotskyism, enjoyed renewed respect.

To see the most clear-cut expression of this displaced contempt, it is necessary to look at Leslie Fiedler's essay "The Middle Against Both Ends," published in *Encounter* in 1955, an article that presents MacDonald's conclusions about cultural classes in a more strident and unfettered way. Fiedler purports to be defending comic books (along with mass education) from the "enlightened genteel" book-banners and other middlebrow critics of popular culture. But his essay, which is usually read as the first of Fiedler's "defenses" of popular culture, is actually a cover for an attack, and the object of his attack is "the sort of right-thinking citizen who subsidizes trips to America for Japanese girls scarred by the Hiroshima bombing."[37] For Fiedler, this kind of citizenship is representative of the high-minded but middlebrow, "egalitarian" mentality that continues to stigmatically distinguish "progressive" people of the sort who had once participated in Popular Front organizations. That mentality, Fiedler warns, is still threatening to spread and colonize the neighboring states of mind of popular culture and high culture, leveling all class distinctions because it is intolerant of their respective reminders of an established hierarchy of taste in a democratic society.

Fiedler suggests that the middlebrow mind, engaged in a "two-front class war," is characterized by a rabid *fear* of hierarchy, in which "the fear

of the vulgar" runs as high and strong as "the fear of excellence." Earlier, in his essay on McCarthy, he had referred to this fear as a "chronic disease of our polity" (EI,87). In "The Middle Against Both Ends," this fear is seen as a fear of being contained, of being caught in the middle, and it is here that his argument (especially when seen in the context of its anti-Stalinist agenda) begins to sound an awful lot like Kennan's theses about the traditional insecurity of Soviet Russia.

While Fiedler maintains that "the egalitarians have been defeated" in their attempts to forge a common culture, a resurgence of this problem is omnipresent as long as middlebrow culture is at large. His solution is to close ranks and consolidate the existence of cultural classes before we are all contaminated by what he calls the middlebrow's "fear of difference." In the hierarchical separation of classes that he calls for, this "difference" is crudely delineated. Each culture is said to contain its own political conception of the world; "populist-authoritarianism" (or "brutal-populist"), "sentimental-egalitarian," and "aristocratic-authoritarianism" (or "ironical-aristocratic") in ascending order, a breakdown echoed in Shils's similar arrangement: "brutal," "mediocre," and "refined."[38] It is quite plain, however, that these respective "differences" are mutual differences, and that they need never interfere with each other, no matter how deeply they might generate antagonisms within their own self-contained limits. In fact, they offer up the appearance of a pluralistic range of differences that "naturally" balance each other out in an ultimately hierarchical but harmonious picture of social distinctions. The internal contradictions of each cultural "class" can then be said to be self-contained within a larger consensus of mutual differences, each defined, finally, against the standards of the highest categories of taste.

In these essays about popular culture by Fiedler, MacDonald, Shils, and others in the fifties, the concept of "class" makes a conditional return after its years in the intellectual wilderness. This time, however, class analysis returns not to draw attention to conflicts and contradictions, as had been the case in the thirties, but rather to serve a hegemonic moment in which a consensus was being established about the non-antagonistic coexistence of different political conceptions of the world. Cultural classes could exist as long as they kept themselves to themselves. At least two questions ought to be asked of this description of socio-cultural relations. The first question, as we shall see later, was one that lay behind the New Left challenge in the sixties to the corporate-liberal settlement— In whose interests, finally, does the idea of a consensus function? The second question, which I shall consider here, involves the exercise of power *through* relational categories of taste. It is a question that is entirely elided in the description of differentiated tastes drawn by Fiedler and others.

Social differences are expressed not through what people produce, but primarily through what they consume, in other words, through the appropriation of distinctive cultural signs. This act of appropriation—showing "good," "bad," or "mediocre" taste in the way in which we present ourselves to the world—depends, in each case, upon an individual's cultural competence, or mastery of the process of decoding/deciphering cultural signs. It is a competence that is usually the result of long apprenticeship in higher education, unless it is inherited as cultural capital. As a result, the intellectual process of responding to "aesthetic" culture like literature, film, or music depends upon accumulated cultural capital, usually derived from a certain labor. So too, as Pierre Bourdieu argues, the exercise of aesthetic taste is no different from the exercise of our taste in any other realm of daily cultural life:

> One has only to remove the magical barrier which makes legitimate culture into a separate universe, in order to see intelligible relationships between choices as seemingly incommensurable as preferences in music or cooking, sport or politics, literature or hairstyle. This barbarous reintegration of aesthetic consumption into the world of ordinary consumption (against which it endlessly defines itself) has, *inter alia*, the virtue of reminding us that the consumption of goods no doubt always presupposes a labour of appropriation, to different degrees depending on the goods and the consumers, or, more precisely, that the consumer helps to produce the product he consumes, by a labour of identification and decoding which, in the case of a work of art, may constitute the whole of the consumption and gratification, and which requires time and dispositions acquired over time.[39]

Social distinctions, then, are signified through a complex intertextual display of cultural choices or preferences and the often unorthodox or creative uses made of these choices. But if Bourdieu's observation is extended far enough, then we would have to recognize that the exercise of taste not only *presupposes* distinctive social categories; it also helps to *create* them, in the shape of apparently "natural" cultural classes.

As the practical governor of cultural consumption, taste, by categorizing, therefore legitimizes social inequalities because it presents social differences between people as if they were differences of nature. This is most apparent at the social extremes. "Vulgar" taste ("I know *what* I like"—thoughtless pleasure) disrespectfully *refuses* the labor of education and the hard school of acquiring cultural competence. By contrast, that same education is *disavowed* by aesthetic purism ("I *know* what I like"—pleasureless thought), which exercises its intuitive judgment as naturally as the air one breathes, and which tries to hide all traces of the process by which it acquired its cultural capital. Just as the former converts the

taste of subordination into an irreverent rejection of all refinements of taste, so the other waives responsibility for a taste that condemns all others in turn as "academic," "pretentious," "ill-gotten," "commonplace," or "barbaric." And just as the emphasis, in popular taste, on function and involvement, signifies an individual's proximity to the necessities of the natural and social world, so the emphasis, in legitimate taste, on form and disinterestedness, signifies an elective distance from those same necessities.

As for those cultural consumers who are socially ranged between the two theoretical extremes, they live out an "unhappy" relation to cultural taste. They cannot say that they "know what they like" because of the constantly shifting state of their *pretentiousness towards* legitimate cultural signs that they are condemned to both try and fail to appropriate. Indeed, it is the seriousness and candor with which groups in the middle are obliged to approach this task that is often interpreted as what Fiedler calls a "fear of difference," and consequently as a naive attack on the ingrained social "prejudices"—anti-intellectualist and elitist, respectively—of popular and legitimate culture.

What, then, of the claim that middlebrow culture is *indifferent* to any kind of distinction, and that it will spread everywhere unless it is contained? On the contrary, we could say that middlebrow culture is even more responsive and sensitive to the marks of difference, and to the pressures and nuances of what Bourdieu calls "distinction," than is either popular or legitimate culture, the users of which, he argues, accept the requisite subject positions of dominated and dominating with what appears to be a more uncompromising air. Far from being the source of a contagious, colonizing, and epidemically spreading condition (MacDonald, in a less successful, Kennanesque metaphor, calls it a "reciprocating engine" set inexorably in motion), middlebrow culture is actually an exemplary model of containment. It contains references to legitimate culture as efficiently as it incorporates the accessible forms and narratives that characterize the more formulaic genres of popular taste. *This mechanism of containment is a process of identification, not an act of annexation.* It results in the formation of new audiences, new cultural identities, and new relations of respect and disrespect, not in the pervasive homogenizing of all realms of cultural production and consumption.

What is the lesson to be drawn from this persuasive activity, on the part of Fiedler, Shils, and MacDonald, of categorizing and classifying tastes in order to allay "fears" about colonization and homogenization? Above all, I would argue that we ought to see this activity of discrimination as part of the reorganization of consent in the Cold War period along lines of cultural demarcation that would still guarantee and preserve the channels of power through which intellectual authority is exercised.

Cultural power does not inhere in the contents of categories of taste. On the contrary, it is exercised through the capacity to draw the line between and around categories of taste; it is the power to define where each relational category begins and ends, and the power to determine what it contains at any one time.

There is nothing essentialist, for instance, about the contents of the categories of taste within which the petty bourgeoisie, or any other social fraction, recognizes itself. As Bourdieu points out:

> It would be a mistake to locate in the works which enter into middle-brow culture at a given moment the properties conferred on them by a particular form of consumption. As is shown by the fact that the same object which is today typically middle-brow—"average"—may yesterday have figured in the most "refined" constellations of tastes and may be put back there at any moment by one of those taste-maker's coups which are capable of rehabilitating the most discredited object, the notion of an "average" culture is as fictitious as that of an "average," universally accepted language.[40]

That the contents of these categories can be moved around does not affect the durable power to define the categories themselves, and to convert the relational differences between them into socially functional inequalities. Rather, it is through the retention of the form or containing structure of the category itself that cultural power, at any one time, is able to designate what is legitimate, on the one hand, and what can then be governed and policed as illegitimate or inadequate or even deviant, on the other.[41] The intellectual's training in discrimination is an indispensable resource in such a process. For this is where the intellectual's accredited power of discrimination reinforces the power to subordinate even as it presents itself in the form of an objective critique of taste.

National-Popular, Avant-Garde, or Public?

MacDonald opens the penultimate section of "Masscult & Midcult" with the question: "What is to be done?" It is a question that addresses the crisis of a national culture, faced, for the first time, in the postwar years, with the task of officially *representing* the popular classes to themselves as participants in power. Because it is a Leninist question, it deserves a vanguardist answer, and MacDonald acknowledges that he would like to oblige. Like his fellow intellectuals in ex-Trotskyist or *Partisan Review* circles, the exemplary form of salvation remains, for him, the memory of avant-garde culture; a movement, as Greenberg noted, that was inspired by "a superior consciousness of history" (i.e. scientific social-

ism) but which was also "against the whole movement of history" (Mac-
Donald) because it refused to compete in the cultural marketplace. Al-
though the "sociologically absurd" community of the historical avant-
garde has ceased to exist, MacDonald wistfully acknowledges that "we
continue to live off its capital."[42]

This is an extraordinary thing to say, since it puts American intellectu-
als like MacDonald in the position of the European *rentier* class whom
Gramsci described as "the pensioners of economic history," because they
live, in a purely parasitic fashion, on their "ancestral patrimony" and
contribute nothing to the world of production.[43] The bulk of this class
is made up of ex-civil servants, clergy, landowners, professional army
officers—in short, all of those whom Gramsci denotes as "traditional
intellectuals," who are archaic hangovers of earlier modes of production
but who constitute, in the accumulated wealth of their cultural capital,
"European tradition" or "civilization." In fact, it was the absence in
America of a *rentier* class of traditional intellectuals who live off past
production that accounted for what Gramsci noted as the absence of
American high cultural "tradition."

If MacDonald and others are still "living off the capital" of the avant-
garde, then it is foreign capital, and they are *simulating* the position of
the rentier for a national culture without a historical rentier class given
over to the cultural pursuits that were once thought requisite to the life
of a gentleman. In particular, these are the dimensions of a national
culture which lacks an intelligentsia that can speak to both the "national"
and the "popular": a culture whose intellectuals live off foreign cultural
capital, and who are unwilling to perceive the popularity of the native
popular culture as a site of contestation. MacDonald concludes in fact
that American intellectuals are "too isolated or too integrated"; they are
either hierophants of a priestly caste, or servants of a business culture.
This is a claim, of course, that depends upon forgetting the enormous
efforts of the thirties, when intellectuals *en force* devoted themselves, in
however imaginary a fashion, to the task of politically creating a culture
that could be both national and popular.

In spite of his willed amnesia about the thirties, MacDonald's comments
about the estrangement of intellectuals point to an essential component
of the national culture—its dependence, for cultural authority, upon
borrowed and accumulated foreign (European) prestige. This has noth-
ing to do with the incorporation and Americanization of "low" immigrant
cultures—quite the opposite in fact. Its origins lie in the historical lack of
an intelligentsia whose cultural authority and prestige could be relatively
autonomous from the economic prestige valorized by a business culture.
In Europe, the power and authority of the cultural establishment has
endured historically because of its accumulation of *precapitalist* prestige,

originally endowed by aristocratic patronage, and it has endured as a body of prestige that is still relatively independent from business interests or State authority. Mills argues this point in his important essay "The Cultural Apparatus," where he observes that European bourgeois culture, despite the power of its economic wealth, lacked the status that comes with cultural authority. To earn that status it had to make itself over in the "honorific ways of precapitalist kinds of cultural sensibilities and political opinion."[44]

Historically, America had no such semi-autonomous "formations of prestige": no authoritative centers of taste or cultural accreditation that did not depend heavily on imported European canons of judgment. The American cultural apparatus has always been an indissociable part of an ascendant capitalist economy. The story of the national culture, then, is not one of commercial patronage, strictly speaking, but of philanthropy on the part of businessmen who establish and fund all of the cultural institutions and foundations. Because of the absence of precapitalist strata in America, and because the business world does not need what Mills calls the "halo" of culture (it often uses European prestige values to *sell* its luxury products, but it does not depend upon cultural legitimacy in order to *explain* and consolidate its power: it feverishly buys up the work of modern American artists, but as a financial investment, not as a manifestation of taste), intellectuals have seldom been in the position of being able to earn power, status, or prestige from their cultural production alone. In what could be read as a riposte to intellectuals like MacDonald, who says that, ideally, he would like to "re-create a cultural . . . elite as a countermovement to both Masscult and Midcult," Mills concludes that if intellectuals despise business culture, "the hand that feeds them," then it can only be because they want the para-aristocratic structure of the European cultural establishment. It can only be because they are unwilling to confront the possibilities of a *postcapitalist culture* that would be different from what Mills sees as the only two dominant cultural models of the future: the commercial (North American) and the political (the Soviet bloc).

To MacDonald's credit, he ultimately rejects the revival of the avant-garde spirit as an impractical solution. But he also dismisses as "absurd" Walt Whitman's eloquent hopes for a national-popular intelligentsia that could "cope with our occasions, lands, permeating the whole mass of American mentality, taste, belief, breathing into it a new life, giving it decision, affecting politics far more than the popular superficial suffrage."[45] In calling, instead, at the end of his essay, for a reinforced cultural class hierarchy, MacDonald looks, for renewed support for high culture, to the classical liberal model of an enlightened and educated "public." In appealing to this nineteenth-century bourgeois idea of a

"public," he demonstrates the continuing *real* historical presence of European prestige within the American value system. Even if this prestige has no substantial base in socio-economic relations, past or present, and is therefore largely a *simulation* of foreign prestige, this does not prevent American culture being "made over" in the honorific shape of the European public sphere. In the case of MacDonald's call for a enlightened "public," with its own *esprit de corps*, it is a simulation of (bourgeois) preconsumerist, rather than precapitalist, values that provides the basis for his hopes for the future of high culture.

Even as he was writing this conclusion, in the early sixties, to the last version of his essay, the rules of the game of taste were being redrawn by Pop, and the protocols of Old World cultural power were being discarded, with little of the ceremony to which they had long been accustomed. Even as he was casting his transatlantic gaze enviously upon *le vice anglais* of clearly demarcated cultural class lines, the republican promise of cultural egalitarianism was coming home to roost. Pontification, the anguished, reflective mode of MacDonald's generation, was giving way to participation, the heady watchword of the sixties. Paternalist questions like "What is to be done?" would soon have to accommodate, if not defer to, more independent initiatives—Do it! More important, the centerless and centrifugal shape of the national culture was being wrenched into a new morphological dimension by the recent appearance of a youth culture at its center. The identity of this youth culture, as we will now see, had as much to do with interracial affiliations and fantasies of sexual mobility as it had to do with the old containing walls of class divisions and groupings.

3

Hip, and the Long Front of Color

I guess all songs is folk songs. I never heard no horse sing 'em. (Big Bill Broonzy)

"Brief?" I said, "I've got three hundred years of briefing" (Dizzy Gillespie, on being summoned to Washington to be briefed for a world tour sponsored by the State Department)

In July, 1959, the day after Billie Holliday died, Frank O'Hara, New York bard of daily life, recorded a celebrated lunchtime walk:

It is 12:20 in New York a Friday
three days after Bastille day, yes
it is 1959 and I go get a shoeshine
because I will get off the 4:19 in Easthampton
at 7:15 and then go straight to dinner
and I don't know the people who will feed me

I walk up the muggy street beginning to sun
and have a hamburger and a malted and buy
an ugly NEW WORLD WRITING to see what the poets
in Ghana are doing these days
 I go on to the bank
and Miss Stillwagon (first name Linda I once heard)
doesn't even look up my balance for once in her life
and in the GOLDEN GRIFFIN I get a little Verlaine
for Patsy with drawings by Bonnard although I do
think of Hesiod, trans. Richard Lattimore or
Brendan Behan's new play or *Le Balcon* or *Les Négres*
of Genet, but I don't, I stick with Verlaine
after practically going to sleep with quandariness

and for Mike I just stroll into the PARK LANE
Liquor Store and ask for a bottle of Strega and
then I go back where I came from to 6th Avenue
and the tobacconist in the Ziegfeld Theatre and

casually ask for a carton of Gauloises and a carton
of Picayunes, and a NEW YORK POST with her face on it

America's consumer markets have never been busier; bank tellers are
dispensing cash to spendthrift clients without even consulting their bal-
ances. Bohemian poets, as we can see from the conspicuous consumption
described here, are no longer immune to the contagious seductions of
the commodity world. This is not Baudelaire's poet-flâneur who was
lured to the marketplace to look but not to buy. In the space of a few
blocks, O'Hara's motivated, discriminating poet-consumer has found an
whole range of cultural goods to purchase from all over the world, from
hamburgers to Ancient philosophy. Robert Von Hallberg points out that
all of art and history (most of it is not American) is available here, not
through Eliotic "tradition," but through the benefits of mass production
and cheapness.[1]

The last stanza, however, suggests that there are some cultural experi-
ences that are literally priceless, and which therefore lie beyond the realm
of paperback shopping:

and I am sweating a lot by now and thinking of
leaning on the john door in the 5 SPOT
while she whispered a song along the keyboard
to Mal Waldron and everyone and I stopped breathing[2]

This memory of a "live" Billie Holliday moment, with its extreme effect
on the motor functions of the body—sweating, constricted breathing—
contrasts with the somnolent, low-key anxiety of "quandariness," which
was the physical effect of making the earlier consumer choices. From the
poet's point of view, such live moments cannot be reproduced on re-
cord—you had to have been there. Although O'Hara's poet seems to be
perfectly at home in the modern environment of consumer culture, the
poem in which he acts out his nostalgia-struck desire ends up paying its
tribute to what we might recognize as the modernist poem, with its own
epiphanic moment to record the loss, in the past, even the very recent
past, of a culture of authenticity evoked by Lady Day's "breath-taking"
live presence.

In a poem called "Jitterbugs," Leroi Jones (a.k.a. Amiri Baraka) puts
the matter more succinctly: "though yr mind is somewhere else, your ass
ain't."[3] Baraka is addressing himself more to the contradictions of ghetto
life than to those of the white bohemian in ritual thrall to the spectacle
of jazz performance, but his tone here might serve as an earthy corrective
to the rapt mood of O'Hara's last stanza. In fact, if we look back through
the poem, beginning with the encounter in the first stanza with the

probably black shoeshine boy, who may be worried about how he is going to be fed in a way that is different from the poet's anxiety about his unknown hosts in Easthampton, we begin to see how the references to postcolonial "Negritude"—Genet's *Les Nègres*, and those "poets in Ghana"—have indirectly, perhaps even unconsciously, prepared the reader for the final encounter with American "Negritude."

By 1959, scenes of jazz idolatry on the part of white intellectuals had become a commonplace, if not a cliché, especially in the poetry world where the Beat cult of hipsterdom had become an object of national media attention. What is striking, however, is that O'Hara is not like that; he is not *that kind of poet*. Sure, he frequented the jazz clubs, and even gave readings at the 5 Spot. There is enough personal testimony around, from friends and acquaintances, to confirm that he was quite familiar with jazz music. But when it comes to his poetry, jazz almost never figures in the urban taste milieu within which he represented himself, or in the realm of daily cultural events about which he wrote in copious detail. True to his impeccably camp sensibility, Carnegie Hall and the Metropolitan Opera House were more standard venues in his poetry than the 5 Spot, Rachmaninoff a more constant source of religious ecstasy than Miles Davis. This scene in the 5 Spot doesn't seem to properly *belong* in O'Hara's work, where it is employed nonetheless to invoke a spirit of authenticity. In fact, it appeals to me as a fond reader of O'Hara that this scenario might possibly be read as an ironic, even parodic, gloss on the stereotyped Beat devotee of the more "authentic" world of jazz culture.[4]

But exactly who and what is being parodied or *imitated* here? And what is there to say about the moment of black musical "authenticity," which is given the last word presumably because it is not something to be *consumed* like the hamburgers and malteds? Although its most recent manifestation—the white hipster—had recently become a media cliché, such a conventional encounter, between black performance and white appreciation, had, in part, governed social and cultural relations in the world of musical entertainment ever since the first minstrel shows over a century before. Consequently, questions about imitation, and (the romanticizing of) authenticity, while they relate primarily to African-American vernacular traditions, are also part and parcel of the long transactional history of white responses to black culture, of black counter-responses, and of further countless and often traceless negotiations, tradings, raids, and compromises.

They are questions, for example, that will come to have a particular significance in the ever-heated debates about the birth of rock 'n' roll, whose classical, or vintage, years were already over by the time O'Hara is writing his poem in 1959. The racial questions of rock 'n' roll—How much of a white component (country, rockabilly) was *truly* present in "white" R & R's

versions of "black" R & B? Did Elvis *imitate* or did he *sing* "black" music?—
were only the latest chapter of a history in which hybrid cultural forms have
themselves begged the question of imitation to the point of absurdity. To
cite only a few convoluted examples: ragtime—a "clean" black response to
white imitations of the "dirty" black versions of boogie-woogie piano blues;
the cakewalk—a minstrel blackface imitation of blacks imitating highfalu-
tin white manners; "moldy figs"—a generation of white middle-class jazz
revivalists trying to sound like wizened, old New Orleans musicians who
were themselves trying to sound like the real thing for the benefit of their
white discoverers; Dizzy Gillespie's satirical imitations of his white bohe-
mian disciples who imitated the bebopper's own version of hipster "cool";
Howlin' Wolf—an "authentic" bluesman (most revered by sixties R & B
purists in the suburbs of London), whose name is taken from his failure to
emulate the yodeling of Jimmie Rodgers, the white hillbilly musician of the
thirties whose own vaudeville-inspired yodeling was spliced with a variety
of powerful blues influences;[5] and Elvis's rockabilly hair, greased up with
Royal Crown Pomade to emulate the black "process" of straightening and
curling, itself a black attempt to look "white."[6]

The everyday, plagiaristic, commerce between white and black musics—
between, strictly speaking, the European diatonic scale and the African-
American non-diatonic harmonies—has been generic and not exceptional.
But it is important to remember that this *overexchanged* and *overbartered* re-
cord of miscegenated cultural production everywhere bespeaks a racist his-
tory of exploitation exclusively weighted to dominant white interests. Given
such a history, it is no wonder that terms like "imitation" are often read di-
rectly as "theft" and "appropriation," and that white definitions of "authen-
ticity" are mismatched with black essentialisms like "roots" and "soul." Given
such a transactional history, it is no wonder that defense mechanisms
would come to be perfected: the technical difficulty of bebop music, for
example, of which the willfully eccentric pianist Thelonious Monk said—
"we're going to create something they can't steal because they can't play it";
or the "put-on," which would lead so many white biographers, document-
arists, and ethnographers of the jazz scene astray with capricious tales of
the jazzman's "hot" bohemian life; or, more recently, the motormouth
speed of rap music, so aggressively remote from white speech patterns.

Equally clear are the grounds for suspicion of white intellectuals' pro-
jected fantasies of an atavistic Other, each trying to outdo the other in
their articulation of a correct white hipness, for which Norman Mailer
was to provide the most well-known version in "The White Negro." Take,
for example, the mawkish confessionalism of Jack Kerouac:

> At lilac evening I walked along with every muscle aching among the
> lights of 27th and Welton in the Denver colored section, wishing I were

a Negro, feeling that the best the white world had offered was not enough ecstasy for me, not enough life, joy, kicks, darkness, music, not enough night. . . . I passed the dark porches of Mexican and Negro homes; soft voices were there, occasionally the dusky knee of some mysterious sensuous gal; and dark faces of the men behind rose arbors. Little children sat like sages in ancient rocking chairs.[7]

Or the no less idealized offering of Norman Podhoretz (who had himself written of Kerouac: "I doubt if a more idyllic picture of Negro life has been painted since certain Southern ideologues tried to convince the world that things were just fine as fine could be for the slaves on the old plantation")[8]:

(J)ust as in childhood I envied Negroes for what seemed to me their superior masculinity, so I envy them today for what seems to be their superior physical grace and beauty. I have come to value physical grace very highly and I am now capable of aching with all my being when I watch a Negro couple on the dance floor, or a Negro playing baseball or basketball. They are on the kind of terms with their own bodies that I should like to be on with mine, and for that precious quality they seem blessed to me.[9]

But my purpose here is not to dismiss or ridicule white intellectuals' fantasies; they can, perhaps, only be deconstructed. Such fantasies, however romantic, like Kerouac's, or jejune, like Podhoretz's, had real and powerful social effects not only for the older liberal intelligentsia (represented by the "young fogey" Podhoretz) and the new underground bohemian intellectuals (like Kerouac and Mailer) but also for the white students in SNCC who participated in the struggle for civil rights, and who supported the black liberation movements of the sixties. Nor do I intend to show yet again how the history of cultural commerce across what Eldridge Cleaver called "the racial Maginot line" reflects an appalling history of racial abuse and economic exploitation. At this stage in the history of writing about the white uses that have been made of black music, I think that it is safe to assume, on the reader's part, a certain degree of general knowledge about both of these histories.

So too, because of the fundamental contribution of Afro-American music to popular taste, any cultural historian of that relationship cannot avoid commenting on the ways in which a discourse about color ("whitened" music) is spliced with a discourse about commercialization ("alienated" music). I will maintain that there is no tidy coincidence between these two discourses; nothing so clear-cut as Cleaver's fixed, territorial sense of a "Maginot line" of color, and nothing that can be so precisely pinpointed as an act of "selling out." And yet it is often assumed that the

two are necessarily aligned; that commercialized music = whitened music, that the black performance of uncommercialized and therefore undiluted black music constitutes the only truly genuine form of protest or resistance against the white culture industry and its controlling interests, and that black music which submits to that industry automatically loses its autonomous power. To subscribe to this equation is to imagine a very mechanical process indeed, whereby a music, which is authentically black, constitutes an initial raw material which is then appropriated and reduced in cultural force and meaning by contact with a white industry. Accordingly, music is never "made," and only ever exploited, in this process of industrialization.

Such an imaginary picture tells us nothing at all about the specific form and appeal of the products of commercial popular music, except to suggest that they are somehow less truthful as a result of their appeal to as broad an audience as possible. In addition, it reinforces the ideology of the superiority of "non-commercial" folk spontaneity, which ignores the fact that commercial and contractual relations enter into *all* realms of musical entertainment, or at least wherever music is performed in order to make a living. In short, this demonizing of commercial music closes off any discussion of the way in which popular musical taste— with its shifting definitions of "black" and "white" meanings—is actually negotiated in the space between the industrial logic of mass distribution and local forms of consumption. Demonizing is all the more purblind if we consider that it is in that very space that the voice of popular persuasion about social change in a multiracial culture is always likely to have its broadest audience and therefore its best chance of making a breakthrough in the process of winning active popular consent.

From the development, in the twenties, of the recording industry, radio technology, and a flourishing commercial dance culture, each based around the increasing popularity of versions of blues-jazz music over and against the efforts of Tin Pan Alley, the struggle for biracial legitimacy was already being waged in white households with radio receivers and Victrolas, in urban dancehalls, and in mixed bands, years before the overtly political movements of the late fifties. And yet, when the civil rights alliance came to fight what W.E.B. Du Bois had heralded as "the last great battle of the West," it was bebop, an *anti-commercial* strain of the jazz tradition, and its associated avant-gardist trappings, which provided many of the decisive, iconic discourses and images for those white intellectuals who helped to support and legitimize the historic bloc behind the civil rights movement.

The pre-history which shaped that moment is the history of at least three stereotypes: the hipster, black *and* white, the black musician for whom "entertaining" was seen to suggest an intolerable degree of "Tom-

ming"; and the romanticizing white, middle-class jazz aficionado. It is a history which I will have cause to describe here, since it is an important chapter in the story of postwar intellectuals' response to popular taste. But I will also call attention to the fragments of another, less idealized history, one that is linked to the capacity of popular music to transmit, disseminate, and render visible "black" meanings, *precisely because of*, and not in spite of, its industrial forms of production, distribution, and consumption. These commercial forms, whether on record or in performance, were, after all, the actual historical channels through which "black" meanings were made widely available, and were received and used by a popular audience, even a black audience. There is little comfort in this other history for purists, but then the cultural and social changes that are mediated by shifts in popular taste are always messy, and never pure; as a result, they are seldom canonized as decisive, and more usually regarded as epiphenomena of *real* changes, which always take place elsewhere.

It is quite symptomatic, then, that at the very moment that the saxophonic rites of the "white negro" hipster were being prepared for urban intellectuals, the rock 'n' roll revolution was already taking sectors of the culture by storm. With its vigorous lyrical praise for the liberating promise of endless teenage consumption ("with no particular place to go"), and its cheerful swerve away from the middle-class ethic of deferred gratification ("a fool about my money/don't try to save"), no music before or since has so directly called attention to itself as "popular" and "commercial," transitory and disposable. Amidst all of the cleanly laundered hullabaloo about the white teenage dream, however—amidst the proliferation of careful white covers of black R & B songs, even those of Pat Boone, the "whitest" of the white—no one seemed to be fooled in the citadels of reaction:

> Stop. Help Save the youth of America. DON'T BUY NEGRO RECORDS. . . . The screaming idiotic words, and savage music of these records are undermining the morals of our white youth *in America*. Call the advertisers of the radio stations that play this type of music and complain to them! Don't Let Your Children Buy, or Listen To These Negro Records.[10]

So ran a circular in New Orleans. The racist authors of this notice and the members of White Citizens Councils all over the South had probably known for some time what official tastemakers had hardly bothered to notice, let alone comment upon—that, ever since the late forties, large numbers of Southern rural adolescents, like a smaller audience of Northern urban counterparts, had been listening religiously, if at ungodly

hours, to "white negro" DJs pumping out R & B on white-owned radio stations.[11]

Selling Out?

Although the ethic opposed to "selling out" had long been active, for white musical performers, in the pop industry, it took on the status of a sacred commandment according to the codes of the "ideology of rock" that flourished in the period from the mid-sixties through the early seventies. With its own auteurism, its creation of a "folk community," its internal critique of pop music, and its adoption of "progressive" values in politics and art, the ideology of the rock counterculture was built around an articulate opposition to the rules of the pop world of entertainment.[12] In that same period, we find that a highly sophisticated, and politicized culture of "free jazz" with its own organic intellectuals—John Coltrane, Ornette Coleman, Archie Shepp, Pharoah Sanders, and Cecil Taylor—had also taken pains to dissociate itself entirely from the rules of popular taste. On the other hand, commercial soul music, with close, secular ties to the world of entertainment, had brought to black music a near universal popularity that was unthinkable ten years earlier, and which increasingly carried with it a sense of political immediacy that spoke to ghetto audiences untapped by the new jazz. In effect, it may be fair to say that the public controversy generated by James Brown singing "Say it Loud, I'm Black and I'm Proud," *mattered* in a way which the controversy over Max Roach's "We Insist—The Freedom Now Suite" did not.

This comparison, between what was happening in the predominantly white rock world and on the Afro-American music scene highlights the different historical relation which black musicians have had to the rules of commercial entertainment, and thus to the experience of success and acceptance that is known as selling out. In fact, the choice, of selling out or not, is one that had seldom been historically available to black musicians in the same way as for white performers, for whom alternative ways of earning a living were generally available. It means something quite different. It is often acknowledged that musicians—along with preachers, gamblers, hustlers, and athletes—have historically held a privileged social role in the black community throughout the meteoric rise of jazz-blues music from the campground and the field holler to the concert hall and the university syllabus. From the post-emancipation years of the traveling musician/minstrel who escaped the necessity of working directly for a white employer, this special role was a result of the very limited freedom to be able to negotiate a contractual arrangement, however exploitative,

with the world of commerce. It could even be said that music was first being used in this contractual way in the earlier work songs of slavery, where as Eugene Genovese notes, slaves would try to slow down the tempo of the songs in order to slow down their work rhythms.[13] Ever since their declaration of economic independence, black blues and jazz performers have had to negotiate between the available support of their home community and the demands of the commercial recording industry. By the time of the electronic urban blues scene of the forties and fifties, which was almost wholly supported by a ghetto audience, the ideological role of the performer within the black community was so established as to be seen as more ritualistic than performative, more priestly than diverting. As Charles Keil argues, the bluesman who merely "sang the blues" had come to take on a sacred function, almost akin to that of the preacher, in expressing the shared values, heritage and history of the community.[14]

By the early twenties, the example of the musician's social mobility had already become a model for those struggling to survive in fields in the South, or sweating for Henry Ford in the North: from the raunchy brothel milieu of the barrelhouse piano boogie to the "star" status offered by the early recording industry to blues singers like Ma Rainey and Bessie Smith; and from the squalor of the New Orleans street marching bands to the clean and respectable performing conditions offered in the Mob-operated Chicago dancehalls.[15] The real commercial dividends were, of course, reserved for white musicians, like the Original Dixieland Jass Band, and Paul Whiteman's orchestra. But with the "creation" of the black consumer in the twenties, jazz and blues performers were not only being commercially supported in some part by a black audience but were also in a position to express "black" meanings in a mainstream or popular domain. Jazz, in the meantime, had become an astonishingly cosmopolitan form, which absorbed and contained every musical influence going, as much to ensure the survival of its black performers as to ensure its acceptability among white audiences of different musical genres and in musical venues all over the country and abroad. There is little doubt that these musical developments would not have occurred if jazz-blues had remained a "folk" music, untouched by the recording industry.

It is in this radically heterogeneous musical culture, however, that the first strains of intellectual purism were heard from Harlem Renaissance figures like Langston Hughes: "You've taken my blues and gone—/You sing 'em on Broadway/And you sing 'em in Hollywood Bowl/And you mixed 'em up with symphonies/And you fixed 'em/So they don't sound like me./Yep, you done taken my blues and gone."[16] Hughes's complaint is obvious, but what it celebrates about folk purism ignores the more difficult questions about what it means, now that it has happened, to hear

the blues being sung in "impure" settings like the Hollywood Bowl before such "inauthentic" audiences. In fact, the Harlem Renaissance philosophy of ethnic purism (classically set forth in Alain Locke's 1925 collection, *The New Negro*) preached virtually the same ethic of folk atavism or spiritual primitivism, albeit with an added proprietary righteousness, as was customarily glorified in white intellectual fantasies of the time. In both versions, black culture, and especially jazz, was cast as a vital, and *natural* source of spontaneous, precivilized, anti-technological values— the "music of the unconscious," of uncontaminated and untutored feeling and emotion.

Tracing the career of Paul Robeson, Richard Dyer has shown how Robeson, the original crossover artist, came to be the popular "representative of blackness" by embodying and expressing exactly these atavistic folk values. The *purity* of delivery and tone in his singing that was so admired by Establishment music critics had almost nothing to do with the "dirtiness," the polyphony, and the communal choral structure of call-and-response under which the spirituals that he popularized were originally sung. On the other hand, Robeson's commercial standing in the public domain, while it was obviously based upon a heavily constructed image of blackness, allowed him to be a visible communicator of "black" meanings. From the time he first sang "Old Man River" in *Showboat* in 1928, for example, he gradually altered the lyrics of this song over the years to transform what had been a "white" version of black speech into an vocal expression of black struggle and resistance to oppression.[17] So too, it could be argued that the image of Africa in his films like *Sanders of the River* (1934), *Song of Freedom* (1936), and *King Solomon's Mines* (1936) provided some kind of imaginative, though hardly ideal, link between the popular nationalist upheaval of Garveyism in the late twenties and the Pan-Africanist consciousness urged by W.E.B. Du Bois and other black left intellectuals from the thirties on. And it was clearly as a result of, and not in spite of, his commercial standing that his later career as a supporter of left struggles registered the public and political effect that it achieved. (A similar kind of case could be made for the public career of Muhammad Ali.)

Even so, Robeson's musical reputation was largely formed in the more respectable circles of concert hall recital appreciation, in other words, in a fine art context. The relatively independent political mobility that he came to enjoy was linked to his status as an "artist," a freedom which was less available to those jazz superstars like Louis Armstrong and Duke Ellington whose cultural power lay almost wholly in the world of popular entertainment. With the Depression and the collapse of the recording industry (100 million records were sold in 1921, 2 million in 1933), it was the question of survival, not mobility,

that was paramount for black musicians. Many dropped out, others retraced their step to New Orleans and to Mississippi, to be "rediscovered" there ten years hence by the revivalists of the trad jazz and the Delta blues scenes. Those who survived the slump professionally, and who played in bands and combos that traversed the length and breadth of the country, contributed to an era in which jazz became the undisputed basis of American popular music.

Through the medium of radio and the jukebox, and in huge dancehalls with crowds of up to five thousand, the formation of a popular taste for jazz in the thirties lay more in its capacity to move and animate bodies than to create an appreciative, listening audience. This was as true for the more sedate white swing sound of the bands of Benny Goodman, Tommy Dorsey, Artie Shaw, and Paul Whiteman, as for the swinging blues-based Kansas City music of the Count Basie band; as important for the classy, showbiz jive of Cab Calloway as for the more populist hot jump hedonism of Lionel Hampton, Chick Webb, and Illinois Jacquet. Many musicians had come to resent that the basis of value in jazz culture remained the production of dance excitement, but it was clear that things had gone quite far when someone like Artie Shaw, increasingly cast as the intellectual of white swing, publicly denounced jitterbugs as "morons." By that time, the split between a "people's jazz," played in commercial dancehalls and clubs, and a "musician's jazz" collectively improvised, after hours, by musicians from different bands in town who would sit in with each other, was already in a fairly advanced stage, and even had its own mythicized origins in the legendary Kansas City jam sessions of the Basie band.

In the transition from the big bands to the smaller, electrified jump combos of the immediate postwar period, it was the publicly voiced desire of those like the honking tenor sax man, Louis Jordan, to "play for the people" rather than for other musicians, that set off the R & B scene from developments in jazz, and which paved the increasingly integrated way that would lead to rock 'n' roll. Inspired by the boogie-woogie craze of the late thirties, and economically encouraged by the flourishing of new independent record companies after the war, Jordan's Tympany Five dominated the world of million-seller hits for ten years, both in the R & B charts (which replaced *Billboard*'s black music "race" category in 1949) and as a big crossover presence in the pop charts. Legitimizing the raw R & B sound of screamers and shouters like Joe Turner and Wynonie Harris, and inspiring the early hits of the likes of Ray Charles and Chuck Berry, Jordan perfected the commercial mix of dance rhythm and jump blues that helped to break up color-coded bodily responses to black music among black and white urban working-class audiences.

Until its increasing crossover successes in the fifties, R & B was primarily a ghetto music, confined to and confirming a segregated

culture. In this respect, it is often seen as a crude, prepolitical, even self-deprecatory, culture that employed playful irony, rather than assertive expressions of dissent, to comment on the conditions of everyday ghetto life. Consequently, the prestige of R & B is relatively low in those histories of black music that are concerned to highlight the autonomous, even protonationalist, tendencies of Afro-American culture as an historical whole.[18]

By virtue of its lower-class constituency, however, R & B belongs on the politically correct side of the line drawn by influential critiques, like that of Amiri Baraka's *Blues People* (1963), waged against the ("co-opted") black middle class, surely one of the most disparaged social groups in all of modern history:

> Only Negro music, because, perhaps, it drew its strength and beauty out of the depths of the black man's soul, and because to a large extent its traditions could be carried on by the "lowest classes" of Negroes, has been able to survive the constant and wilful dilutions of the black middle class and the persistent calls to oblivion made by the mainstream of the society. Of course, that mainstream wrought very definite and very constant changes upon the *form* of the America Negro's music, but the emotional significance and vitality at its core remain, to this day, unaltered. It was the one vector out of African culture impossible to eradicate. It signified the existence of an Afro-American, and the existence of an Afro-American culture.[19]

In *Blues People*, Baraka focuses on the conflict between what he sees as autonomous "Afro-American" developments in jazz and their assimilated forms. But his account of the perpetual cut-and-thrust between pure and impure, black and white, good and evil, always depends on his demonizing the cut-and-paste mainstream culture of musical meanings as a Gehenna of white appropriation and black Tomming. So while Baraka's polemical purism ensures his sensitivity to the changes wrought within black music, it leaves him little room to consider the actual changes wrought upon mainstream popular culture by black musical influences. As a result, black meanings, in whatever form, which reach "acceptance by the general public" can only be seen as evidence of "dilution," and testimony to a "loss of contact with the most honestly *contemporary* expression of the Negro soul."[20]

In the early sixties, Baraka's purism was a cogent, militant response to the widely known but sparsely documented black history of the exploitation of black musicians, and it had a galvanizing effect upon popular and intellectual consciousness of that history. On the other hand, there is not much to be learnt from Baraka about the conditions of popular taste, because his is a polemic that can only browbeat what it calls "the shoddy

cornucopia of American popular culture." Critics of *Blues People*, like Ralph Ellison, who disapproved of its focus on "sociology" or "ideology," and its reluctance to consider the "poetic" significance of the blues as "an art form and thus a transcendence of those conditions created within the Negro community by the denial of social justice," surely (or perhaps intentionally) miss the political point of Baraka's analysis.[21]

But when Ellison objected to the too "rigid correlation between color, education, income and the Negro's preference in music," his objection to Baraka's fixed categories of analysis looks forward to the kind of critique that would focus on the diverse consumption of musical meanings by different audiences, rather than solely on the industrial production and marketing of these meanings for particular groups, classified as taste markets. An analysis of industrial production cannot explain why some musical products fail and others become popular choices (ninety-five percent of all records *fail* to become popular hits). Just as the music industry cannot fully anticipate how its products will be received, so too, a fixed socio-economic analysis cannot fully account for the popular taste of consumer groups, many of whom "misbehave" in the choice of their musical tastes, a delinquent practice that surfaced most visibly with the appearance, in the mid-fifties, of a "youth culture" whose generational identity was organized around its willingness to cut across class-coded and color-coded musical tastes.

Nowhere are the implications of Baraka's critique (long on militancy, and short on pleasure) more fully played out than in the case of the legendary bebop period in the forties, when a group of musicians collectively transformed the rhythmic and melodic structure of jazz music: Dizzy Gillespie, on trumpet; Charlie Parker, on alto sax; Thelonius Monk and Bud Powell, on piano; Sarah Vaughan's singing; Milt Jackson, on vibraharp; Dexter Gordon, on tenor sax; Max Roach and Art Blakey, on drums. At least part of the mystique with which bebop has come to be regarded is a result of the unrecorded, and largely undocumented conditions under which these musicians began to play together in jam sessions in the early forties. Compounded with the wartime ban on the use of shellac by the recording industry was the national strike of the American Federation of Musicians, begun in 1942 to force the major recording companies to endow the musicians union with monies for welfare and pension funds in addition to royalties. Unable to record for three years, the beboppers developed a form of playing that seemed to go against every commercial grain. Using a conventional but irregularly accented chord structure as a basis for improvisation, soloists developed complex melodies out of free floating, abstract patterns above a pulsing and often asymmetrical rhythm section. Its speed—Parker's 360 quarter notes per minute—and irregularity—Monk's esoteric dissonance—an-

nounced that this music intended to eschew the danceable rhythms of commercial jazz, while upping the ante of musicians' music—other performers simply couldn't keep up.

While bebop broke the rules of the game in every technical way possible, the wider cultural meanings that it generated can be read in more accessible ways. Most of the bebop classics are, in fact, variations of well-known popular tunes and melodies (most jazz music was and still is based on the reworking of popular tunes) which all musicians knew from their years of playing the commercial circuit. So too, the celebrated garb—sneakers, wide-lapelled suits, berets, "smoked window" glasses, and goatees (mainly attributable to Monk but classically associated with the more publicity conscious Gillespie)—bristled with subcultural meanings. The suits were a kind of faded complement to the fashionably sharp urban style of the period, which had displaced the pre-war zoot suit as the flashy commercial style.[22] The smoked glasses were a concrete expression of the hipster ethic of the inside-dopester, impenetrable to outsiders, while the beret and goatee (worn by Gillespie, at least, to cushion his mouthpiece) were read as signifiers of nineteenth-century French avant-garde bohemia. It is easy to see how this outfit, which became increasingly dandified as the bebop cult was established in the national press, would be increasingly associated with the fifties popular image of a certain kind of nonconformist in the arts and on the streets.[23]

So too, the anti-social sensibility attributed to the bebop musicians— a manifest contempt for audiences, further cultivated by the insider's language and lifestyle—was interpreted as a proto-political attitude not only towards the exploitative conditions of working in the entertainment business, but also towards the possibility of an autonomous expression of black culture. To the popular complaint that "you can't *dance* to this music" (a feat that Monk *did* perform unobtrusively on stage), Baraka remembers how he and his youthful friends would retort, "*You* can't dance to it," and whisper, "or anything else, for that matter." And as for the charge that bebop had no "functional use" as a music, Baraka points out, somewhat irrelevantly, that it is true that it "would not be used to make a dance out of picking cotton, but the Negroes who made the music would not, under any circumstances, be willing to pick cotton."[24]

Regardless of its prominence in the popular media, the impact of bebop, of which successful commercial versions *were* actually made, ensured that the future direction of jazz playing would lead away from the realm of popular music. The "cool" West Coast jazz style of the early Miles Davis was developed by Stan Getz, Stan Kenton, Chet Baker, Herbie Mann, and Dave Brubeck into so-called progressive forms, modeled directly on the functions of classical musical instruments, while "hard

bop," the response to "cool" instigated by Davis (again), Sonny Rollins, Coleman, and Coltrane developed into the explicitly confrontational, anti-commercial new wave of "free jazz" in the sixties. In the early postwar period of bebop, jazz had in fact all but renounced its claim to popular influence among a mass audience, and had begun, irrevocably, to become a part of elite, minority taste.

So too, in the fifties, it became common for beboppers like Gillespie to participate in world tours as part of the cultural crusades planned and financed by the State Department. Jazz, both "hot" and "cool," was a new weapon in the Cold War.[25] But the iconic or charismatic moment of bebop was best exemplified by the erratic, hedonistic life of Charlie Parker, whose early death entered him into the mythological rebel lists of other "lost, violent souls" of popular culture: (Robert Johnson, for the purists), Jackson Pollock, James Dean, Neal Cassady, Dylan Thomas, Billie Holliday, Marilyn Monroe, Janis Joplin, Jim Morrison, Jimi Hendrix, and Sid Vicious. None were "rebels" in overtly political ways, and yet the symbolic power of the sharp images they projected across the landscape of modern popular culture exercises the kind of affect for the collective youth consciousness that intellectual activism, organized or not, has striven, usually without success, to harness.

Why should white intellectuals, in the late fifties, have made such an attractive living religion out of the hipster trappings that surrounded Parker and the other "holy saints" of jazz? What was the function of this vanguardist cult in a milieu that is often cited as the last pure manifestation (if only because of the explosive rise, since then, of urban rents) of American artistic bohemia? The answer to this phenomenon of the "white negro" lies only partially in the glorified narrative of continuity with the bohemian tradition. I will argue that it is just as important to view this phenomenon in the context of its relation to the new postwar patterns of affluence, work, and leisure, a relation quite different from that which determined the antagonism of the historical bohemian avant-garde to high, bourgeois culture.

White Negro Scholarships

In the early twenties, jazz had drawn its first enthusiasts from the white college boy ranks, with the likes of Bix Beiderbecke. But the first "white negro" to play a mythical role in the history of "hip" was Milton "Mezz" Mezzrow, a poor Jewish kid from the North side of Chicago whose legendary career stretched all the way from the gangster-operated dance hall scene of the South side (on one occasion he had the nerve to stand up to Al Capone, who nicknamed him "the Professor" for his audacity)[26]

to his semi-institutional role as "dean of the moldy fig" purists in the
New Orleans revival craze that began in the late thirties as a reaction,
contemporary with that of bebop, to the sweetness of commercial jazz.
In the interim, he pursued such a successful non-musical career as a
peddler of marijuana in Harlem that his name passed into jive jargon
in the form of a "mezziroll"—the term for a particularly fat kind of
high quality reefer. Whether or not he actually believed, as the story
goes, that his nostrils widened and his skin darkened over the years,
his fulltime commitment to the hipster ethic seems to have been almost
flawless, and is amply recorded in his autobiography *Really The Blues*
(1946).

Written in an accessible form of hip, street patois, his memoir
celebrates the agility of the insider's jive talk, the richly eloquent
rapping language popularized by radio DJs like Daddy O'Daylie and
Dr. Hep Cat, and "documented" in Cab Calloway's *Hepster's Dictionary*
(1938) and Dan Burley's *Original Handbook of Harlem Jive*.[27] For Mezz-
row, jive has certain artistic credentials, as "a four-dimensional surrealist
patter," for example, and is, of course, largely impenetrable to outsid-
ers. But he also notes how much it is based upon parodic distortions
of "fancy ofay phrases," and how it "stays conscious of the fraud of
language" in its caricaturing and mimicry of educated white speech.[28]
Thus, although jive was twice as fast and twice as witty as anything
heard hitherto by a human ear, although it was constantly changing
its codes and its vocabulary, and was often *used* to exclude the
uninitiated, it was not, as is often assumed, simply a secret language.
In fact, it was constructed in symbolic, and thus symbiotic, relation to
the most polished, sophisticated, and learned forms of the parent, or
stepparent, white idiom; it was like "a satire on the conventional ofay's
gift of gab and gibberish." This is an important point to recognize
since it concerns the contradictory relation of the hipster style to
cultural capital. For the hipster's enduring reputation as a street
intellectual, or "diploma-less professor," had everything to do with his
lack of institutionally accredited learning. Mezzrow begins his book
thus: "Music School? Are you kidding? I learned to play the sax in
Pontiac Reformatory!" and "earned my Ph.D. in . . . creep joints and
speakeasies and dancehalls." Add to this the countless oral testimonies
of blues and jazz musicians who have responded to the persistent
questioning of journalists and scholars in the following way: "It's all
about 'feeling.' You just have to feel it to play it." Or: "It's natural.
You can't study up on it."

That form of conventional response on the part of musicians can be
compared with the way in which a critical aficionado like Nat Hentoff,
himself responsible for collecting many of such oral testimonies, writes

of what he calls his own "night school" education in jazz in his 1961 memoir *The Jazz Life*. Hentoff's story is laced with metaphors about education, about his own course of learning in the hard school of nightclubs where, more often than not, "the musicians themselves were faculty, student body and critics."[29] So too, he takes pleasure in noting how Charles Mingus read Freud, or in seeing John Lewis with a copy of the *New Statesman* in his pocket, just as other intellectuals were comforted by the image of Parker reciting Baudelaire or the *Rubaiyat of Omar Khayam* (or pleading with the composer Edgar Varèse—"take me as you would a child"), while others swapped stories about the alleged high IQ's of the beboppers with their vaunted tastes for Ravel, Stravinsky, Dali, and Sartre.

By the fifties, however, the legitimizing of jazz demanded its inclusion among the world of high, and not just strictly avant-garde, cultural references. Pretentious technical appreciations of the music, like the following by Marshall Stearns, a Cornell English professor and leading critical exponent of jazz, further emphasized the musical development of "legitimate" jazz in the face of the revivalist throwbacks:

> What had happened since 1940? In terms of harmony, jazz developed along the same lines as classical music (by adopting the next note in the overtone series), but more recently and rapidly. It still lags behind. Bop represented a stage in the harmonic evolution of jazz roughly comparable to the period that followed Wagner and Debussy. Ninths and augmented fourths (flatted fifths) became the clichés of bop, although they continued to sound like mistakes to the average Dixieland musician whose ear could adjust no further. "We really studied," trumpeter Miles Davis informed me . . . [30]

Jazz had become "Ph.D. music," studied by what Hentoff proudly remembers as an "elite secret society," an educated audience of late fifties youths who were initiates in the cabalic knowledge of a musical taste that "eschewed whatever trend of popular music was in favor."[31]

What did this emphasis on scholarly endeavor and superior tastes have to do with the illegitimate relation of the hipster to cultural capital? To be hip, after all, was to be "in the know," to possess a certain kind of knowledge, not legitimately acquired of course, but linked to the practices of high art and scholarship through a respectful but mock imitation of their institutions. The jive dictionary is a good example of this, itself reduced to the "nonsense" scholarship of Slim Gaillard's Vout Dictionary, his contribution to the jive dictionary craze; or, consider the mock-scholarly suggestiveness of song titles like Parker's "Ornithology" and Monk's "Epistrophy." By that same token, hip could be presented as an essential-

ist quality that inhered in those who did not need education to excel in what they did. As Billie Holliday explains, "some people is and some people ain't:

> Charlie Parker and people like him, and people like me, we just had it
> in us. It's got to come out someway. These cats didn't have it in them.
> They had to work and study and listen and work some more and get it
> the hard way.[32]

To outsiders, especially intellectuals whose social position is wholly predicated upon education, study, or the critical prestige of their artistic work, the privileges of *hip* appear to resemble those of a revealed religious grace.[33] And yet, there are more structural reasons why the vanguardist intellectual would identify with the hipster as Same and not just as Other. Hip is not simply a saturnalian inversion of the hierarchical categories of cultural capital, although it does claim for its adherents a kind of mock honorific superiority associated with the most legitimate of these categories. The hipster is not anti-intellectual, but in fact, stands in a similar, structural relation to cultural capital as does the intellectual. In the hipster's case, with no real (financial) capital to speak of, he is definitively on the outside of the order of cultural capital; in the intellectual's case, for whom real capital does not "count," he is definitively on the inside. Because of their relative independence, respectively, from the world in which economic power is felt and exercised, both are positioned as pariahs of the social order, and therefore they meet in the imagination and sometimes in reality as fellow citizens of the demimonde, each with their own imaginary relation to the straight world of steady jobs, material accumulation, mortgages, family life, insurance policies, and popular taste.

But the spirit of this encounter, in the fifties, between "subterranean" intellectuals (as opposed to the older, straighter, and "accommodated" anti-Stalinist intelligentsia) and hipsters is not the same as that which inspired the *nostalgie de la boue* of the historical avant-garde. To begin with, we must consider the initial ghetto expression of hip as a category of advanced knowledge about popular or commercial taste and style. In his autobiography, Malcolm X describes his early career as a hustler in Harlem in the thirties and forties, where he discovered the hip availability of a new zoot suit in the same instant as he discovered the world of consumer capitalism: " '*Save?*' Shorty couldn't believe it. 'Homeboy, you never heard of credit?' " After thirty minutes in the clothing store, he was "sold forever on credit":

> I took three of those twenty-five-cent sepia-toned, while-you-wait pic-
> tures of myself, posed the way "hipsters" wearing their zoots would "cool

it"—hat dangled, knees drawn close together, feet wide apart, both index fingers jabbed toward the floor. The long coat and swinging chain and the Punjab pants were much more dramatic if you stood that way.[34]

The zoot suit, which inspired racially motivated riots during the war,[35] was an affordable, parodic expression of the extravagant, celebrity styles flaunted by thirties Hollywood to sweeten the effects of Depression poverty. More important, it was also a dandified expression of the social aspirations of the ghetto teenager, newly introduced, like Malcolm X, to the attractive world of consumer credit.

A mark of his independence within the ghetto economy, the hustler's ability to outhip his peers was associated with the brash audacity with which he interpreted the sharp consumer styles. With his sharkskin gray zoot suit, long knob-toed shoes, and four-inch brimmed hat over conked red hair, Malcolm X boasted that his outrageous appearance as "Harlem Red," one of "the most depraved, parasitical hustlers among New York's eight million people," was often the cause of near automobile collisions. Hipness, then, was all about a total immersion in style to the point where the hustler not only had style to spare, and thus to reject or disdain, but also, as Claude Brown put it, "masculinity to spare."[36] So too, it is because the hustler-hipster is so well-versed in musical knowledge that he will stage his distance from the fever-heat dancing of the popular mode. His cool, retreatist position is a result of a profitable disengagement, but not a snooty aloofness, from the codes of the popular culture. Attempts to emulate this position by way of a short cut were branded as "hep" or "hippie," the mark of the pseudo-hipster, usually but not exclusively white.

Hip to the Beat

The long enduring distinction between hip/straight has been through many different permutations since Mezzrow's career in the twenties and thirties and Malcolm X's in the forties, and especially since it passed into the cultural mainstream in the sixties. Its line of demarcation is a shifting frontier of taste that does not always fall along color lines or class lines. Hip is a mobile taste formation that closely registers shifts in respect/disrespect towards popular taste. For the lower-class hipster, this is manifest in being *overinformed* about popular taste—he knows all about it, even as he keeps his distance. For the middle-class, hip intellectual, whether Beat or, later, countercultural, it assumes the appearance of being ill-informed or *underinformed*—he doesn't want to appear to know anything about it. For the former, hip can also be a defensive, symbolic expression

of his capacity to ward off persecution and exploitation, while for the latter, hip can be a way of appearing to engage directly with the "truth" of popular behavior, as opposed to its phoney representations in the pages, sounds, and images of "mass culture."[37]

Howard Becker describes a group of young white jazzmen in the early fifties, reputedly from well-off, middle-class families:

> They were unremittingly critical of both business and labor, disillusioned with the economic structure, and cynical about the political process and contemporary political parties. Religion and marriage were rejected completely, as were American popular and serious culture, and their reading was confined solely to the more esoteric *avant-garde* writers and philosophers. In arts and symphonic music they were interested in only the most esoteric developments. In every case they were quick to point out that their interests were not those of the conventional society and that they were thereby differentiated from it. It is reasonable to assume that the primary function of these interests was to make this differentiation unmistakably clear.[38]

Here, in this portrait of the first wave of fifties white hipsters are many of the lineaments of the underground scene that would come to be celebrated in the novels, poems, and biographies of the Beats.

It was a scene that is often portrayed as politically apathetic, although it should be remembered that the impulse to go underground had as much to do with the recent McCarthyist victimization of the identifiable left as it had to with a romantic infatuation with the nihilist vanguardism of Dostoevski's *Notes From Underground*.[39] In fact, the link between the Beats' visionary identification with the nineteenth-century avant-garde (Dostoevski, Rimbaud, Blake, Nietzsche, Lautréamont) and their own contemporary patronizing of drifters, hobos, proles, and reform-school prodigies, must be viewed in a specific historical context. Between the time of the anti-bourgeois demimonde and the romantic pietism of Beat comes the period when intellectuals put themselves in the service of revolutionary movements, and when intellectual sponsorship of the masses was seen as a *responsibility*, and not as an act of free political will. This is why the existentialist *acte gratuite*, which Beat culture celebrated, represented something like a release or relief from that burden of responsibility. The older, liberal intelligentsia looked to European high modernism for relief, while younger artists, "the know-nothing bohemians," to use Norman Podhoretz's famous phrase, looked to the devotional confessions of a nineteenth-century avant-garde, filtered through the esoteric strains of bebop. What these groups shared in spirit if not in flesh was their respective commitment to cults with more authentic heroes

than the "plastic" youth idols which were to be found, increasingly, at the religious center of contemporary pop culture.

The tender-hearted humanism with which the "dharma bums" of Beat embraced down-and-outs has drawn derision from many quarters: the protected pacifism of a middle-class, drop-out Underground is often unsympathetically compared with the harsh survivalism of petty criminal life in the Underworld that the Beats patronized. But such a comparison almost always appeals to its own kind of romantic proletarianism. Herb Gold, for example, remarked that the generally middle-class Beat "bears the same relation to the [lower-class] hipster as the cornflake does to a field of corn."[40]

On the other hand, it is easy to see how idolization of the black jazz musician by white hipsters and Beats could have been reinforced by a "romantic version of racism" which, in Simon Frith's view, imagines "blacks as presocial, at ease with play."[41] In the image of jazzmen as untutored, natural geniuses whose spontaneous "work" on stage is both collective and virtuoso, there are indeed elements of this mythical mastery of leisure. To be "cool" while playing "hot" is best of all, because it signifies effortlessness. While these are primarily stage conventions, the spectacle of work, on the other hand, visibly signified by sweat on the brow, carries with it all sorts of meanings that make it less easy to romanticize. It is the sweat of the vestigial minstrel clown (Satchmo's ever-ready handkerchief), but it is also the reminder of the sweat of slave labor. It is a comforting reminder to a white audience that labor exists, and is elsewhere, in a black body, but it is also a militant negation of the racist stereotype of the "lazy" i.e. underemployed black male. In the sixties and seventies, it became conventional for white rock musicians to sweat as representational proof of their hard labor—the audience can see that it has got its money's worth. The same convention applied in the funkier categories of soul music, albeit with different meanings that relate to gospel emotionalism as well as secular excitement. By contrast, in the "cool" world of modern jazz ushered in by bebop, evidence of strenuous activity is supposed to be interpreted as a sign of mental and not physical labor.

What can we say about the respective relations of hipster and Beat to the category of work? In the tradition of the "responsibility of intellectuals" which, in the fifties, has fallen into disfavor, "work" had also meant "working for the masses," whether through committed writing, organizing, or other forms of activism. It is just as important, I think, to emphasize the distance of the Beats from activist work of this sort as to focus on their more obvious antagonism to the working regimen of the middle-class "organization man" of the fifties. In *Growing Up Absurd*, however, Paul Goodman traced the similarities between hipsterism, Beat, juvenile delinquency, and what he called "the middle status of the organized

system." To his mind, all shared a lack of goals, a cool cynicism, and a disdain for ethics and politics which had alienated, with its "contempt of honest effort and honest goals," the "earnest boys" of the working class and lower middle class. Goodman's influential critique called for a return of meaningful work and meaningful values, but his true, and less visible, target was the new popular uses, culturally inferior to his mind, that were being made of increased leisure time in an age of abundance. The real source of unmeaningful, spirit-sapping values was the spread of popular culture, abstention from which, Goodman agreed, "bespeaks robust mental health."[42]

If the "problem" of work was really a problem of leisure, then clearly the "problem" of affluence was really a problem of poverty. The Beat's neo-Franciscan cult of "voluntary poverty" was an imaginary solution for an impiously affluent society that would not officially discover its invisible *real* poor until the publication of Michael Harrington's *The Other America* (1962). The Beats' holy poverty had little to do with conditions in the ghetto; it was a response to a perceived middle-class "poverty of spirit" which the rites of the "angel-headed hipster" were designed to exorcize. The purgatorial journeys of Beat heroes, whether undertaken by the criminal-saint type of Neal Cassady, the boy scout, joyster type of Kerouac, or the later poet-monk type of Allen Ginsberg and Gary Snyder, all called attention to the sinful consumerism of the new middle classes. But, unlike the "ethnographers" of the thirties, and the SNCC activists of the early sixties, the Beats were neither missionaries nor sympathizers in respective solidarity with the people. Their personal itinerary—to be on the road, and burning like "fabulous yellow roman candles"—recalled the code of aristocratic self-extinction espoused by fin-de-siècle aesthetes like Walter Pater, who had wanted to "burn always with [a] hard gemlike flame." Roman candles were a different kind of high (they quickly burned out), but they evoked a similar fantasy of transcendence, now projected on to identification with a lower class for whom *survival* and "getting burned" was a daily problem.[43]

Alongside the worldly-otherworldly exploits of the Zen Hipster, we ought, then, to place the contradictory picture that Malcolm X gives us of the hustler-hipster—a picture from a morality play, in which his glamorous, sinful person à la Mailer is both celebrated and infernalized as Public Enemy Number One:

> The hustler, out there in the ghetto jungles, has less respect for the white power structure than any other Negro in North America. The ghetto hustler is internally restrained by nothing. He has no religion, no concept of morality, no civic responsibility, no fear—nothing. To survive, he is out there constantly preying upon others, probing for any human weakness like a ferret. The ghetto hustler is forever frustrated,

restless, and anxious for some "action." Whatever he undertakes, he commits himself to it fully, absolutely.[44]

For black leaders, the seductive qualities of the hustler, as role model for the young, were to be resisted and fought against through social programs. For some white radicals, on the other hand, the same qualities offered a model of social confrontation that was more potent than the pieties of liberal reform, and it was this perception which fueled the kind of apocalyptic romanticism that Norman Mailer celebrated in his essay "The White Negro" (1957).

The hipster street code had been fashioned out of ghetto survivalism, and, however uncommunicative, was impelled by a defensive revolt against defeated social expectations. Mailer's essay was an attempt to provide a political form for the disaffections of the hipster code, to re-articulate "the destructive, the liberating, the creative nihilism of the Hip." The result was a kind of revolutionary tract that bore as much relation to the hortatory strictures of the traditional political pamphlet as a lyrical ode does to a chemistry textbook. But Mailer was as close to the older liberal intelligentsia (his essay was published in *Dissent*) as he was intimate with the artists and poets of the Underground, and therefore he was respectful of the socially minded tradition of the "responsibility of intellectuals." As a result, the essay made its own gestures towards social Messianism. In place of the orthodox "mass consciousness" of the proletariat, he wrote, in the new psychobabble of the fifties, about a "new mass psychological imbalance" which would harness the energies released by the "psychopathic brilliance" of the hipster. To "encourage the psychopath in oneself" was not to trust in History in the old marxist-Hegelian way, but to exploit the libertarian possibilities of free enterprise with one's most violent fantasies and desires.

Here, at least, were some of the roots of the revolution of self-liberation that was to inspire the consciousness of the sixties counterculture. While Mailer admitted that this extreme self-reliance was as likely to lead to the "potential ruthlessness of an elite" of "authentic psychopaths" or stormtroopers, "swinging" with the forces of reaction and mass murder, he also noted that the chances for a better world lay in the precarious hope that the hipster will come to see that "if he would be free, then everyone must be free." Mailer's psychic and sexual outlaw who saw "hip" as the basis of a "new nervous system," was posed as a compulsively subversive, anti-social threat, and, in this respect, could be distinguished from the Beat's bouts of "voluntary madness" ("flipping your wig" was often the hip thing to do to attract attention around the Beat scene).[45]

In invoking the apocalypticism of Bomb culture, Mailer sought a fashionable explanation for the hipster's rejection of the past in favor of the worship of the spontaneous unplanned present. History no longer

mattered, because the future was now impossible; the imaginary of the Bomb had changed everything:

> It is on this bleak scene that a phenomenon has appeared: the American existentialist—the hipster, the man who knows that if our collective condition is to live with instant death by atomic war, relatively quick death by the State as *l'univers concentrationnaire*, or with a slow death by conformity with every creative and rebellious instinct stifled . . . , if the fate of twentieth-century man is to live with death from adolescence to premature senescence, why then the only life-giving answer is to accept the terms of death, to live with death as immediate danger, to divorce oneself from society, to exist without roots, to set out on the uncharted journey into the rebellious imperatives of the self.[46]

Eventually, the post-apocalyptic genres of the SF novel and film would succeed in imaginatively assuaging the fear of a present without a future. In the early fifties, however, apocalyptic "ends" were new and thus more final, and for every liberal who announced the "end of ideology" because "there were no more problems to be solved," there were many others who were struck by their own gathering irrelevance. "There are no longer problems of the spirit," said William Faulkner in his 1950 Nobel Prize acceptance speech, "there is only the question: When will I be blown up?"[47]

This collapsed sense of temporality, which wrenched infinity from the future into the present, was equally reproduced, at a different level of everyday life, in the experience of a consumer present. No saving, no deferred gratifications, no hanging on a life to come; everything could more or less be bought now, and paid for later. This mode of instant availability (which soon included planned obsolescence and later, instant disposability) was supposed to include the potential acquisition of culture, however "middlebrow," for everyone. The instant availability of culture was an affront to intellectuals whose cultural authority was based upon the long, slow accumulation of cultural capital. In this respect, Mailer's radical claims for the "orgasmic" moment of hip can be seen as part of the intellectuals' revenge. Ten years before "radical chic"—among other things, a joke at the expense of orthodox liberals—here was "radical hip," Bomb-style—among other things, a slap in the face of the newly "cultured" classes who were being told that their long awaited entry into the pantheon of culture meant nothing, because "nothing" mattered anymore.

In acknowledging that his essay was aimed at the enduring white anxiety about black male sexual superiority, Mailer's celebration of virility and ultimate orgasms fed the macho obsession that was later to draw endless fire from the women's movement, while it played into many of the cultural myths about black masculinity and sexuality. Even at the time, the Beats were critical of Mailer's aggressive posturing. Kerouac

hated the implied celebration of violence, Ginsberg recalls that the "notion of the hipster as being cool and psychopathic and cutting his way through society was a kind of macho folly that we giggled at," while Michael McClure, too young to bear the mark of hipsterism, merely thought the whole thing "quaint," and old-fashioned.[48] For black radicals like Eldridge Cleaver, however, Mailer's aggressive demand for the hipster to end his "skulking" and pursue his desires to their anti-social conclusions was a stirring, sexualized call to militancy for the symbolically "castrated" black male.[49] Others, like Charles Keil, emphasized the destructive social effects associated with Mailer's "existentialist stud" within the context of the matrifocal ghetto family structure, littered with broken homes as a result of the economic difficulty of sustaining paternal responsibilities.[50] Demonstrating concern about "the absence of meaningful work in the lives of the prototypical Negro hipsters," Nat Hentoff's response was typical of the more orthodox and responsible liberal view: "It is one thing for him, a white man of the middle class, to seek danger and violence as a means of self-liberation, but I do not believe he can begin to equate whatever he thinks he has discovered in his own raids into himself with the way the 'authentic' Negro hipster lives and feels."[51]

Sick White Negro

As these responses to Mailer's essay demonstrate, there were different risks involved, for whites and blacks, in confronting the officially defined limits of social masculinity. The crossover potential of "hip" made this quite clear. In fact, the most public political struggle of any figure in the white hipster tradition—that of the comedian Lenny Bruce—would take place, not in the streets, but in the courts, and on the stage of free speech. Described by Jonathan Miller as the "sick white negro," Bruce rose to prominence among intellectuals along with other "sick" humorists like Jules Feiffer, the cartoonist, and Mort Sahl, the political comic-satirist. Sick comedy, which turned its merciless attention to sacred or politically sensitive topics like physical deformity, disease, disaster, or racial persecution, was a way of providing relief from the pieties of the over-serious liberal conscience. But Bruce, the "sickest of the sick comics," was to do more than stretch the formal rules of the game to accommodate the new fashionable boredom with the clichés of liberal tolerance.

There were early attempts to contain his act within formal, or generic boundaries. Appearing, for example, on *The Steve Allen Show* in 1958, he was introduced to his first popular television audience as the "comedian who will offend *everybody*" of every race, sex, or class. This was the Bruce who would soon be performing monologue sketches like "How to Relax

Your Colored Friends at Parties," or "Are There Any Niggers Here
Tonight?" and who would soon be periodically arrested in clubs at home
and abroad for transgressions of the obscenity laws. His subsequent battle
with the courts was to fully occupy his act and his brilliant cultural persona
for the rest of his narcotics-abusing life; Phil Spector said that Bruce died
from "an overdose of police." By the turn of the decade, the cult of Bruce
embraced many in the higher intellectual circles who were prepared to
publicly defend his legal right to free speech as an "artist." By then,
Bruce's appeal had gone far beyond the ideological limits of the popular
comedy genre. In fact, on this point, he was insistent, both in public and
in private: "I am not a comedian. I am . . . Lenny Bruce." It is in this
shift, however, from the low-culture status of the comic to the legitimate
status of the public satirist, folk philosopher, and outspoken defender of
free speech, that we can see at least one fully articulated version of a
career that was developed out of the internal contradictions of the hipster
ethic.

Albert Goldman has described the ethnic comic background of Bruce's
milieu as being like the "Jewish equivalent of the black jazzman," in which
"funny" was Jewish for "soul," and the *spritz*—a kind of rap-cum-interior-
consciousness-monologue—was a multi-cultural speaking in tongues:

> [Of Joe Ancis, Bruce's early model] Big intellectual words would rub
> shoulders in his spritz with old-country Yiddishisms and hipster jazz
> slang, American underworld argot and baby talk. It was a crazy pot-
> pourri of language with the most astonishing riptides and undercuttings
> and oneuppings and incongruities and sparks. . . . Words were jammed
> together like nests of jackstraws. Single phrases were thrust out at you
> like slogans on billboards or commercials on the radio. Syntax, word
> order, the whole decorum of prose was short-circuited impatiently.
> Bang, bang, bang! That was the rhythm. Underscored with alliteration
> and pounded home with sledge hammer accents, a verbal rock 'n' roll.
> The language was constantly failing the Brooklyn hipsters, cracking,
> breaking, sinking under the enormous weight of their demands. Like
> crazies they were tearing the books off the shelves, ransacking the files,
> schlepping up words and images from unterem drerd. The appropriate
> conclusion for any of their raps and shticks would have been a cerebral
> hemorrhage.[52]

Because of his drug habit and a certain verbal laziness, Bruce never
entirely perfected this kind of performance style. It was clear, however,
from many of his sketches that the "synapses" of the *spritz* were supposed
to be in synchrony with the offbeat rhythms of bebop, while his mono-
logues had the same improvisatory character. And Bruce himself was not
only tuned in to the hipster's view of the jazz scene, he was also responsible

for much of its popular crossover appeal, in other words, for shaping the popular image of the hipster. But some critics of Bruce resented his perpetuation of the division of the world into a hip elect always in advance of a mass of straights. Demonstrating the social irony of this principle of advancement, Bruce would say, for example, "the reason I don't get hung up with well, say, integration, is that by the time Bob Newhart is integrated, I'm bigoted."[53] Others suggested that a more telling division was between Jewish and *goyish*; to Bruce, everything that was stylishly hip, including all non-WASP ethnic culture, was "Jewish," while everything that was tastelessly and unimaginatively WASP, including Reform Judaism, and ultra-provincial Jewishness ("If you live in Butte . . . you're going to be goyish even if you're Jewish") was *"goyish."*[54]

As for the hipster's pseudo-scholarly sensibility, Bruce's repertoire everywhere demonstrates a similar relation to the cult of intellect. Because it drew upon a long ethnic tradition of respect for learning, his Jewish version of the hip outlaw unraveled and fully revealed the hipster's coded relation to intellectual authority. In fact, Bruce was quite disdainful of the more popular elements of his audience, especially when they had a provincial, WASP background, and he was never happier than when playing to a crowd stacked with intellectuals—the tweedier the better. The logic of this tendency was fully played out in his confrontations with the law courts.

It is probably unfair to say that Bruce actively courted the storm of police harassment and persecution that descended upon him in the early sixties, but it nonetheless gave him the chance to "perform" in the courts before his most legitimate audience of all. There were those who took a specific pleasure out of the spectacle of Bruce's testing of legal authority— "the vicarious thrill of being a really bad boy."[55] For the legal issue at stake here was naughty words and not naughty deeds, and therefore Bruce's legal appearances could be seen as more than just a properly articulate replay of the spectacle of the J.D. "bad boy" before the law. In contrast to the persecuted "badness" of the black "offender," however, for whom the coercive legal apparatus reserved its most extreme forms of repression, Bruce's paranoia might seem like an extreme instance of white middle-class anxiety. His trials bore little resemblance to those of the Black Panthers a few years later.

More important to the code of hipsterism was the meaning of Bruce's legal activism. As the arrests and prosecutions piled up, he became a voracious student of legal textbooks, and was soon addicted to the forms and discourses of legal argument, mounting his own defenses, and sometimes, attacks. Here, at last, was the triumph of the hipster as guerrilla autodidact, having forced his own illegitimate entry into the scholarly apparatus of the law in order to confront the unified face of power and

education. This was an image coveted by intellectuals, because it was not a *popular* move, even though he was defending the "rights of the people" to free speech. In fact, when Bruce started out by spouting four-letter words in order to rile the policemen monitoring his club acts, these cops knew that he was offending *their* plebeian codes of decency. The sophisticates in the audience could take abuse; it was what they had paid for. But the humor was often at the expense of the redneck straights, like these policemen, who were just too damn dumb to get the jokes. So even as he was lambasting the bourgeois interests that were trying to silence him, he wasn't playing to the gallery. On the contrary, he was more likely to be vilifying the taste of those who were "in the gallery," or else policing their own class; in other words, those who could not afford to be anything but serious about their taste. Even in the courts he would pull the same routines on the judges and juries, appealing to their sense of superiority over the morality and tastes of the uninitiated. The fact that Bruce never served a proper prison sentence had as much to do his ability to convince the authorities that his "artistry" had nothing to do with popular codes of communication, as it had to do with a victory for free speech. This, more than anything, was the lesson of Bruce's hipsterism.

On the night that Bruce succumbed to an overdose in 1966, the scene of his death was visited by a distraught and irate Phil Spector, the rock mogul who had been his patron for the last fifteen months of his life. Spector had recently become the first *auteur* producer-intellectual of the youth scene that had generated rock culture at the time Bruce was starting out in the early fifties. He was the producer, and the product (the "first teenage millionaire") of what had been happening to popular taste all over the country while urban intellectuals were ritually crowding into the jazz clubs.

Caught Napping

In the late forties, Sidney Finkelstein wrote a book that claimed jazz as a "peoples' music." He began by complaining about the "snobbery which still keeps jazz from being properly respected," and ended his sympathetic history by describing how jazz was now "knocking at the door of musical composition" that said "for whites only." It is a book that is typical of an intellectual populism that was already struggling to survive the Cold War climate. For Finkelstein, it was important that jazz had attracted the scholarly accompaniment of exhaustive discographies and documentation, critical debate, and even "European" polemical strife of the sort that had been fashionable in Parisian jazz circles for some time. This

war of persuasion on the part of intellectuals naturally complemented
Finkelstein's marxist recognition that "jazz reasserts the truth that the
creation of art is a social function, that music should be made for people
to use . . . music is something people do, as well as listen to."[56]

Twelve years later, Francis Newton (a.k.a. the historian Eric Hobs-
bawm) reaffirmed this populist claim, while noting that jazz had been
kept in an "odd and complicated family relationship with popular music."
As a truly democratic "art of the people" jazz coexisted with commercial
pop, living "within it as waterlilies live in ponds and stagnant streams,"
while it was ostracized by the elite minority arts as a cultural form that
was clearly below the salt.[57]

For intellectuals like Finkelstein and Hobsbawm, jazz had become the
ideal embodiment of an authentic music by the people, for the people.
Although it was not the mythical folk music of the revivalists in search of
the lost chords of the New Orleans pioneer, Buddy Bolden, it had once
been a folk music, all the same, changed now beyond recognition by the
urban conditions which it had survived and in which it now thrived.
Steering a charmed course between the Scylla of the "Mickey Mouse
music" of the music industry and the Charybdis of art music's "academic
etiolation," Hobsbawm declared that jazz would outlast the "wholly ado-
lescent" "infantilism" of the R & B boom just as dynamically as it had
sidestepped the cloying sweetness of earlier Tin Pan Alley forms. As for
jazz's political potential as protest music, its links with the history of an
oppressed minority could not and would never be glossed over, while its
anti-puritan spirit distinguished it from the ascetic militancy of the leftist
folk song culture. In short, jazz was the Golden Fleece of the intellectuals'
century-long search for a democratic people's art that was both truly
organic and post-agrarian.

No cynicism is intended when I suggest that this was a mythical, short-
lived moment in that history. Similar claims for the authenticity of an
organic communitarian culture would also be made in the subsequent
course of rock music by musicians, youth leaders, and pop critics at the
height of the equally short-lived rock counterculture in the late sixties.
But the period of jazz's authentic "moment" as a legitimate populist art,
from the late forties of Finkelstein to the late fifties of Hobsbawm no
longer belonged to the large, popular audience it had once enjoyed.
Instead, it belonged to traditional intellectuals, in possession, finally, of
their Holy Grail, and, increasingly, to the organic black intellectual voices
of musicians, from the embryonic self-sufficiency of bebop to the articu-
lated dissent of Miles Davis, John Coltrane, Archie Shepp, Pharoah Sand-
ers, Charlie Mingus, Albert Ayler, Rahsaan Roland Kirk, and many
others in the later years of the Civil Rights movement. Even as these
intellectual claims about organic populism were finally being made on

behalf of jazz culture and from within it, the popular audience for the
music itself had long been in decline.

In that same period, at the height of the Cold War, the changes that
are constantly being rung in the temple of musical democracy were to be
heard elsewhere, not in jazz clubs, but in bars, dancehalls, and blues
clubs, and during radio's moondogger hours all over the country. If you
had been listening only to what jazz aficionados or hip intellectuals like
Norman Mailer were saying, then it may well have seemed as if rock 'n'
roll, as Greil Marcus put it, had "come out of nowhere."[58] You might
have concluded that it was a teenage product manufactured exclusively
by industry producers. Numerous histories have, by now, made it crystal
clear that nothing could be further from the truth. The industry was
caught napping by the popular appeal of R & R, whose venerable roots
lay firmly in the danceable rhythms of the postwar urban blues scene.
Ahmet Ertegun, the founder and owner, at that time, of Atlantic Records,
and one of the biggest producers of the R & B boom, describes how the
honking and shouting came to provide the definitive crossover taste for
popular beat music in the early fifties:

> The change came gradually. It started, oddly enough, in the South
> where white stations began to play R & B. Many white southerners liked
> R & B. As he was growing up, Elvis Presley was singing Clyde McPhatter's
> hits like "Money Honey." He didn't hear them in a publisher's office.
> He heard them on the radio. He wasn't the only one. Many of the people
> in Memphis dug R & B, and pop stations started playing it. Programmers
> found their ratings going up because they were not only getting new
> listeners (black people) but more white listeners who happened to like
> the music.[59]

Individuals like Ertegun and his fellow producer Jerry Wexler, who
fostered the talents of many of the major fifties R & B acts (even Ed
Sullivan featured some of them on his TV show), and, most important,
Moondog disc jockey and pioneer tastemaker of youth music, Alan
Freed, "discovered" the teenage taste for R & B, and helped to make
it nationally popular: *they did not "create" it.* In fact, the major recording
companies were outmaneuvered for over ten years by the hundreds
of independent companies that sprung up along with a music that ran
counter to the white pop crooner taste. As result of this open threat
to monopoly profits, a full-scale legal war was declared by the establish-
ment ASCAP (American Society of Composers, Authors, and Publish-
ers) upon BMI (Broadcast Music Incorporated), the new rival organiza-
tion of independents, to try to prevent BMI material (R & R) from
being played by major radio networks.[60] The moral outcry over the

sexual connotations and the "negritude" of R & R is well recorded and well known, as is the resentment expressed by black performers over the "theft" of their music by whites, although popular recognition of this fact had to wait for the British Invasion, when groups like The Beatles, the Rolling Stones, and the Animals openly discussed their fond indebtedness to R & B musicians.

In spite of these reactions, the moment of R & R was itself a radical rearticulation of the color line. In the vintage years of R & R, while there were any number of white covers of R & B songs, a large number of the popular hits were sung by black artists like Chuck Berry, Fats Domino, Little Richard, Junior Parker, Bo Diddley, Sam Cooke, the Drifters, and the Coasters, and, in some cases, at the urging of the influential Freed, white covers were rejected by the most dedicated white listeners in favor of black originals. In 1963, the segregated charts were so similar that *Billboard* ceased publishing a separate R & B chart (for the first time since 1920), a decision that had to be reversed with the coming dominance of the raw R & B sound of the British Invasion. But for British musicians, raised in a culture that would not have to begin to properly acknowledge its multiracial constituency for another decade, blues music represented an exotic taste, not a lived experience for a racial minority. This was not the case with the earlier rockabilly culture of Southern kids. What was extraordinary about the boldness of a fresh, young country rocker like Elvis Presley was "not his ability to imitate a black blues singer, but the nerve to cross the borders he had been born to respect."[61]

There is no single, or unified explanation for the fact that white trash kids from Baptist backgrounds would be attracted to the same kind of music as adventurous teenagers in the high schools and colleges of the more integrated North. But, for all the class differences and regional differences, the excited response to R & B and then R & R was probably much more affinitive than could ever have been predicted, and certainly too broadly based to be interpreted as the achievement of a tastemaking teenage vanguard. Whether or not such a vanguardist role was played by teen rebels, Richard Middleton argues that the crucial "midwife" factor in the birth of R & R was the influential legacy of "pre-existing artistic bohemianism,"[62] in other words the hipster and Beat subcultures associated with jazz. However, it is just as important, I think, to consider the differences between the bohemian tradition and the embryonic rock culture. White teenagers who were hip to R & B had been listening to the screamers and honkers since the late forties, *at the same time* as the hipster cult of modern jazz began to flourish among "white negroes." But whereas the beboppers and their followers were "aristocrats," with musical laws unto themselves, the R & B performers were professional

servants of a popular audience: Big Jay McNeely, Bull Moose Jackson, Etta James, T-Bone Walker, Brownie McGhee, Dinah Washington, Fats Waller, Nat King Cole, Bobby Bland. R & B was music to move to, and it did not invite anything like the cool, disconnected response that the danceless bebop and modern jazz culture had gone out of its way to encourage. Because of this, R & B was never part of the war against popular taste which had brought together the alliance of hipsters, white intellectuals, and avant-garde black musicians. The taste, black and white, for R & B was more likely to be disparaged by that same alliance of hip tastemakers who shunned the dance floor.

By the end of the fifties, with the Civil Rights movement under way, the white minority taste for R & B (as opposed to the general teen audience for R & R) had taken on a more openly political connotation; it was also an expression of *solidarity* with the social and political aspirations of black people. The category of hip taste began to include the sense of a white lifestyle that was "politically correct," and signified to be so by the cultural options which it chose. By the end of the sixties, to be white and hip no longer meant a wholesale identification with black culture although it still included a ritual quotient of references to black music. By then, hip had become the distinctive possession of an ideological community—the predominantly white counterculture—bound together by a set of "alternative" taste codes fashioned in opposition to the straight world. In musical terms, this of course included a stringent critique of the pop culture industry.

To be hip, however, always involves *outhipping* others with similar claims to make about taste. Hip is the site of a chain reaction of taste, generating minute distinctions which negate and transcend each other at an intuitive rate of fission that is virtually impossible to record. It is entirely inconsistent with the idea of a settled or enduring commitment to a fixed set of choices. Thus, while the evolving white counterculture's taste in black music ran to the purist urban blues of Muddy Waters or to the free jazz of Pharoah Sanders, arguably the *most* hip white tastes, from the mid-sixties on, were attuned to popular soul music; this accounts, for example, for the piously respectful reception by the "love crowd" of Otis Redding's legendary set at the 1967 Monterey Festival. The hippie ethos of anti-commercialism had begun to penetrate mainstream middle-class culture, and had quickly been absorbed and taken up commercially by Madison Avenue. So too, the counterculture's purist devotion to values of "authenticity," and "sincerity" was based upon an ideology of good community faith, all of which dogma had little to do with hip's essentially agnostic cult of style worship. When Madison Avenue started paying profitable lip service to hippie values, then "where it was at" had to be elsewhere, not in the self-righteous world of progressive rock music.

The result was a continuing attention to the commercial development of black R & B, now infused with the ideology of "soul"—a new essentialist category. But soul governed a cultural territory that was forbidden for whites in a new way, because it was articulated to exclude them, not just out of the old fear of exploitation but also out of the new separatist pride. With soul, the category of the "white negro" was no longer so easily available; there was no such thing as a "white Black."

Bearing Witness

Calling attention in 1965 to the dangers of avant-garde abstraction among the practitioners of free jazz, Amiri Baraka advised young jazz musicians to

> make sure they are listening to the Supremes, Dionne Warwick, Martha and the Vandellas, the Impressions, Mary Wells, James Brown, Major Lance, Marvin Gaye, Four Tops, Bobby Bland, etc., just to see where contemporary blues is; all the really nasty ideas are right there, and these young players are still connected with that reality, whether they understand why or not. Otherwise, jazz, no matter the intellectual bias, moved too far away from its most meaningful sources and resources, is weakened and becomes, little by little, just the music of another emerging middle class.[63]

A year later, Baraka described the distinction between "what the cat on the block digs"—R & B songs *about* their lives—and the less populist but more "complete existence" of avant-garde jazz—in which musicians *play* their lives—in terms of a distinction between "different placements of the spirit." Once it had freed itself from the "practical God" of gospel music, R & B, Baraka argues, took on the commercial role of describing the daily sexual shortcomings of "practical love" between black men and women. By contrast, the New Music of jazz never had to acknowledge the "practical God," and could therefore seek the "love triumphant" of the "mystical God."[64] Baraka obviously regrets the social gap that has opened up between this "religion of the masses" and the art-religion of the mind that occupies the jazz avant-garde, and he calls for a "unity music" to transcend the "spiritual" differences. That his call to order had little success, in retrospect, is proof of how far jazz had gone beyond the realm of popular taste.

In fact, a more successful cultural union had already been forged in soul music between the communal tradition of gospel choir music and the more individualistic forms of secular blues. While this unholy alliance drew the wrath of black preachers (at the same time as white evangelicals

were railing against R & R) the practice of setting gospel anthems to R & B rhythms actually helped to overcome black urban resistance to the culture of the store-front church, and to what had been seen as backward, Southern-identified music. It also brought an exalted, emotional power to the raw, profane excitement of blues shouting, and, with the addition of commercial style and star presentation to the mingled praise of God *and* sex, soul became an unbeatable popular sound from the early to late sixties. "How can a two-minute-thirty second song be so perfect?" asked Gerri Hirshey.[65] The answer had as much to do with the cultural politics of the time as it had to do with the successful musical formulae that carried the phenomenal hits of the recording artistes from Motown, Atlantic, and Stax.

Although it never lost sight of the consumer dream of endless teenage romance, for which it produced some of the most enduring anthems, soul music also, and increasingly, offered a representation of the everyday realism of black life. Even the sweeter Motown product, aimed unabashedly at the white market, was supposed to contain, in Berry Gordy's words, the "rats, roaches and soul" of ghetto life.[66] Social problems were often addressed in a forthright manner and in the spirit of sexual and economic realism. More often than not, the tone was one of conversational intimacy, "expressing personal feelings in a very public manner, stating the problems and drawing the audience together in a recognition that those problems were in many ways shared."[67] In the operetta-like monologues of soul, black stereotypes, especially sexually constructed ones, were frankly discussed by the upfront female singers. This code of gritty honesty about the community—telling it like it is—had been a component of the female blues ever since the twenties; it may be contrasted with the cultural messages of the male blues tradition that had nurtured a music about despair and involuntary resignation to the task of surviving an unchangeable daily round of suffering and oppression.

Increasingly, soul began to express more politically explicit messages about the crises within the black community. Demanding "respect" led to assertions about black pride, which gave way to anger as the Vietnam War claimed young black lives abroad, and urban riots devastated communities at home. The deepest political currents of gospel preaching surfaced in a discourse of liberationism. Gospel's emancipatory themes, "the rivers to be crossed, the promised land to be reached, the trains to ride, the sweet release to be enjoyed, the babylons to escape," all took on an inspirational, proto-revolutionary expression in the face of the new public visibility of "social problems."[68] Martha and the Vandellas were embarrassed to discover that their popular hit, "Dancin' in the Streets" had been interpreted as an incitement to riot,

but such interpretations were a typical consequence of the intimacy that commercial soul enjoyed with the public and political turn of events within black communities.

Soul is often thought of as a "politically correct" form of popular music, but only because it is equally cited as the epitome of perfect pop pleasure. In the songs of the legendary songwriting teams of Leiber-Stoller and Holland-Dozier-Holland, the rhythm, the feeling, and the dramatically voiced, melismatic stretching of notes and vowels that are all historical features of African-American music, come together with a haunting urgency that stands out against the "soulless" voice of bubblegum pop. While this combination achieved enormous international popularity, especially with the Motown stable of artists, it almost immediately engendered its own hip/straight distinctions in the face of commercial success. The sign outside Motown's buildings in Detroit read "Hitsville": the sign outside the Memphis base of Stax, which produced a rawer, "blacker" soul sound for predominantly black audiences, read "Soulsville." Motown began to be seen as a hit-making factory system that exploited its artists while producing music for the historically maligned black middle class as well as for a substantially white audience. Consequently, the soul sound toughened up in accord with the new spirit of ghetto realism. Something more "funky" was demanded, and emerged—Aretha Franklin, Isaac Hayes, Curtis Mayfield, Ike and Tina Turner, Nina Simone, Bobby Womack, Marvin Gaye, Carla Thomas, Sly and the Family Stone, Millie Jackson, Otis Redding, Rufus Thomas, and the most "superbad" of all, James Brown. Funk contained its own critique of pop soul, but it was a critique that fought for and responded to popular taste; it was not a flight from popular taste into areas of recondite pleasure.

It was a similar dialogue with pop culture that marked the astonishing technological feats of rap virtuosos in the Bronx hip hop subculture from the mid-seventies to the mid-eighties. The rapping DJ's stream of rhyming and toasting worked upon and against a richly dislocated mix of cannibalized riffs and percussion breaks stolen from the entire musical spectrum, from street funk and sci-fi electro boogie to the stylized black dance rhythms that had been the basis of disco music. The result was a startling cultural cross talk, literally "scratched" out at the limits of rhythm, and produced for a dance and street performance culture that was similarly dedicated to exploring the possibilities of rhythm.[69]

In hip hop vernacular, "def" was a descriptive category that covered those tastes, choices, or qualities that were unchallengeably correct, in other words, the essential trappings of hipness. In the sixties, "soul," while it embraced a much larger set of ideological meanings, was equally a mark of cultural essentialism, a cultural style of doing things that *inhered*, and was thus inscrutably beyond any organized hermeneutics of

meaning. Above all, soul was something that *happened to the body as it was moving*, and therefore it was nowhere more apparent than in the response to musical rhythms, whether carried in the head, or heard through the air. It is finally there, in the way in which people move and physically interact in everyday spaces that were once officially segregated, that black musical culture has made its deepest impact on mainstream American life. If today's *de facto* segregation is still unofficially governed in part by bodily codes of avoidance and confrontation, racist bromides about the mythologies of athletic finesse—white "stiffness" and black "flexibility"—do not carry quite the same embedded social power they once did.

Here, for example, is how Eldridge Cleaver, writing in 1968, remembered the first multi-class, cross-generational Pop musical phenomenon of the sixties:

> The Twist, superseding the Hula Hoop, burst upon the scene like a nuclear explosion, sending its fallout of rhythm into the Minds and Bodies of the people. The Fallout: the Hully Gully, the Mashed Potato, the Dog, the Smashed Banana, the Watusi, the Frug, the Swim. The Twist was a guided missile, launched from the ghetto into the very heart of suburbia. The Twist succeeded, as politics, religion and law could never do, in writing in the heart and soul what the Supreme Court could only write on the books. The Twist was a form of therapy for a convalescing nation. . . . They came from every level of society, from top to bottom, writhing pitifully though gamely about the floor, feeling exhilarating and soothing new sensations, release from some unknown prison in which their Bodies had been encased, a sense of freedom they had never known before, a feeling of communion with some mystical root-source of life and vigor, from which sprang a new appreciations of the possibilities of their Bodies. They were swinging and gyrating and shaking their dead little asses like petrified zombies trying to regain the warmth of life, rekindle the dead limbs, the cold ass, the stone heart, the stiff, mechanical, disused joints with the spark of life.[70]

All of this fuss, over what Nik Cohn diagnosed as "the least sexual dance craze in forty years."[71] The Twist was a snooze in comparison with the breathless spectacle of rock 'n' roll excitement of a few years before, and the vocal hysteria of Beatlemania a few years hence, and, compared with the dexterity of James Brown's acrobatic stage show, it was like a baby taking its first steps. But Cleaver's vignette is an attempt, however steeped in racial mythologies, to describe a symptomatic shift in official taste. His imagery, with its guided missiles and cold white asses, is clearly drawn from the Cold War verbal stockpile, enlisted here to describe a "melting" of the national mood; it is addressed to the national-popular in the broadest sense.

Whatever it had helped to politically negotiate, in the fifties, with its fantasies of racial and class otherness, and whatever sense of subterranean mystique it continued to cultivate within the mainstream, the biracial imaginary of "hip" now had to confront the likes of Zsa Zsa Gabor and the Duke of Bedford on the dance floor of the Peppermint Lounge, publicly infused with what Cleaver called an "injection of Negritude." If that meant facing up to the prospect of further cooption, recuperation, and other modes of absorption so despised by the hip vanguards, it also meant recognizing the far from ideal conditions and circumstances under which racial integration was beginning to feel its uncharted way under the guarantee of gains in civil society. Not in the best possible world, where ethnic self-respect and self-determination can always be guaranteed a fair hearing, but in the impure setting of the marketplace of cultural exchange, where, in a capitalist society, contests for legitimacy have to be waged on ground that is shared with those who have the power to buy and sell the minds, bodies, and images of others with impunity. As a category of advanced knowledge about the illegitimate, hip, even today, has an important but limited use for such a contest. It makes its mark, and moves on, dreading to be caught in the straight world it does not respect. Hip is the first on the block to know what's going on, but it wouldn't be seen dead at the block party.

4

Candid Cameras

Each week 350 million people see *Bonanza* in sixty-two
different countries. They don't all see the same show,
obviously. In America *Bonanza* means "way-back-
when." And to many of the other sixty-two countries
it means a-way-forward when we get there. (Marshall
McLuhan)

Reach Out and Touch Someone (Bell Telephone)

On November 2, 1959, at the end of a decade disfigured by McCarthy's
dirty war against the intellectuals, a Columbia professor was making his
confession before a House Subcommittee. The scene and its conse-
quences were, by now, familiar. Publicly humiliated, but "cleansed in-
side," he would lose his university position, but not before confessing
that he had "learned a lot about good and evil" from having been so
"deeply involved in a deception." So too, the organization with which
he had worked would come under close scrutiny, resulting in further
prosecutions and criminal indictments by a Grand Jury. President Eisen-
hower was officially shocked, and there was talk of introducing new
legislation. A *Chicago Tribune* editorial cited the opinion of a man in the
street that the confession had "set the cause of the egghead back a
thousand years."

In the case of Charles Van Doren, scion of one of the nation's most
distinguished literary families, the organization under question was not
a left-wing political party, but NBC, producers of the "rigged" quiz show
Twenty-One on which he had earlier made a number of prize appearances
that had turned him into a national celebrity. *Twenty-One* was one of a
host of big money quiz shows exposed in the 1959 investigations—*The
$64,000 Question, The $64,000 Challenge, Tic Tac Dough, Dotto,* and *Dough-
Re-Me*—which had escalated to unprecedented popularity (with single
audiences of up to 55 million) the television spectacle of interrogating
"ordinary" people who nonetheless appeared to possess a special relation
to knowledge.

At first, the stakes had been low, both intellectually, as on the 1949
radio show, *It Pays to be Ignorant*, where the less a contestant knew the
better, and financially, as in radio's *Take It or Leave It*, which concluded
with "the $64 dollar question," or even in the earliest TV games like *Down*

You Go, a relatively low-key quiz show version of "hangman," hosted by Bergen Evans, an English Professor at Northwestern University. As the stakes rose from 1955 onwards (the all-time record win, on *The $64,000 Challenge,* was Teddy Nadler's $252,000) the quiz show spectacle embellished the national fantasy of amassing fantastic wealth outside of the rules of the system of production, through a form of mental labor which avoided the beaten path of success via hard work. While this alternative route to success often seemed to depend upon a natural advantage, like having a photographic memory, rather than an acquired asset, like Van Doren's Cambridge/Sorbonne/Columbia education, it was just as important that bona fide intellectuals be seen as not exempt from the rules of the game. Although the ideal and sought-after contestant was "the blue collar guy with the white collar mind," the success on a quiz show of a legitimate intellectual like Van Doren was the reality test for a fantasy from which no one was supposed to be excluded. To have a scholar as hero also provided a convenient gloss for the corporate producers, still mindful of the educational mandate laid at television's door. In fact, the producer of *Twenty-One* had suggested to Van Doren that his appearance would be a great service "to the intellectual life, to teachers, and to education in general by increasing respect for the work of the mind."[1] Not least, he would be playing a visible role in the new Cold War of brainpower declared in response to the 1957 Soviet launching of Sputnik.

Competing successfully against Herb Stempel, the *idiot savant* and "GI bill" student at City College, who was one of the first to blow the whistle on the game shows, Van Doren went on to become television's intellectual idol.[2] After losing on *Twenty-One,* he occupied a regular slot on the *Today* show, in which he read seventeenth-century Metaphysical poetry and offered his meditations on science, history, and philosophy to the nation over breakfast. When the bubble burst, and the lies, the pay-offs, and the elaborate staging of the shows for dramatic effect were all revealed, it was doubly convenient that an articulate and respected figure like Van Doren was available to take the heat in the courts, and be commended by his judges for the "soul-searching fortitude" and rhetorical aplomb with which he made his confession.

At the hearings, Illinois Representative Peter Mack asked Van Doren if he thought it was "necessary to have a phony arrangement or a deceptive arrangement in order for one to gain this national popularity in our entertainment field, particularly as it relates to television." While Van Doren, as a proponent of high culture, was not *expected* to know very much about the entertainment business, and in fact said as much in response, the question was thought a worthy one to ask. Intellectuals, after all, were increasingly known for having views about popular culture, and his thoughts on this question would be considered more valuable

than those of other witnesses. Van Doren's evasive response—he certainly "hoped" that Mack's proposition wasn't true—put the seal on the spectacle of a legal process which was a fittingly dramatic conclusion to the great quiz show scandal.

In fact, the hearings were a necessary component of the scandal, serving as ritual proof, when the air had cleared, that corruption was a local aberration, and that a broadcasting system that was short on regulation but crucial to consumerism, actually did "work." The ritual importance of televised confessions, beginning with Nixon's 1952 Checkers speech, and later, at large scale hearings like Watergate and Iran-Contra, were to become a necessary cathartic component of American political culture. But the quiz show scandal was the first and in many ways the most gross deception to actively involve such a hoodwinking of popular confidence. Unlike public distaste, say, for the "selling of the President" by the media, this was primarily a television crisis. In this respect, it appeared to *matter* at an everyday level in a way that was different from scandalous affairs of State, generated from on high. The breach of faith which it represented seemed even more monstrous than anything which the government could contrive. It is often said that commercial television, which sells itself ethically on the idea of the "honest commodity," has never recovered from the fall from grace which the quiz show scandal came to represent.

To intellectuals, utterly convinced of the gross deceptions and manipulative nature of "mass culture," the quiz show scandals were grist to the mill. Writing in *Dissent*, Murray Hausnecht pointed out that, like planned obsolescence in the auto industry, the "rigging principle" was part and parcel of capitalist mass production; it was "an important means of controlling the risks inherent in a 'free' market," and was necessary to stimulate the jaded mass appetite.[3] So too, it was a manipulative way of molding a "mass" audience, as opposed to the kind of "coherent public" or "class" audience which Hausnecht would prefer. Writing in the same issue, Jay Bentham and Bernard Rosenberg melodramatically saw Van Doren's confession as the confession of "everyone who profits from the operations of a fixed society," a confirmation of what ought to be a commonly shared belief in the fraudulence of public life: if there did not already exist a national consensus about institutionalized fraud in the United States, then Bentham and Rosenberg hoped the scandal would generate one.[4] The emergence of such a consensus would presumably be the sign of an enlightened "public," as opposed to the mass of dupes which constituted the intellectual's image of a television audience of the time.

But if the opinions of Hausnecht, Bentham, and Rosenberg are predictable enough, they tell us nothing at all about the extraordinary success and immense popularity enjoyed by the quiz shows. This is hardly surprising if we consider that television had become the latest unredeemable

object in the continuing debate about mass culture. With television as the new bad object, the familiar Cold War rhetoric was enjoying a new life: whether in the form of bourgeois nausea—TV "stinks to heaven," and if you have to study it, "hold your nose, take a bath later on"; medical containment—"we must learn to look upon [TV] as a physician does a virus"; or weird castration threats—"we are all in danger of losing our manhood as modern technological communications turns us into processed cheese."[5]

Suddenly, with television, the stakes seemed higher: as Gilbert Seldes asserted: "next to the H Bomb, no force on earth is as dangerous as television." With live TV's capacity to present and *simulate*, rather than represent, reality, the capacity to (falsely) identify TV with "the real thing" had increased a thousandfold, and with it, the capacity for "falseness" already attributed by intellectuals to TV's docile mass consciousness of viewers. A *New York Times* editorial on the quiz show scandals obliquely addressed the ntellectuals' public fear by interpreting Van Doren's confession as "symptomatic of a disease in the radio and television world that frequently permits things to be represented not quite as they are."[6] As representative of a print medium that still wielded greater cultural authority than the visual media, the *Times* was in a position to paternalistically chide the latest contenders on the communications scene. At least the *Times* acknowledged in its motto that it merely presented a *selective*, or discriminating coverage of events—"all the news that's fit to print." Television would arrogate to itself a more absolutist privilege, encapsulated in what was to become Walter Cronkite's famous *CBS News* sign-off—"and that's the way it is."

But this clash between print and visual media, which was soon to become a public controversy with the popular reception of Marshall McLuhan's work, was the latest symptom of an old war of persuasion waged around the influence of new cultural technologies over popular taste. The charge, that things are being "represented not quite as they are," was as old as Plato, as was the fear of barbaric consequences. Its latest manifestation, however, in the battle over television, was in a game of taste in which traditional intellectuals seemed to have been almost wholly excluded from the ground rules.

While programming often paid lip service to cultural "standards," the development of American TV was oriented more exclusively towards market criteria of taste. This was in stark contrast to the public service orientation of European TV, best represented by the relentlessly paternalistic BBC, officially commissioned to hand out doses of the kind of culture that was thought to be "good for the people." Of course, "American" and "European" are shorthand here for two differing ideological conceptions of the "popular," each of which has been historically shaped

by its respective national cultural apparatus. This does not mean that
either model is any more, or less, successful in performing the ideological
functions of securing popular consent, for which the media generally
follows an agenda set by the state, or dominant social bloc. Whether
public or private, state-monopolized or deregulated, media systems are
complex, incomplete, and partially efficient channels for reproducing
existing social relations. For my purposes, what is important about the
difference between the two models is that the public service model makes
provision for cultural standards set by intellectuals and also accommo-
dates interventions by intellectuals, while the American model is *character-
ized* as exempt from such autonomous standards and interventions. In-
stead, its most popular shows, like the quiz shows, then and now, contain
appeals to the benefits, usually financial, to be derived from acquiring
knowledge; in their own symbolic way, they bluntly suggest that cultural
capital can be directly converted into financial capital, while implying
that the process is not reversible.

More than any other medium, American television has officially been
associated with the "ideology of mass culture," in other words, defined
(and often produced) as culturally unredeemable. The derogatory phrase
which still echoes through the memory of the TV industry is President
Kennedy's FCC chairman Newton Minow's description, in 1961, of TV
programming as a "vast wasteland." Its Eliotic resonances have scarcely
been matched by subsequent chairmen who, in the same rhetorical tradi-
tion, ritually visit disdain on the culture industry they have been ap-
pointed to regulate: Johnson's appointee—"an electronic Appalachia";
Reagan's man—TV as "a toaster with pictures." This tradition is infused
with the language of a high cultural conscience but it scarcely masks its
much more powerful complaint, that TV shows things *too much as they
are*—in other words, that TV too blatantly reveals the commodity basis
of culture in a capitalist society, and that it too often suggests that the
primary use of education and cultural capital in such a society is to enjoy
financial capital and social privileges.

Smile

In the fifties, the most constant target of the mass culture critique had
been the alleged *passivity* of modern cultural life. In the sixties, *involvement*
and *participation* became ever more urgent cultural imperatives, while, as
I will show later in this chapter, they also came to reveal ever larger
political consequences in the world, both domestic and international,
that lay outside of the national perimeters drawn up by the Cold War
consensus. It would be a mistake, however, to accept the thesis that

passivity could be mechanically manufactured by the popular media. Even at the dawn of the sixties, television's version of the invitation to *participate* was too articulate to take for granted as a guarantee of false consciousness. This can be demonstrated by looking at a show like *Candid Camera*, one of the first TV spin-offs, which ran as a feature of *The Garry Moore Show* in 1959 and then as a CBS Sunday evening program, hosted by Allen Funt, from 1960–1967.

In the wake of the quiz show revelations, network television was obliged to demonstrate anew its tarnished commitment to realism. Canned laughter and applause were to be identified, the news documentary was revived, and the CBS president announced that thenceforth, everything on his network would be "what it purports to be."[7] By 1959, the "golden age" of live television drama, with its slips, gaffes, and ever embarrassing potential for technological bungles, was long over, but *Candid Camera*, because it purported to catch people "in the act of being themselves," proved to be a successful formula for managing the new demand for *TV verité*. So too, it presented a timely method for introducing a new domestic relation to technology, not least of all media technology, at a time when people were still relatively undecided, for example, about how to respond to the presence of TV sets in the home.[8] Finally, in its presentation of the "candid," it helped to reinforce the link between voyeurism and surveillance. Thus, while the effect of catching people in the act with a hidden camera was usually hilarious, the accompanying message was that no one ought to think that their *own* actions or "free speech," whether in public and in private, could ever go completely unnoticed or unheard. Everyone and everything could be monitored. In fact, the show customarily ended with a friendly word of warning from Funt:

> The candid camera now goes back into hiding, the better to catch you in the act, but two hours from now, a *Candid Camera* crew will be arriving perhaps in your city, so be very careful where you go. And don't be surprised if, tomorrow morning, someone should step up to you and say—"Smile, you're on *Candid Camera*."

For some viewers, this reminder of a seemingly arbitrary, if not constant threat of surveillance, might have had an ironic or even chilling effect, and with good reason—the national paranoia about Communism and other alien domestic tendencies had established deep roots in the popular consciousness. From the industry's point of view, the promise of surveillance might even have been a risky message to transmit, encouraging an element of distrust or wariness among the audience about the benevolent intentions of the media producers.

But this is only half the story, and it hardly explains the popularity of the show. Consider the *Candid Camera* jingle:

When it's least expected
You're elected
You're the new star today
Smile, you're on *Candid Camera*

With the hocus-pocus
You're in focus
It's your lucky day
Smile, you're on *Candid Camera*

In this context, to be caught in the act was presented as a moment of grace. To be caught was rewarding, and not chastening, because it brought to the victim a temporary celebrity: election, stardom, media focus. With each viewer a potential target or choice, this was something to look forward to. And if it never happened, you could still get in on the action by creatively pretending, in everyday life, to be a camera eye: "every person," Funt was forever declaiming, "can be involved without ever touching a camera . . . just watch other people doing trivial things, racing around, and being deadly serious."

For the viewer in the home, the pleasure of *Candid Camera* lay in the scopophilic link between voyeurism and surveillance: the pleasure of watching people being watched, with no apparent risk involved—except, of course, the possible risk of one day being caught in the act. It was also the pleasure of watching people transgress, or on the visible verge of transgressing social codes (but not quite knowing if they ought to) out of anger or frustration at being placed in "situations." But the viewer's pleasure also derived from knowing at the same time that things would never get out of hand, that the transgression would be interrupted and contained by the sudden unveiling of the hidden camera to the victim. The viewer was thus positioned, by the show's revelatory structure, to congratulate and "forgive" those victims whose mood changed so abruptly and visibly from one of hostility at being imposed upon, to one of gratitude at being rescued and saved from doing something regretful.

There was also the educational pleasure of learning how to *behave* around technology. A majority of the *Candid Camera* situations focused on people encountering problems with "doctored," and thus wayward, technology: telephones, automobiles, toasters, cameras, microphones. The more elderly the victims, the more inept, disoriented, and comical was their response. The most favored and admired responses were those of younger children who were seen to adapt more "candidly" and expediently to new technologies. Technology, however alienating initially, would always prove to be benevolent, provided we were prepared to develop the correct attitude toward it. It is easy, then, to see how *Candid Camera* showcased the capacity of television to "involve" its audience with

its technological environment by mobilizing a whole range of pleasures, some of them reassuringly familiar, many of them quite unpredictable. So too, the uses made of this capacity often went beyond the context of the show. The *Candid Camera* "situation," for example, quickly passed into the vernacular repertoire for dealing with potentially hostile everyday social encounters as well as with staged practical jokes. Many an awkward moment was explained or defused by invoking the well-known *Candid Camera* line.

Candid Camera was taken off the air in the late sixties, at a time when the networks were beginning to respond to the public pressure for more "relevant" broadcasting, especially with regard to treatments of color, sex, and class.[9] This change in broadcasting was an indirect response to the pervasive disdain for TV which countercultural youth—the TV generation—had come to express. Jerry Rubin, more attuned to the possible uses of the media than others, had described TV as "chewing gum for the mind." *Candid Camera*, then, had been (one of) TV's ideas of *participation* in an age before the meaning of the idea of participation would be temporarily redefined in the public sphere in ways which emphasized not only adaptation and consent, but also (participatory) democracy, contestation, dissent, protest, and even resistance.

Spectacular Diseases

The more traditional complaint about false consciousness, mediated or not by participation, is what we find in the work of intellectuals, both conservative and radical, who have inveighed against the increasing dominance of images and spectacles in everyday life. Two of the best known and most extreme examples are Daniel Boorstin's *The Image: A Guide to Pseudo-Events in America* (1972) and Guy Debord's *The Society of the Spectacle* (1967). Boorstin's account of the *pseudo-event*, a term that has entered the language since he wrote about it, is a marvel of consensus thinking. In his preface, he writes of an "experience [he] shares with nearly all Americans" who are concerned about the "many new varieties of unreality which clutter our experience and obscure our vision." In opposition to his "more profound philosophical colleagues," he chooses to identify his voice with the no-nonsense perspective of "the people." Consequently, he takes theoretical refuge in a neo-populist epistemology: "I do not know what 'reality' really is. But somehow I do know an illusion when I see one."

Having established, rhetorically, this imagined solidarity, what follows is a jeremiad; a critique of the ways in which "we" have delivered ourselves into the servitude of the image, a "world of our making" in which photo-

opportunities and other pseudo-events stage the realm of lived experi-
ence around a series of illusions, remote from the authentic world of
material reality:

> Much of our interest comes from our curiosity about whether our im-
> pression resembles the images found in the newspapers, in movies, and
> on television. Is the Trevi Fountain in Rome really like its portrayal in
> the movie *Three Coins in the Fountain?* Is Hong Kong really like *Love is a
> Many-Splendored Thing?* Is it full of Suzie Wongs? We go not to test the
> image by the reality, but to test reality by the image.[10]

Boorstin's many quotable observations about the hijacking of reality by
images are based upon a hip epistemology that has become a common-
place among postmodernist thinkers: "The Grand Canyon itself becomes
a disappointing reproduction of the Kodachrome original"; "we should
have stayed home and watched it on TV"; "the artificial has become so
commonplace that the natural begins to seem contrived"; "experience
becomes little more than interior decoration."

His conclusion, which scarcely conceals his cultural prejudices, is that
our everyday experience is like a "reader's digest," unable to encounter
the world without the aid of mediating discourses. Who is to be held
accountable for this lamentable decline in the quality of life? We have
only ourselves to blame, replies Boorstin. Each of us is a self-appointed
victim of this shift from ideals to images, for it is a fate we have brought
upon ourselves. A backslidden people (miserable sinners!), we must indi-
vidually disenchant ourselves with the world of illusion. As for Madison
Avenue and the general agency of consumer capitalism, the forces that
are generally held responsible for the "synthetic novelty" of pseudo-
events, Boorstin vaguely refers to "great historical forces" and advances
in technology and production; "advertising men," he insists, "are at most
our collaborators, helping us make illusions for ourselves." The most
astonishing part of his conclusion, however, is his suggestion that "the
menace of unreality" is much greater than the "menace of class war, of
ideology, of poverty, of disease, of illiteracy, of demagoguery, or of
tyranny."[11]

Boorstin's studied evasion of all questions of power have seemed ludi-
crous to those on the left, who, like Debord or Marcuse, see the staged
spectacles of the pseudo-event as an advanced and increasingly mono-
lithic, or "one-dimensional" exercise in the social control of mass popula-
tions. However, his emphasis (no matter how disingenuous) on *participa-
tion*—that the world of the image is one which we help to create—is useful
to any analysis which wants to take serious account of the mechanisms
of popular consent. Not all images, pseudo-events, and spectacles are

successful; certainly none are equally successful in "absorbing" our lived experience. In fact, the power of the "spectacle" depends upon its success in addressing and intersecting with deeply felt everyday needs and anxieties, and its articulation of an incomplete circuit of desire is one in which we recognize ourselves and which we therefore want to complete by acknowledging its power.

While Boorstin's complaint assumes far too much responsibility on the side of the individual, Debord's marxist analysis of the spectacle is equally overbalanced, this time on the side of the objective processes of capital accumulation. *The Society of the Spectacle* presents the most unsparing critique of a late capitalist environment in which the spectacle is the *only* actor; the guardian of the sleep of the masses, the forgettor of time, history, and production, and the general abstract equivalent of all commodities. For Debord, "the spectacle is capital to such a degree of accumulation that it becomes an image." On the one hand, then, it is "no more than the economy developing for itself," "the commodity contemplating itself" in the very moment when commodification has completed its planned occupation of all untouched areas of everyday life. On the other hand, its effect has been to annex "into a representation" everything that was once "directly lived":

> The spectacle is the existing order's uninterrupted discourse about itself, its laudatory monologue. It is the self-portrait of power in the epoch of its totalitarian management of the conditions of existence. The fetishistic, purely objective appearance of spectacular relations conceals the fact that they are relations among men and classes: a second nature with its fatal laws seems to dominate our environment.[12]

Debord's belief that all social choices today are made in accord with the objective logic of capital accumulation is simply the mirrored opposite of Boorstin's suggestion that, as potentially free individuals, we choose to live by illusion. Neither contains an adequate account of how cultural power operates by incorporating a whole range of popular feelings, desires, and aspirations *in accord with* the rational interests of a dominant logic. Each, moreover, employs the language structures appropriate to his arguments. Debord's discursive mode is that of a rigorous series of defining theses, each structured by the proposition: "the spectacle is. . . " It exactly reproduces on the page a totalitarian environment in which the spectacle is always the subject, and socialized desire is only present as a passively organized sideshow. The result is as rhetorically exclusive as Boorstin's repetitious subjectivism—"we have come to expect. . . "; a trope that invites us to see human agency as relatively free and undetermined in its choices.

Debord's arguments can be read in the light of their continuity with the critique of mass society and mass culture developed by the Frankfurt School, in which people have long since become audiences of "cheerful robots," to use Mills's phrase. By contrast, Boorstin's emphasis on self-help and his faith in the "honest commodity" is symptomatic of the neo-conservative thinking that grew out of postwar liberal critiques of the mass society thesis. In her book, *On Photography*, Susan Sontag largely agrees with the Boorstin position that "photographs have become the norm for the way things appear to us," while she provides a fuller historical explanation of this phenomenon than he:

> A capitalist society requires a culture based on images. It needs to furnish vast amounts of entertainment in order to stimulate buying and anesthetize the injuries of class, race and sex. And it needs to gather unlimited amounts of information, the better to exploit natural resources, increase productivity, keep order, make war, give jobs to bureaucrats. The camera's twin capacities, to subjectivize reality and to objectify it, ideally serve these needs and strengthen them. Cameras define reality in two ways essential to the workings of an advanced industrial society; as a spectacle (for masses) and as an object of surveillance (for rulers). The production of images also furnishes a ruling ideology. Social change is replaced by a change in images. The freedom to consume a plurality of images and goods is equated with freedom itself. The narrowing of free political choice to free economic consumption requires the unlimited production and consumption of images.[13]

One could say that Kodak's first sales invocation in 1888—"You press the button, we do the rest"—already prefigures a kind of servomechanistic relation to the technology of image-production. In this respect, it, and the long history of the use of the photographic image for surveillance, stands as a corrective to the naivete of Boorstin's "world of our own making." But Kodak's invocation also contains the popular promise not only of ease and democratic availability but also of subjective control over an object world in which most people in the nineteenth century served technology rather than the other way around. No special training or competence would be needed to read the language of images. Visual literacy could not be withheld in the same way as the withholding of print literacy had been used as an efficient mode of social control. The ideological invitations which "introduce" new cultural technologies must include such popular hopes and desires in order to secure their appeal.

Sontag herself is barely attentive to the multiple appeals that are made in this process of persuasion. Where the omnipresence today of a camera in lower-class homes might signify a genuine opportunity for "self-orientation," and for making one's impression in a world controlled by others,

her general tendency is to see it as merely another opportunity for self-surveillance. Where family snapshots might be exchanged as a way of repairing the social injury of fragmented communities, she tends to see evidence only of the counterfeit, or "token presence" of the dispersed relatives.

She has a different story, however, to tell about the centrality of photography to the avant-garde milieu of Pop intellectuals in the sixties. Resonating with the documentarist call for *cinema verité*, photography in the sixties zeroed in on the everyday, the vulgar, the freakish, in short, the anti-aesthetic. In this respect, the new photography presented a broad critique of the cult of art photography which had decorously framed the everyday in a distancing, noninterventionist way. So too, Sontag thought that the sixties freakish taste for the "grotesque, private, fascinating, and ugly," typified by the work of Diane Arbus, was a daring revolt against the hyperdeveloped moral sensibility of the liberal intelligentsia. The problem with this freakish taste, however, lay in its photographic exploitation of a landscape of people and environments that had been disfigured and "underdeveloped" by the inequalities of color, sex, class and wrongheaded social planning. To progressively broaden the perspective of middleclass intellectuals accustomed to a more folksy image of the populace was one thing. But Arbus's camera focused on social victims in a way which could not even begin to transform the conditions of their victimage. Ultimately, work like hers encouraged a sort of retrenchment; its audience could now see how truly awful life was "out there" in the Twilight Zone of freaks and rejects—best not to risk going there!

Sontag's discussion of Arbus demonstrates many of the contradictions encountered by Pop intellectuals in the sixties. Each brave new world of popular experience which they "discovered," patronized, and annexed after the fashion of Renaissance explorers was a world which was often returned to them in its colonized image, *as an image of the colonized, and therefore bearing all of the marks of underdevelopment.* The tragic effects of this became all the more evident as the decade wore on, and as the crisis surrounding American military involvement in Vietnam focused attention on U.S. cultural imperialism in other parts of the globe. The war was brought home, not just by the candid news camera, or by the National Guard patrolling ghetto streets and antiwar demonstrations, but also by the starkly perceived affinity of Vietnamese village life with the domestic scene of ghetto poverty and conditions of feudal backwardness in the South.[14] While it was partially aimed at calling attention to the cultural shock of this economic polarization, the domestic identification on the part of the counterculture with the "archaic" and the "primitive," or less developed forms of social organization, began to appear like an unintended parody of the larger global tragedy of underdevelopment.

Media Shepherd, King of Popthink

Of all the Pop intellectuals who took the measure of the new cultural forms and technologies, it was Marshall McLuhan who spoke most directly to the larger consequences of "media participation." It is in his work that we find revealed many of the problematics associated, in the sixties, with the cultural crusade to replace "passivity" with "participation." Almost by definition, Pop intellectuals were not theorists. Of the most well known—McLuhan, Buckminster Fuller, Norman O. Brown, Susan Sontag, R.D. Laing, Norman Mailer, John Lennon, Leslie Fiedler, Tom Wolfe, Andy Warhol, John Cage, Timothy Leary, Abbie Hoffman, Jane Fonda, Bob Dylan—none have retained any lasting theoretical respect of the sort that is still accorded to the older liberal intelligentsia, redolent of the hard school of marxist dialectic. Herbert Marcuse, the exception, was an unwilling Pop guru, and belonged, like Wilhelm Reich, to a markedly older generation of foreign thinkers. Ideas, and not theory were the stock-in-trade of the sixties, and no one, finally, was more attuned to the speculative market for ideas than McLuhan.

In the mind's eye of the media, the Pop intellectual with new groovy ideas was required to be somewhat hokey, not entirely legitimate, at least not in the mold of the "eccentric but responsible academic" media type, and there is no doubt that McLuhan, once a respectable literary scholar, came to know what kind of role he was being asked to play. That he became a "corporate intellectual" (a hireling and a flunky, some would say) in the snappy, fast-talking, fast-thinking Madison Avenue mode was perhaps inevitable; it was a relationship which his work actively courted. That his ideas would touch a responsive chord in countercultural hearts and minds was less easy to anticipate, and demands closer examination. In any case, it is clear, even from the intellectual response of his day, that McLuhan's influence was not based upon his own theoretical rigor. Dwight MacDonald shrewdly described his ideas as "nonsense adulterated by sense." Indeed, his brazen raids upon scholarly fields and disciplines like anthropology, psychology, sociology, and economics were all conclusively challenged and debunked in his time. And yet Tom Wolfe's famous question—"What if he is right?"—was not at all (intended to be) a rhetorical question, and the debate about culture and technology which McLuhan's work generated was one in which many intellectuals were led to reconsider how their work, thought, and cultural activism stood in relation to the new communications technology and the popular culture of the day.

Of all of the claims of McLuhanism, the most resented was that he had delivered the literary, or print-oriented intelligentsia into historical irrelevance. In McLuhan's unremittingly formalistic scheme, they were

excluded from drawing up the cultural ground rules of the new electronic age of global teleparticipation, because their analytical training in a field of *content*, predicated upon a fixed Cartesian point of view, was ill-fitted to adapt to the new field of *form*, with its multiple interfaces, its decentralizing channels of communication, and its altered ratios of sense perception.

In its methodology, *The Gutenberg Galaxy* was McLuhan's densely packed tribute to the traditional scholarly apparatus of print. But it was also a book that was morally opposed to the culture which had produced that apparatus and its literary intellectuals over the course of five centuries. Inveighing against individualism, rationalism, linearity, visuality, and the other privatizing qualities characteristic of "civilization" in the West, McLuhan attributed the fragmenting effects of this civilization to the determining cause of the print medium. His historical overview relied heavily upon the work of Canadian political economist Harold Innis, who had demonstrated how societies had been organized by successive media like papyrus, stone, parchment, paper, and print.[15] He certainly inherited Innis's dualism—a tendency to see this successive restructuring in terms of its effects, or *bias*, on space or on time respectively—as well as his moralism—weighted in favor of pre-print oral cultures. Patrick Brantlinger suggests that McLuhan, in his role as popularizer, played Engels to Innis's Marx; each made their master's work seem more deterministic than it had been.[16] Indeed, it has become standard to refer to both Innis and Marx as examples of a monocausal theory of the political economy of history; capital accumulation in the case of Marx, communication media in the case of Innis. But the difference between Innis and McLuhan, as James Carey argues, is that whereas the former "sees communication technology principally affecting social organization and culture, McLuhan sees its principal effect on sensory organization and thought."[17] McLuhan's utopian picture of a brave new world, psycho-physiologically liberated by the new possibilities of the electronic media, is strictly tied to an empirical or behavioral conception of bodily response. One of the projects initiated at his Center of Culture and Technology, for example, was to study how the sensory balance of the population of Toronto had been altered by watching TV.

McLuhan's method of reasoning can, in fact, be seen as the endpoint, or triumph of positivism—that same scientific revolution based upon fact and reason to which he was morally opposed. In the eyes of its critics, the supreme principle of positivism is the rule of technological rationality, which infallibly determines human behavior, and which comes to dominate each and every structure of social relations, leaving no space at all for human agency.[18] To put it another way, we could say that McLuhan's thinking is governed by a paradigm of effects, a paradigm which seeks

to explain how communication is produced and received, but which cannot account for the possible uses and meanings which people make of communication exchanges in everyday social relations. This dependence on behaviorist models helps to account for his notorious formalism.

From a more humanistic point of view, the thinking for which McLuhan became celebrated is also redolent of the formalism that characterized not only the modernist movement in the arts, but also the literary critical revolution that accompanied it. The modernist emphasis on formalistic innovation (Pound's "make it new") and technical "progress" through experiments in form can be read, on the one hand, as an uncomfortable, but nonetheless complementary, tribute to the Fordist or Taylorist methods of modernization in industry. On the other hand, the ideology of form which modernism espoused was a clear-cut rebuttal of an *idea* of consumption which was seen to underpin the new mass culture. If intellectuals thought of mass consumption as a process of passive reception, then the counterchallenge of modernist form—open, fragmented, and defamiliarizing—was to produce a subject who would have to actively *work* at reading a text.

Modernist ideology, then, is fundamentally based upon the assumption that forms not only dictate responses but that they also directly determine effects. This assumption has subsequently bedeviled not only the cultural politics of vanguardism—governed by the equation: "active" readers = active citizens—but also the critique of popular consumption—governed by the equally strict equation: "passive" consumers = passive citizens. While McLuhan does not challenge the logic which generates these equations, he transposes the terms, and the audiences associated with the terms, by claiming vanguardist kinds of response for popular audiences. It is a strategy that can be compared with Brecht's theatrical attempts to produce a necessarily participatory audience by transforming the relation between audience and actors/producers. Because of its openly didactic content, however, Brechtian theater also openly addresses the needs, desires, and struggles of a popular audience. When McLuhan proclaims that the TV audience is no longer consuming but participating (and that every living room has become a "voting booth"), his supposition is based only on the formalist half of the Brechtian premise—no account is taken of what is being watched and heard, only that TV is being watched and heard. The result is a kind of cultural politics which I will call *unsocial realism*.

McLuhan's brand of unsocial realism owes a good deal to his literary modernist training. Jonathan Miller has demonstrated the importance of the modernist ideology of agrarianism in McLuhan's intellectual formation; from the distributionist idealism of the Canadian Northwest where he grew up, through the influence of Leavis's organic precapitalist

"villagism," in his studies at Cambridge, to his connections with the Agrarianism of the New Critics, who romantically posed the "chivalric" feudalism of the South against the mechanistic technologism of the North.[19] In fact, the presiding modernist myth of a prelapsarian moment of unified, or undissociated, sensibility was to provide the structural impetus for that part of McLuhan's thought which advocates going back to reclaim the "archaic" in order to go forward. So too, the dualism of modernist thought served him well with the enduring Manichean oppositions which were his polemical staple: visual/aural, hot/cool, image/ print, oral/linear. Finally, the Catholicism which inspired him to imagine a new "universal" community, beyond the provincial reach of the nation-states, was influenced as much by the modernist appetite for medievalism as by the very similar language he found being spoken by postmodern, transnational corporations in search of the global market.

It could be argued that McLuhan's emphasis upon "participation" bears a close resemblance to the New Critical emphasis on "closure"— the critical process by which a reader is *invited* to resolve the open tensions and paradoxes presented by a literary text. What McLuhan did was to apply this invitation to popular communications media. He argued that television was a *cool* medium, like the woodcut, the telephone, and the cartoon comic strip, because it was low on definition and low on information. Unlike in the film image, where a fully formed picture is *there*, twenty-four times a second, the TV image is never fully present; it is a constantly shifting impression on the screen, created by its electronic scanning process that illuminates, one at a time, a series of dots, arranged in alternate lines. Consequently, McLuhan proposed that viewers are more involved in filling up the image for themselves; they have to participate more than they would in responding to *hot* media like radio, movies, and print, all of which are high on definition and information.

There is some empirical evidence for McLuhan's views, although its exact consequences have been subject to a great deal of dispute.[20] What is more important to recognize, however, is that McLuhan's model of participation depends solely upon an involuntary bodily response. Participation here stems from a motor reaction, and is therefore an *objective* result of an objective property of the television medium. If this in-built participatory response is a real physiological consequence of the medium's effects, it is not, however, a socialized response which engages the socialized needs and socialized desires of the viewing audience. Rather, it records the capitulation of human agency, and the deliverance of the body into what McLuhan calls "servomechanistic fidelity" to technology: "Man is not only a robot in his private reflexes but in his civilized behavior and in all his responses to the extensions of his body, which we call technology."[21] Each technology, in McLuhan's evolutionary scheme, is an

extension of a bodily part which then becomes a "numb" and passive servant of its more efficient "extension":

> By putting our physical bodies inside our extended nervous systems, by means of electric media, we set up a dynamic by which all previous technologies that are mere extensions of hands and feet and teeth and bodily heat-controls—all such extensions of our bodies, including cities—will be translated into information systems. Electromagnetic technology requires utter human docility and quiescence of meditation such as befits an organism that now wears its skull and brains outside its hide. Man must serve his electric technology with the same servomechanistic fidelity with which he served his coracle, his canoe, his typography, and all other extensions of his physical organs. But there is this difference, that previous technologies were partial and fragmentary, and the electric is total and inclusive. An external consensus or conscience is now as necessary as private consciousness. With the new media, however, it is also possible to store and to translate everything: and, as for speed, that is no problem. No further acceleration is possible this side of the light barrier.[22]

The tone of this passage, as with McLuhan generally, is deeply ambivalent. It is at once chillingly grave, apocalyptically nonchalant, and swollen with emancipatory promise. On the one hand, one recoils from the dystopian premise that technology may have entirely colonized the body. On the other hand, there is no mistaking the note of creative possibility which accompanies his observations about what he called "the electric extension of the process of collective consciousness" (UM,130).

To be fair, McLuhan's celebratory enthusiasm for what the new electric technology promised—a "Pentecostal condition of universal understanding and unity"—has been widely discussed in a way in which his often critical concerns and warnings were not. In particular, he cautioned against viewing technology as external, rather than as an extension of the body. He warned that "once we have surrendered our senses and nervous systems to the private manipulation of those who would try to benefit from taking a lease on our eyes and ears and nerves, we don't really have any rights left. Leasing our eyes and ears and nerves to commercial interests is like handing over the common speech to a private corporation" (UM,68). While he could hail these same "great corporations" as "new tribal families" that have replaced older, private forms of business and wealth, he was just as capable of suggesting, for example, that one of the results of the "dream made respectable by industry" is that "data banks know more about individual people than people do themselves."[23] In later years, when his ideas were eagerly absorbed by the advertising industry, McLuhan was generally inclined to speak more

directly to the interests of the corporate world. It would be a mistake, however, to see this as a simple orientation of his thinking, or, for that matter, his politics. McLuhan presented himself as an *uncommitted* intellectual who merely purported to describe what he saw as important changes in the technostructure of Western culture: "I don't *approve* of the global village," he said in an interview, "I say we live in it. . . . I accept media as I accept cosmos. They assume I'm for or against Gutenberg. Bunk!"[24] In fact, it is the uncommitted intellectual, and not the hireling, who speaks most *persuasively* to, and thus on behalf of, ruling interests, and the McLuhan of the sixties is one of our best examples of this sorry truth.

McLuhan's noncommittal role was complemented and perhaps explained by his exclusive attention to the formalistic effects of the media. To pay attention to content was merely to see "the Emperor's old clothes," since, for him, the content of any medium was simply another medium, specifically, the old media environment that had been surpassed but which was still all too visible, like the image in a rear view mirror. Attention to form was always the endpoint of understanding, and never the beginning of contestation—this is the paradigm of his unsocial realism. Thus, while McLuhan insisted that the new media *are* "the real world" and not just "ways of relating us to the old 'real' world"; while he argued that the new media *are* "nature" and not just "bridges between men and nature,"[25] he could offer little more than *formal* encouragement toward creating a "counter-environment" which would convert people's knowledge about their intensely mediated relation to the social world into a form of action. No advice about how to use this knowledge other than for the sake of awareness; no ideas about how to act upon it.

When McLuhan *was* diagnostic about a course of action concerning media technology, as he increasingly proved to be toward the "dangers" of watching too much TV, his reasoning was relentlessly high-minded, and his diagnosis impractically high-handed:

> I think we should do ourselves a considerable kindness if we closed down TV operations for a few years. . . . TV, in a highly visual culture, drives us inward in depth into a totally non-visual universe of involvement. It is destroying our entire political, educational, social, institutional life. TV will dissolve the entire fabric of society in a short time. If you understand its dynamics, you would choose to eliminate it as soon as possible. TV changes the sensory and psychic life. It is an oriental form of experience, giving people a somber, profound sense of involvement.[26]

McLuhan's complaint here is a profoundly technocratic one, grounded in circumstances that are seen to be beyond any human control. Contrary to his reputation as a sympathetic interpreter of popular culture, this

kind of autocratic suggestion, masquerading as responsible, paternalistic
advice from an expert, reveals how little McLuhan understood or cared
about the uses which people made of TV programming in their everyday
lives. It also demonstrates to what extent his optimistic, and radically
unorthodox, appraisal of "mass" society as a "creative, participating
force,"[27] superior to the individualistic construction of the enlightened
liberal "public" sphere, was simply an inverted mirror-image of the dysto-
pian mass society critique. McLuhan was incapable of thinking of the
"mass" as anything other than an inert block of public energy that could
be tapped and channeled towards benign, rather than, tyrannical ends.

I find it difficult, in this respect, to provide a popular gloss to what
Arthur Kroker calls McLuhan's "technological humanism": "he sought,"
Kroker writes, "to recover the civilizing moment in the processed world
of technological society by developing a critical humanism appropriate
to the popular culture of North America."[28] While I am sympathetic to
Kroker's view that McLuhan was prepared to try anything to emphasize
the emancipatory possibilities of a media processed world that had re-
placed "natural" experience, there is little evidence that McLuhan ever
thought about the popular experience, meaning, or uses of such possibili-
ties. On the contrary, his interest lay exclusively in the domain of the
vanguard. In fact, just as he saw Canada, home of the DEW line, acting
as an early warning system for detecting changes in the U.S. technostruc-
ture, it was the avant-garde artist whose moment as the "antenna" of a
transformed future, had finally come in McLuhan's new electric age. In
his view, artists could not only provide immunity from the most numbing
effects of technostructural change; they could also move from the periph-
ery of the "ivory tower" in which they were imprisoned by the ideology
of "art appreciation," to the command center of the "control tower,"
from whence their skills in "social navigation" would be harnessed toward
the task of engineering a new ecological balance between the human
body and technology (UM,65–66).

Indeed, McLuhan's inspirational creed of participation in media tech-
nology was most exhaustively explored in the avant-garde realm of video
art, most directly in the work of Nam June Paik (who proclaimed that
just "as collage technic replaced oil-paint, the cathode ray tube will replace
the canvas"),[29] but also by Dara Birnbaum, Juan Downey, Ira Schneider,
Peter Campus, Bill Viola, Bruce Nauman, and Frank Gillette. In their
shared critique of commercial TV, the equation between form and activ-
ism prevailed; alienating and defamiliarizing forms would activate a new,
participatory relation to television. Pictorial distortion and nonrepresen-
tational imagery were common features used to involve the viewer in this
new interactive relation to technology. So too, Paik shared McLuhan's
sense of the global, even cosmic, possibilities of the new media as a

"simultaneous Happening": "Participation TV," he wrote, would offer an "electronic Nirvana, without the consumption of energy and without the hazard of taking drugs."[30] Paik's *Global Groove* (1973), and his more spectacular *Good Morning, Mr Orwell*, transmitted simultaneously on New Year's Day, 1984, from New York, San Francisco, and Paris, presented the media possibility of global encounters between avant-garde artists like John Cage, Joseph Beuys, Allen Ginsberg, and others who hitherto had never had the chance to participate together in the same space. Other, more communal activities were pursued by "guerrilla TV" video collectives in the late sixties like Global Village, Raindance, Optic Nerve, and TVTV.

A larger theoretical backdrop to these activities was the debate, which became particularly heated in the late sixties, about the radical uses of media technology. In "The Work of Art in the Age of Mechanical Reproduction," a 1936 essay which enjoyed a considerable revival at the time, Walter Benjamin had argued that the new film technology was inherently democratizing because the process of mechanical reproduction at the core of film production lent itself to mass distribution.[31] In "Constituents of a Theory of the Media," his 1969 response to the Luddism of the New Left, Hans Magnus Enzensberger agreed with Benjamin's observation that the new media opened up the possibility of mass accessibility, while he proposed that the promises inherent in communication technology—participation, decentralization, mobilization, education— ought to be more fully realized. Every receiver is also a transmitter! Enzensberger's slogan spoke directly to ways of transforming the means of production (it had less to say about the actual conditions of consumption), and it was a direct injunction to the New Left to abandon its technophobic allegiances to pre-industrial forms of communication, and to make "proper strategic use of the most advanced media."[32]

This was a strategy, for example, that had been urged by Franz Fanon, and had proved successful in many of the African national liberation movements. To urge the same strategy, in the late sixties, upon a Western hegemonic politics was another matter, however, especially in the context of communications networks which were so firmly established as the electronic arteries of the multinational economy that it was unthinkable to believe that they could be democratized let alone "liberated." Besides, the specific history of the development of communications technology meant that as little as 30% of the U.S. electro-magnetic spectrum remained accessible and thus available for general broadcasting in the public domain. The rest was reserved solely for the use of the military and state-political apparatuses, for whose political needs the technology was originally developed and in whose interests the closely allied electronics industry directed much of its research.

While the response of the burgeoning counterculture—alternatives would have to be imagined, communication would have to reinvented—was easily ridiculed, key sixties terms like "turning on" could only have made sense in the context of the instantaneous possibilities bred out of living with the new media technology. Humans, like electronic media, could now be "switched on." A viewer's flip of the wrist to turn on a dial would be rearticulated as the counterculture's utopian flip of the mind, available through a whole range of adventure drugs, in turning on and tuning in to more "authentic" realms of private and communal experience than could never be imagined by prime time TV. On the one hand, there was the act of communal solidarity in "tuning in" to the colorful network of alternative media (800 underground papers, for example, with an estimated readership of 10 million, at its height), and thereby "dropping out" of established circuits and channels of communication.[33] On the other, there was the more individualistic adventurism of the counterculture, for whom "doing your own thing" was an important insistence on new kinds of subjectivity, but which, more often than not, led to the kind of New Age "channeling" that had little to do with the world as most people experienced it.

However, when Yippie leaders like Jerry Rubin and Abbie Hoffman began to stage media events in the late sixties, a different level of activism, which claimed to use McLuhanism, became apparent. Levitating the Pentagon, burning dollar notes in the Wall Street Stock Exchange, appearing in Revolutionary costume before the HUAC, mobilizing a mass Yip-In in Grand Central Station, and leading pigs through the streets of the "Czechago police state" at the 1968 Democratic Convention—these were the memorable successes of a new politics of the spectacle, of which, Rubin claimed, the right-wing owners of the media were his "theatrical directors."

Borrowing most of its ideas and stunts from the Diggers, the organic anarchist group and hippie cadre activists of post-scarcity, Yippie media-guerilla theater was founded in order to irradiate the activism of the New Left with the expressive energies of the hippie counterculture. An attempt to "organize" through electronic means, it also sought to fill the media frame with subversive content.[34] Although Yippie events were staged (in the terms of the Situationists), in order to turn "spectators" into "actors," theirs was not a strategy tied to ideas about form or productivism. It was an attempt to play by the rules of the game of public relations, by *making* spectacular newsworthy events that would communicate radical messages to the general population. The role of the Yippie vanguard was more akin to that of P.T. Barnum than Rosa Luxemburg, in creating a "spectacular myth of the revolution" by which to live out, in a more radically directed fashion, the heady countercultural mix of

fantasy, hedonistic devotion, and creative anarcho-violence. Distrusted and ridiculed by the more austere politicos of the New Left, the Yippies' dramaturgical management of media spectacle produced many of the images that are now standard footage for the media's official histories of the sixties. Staging media events has since become an indispensable cultural politics for all groups struggling for change and self-determination.[35]

Gathering the Tribes

In his widely read guide to the "scenarios of the revolution," *Do It!* (designed by Quentin Fiore, McLuhan's sometimes Pop graphics collaborator), Rubin records a generation's disdain for the old order of intellectuals:

> We fall off chairs roaring with laughter when we hear our professors, teachers, experts—the people we're supposed to learn from—discussing us, our culture, grass. We feel like those primitive African tribes must have felt when Margaret Mead came popping in with her pencil and paper.[36]

Rubin's ethnographic frame of reference deliberately plays up the counterculture's expressive identification with archaic forms of social organization, not only those in non-Western cultures but also in the native American tradition. This cultural tendency ran strong and deep, through the "tribal councils" of the hippie communities, the christening of a "Woodstock nation," the Gathering of the Tribes at the 1967 Human Be-In in San Francisco, the Krishna-Whole Earth-Zen consciousness explosion, with its transcendentalist worship of swamis and Shoshone chiefs alike, and the many other Rousseauistic tributes to primitive communism among sixties experiments in collective living arrangements.[37] All of these naturalistic currents were the culmination of the critique of a highly developed capitalist culture at a time when the cost of Western development—the exploitative underdevelopment of other cultures—was being revealed.

Ever since the late fifties, for example, poets like Kenneth Rexroth, Charles Olson, Gary Snyder, W.S. Merwin, Allen Ginsberg, and Jerome Rothenberg had been engaged in an attempt to revive primitive-archaic modes of oral expression that had thrived in the West prior to the linear and rational discursive categories of Aristotelian logic, and that could still be found in the oral rituals of preliterate cultures. Inspiration came from the scholarly work of Milman Parry, Erik Havelock, and Albert Lord on

the oral-formulaic structure of Homeric poetry.[38] "Oral" poetry was composed anew, with sensory attention paid to "music, non-verbal phonetic sounds, dance gesture & event, game, dream etc."[39] The poet was reincarnated as a shaman, with powers beyond those associated with Western metaphysics. More often than not, the result was a massive eschewal of contemporary experience. Modern technology was demonized and not engaged; cultural imperialism was avoided rather than challenged; racism was "exorcised"—expel the "white man" in me (Snyder)—and not analyzed in its social and economic context. This archaic tendency (a premodernist impulse that presented itself as "postmodernist") came to be broadly expressed across the whole range of countercultural discourses in the late sixties.

McLuhan's contribution to this milieu is important if only because his ideas did not eschew but directly engaged, or so it appeared, the new cybernetic technology. His relevance stemmed from his proposition that the age of electronics, far from removing people further away from preindustrial and communal forms of social organization, actually had the technological capacity and effect of *retribalizing* a mass population. For McLuhan, the new electronic culture of intense involvement and participation would be "tribal," populated with "information hunters and gatherers," and characterized by the kind of communal equilibrium "enjoyed" by less complex cultures. It would be a postindustrial "forest of Arden," a leisure-filled "golden world of translated benefits and joblessness" (UM, 58) in which electric circuitry would recreate the "multidimensional space orientation of the 'primitive.'" If only because of his tendency to identify with those who had possession of the technology of the future, McLuhan's vision of an achieved Utopia was more pragmatic than the conventional, romantic nostalgism of the day. He had no illusions, for example, about the archaic "good life": before print, he suggested, "we lived in acoustic space, where all backward peoples still live: boundless, directionless, horizonless, the dark of the mind, the world of the emotion, primordial intuition, mafia-ridden."[40]

Despite his warnings about the lure of nostalgia, McLuhan's prognostications about the "tribal" future went far beyond even his own patronizing analyses of popular culture. In casting the new tribal man as a "super-civilized sub-primitive" he produced, on the one hand, a more acceptable image of "mass man" in the folksy mold cherished by intellectuals, and, on the other hand, the image of a subversive survivor of forgotten non-Western mentalities in the style favored by the turned-on countercultural ecology. In both instances, the image of the people which McLuhan presented was far from flattering, and, in fact, depended upon the crude misrepresentation of a sizeable part of a domestic population that was still struggling with scarcity, poverty, illiteracy, and other problems usually

associated with underdeveloped societies. However, when McLuhan spoke about how electronic circuitry was reinventing "the Africa within" every individual, a different note of cultural arrogance was sounded. In fact, by far the greater semantic violence inherent in his characterization of "tribal man" was to lie abroad, at the heart of the cultural imperialism which had accompanied the global spread of American communications technology.

It is rare to be able to read more than a dozen pages of the later McLuhan without coming across a reference, example, simile, or parable involving African tribesmen or other non-Western preliterates. Beginning with his work in the fifties with the anthropologist Edward Carpenter on the journal *Explorations*, McLuhan's observations about the effects of the new media on non-Western subjects became an integral part of his polemical style. In *The Gutenberg Galaxy*, he had touched upon the reasons why "African audiences cannot accept our passive consumer role in the presence of film."[41] From then on, this exemplary model of involvement—the mythical "African tribesman"—is regularly invoked, as in the case of "the African who took great pains to listen each evening to the BBC news, even though he could understand nothing of it" (UM,20).

Soon, McLuhan was generalizing about how particular media raised or lowered the "tribal temperature": "Radio is the medium for frenzy, and it has been the most major means of hotting up the tribal blood of Africa, India and China alike. TV has cooled Cuba down, as it is cooling down America" (UM,310). It was but a short step from there to suggest that media could be used as a more or less direct means of social control:

> We are certainly coming within conceivable range of a world automatically controlled to the point where we could say, "Six hours less radio in Indonesia next week or there will be a great falling off of literary attention." Or, "We can program twenty more hours of TV in South Africa next week to cool down the tribal temperature raised by radio last week." Whole cultures could now be programmed to keep their emotional climate stable in the same way that we have begun to know something about maintaining equilibrium in the commercial economies of the world. (UM, 28)

Such was the advice/warning McLuhan offered in a report on the effects of television originally delivered to the National Association of Educational Broadcasters for the U.S. Department of Education. Ludicrous as these comments are, we can hardly fail to recognize the fantasy of imperial power, however embryonic, which resides here, and which elsewhere colors McLuhan's many comments about the radical changes wrought by the introduction of media technology into less developed countries. It is

a fantasy, moreover, that is seen to begin in the American home. What better image to suggest this than the American "television child," a "profoundly orientalized being," in McLuhan's words, who, as he sits in front of a television image, "is covered with all those little dots; all the light charges at him and goes inside him, wraps around him and he becomes 'lord of the flies.'"[42]

By the mid-sixties, the American TV viewer had become "lord of the flies" in at least one rather striking way. Because of the importance to the television industry of the overseas export market, metropolitan taste in America was directly determining the cultural consumption of local populations in every corner of the globe, from Manila to Rio. In accord with the absolutism of the weekly ratings, the most successful TV shows would enjoy a long domestic life in syndication, but they would also be "dumped" at discount prices, along with some less successful shows, on foreign markets. Seventy-five percent or more of a show's production costs could be recouped from domestic network and syndication runs, but export sales were needed for the remainder and for profits. In 1974, a now famous UNESCO report outlined the full extent of U.S. domination of other countries' programming schedules. Some markets proved to be almost saturated by dumped American programming—the Latin American market by as much as 50%, and as high as 80%, in parts of Central America.[43] What this meant is that the networks' battle over American popular taste in TV consumption was not confined, in its effects, to the domestic market, even though many of the shows, at least before the industrial concept of the "internationalization" of the product was fully implemented, only seemed to make sense in relation to the national culture and to the political and historical features specific to that culture. Any consideration of domestic taste somehow had to take into account its effects elsewhere in the world, where ideas about democratization and where the structural references to a common American culture were certain to have entirely different meanings.

It is in this context, alongside other, more utopian promises, that we ought to see McLuhan's blithe prognostications about a "global village" made possible by telecommunications. We need to set McLuhan's "global village" alongside the Alexandrian plans of American empire for what Zbigniew Brzezinski called "a new planetarian consciousness."[44]

We need to compare it to the benevolent image cast for the cultural imperialism that accompanies foreign aid—the cultural penetration which Nelson Rockefeller referred to as "exposure to the fundamental achievements of the U.S. way of life."[45] We need to see how its dream of a "global embrace" pales besides the established global reality of American communications power, which, in 1970, when McLuhanism was just past its peak, controlled over 65% of the world's communication flows.[46]

In its competitive replacement of the imperial communications net-
works of Britain, the U.S. "military-industrial complex" had successfully
"recolonized" a world that had only recently been decolonized. In many
instances, the dependency built up around assistance programs and the
offer of technological development proved more restrictive and harder
to escape than the administrative regime suffered under colonialism.
Aid, of course, was tied to the acceptance of military and communications
technology, but it was also consequent, in practice, upon the acceptance
of an increasingly quickening flow of consumer and cultural products.
Television technology, for example, eagerly set in place by the three
networks in countries worldwide, was installed in a package that included
a constant supply of cheap, cut-rate programming which indigenous
industries could not afford to produce at a competitive cost. The military's
establishment, through the Department of Defense and the USIA, of a
vast transnational communications network in the postwar years was
closely linked to the creation of a commercial empire, carved out by huge
communication conglomerates: AT&T, RCA, IT&T, General Tele-
phone, Warner Communications, IBM, MCA, General Electric, Westing-
house, Xerox, Time Inc., etc.[47] Vertically and horizontally integrated,
these giants link together goods and services in all sectors of the culture
industry. The selling of communications hardware and the selling of
films, TV, comics, along with a whole range of consumer goods is pro-
moted by the same conglomerate with a parallel and equal interest in all
of these sectors.

In effect, the logic of foreign assistance was vital not only to the expan-
sion of political influence, but also to the expansion of commercial em-
pires, ensuring that "development" went hand in hand with the accep-
tance of American popular culture and American values. Postcolonial
penetration of foreign markets went under the aegis of "free trade," or
in its specific communications form—the "free flow of information."
Attempts to regulate the "one-way flow" from the West, have been inter-
preted by the information cartels as evidence of "unfair trade practices"
or as "government interference" with the rules of the free market. In
most cases, it is only the strongest Western nations, with developed na-
tional and public institutions in the cultural sphere, if not culture indu-
stries of their own, that could succeed in imposing import quotas or high
taxes on American cultural exports, or else offer subsidies to stimulate
domestic production wherever it existed.

The high point of U.S. influence and domination of foreign markets
was reached in the mid- to late sixties, and has been in decline ever since.
Mexico and Brazil, followed by Argentina, India, Egypt, and Hong Kong
have all developed sizeable export markets, and have joined the ranks of
the major source nations: the U.S., the U.K., France, U.S.S.R., and the

F.D.R., followed by Italy, Spain, and Japan. Consequently, the "conspiracy theory" of American communications imperialism—it's all part of a single plan on the part of the military-industrial complex!—has been replaced by more sophisticated accounts of the modern transnational scene. So too, the conspiratorial view that American "mass culture" is spreading its homogenized message across the globe has been challenged by analyses of local, cultural diversity in the developing peripheral nations.

Critics like Ariel Dorfman and Armand Mattelart, who continue to espouse the strong theory of cultural domination, have drawn attention to the way in which the representations of indigenous "types" in American popular culture were often constructed in politically patronizing forms. In their classic study of the widespread influence of the popular Disney comics in Latin America, Dorfman and Mattelart described how Latin Americans are encouraged to view the caricatured images of themselves as they are given in Disney's Aztecland, Inca-Blinka, and San Banador:

> Who can deny that the Peruvian is somnolent, sells pottery, sits on his haunches, eats hot peppers, has a thousand year old culture—all the dislocated prejudices proclaimed by the tourist posters themselves? Disney does not invent these caricatures, he only exploits them to the utmost. . . . The only means that the Mexican has of knowing Peru is through caricature, which also implies that Peru is incapable of being anything else, and is unable to rise above this prototypical situation, imprisoned, as it is made to seem, within its own exoticism. . . . By selecting the most superficial and singular traits of each people in order to differentiate them, and using folklore as a means to "divide and conquer" nations occupying the same dependent position, the comic, like all mass media, exploits the principle of sensationalism.[48]

From the point of view of the producer, Dorfman and Mattelart argue, the Third World picture of the carefree peasant as an exotic and noble savage reinforces the myth of primitivism and a fantasy of "sin-free production" or wealth created out of nature without the intervention of labor—workers hardly ever appear in Disney. The tribal village of leisure without work or industrial pollution is the polar complement to the metropolitan site of industrialization, and the folkloric peasant is asked to choose one or the other. Either technology and benign development from his new foreign friends, or a return to the simple self-sufficient life of the village—there is no alternative, for each world is represented as excluding the other. He can remain a subordinate child, as under the administrative hegemony of the old colonial paternalism, or he can grow up under the influence of a self-image

of developing maturity offered him by the benevolent (Donald Duckish) uncle of a foreign power.

However powerful this descriptive model of change, the strict polarity between metropolis and village hardly exists in reality. In fact, it is the relation *between* such oppositions and economies which determines the course of underdevelopment. In the classic model of underdevelopment, foreign markets provide a consumption outlet for absorbing the effects of a crisis of overproduction in the core economy. By contrast, the peripheral economy underproduces for its domestic population. The economic surplus which results from peripheral consumption of core products is appropriated either by core companies or by the domestic elites; it is not invested in the domestic economy of the peripheral nation. As a result, this domestic economy lacks the productive capacity to satisfy the basic needs of the mass of its population because its only active sector is the one that produces commodities either for the indigenous elite or exotic staples for the core, metropolitan market. Encouraged to "develop" by contact with foreign capital, the peripheral economy is forced to underdevelop, or unevenly develop, the domestic sphere which it serves.

What this means, however, is that the small Westernized elite of a developing nation becomes instilled with consumerist values well in advance of the indigenous population. It is this elite which "receives" the cultural products that were primarily created for a Western mass population. As Alan Wells points out, media like radio and television which "don't require literacy, can play a major role in mass mobilization and social change," but, because of limited access, they are more likely to simply "encourage the affluent segment of the population to participate in the material consumer culture of countries having a much stronger economic base."[49]

This, then, is what McLuhan's universal *participation* meant for many underdeveloped countries; partial access to Westernized popular culture for the elite, a parasitic relation to the same popular culture on the part of the impoverished urban labor force, and a denial, or at most, an elite-supervised diet of cultural consumption for the indigenous peasantry. Set against the complexity of these internal contradictions, McLuhan's lonely African tribesman's rapt but non-passive fascination with the formal qualities of the TV picture seems like a crude fantasy of redemption. In fact, as Anthony Smith points out, it is the peasantry's continuing ties to the ethnic culture in general that make it "comparatively immune from Western information dependence, while at the same time it is held up [by Western intellectuals and the indigenous elite alike] as the most extreme victim of Western economic expansion." What we have, then, is the "elite of the East and West patronizing their respective 'masses' for

opposite reasons," a complex picture of cultural power further diversified
in countries of the semi-periphery which have developed their own cul-
ture industries.[50]

There are other reasons why the large, conspiratorial picture of global
domination by U.S. popular culture does not always give us the whole
story. It discounts the ability of people, under different social circum-
stances, to variously interpret and use what they see and hear in foreign
mass-produced culture, and it ignores the still pivotal importance of
appropriating media technology in the course of national liberation
movements. So too, it underestimates the potentially democratizing effect
generated when Western representations, especially those of liberated
women or of multiracial and multicultural life, enter into conflict with
cultural milieux that demand a more strict observance of patriarchal
and caste traditions. One of McLuhan's favorite anecdotes is to cite the
example of the dictatorial President Sukarno of Indonesia, who baited
Hollywood executives as "political radicals. . . . who had greatly hastened
political change in the East" because of the liberal-democratic lifestyles
which their films portrayed (UM, 294).

It is too easy to generally depict the impact of exported popular culture
in foreign cultures as one of global homogenization, especially at a time
when the staggering complexity of cultural, economic, and political dif-
ferences among less developed countries (and the so-called newly indus-
trializing countries) make a nonsense of the conventional models of
analysis—East-West, North-South, and "three worlds"—and when the
new *transcultural* product of the transnational culture industries strives
to be at home and to be "national" everywhere in the world. Each national
culture is a very specific case, and the nature of its absorption of imported
culture depends upon a whole range of factors: existing levels of develop-
ment; existing relations of dependency upon stronger, semi-peripheral
nations in the region; the status of its intelligentsia; the existence and
stability of public institutions; the nature of alliances between peripheral
elites and core elites, and between domestic and transnational capital;
and the political uses that are made of ethnic cultural traditions (which
critics of domination often romanticize as "authentic") to promote stabil-
ity and conformity.

A similar caveat, I think, applies to the debate about threats to
national sovereignty. The global network of telecommunications, as it
has been established by transnational corporations, has little structural
regard for national sovereignty, while its overseers benefit daily from
any further deregulation of the agreements insisting on oversight by
sovereign national bodies. Increasingly, information flow can bypass
all territorial regulation, and can thus traverse a country's borders with
little or no hindrance whatever. In response to the United Nation's

proclamation, in 1974, of a New International Economic Order, aimed at reducing the disparity between industrialized and non-industrialized nations, UNESCO has urged a New International Information Order, which would seek to reorganize the existing global channels of communication in a more egalitarian way.[51] Much of the inspiration behind these attempts has come from the widespread perception that "the threat to independence in the late twentieth-century from the new electronics could be greater than was colonialism itself."[52]

Consequently, the campaign to deflect this threat and to reverse the extended "imperial" flow of information has run counter to the interests of the giant communication conglomerates which McLuhan affectionately termed "tribal families."

McLuhanism, as we have seen, is underscored by a benign vision of postnationalism, which sees the liberal moment of the nation-states as having been superseded by a new internationalist fraternity. McLuhan was himself the citizen of a country that, in the early sixties, was the most "wired nation on earth" because of its cable boom, engineered to channel in U.S. commercial broadcasting.[53] Its national identity having been commercially constructed in the nineteenth century by railways and other communications, Canadian sovereignty had been a particularly unstable entity, due to its colonial history and its geographical contiguity with a giant cultural exporter and colonizer to the south. In 1966, McLuhan proclaimed that "Canada is coming to an end. A country three thousand miles long cannot be held together by rail while putting up with airplanes, radio, and television, which are decentralizing forces. Separatism is a simple fact of radio and television."[54]

Many Canadians, in the nationalist turmoil of 1966, might have been inclined to interpret McLuhan's comments about the "simple fact" of separatism in a more immediate, and less formalist, context than he was accustomed to do. In fact, radio and television, particularly in the case of Montreal's Radio-Canada network, had played a crucial role in creating the consciousness for the Quebecois movement for self-determination. By doing so, it challenged the pan-Canadian view of nationalism articulated by the "official" public voice of the Canadian Broadcasting Company (CBC).[55] Here then, was a heterogeneous culture in which competing definitions of nationalism had been rendered legitimate largely through the existence of communication channels *other than that of the public corporation* which had been established expressly in order to combat U.S. influence and build up national and cultural unity as a bulwark against that influence.

The lesson to be drawn from the Canadian example is that the universal call for strengthening national identity through public broadcasting institutions is often answered only at the cost of bolstering

internal unity *against* the threat of regional differences. Another Western version of this practice is the example of the BBC. If it hadn't been for the "populist" introduction of commercial television, the BBC's paternalist sway over national cultural life might still be flourishing in spite of all the stark regional differences and alternative nationalisms which mark the internally colonized settlements that still pass for political unity in the U.K. Outside of Europe and North America, similar examples abound of national communication policies being used to bolster an internally repressive nationalism. Public broadcasting, whether national or state-controlled, is not a universal answer, especially in cultures where "nation," "public," and "state" can have meanings that are often in conflict with each other. The importance of encouraging self-reliance in countries whose sovereignty is threatened by the new communication technologies must start at a popular level of organization which is not necessarily congruent with the national bourgeois idea of the state.

In the same 1966 lecture in which he cavalierly announced that "Canada is coming to an end," McLuhan gives an example of the contradictory face of technologist ideology which he termed "rear-view mirrorism":

> *Bonanza* is not our present environment, but the old one; and in darkest suburbia we latch onto this image of the old environment. This is normal. While we live in the television environment, we cannot see it. . . . Anyone who talks about centralism in the twentieth century is looking at the old technology—*Bonanza*—not the new technology—electric technology Our thinking is all done still in the old nineteenth-century world because everyone always lives in the world just behind—the one they can see, like *Bonanza*. *Bonanza* is the world just behind, where people feel safe. Each week 350 million people see *Bonanza* in sixty-two different countries. They don't all see the same show, obviously. In America, *Bonanza* means "way-back-when." And to many of the other sixty-two countries it means a-way-forward when we get there.[56]

Here, McLuhan, who rarely offers a reading of a specific TV show, proposes a cultural parable for advanced technological societies. But it is also a parable about underdevelopment in many of the sixty-two countries (eventually a hundred, in the case of *Bonanza*) in which a technologically advanced culture's own imaginary and anachronistic relation to its past development is being introduced. McLuhan chooses to see the witty, or ironic, side of the resulting contradictions. As always, he chooses to ignore the ugly, exploitative side of development which he might otherwise have exposed in his many "probes" or "explorations."

His is the relentless optimism of the liberal who chooses not to see how the promises of technological development invariably present opportunities for existing interests to extend and reproduce their power. On the contrary, he sees technological development only in terms of a furthering of the "competitive fury" of the "egalitarian pattern against which the strategy of social class and caste has often been used in the past" (UM,344). So too, he opposes, in principle, the supervision of taste from above, and is always announcing that the days when intellectuals legislated "values" and "standards" on behalf of the people are now over. But his faith in the independent and abstract capacity of new technological development to generate a more egalitarian culture relinquishes entirely the field of power struggles waged over cultural "taste." He sees no danger in this complete withdrawal or abdication of intellectuals from the war of persuasion; it is simply a fact, made inevitable by the development of the culture and advertizing industries. To recognize that fact is the mark of the realist, but it also betrays a lack of social analysis—the result is what I have called unsocial realism.

If McLuhan had been less of a formalist, he might have reached some different conclusions, for example, about the ideology of the TV Western genre, of which *Bonanza* was the most successful export. First aired in 1959, as one of a host of telefilms which replaced the quiz shows, *Bonanza* was the latest in a flood of TV Westerns which began, in 1955, with Warner Brothers' *Cheyenne* (the first Hollywood venture into TV) and was followed by *Maverick, Colt 45, Lawman, Wyatt Earp, Gunsmoke, Death Valley Days, Broken Arrow, Adventures of Jim Bowie, Tales of Wells Fargo, Wagon Train, Annie Oakley, The Lone Ranger, Davy Crockett, Wild Bill Hickok, Cisco Kid, Tales of the Texas Rangers*, and many others. In the early sixties, President Kennedy's New Frontier of technology was being touted while these versions of the Old Frontier propagated the benign myth of pioneerism at home and abroad. At this time, before public consciousness about the historical fate of the American Indian had properly found its voice, it was less common to see the cult of the Western from the point of view of those who had been pioneered out of their land, their culture, and their sacred ways of life. In the classic Western, the Indian has no legitimate relation to the land that has been wrested from him; to establish a relation to the land, one has to invent a technology to dominate it. The story about technology told by the Western subscribes to a history, as Dorfman puts it, "in which Pontiac is an automobile and not a chief of the first Americans."[57]

Perhaps we ought to imagine, if only because McLuhan did not, the bitterly ironic reading of Westerns like *Bonanza* which his mythical "African tribesman" might have provided in retrospect. This mythical tribesman might have seen, in the Indians' already prefigured fate within the

Western narrative, a post-pioneer future that would come to erase his own native history after his culture and land had been transformed beyond all recognition. Instead of a rear-view mirrorism which wants to accelerate away from the past, such a reading would see its own historical fate prefigured in the mirror of another culture's future. Such a reading would draw conclusions from the lessons of other peoples' history rather than teach preachy lessons about the future to those who are judged to be living in the past.

5

Uses of Camp

"It's beige! *My* color!" (Elsie De Wolfe, on facing the
Parthenon for the first time)

The best thing about subscribing to the *National En-
quirer* is that it arrives in the mailbox the same day as
the *New York Review of Books*. (John Waters)

Take four iconic moments from the sixties:

1961: In *Whatever Happened to Baby Jane?* (Robert Aldrich)—according
to Bette Davis, the first "women's picture" for over ten years, bringing
together for the first time the aging, uncrowned royalty of classic Holly-
wood, Davis and Joan Crawford—"Baby Jane" Hudson, ex-child-star,
now grotesquely made-up (at Davis's own inspirational insistence) like a
pantomime Ugly Sister, serves up steamed pet bird for lunch to her
wheelchair-bound sister Blanche, a big film star in the thirties, whose
career was tragically cut short by a car accident. Blanche spins in terror
in her wheelchair, shot from above; Jane laughs from the belly up, her
face twitching with glee. Their House of Usheresque present refracts the
Babylonish history of Hollywood stardom, while it creates a new horror
film subgenre for the new decade.

1964: A different Baby Jane, in a New York photographer's studio in
the year of the British Invasion—Baby Jane Holzer, in Tom Wolfe's
"Girl of the Year," cavorting at her twenty-fourth birthday party which
doubled as a publicity event for her star guests, the Rolling Stones. Back
from the London "Pop" summer of 1963, sporting the Chelsea Look,
and talking Cockney ("Anything beats being a Park Avenue housewife"),
Holzer, for Wolfe, for *Vogue*, and for Andy Warhol, is the living symptom
of the new, pluralistic, "classless" melting pot culture, where socialites—
though not only the Social Register type—enthusiastically took up the
styles and subcultural idioms of arriviste "raw-vital proles" (the party's
theme was Mods vs. Rockers) by way of the exotic British import of "East
End vitality" ("they're all from the working class, you know").

1969: The evening of the funeral of Judy Garland (a long time gay
icon), members of the New York City Vice Squad come under fire, from
beer cans, bottles, coins, and cobblestones, as they try to arrest some of
the regulars at the Stonewall Inn in Christopher Street. The mood of the

protesters, many of them street queens in full drag, had changed from that of reveling in the spectacle of the arrest, even posing for it, to one of anger and rage, as one of the detainees, a lesbian, struggled to resist her arrest. Within minutes, the police were besieged within the burning bar. Some of those present thought they heard the chant "Gay Power," while others only saw a more defiant than usual show of posing; it wasn't clear whether this confrontation was "the Hairpin Drop Heard Around the World" or the "Boston Tea Party" of a new social movement.

Later in 1969: A different scene of conflict at the Altamont free festival, the dark sequel to Woodstock, and the Stones again. Jagger is up front, berobed and mascara'd, swishing, mincing, pouting, and strutting before a huge audience barely in check, while on every side of the stage are posted Hell's Angels, confrontation dressers all—the sometime darlings of radical chic, which saw in them an aggressive critique of the counterculture's "male impotence." Here employed as soft police, they stare, bluntly and disdainfully, at the effeminate Jagger, some of them mocking his turns and gyres, while the off-stage violence escalates, to end soon in the death of Meredith Hunter, caught on film in *Gimme Shelter*, the Stones's blatant attempt at self-vindication, in which Jagger poses the rhetorical question: "Why does something always happen when we start to play that song?"—"Sympathy for the Devil."

There are many sixties themes that could serve to link each of these highly mediated moments together: the spectacle of narcissism, radical chic, carnivalesque conflict, and so on. The purpose which they will serve here is to introduce particular aspects of the history of camp, that category of cultural taste, which shaped, defined, and negotiated the way in which sixties intellectuals were able to "pass" as subscribers to the throwaway Pop aesthetic, and thus as patrons of the attractive world of immediacy and disposability created by the culture industries in the postwar boom years. On the importance to the sixties of this category of taste, George Melly, the English jazz musician and Pop intellectual, is adamant: camp was "central to almost every difficult transitional moment in the evolution of pop culture. . . . [it] helped pop make a forced march around good taste. It brought vulgarity back into popular culture . . . "[1]

Beyond these few iconic moments, there is, of course, a much larger story to tell about the transitional function of camp as an *operation of taste*. It is a story of uneven development, because it demonstrates the different uses and meanings which camp generated for different groups, subcultures, and elites in the sixties. The exercise of camp taste raised different issues, for example, for gay people, *before* and *after* 1969; for gay males and for lesbians; for women, lesbian and straight, before and after the birth of the sexual liberation movements; for straight males, before and after androgyny had become legitimate; for traditional intellectuals,

obliged now, in spite of their prejudices, to go "slumming," and for more organic intellectuals, whose loyalty to the Pop ethic of instant gratification, expendability, and pleasure often seemed to leave no room for discriminations of value; for disadvantaged working-class subcultures whose relation to Pop culture was a glamorous semiotic of their aspirations and dreams of social mobility and leisure, and for the middle-class counterculture, whose adherents could afford, literally, to redefine the life of consumerism and material affluence as a life of spiritual poverty.

While it would be wrong to see camp as the privileged expression of any of these groups, even the pre-Stonewall, gay male subculture for which the strongest claim can be made, there are certain common conditions which must be stressed. Just as the new presence of the popular classes in the social and cultural purview of the postwar State had required a shift in the balance of *containment*, so too, the reorganization of the culture industries, the new technologies and the new modes of distribution which accompanied that shift had yielded structural changes in the shape of aesthetic taste. New markets—the youth market and the swinging "Playboy" male in the fifties (to be followed by women in the sixties and gays in the seventies)—had generated massive changes in the patterns of consumption. Full employment, growing surplus value, and widely shared levels of material affluence provided a secure basis for the expressive leisure activities and the cultural risk-taking which characterized the sixties. In the writing of Tom Wolfe and others, the interlocking subcultures of the late fifties began to emerge as visible phenomena in the early years of the decade: "Practically nobody has bothered to see what these changes are all about. People have been looking at the new money since the war in economic terms only. Nobody will even take a look at our incredibly new national pastimes" among which Wolfe himself was to number stock car racing, demolition derbies, customized auto styling, surfing, the new teenage dance scenes, and many others.[2]

To illustrate some of the specific effects of these changes in cultural technologies, I will take a closer look at the four iconic moments with which we began.

What triggers the narrative action in *Whatever Happened to Baby Jane?* and the newly heightened sadistic-jealous mood of Jane is the showing of one of Blanche's old movies on television. The most recent version of Old Hollywood (a prelapsarian myth) was in decline, the star system had foundered, and the whole industrial economy of the studio system had been challenged and largely outpaced by the television industry. The late fifties and early sixties saw the recirculation of classic Hollywood films on television, giving rise to a wave of revivalist nostalgia, and supplementing the cult of Hollywoodiana with all of the necrophilic trappings that

embellish its initiates' "sick" fascination with the link between glamor and death.[3] No longer was this a taste reserved for members of film societies and clubs; or for avant-garde filmmakers like the celebrated Jack Smith, who had studied every frame of certain thirties films, and whose cult of Maria Montez, one of the most cherished of the pantheon of camp screen goddesses, was to irradiate important sectors of the early underground film scene. In *Whatever Happened to Baby Jane?*, this cult taste is exploited for the mainstream, as never before.

Of course, the stylized morbidity of this cult had long been an object of devotion for its aficionados. In Billy Wilder's *Sunset Boulevard* (1950), for example, Hollywood had produced its own sick and baroque elegy for silent film. Joe Gillis (William Holden), the young, down-on-his-luck scriptwriter and heel, recognizes the mark of movie history beneath the faded glamor of Norma Desmond (Gloria Swanson): "You used to be in silent pictures. You used to be big." Desmond shoots back: "I *am* big. It's the pictures that got small." In a sense Desmond is correct (in spite of Gillis's crass, authoritative voiceover, Norma is almost always correct), but her outrageous self-conceits and her tirades against "words," "writing," and "dialogue" can only produce their truly camp effect in a film, like Wilder's, which relies so heavily upon words and dialogue, and in which the new Hollywood—the "smallness" of today's pictures—is represented by the no-nonsense, professional earnestness of Betty Schaefer (Nancy Olson), a scriptreader who finds "social interest" themes to develop in the scripts of the noirish gigolo Gillis.

The camp meaning of Norma Desmond's *grande damerie* is generated, then, by incongruously juxtaposing the technological environment of the present with the traumatic passing of silent film. In 1950, the studio star system, already in trouble, was about to enter its last phase—the Monroe phase. The anxiety of that moment is ironically figured in the other great camp film of that year, Joseph Mankiewicz's *All About Eve*, in which a young Monroe plays the role of a talentless ingénue hotly pursuing a career in one of the vacuums created by the retirement of a great Broadway actress (played by Bette Davis), just as the traditional hierarchy of prestige between Broadway and Hollywood is being expanded to include a third, and much despised third term—television (in the words of the film's theater critic, Addison De Witt: "That's all television is, my dear, nothing *but* auditions"). As Hollywood is passing out of its lavish "bourgeois" moment, the origins of that moment are invoked in *Sunset Boulevard* by the anachronistic spectacle of Norma Desmond, a gaudy survivor of the pre-bourgeois age of screen gods and goddesses, whose crumbling aristocracy now serves, in the fifties, as a displaced symptom of the current crisis in prestige of the film medium. It is the historical incongruity of this displacement which creates the world of irony that camp exploits.

Over a decade later, a similar play upon the displaced grandeur of the past, this time reinforced by the domesticity of the television environment, brings a sense of macabre tragicomedy to *Whatever Happened to Baby Jane?* But the conclusion of this film is even more incongruous yet. At the end of *Sunset Boulevard*, Norma Desmond gets to play her final, grandiose entrance in the garish, artificial light of camera flashes, where she basks in the knowledgeable attention of a crowd of reporters and voyeuristic Hollywood hangers-on who appreciate the scene, however bizarre, for what it's worth as a Hollywood publicity event. Eleven years later, Baby Jane Hudson strikes up her blithe child-star routine in the beach light of a California sun, surrounded by a puzzled group of teenagers for whom her appearance in that setting has about as much meaning as that of a visitor (to a beach party) from another planet.

The camp effect, then, is created not simply by a change in the mode of cultural production, but rather when the products (stars, in this case) of a much earlier mode of production, which has lost its power to dominate cultural meanings, become available, in the present, for redefinition according to contemporary codes of taste. Today's commercialized camp taste is exploited by the former Hollywood stars who star in television's own aristocratic soap operas, like *Dynasty*, *The Colbys*, and *Falcon Crest* (not to forget *The Reagan Presidency*). The camp taste of tomorrow, however, may be for the made-for-TV movies of the seventies and eighties, which seem so stale and flat to the eyes of today's tastemakers, but which may, one day, be seen in the retrospective light of their early, futile response to a more fully achieved cable and video revolution.

As for Baby Jane Holzer's Pop moment of the early sixties, a similar relation to disempowered modes of production can be seen there in the crucial importance of the "British invasion" to the redefinition of American taste. British Pop was the first evidence of a foreign culture making brilliant sense of the American popular culture which had been exported since the war. For Britons, the importation of American popular culture, even as it was officially despised, contained, and controlled, brought with it the refreshing prospect of a boycott of traditional European judgments of elitist taste.[4] By the early sixties, the successes of this wave of American exports among the new "angry young" British tastemakers were such that they provided the final seal of approval for the formation and acceptance of Pop taste in the U.S. itself. Thus, the British version of Pop (always an *imaginary* relation to a foreign culture— James Hadley Chase, for example, invented the America of his many bestselling novels, after one short visit to Florida as a tourist)[5] was somehow needed to legitimize American Pop for Americans, as if in accord with the higher canons of European taste to which Americans were still, in some way, obliged to defer.

The camp moment in this complex process, however, is the recognition of the eclipsed capacity of real British power to play the imperialist game of dominating foreign taste. That is why the British flag, for Mods and other subcultures, and Victoriana, for the Sergeant Pepper phase of the later sixties, became camp objects—precisely because of their historical association with a power that was now in decline. The Stars and Stripes, and most Americana, by contrast, could only be kitsch (gracelessly sincere), because they intend serious support for a culture that still holds real power in defining the shape of foreign tastes. It is quite symptomatic, then, that in Wolfe's "Girl of the Year" the "supermarvellous" Holzer plays her part opposite a group of Cockney primitives, or Teen Savages, among whom Jagger is described as almost not human, "with his wet giblet lips," forcing out a deformed language, a slurred, incomprehensible "Bull Negro," at least when he is not mumbling away in a willfully inarticulate Cockney. At the very moment when the balance of transatlantic taste is being redefined, Wolfe, at least, found it ironically appropriate to turn on its head the kind of Calibanesque imagery that recalls British colonial history in the New World (elsewhere he describes the world of his "discovered" Californian subcultures as "Easter Island"—Who are these people and how did they achieve this level of civilization?).[6]

Aside from this rewriting of the rules of the Old/New World game of taste, concrete relations to changes in cultural technology can be seen in the formation of Pop. The *nouveau riche* Holzer is crowned as "Girl of the Year" for her charisma, pep, and daring, and not on account of her youthful interpretation of traditional *prestige*, or some other inflection of accumulated cultural capital. So too, it is clear that the intellectuals who were creating and defining Pop tastes were organically associated not only with rising groups or classes, but also with the commercial industries themselves. In the mid-fifties, the International Group (Lawrence Alloway, John McHale, Reyner Banham, Eduardo Paolozzi, Richard Hamilton, Frank and Magda Cordell) at London's Institute for Contemporary Art, responsible for most of the early theorization of Pop, was described by Banham, in class-marked terms, as "the revenge of the elementary schoolboys."[7] Roy Lichtenstein, Jasper Johns, and Andy Warhol all came out of the commercial art industries. Wolfe and the New Journalists like Hunter S. Thompson, Joan Didion, and Terry Southern, retained their allegiance to the ethos of the journalistic world, flying in the face of the higher prestige of the literary world (Mailer and Truman Capote had ventured into the "new" journalism, but their debuts and their finales were, and are likely to be, literary ones). The new pop stars were, for the most part, from lower-class backgrounds, even when filtered through art school educations, as was the case with many of the British, or with Americans provided with respectable identities (on his show, Ed Sullivan

presented Elvis as "a nice decent boy"). So too, the boutique revolution in design, distribution, and consumption brought about almost single-handedly by Mary Quant was a reflection of the need for a new youth style market for a fashion industry in the throes of reorganization.

But perhaps the most significant tastemaker of the day was David Bailey (the photographer who "created" Baby Jane Holzer along with three other "model girls"—no longer "fashion models"—in the summer of 1963), not least for his embodiment of the new kind of masculinity, described here by Melly:

> uneducated but sophisticated; charming and louche; elegant but a bit grubby; the Pygmalion of the walking-talking dolly; foul-mouthed but sensitive; arbitrary yet rigid; the openly sardonic historian of his time elevating a narrow circle of his own friends and acquaintances into a chic but deliberately frivolous pantheon; hard-working but ruled by pleasure. . . . he has transferred those qualities which, until the 60s, were thought of as essentially homosexual and made them available to what used to be known as "red-blooded males."[8]

In addition, Bailey's transatlantic capacity to move from one sphere of Pop activity to another—fashion, rock, journalism, art—made him the model Renaissance courtier in a world where debutantes were beginning to swear like troopers, and learning to patronize the tastes and bodies of their chauffeurs.

But what was the meaning of this newly proclaimed "classless" culture? The purist Pop intellectual like Warhol simply proclaimed and celebrated that everyone (and everything) was equal: "It was fun to see the Museum of Modern Art people next to the teeny-boppers next to the amphetamine queens next to the fashion editors."[9] Others, like Wolfe, made assertive claims about the new cultural power of the disenfranchised—"now high style comes from low places . . . the poor boys . . . teenagers, bohos, camp culturati . . . have won by default"—and went on to emphasize the pioneering risks which writers like himself were taking in order to champion those who had neither "stature nor grandeur," among whom were "petty bureaucrats, Mafiosi, line soldiers in Vietnam, pimps, hustlers, doormen, socialites, shyster lawyers, surfers, bikers, hippies and other accursed Youth, evangelists, athletes, 'arriviste Jews' . . ."[10] While for those, like Susan Sontag, with more orthodox avant-garde inclinations, the new egalitarianism meant a passport, from the top down (but not necessarily from the bottom up) to all corners of a cultural garden of earthly delights: "From the vantage point of this new sensibility, the beauty of a machine or of the solution to a mathematical problem, of a painting by Jasper Johns, of a film by Jean-Luc Godard, and of the personalities and music of the Beatles is of equal access."[11]

Each of these heady claims pays lip service, in its own way, to what had become the official national ideology of liberal pluralism, celebrating a heterogeneous range of special interest or status groups and subcultures, each pledged to harmonious co-existence. The noncommittal, if not always celebratory, stance of many Pop intellectuals, while it was a important break with the morally charged paternalism of their Cold War forebears, did little to uncover what the liberal pluralist model had repressed—all of the signs of conflict generated by the uneven development of the "affluent society," and the antagonism on the part of those groups, still oppressed by exclusion or marginalization by sex, color, and class, towards those who were especially privileged by the new pluralist conjuncture.

When Wolfe, for example, wrote about the new middle-class subcultures which he termed "statuspheres," his was a straightforward, functionalist description of autonomous groups seeking their share of the pie; "they just want to be happy winners for a change."[12] No one was more brilliantly merciless on the topic of class and taste than Wolfe, and no one argued a stronger case for the crucial importance of popular pleasure in the new cultural conjuncture. But his characteristic refusal to read and interpret, within popular culture, the signs of dissatisfaction and resentment, let alone dissent or resistance, left him unwilling and ill-prepared to chronicle the less harmonious story of subcultural conflicts. In fact, as the decade wore on, the "lessons" of the sixties, which were increasingly about divisions and antagonisms, helped to confirm the New Left's early rejection of consensus theory as a congratulatory liberal myth. Hence the frustration of Wolfe, and others, at the turn of events in the later sixties, when a law-and-order, or "control," society was hurriedly being put in place to contain the anti-war movement and the Black, American Indian, and Chicano liberation struggles. Appearing at a symposium at Princeton with Paul Krassner, Günter Grass, Allen Ginsberg, and Gregory Markopoulos, he was blithely puzzled by his fellow panelists' talk of police repression, "the knock on the door," and other strategies of coercion. "What are you talking about?," he said, with only partial irony. "We're in the middle of a Happiness Explosion."[13]

The shortcomings of the liberal pluralist model can be seen more clearly in the case of Altamont, where subcultures are set at odds with an expanded counterculture itself at odds with the straight consensus-bound world. For working-class cultures, the consumer ethic of immediate gratification had informed a grammar of achievement and mobility, which could yet be articulated as a hostile or delinquent response to the status quo. By contrast, the vocabulary of dissent mobilized by the middle-class counterculture drew upon an ideology of withdrawal or disaffiliation from the institutional responsibilities, powers, and privileges for which

its college-educated initiates had been raised. The result, for the latter, was a fully articulate version of an alternative culture, with its own alternative structures in the areas of family, education, media, spiritual philosophy, lifestyle, and morality. Loosely aligned with, but often antagonistic towards the dominant white student fraction of the New Left (itself increasingly divided along lines of race and gender, and ultimately by sectarian political elements), the countercultural bloc focused its inspirational energy upon a pantheon of expressive culture heroes—mostly rock stars—as part of its independent campaign to "elect" its own organic community leadership.

One highly visible feature of this campaign was a running battle, from the mid-sixties on, with the youth-oriented entertainment industries which sought to absorb, assimilate, and generate countercultural values for profit, and whose management of this process increasingly and logically demanded the celebrification and consent of rock stars as culture hero-leaders. The free music festival (usually planned and managed by astute young entrepreneurs) became a heroic symbol of this struggle, a test of the capacity to mobilize the liberated sectors of the population in support of a vast non-commercial celebration of the alternative culture.

At Altamont, which is often depicted, rightly or wrongly, as much less of a middle-class gathering than Woodstock or Monterey had been, the inept and callous planning of the festival as an end-of-tour publicity stunt for the Rolling Stones, the violence, associated with the "retarded masculinity" of the Hells Angels, and the "bad vibes," associated with bad drugs and lack of medical aid, all came to be seen as a diabolic presage of a loss of control within the counterculture.[14] In fact, it is important to see that the actions of the Angels, recruited by the Grateful Dead as alternative police, arose out of a different, working-class ethic of *delinquency*, which, unlike the countercultural disaffiliation, had never sought to devolve itself from the parent culture, and which retained its suspicion and resentment of the libertarian privileges of the student and other middle class groups. While they clearly found it offensive to be cast as police, and were right in thinking they were being patronized (no properly countercultural group would play this role), the Angels were just as likely to be found marching against the "unpatriotic" students (as happened infamously in Berkeley) and alongside the riot police, with whom they shared a common, if uneasy, class constituency.[15] This antagonism, and these tensions, were symbolically reduced at Altamont to the frozen, iconic spectacle of the hardass Angel confronting the liberated camp masculinity of Jagger's countercultural Devil.

At Stonewall, where a traditionally persecuted group fought back and made history, but not under conditions of its own making, a more clearcut picture of the *control* society of consumer capitalism emerges. The

immediate local problem in the Stonewall "riots" was as much illicit Mafia control of gay bars as the routine acts of police repression.[16] Thus, the commercial control of the gay subculture, which existed hitherto as a network of codes of concealment, was *already* an issue in the founding moment of the movement that was soon to emerge under the aegis of Gay Pride, Gay Power, and the Gay Liberation Front.[17] Gay leaders contended that the liberation movement's creation of a gay culture had to consist in more than simply placing gay businessmen in control of the bars, stores, and clubs; alternative institutions had to be created. The success of the lesbian community in creating such a network of institutions (along with its achievements in forming the vanguard of feminist politics) is often seen as the most positive legacy of the pre-AIDS phase of the movement.

In the post-Stonewall years, gay males emerged as one of the prime target, cachet groups that was ripe for new consumer marketing in the early seventies. The result was a thriving sexual marketplace where the advancement of sexual freedoms was often inseparable from the commodification of sex itself. The gay male became a model consumer, in the vanguard of the business of shaping and defining taste, choice, and style for mainstream markets.[18] On the one hand, then, the libertarian ethos of the sexual marketplace helped in part to protect the sexual freedoms that were partially achieved by the liberation movements. On the other hand, the commercial categorizing of sexual identities made it easier to socially control and "quarantine" groups identified by sexual orientation. Marcuse's warnings about the "repressive tolerance" of consumer capitalism resonated within the gay liberation movement: the technical rationality of capitalism had found ways of administrating and exploiting the liberalization of attitudes towards sexual pleasure.

It is in this dialectic between personal liberation and corporate-State regulation (of medical technologies, etc.) that gay intellectuals locate the problems faced today in a control society reinforced by the newfound capacity to define the "threat" of AIDS on its own terms. How does a subculture make sense of this dialectic in terms of cultural politics? Perhaps this is where the question of camp, which was often posed as an embarrassment to post-Stonewall gay culture ("the Stepin Fetchit of the leather bars"),[19] becomes political all over again, because camp contains an explicit commentary on feats of *survival* in a world dominated by the taste, interests, and definitions of others.

Camp Oblige

In her seminal essay, "Notes on Camp" (1964), Susan Sontag raises the question of survival in a quite specific way: "Camp is the answer to the

problem: how to be a dandy in an age of mass culture."[20] Her formula suggests that what is being threatened in an age of mass culture is precisely the power of tastemaking intellectuals to influence the canons of taste, and that the significance of the "new sensibility" of camp in the sixties is that it presents a means of salvaging that privilege. (The term "dandy," here, can be seen as standing for intellectuals who are either personally devoted to the sophistries of taste, or whose intellectual work it is to create, legitimize, and supervise canons of taste.)

The pseudo-aristocratic patrilineage of camp can hardly be understated. Consider the etymological provenance of the three most questionable categories of American cultural taste: schlock, kitsch, and camp. None are directly of Anglo origin, and it is clear, from their cultural derivation, where they belong on the scale of prestige: *Schlock*, from Yiddish (literally, "damaged goods" at a cheap price), *Kitsch*, from German, petty bourgeois for pseudo-art, and *Camp*, more obscurely from the French *se camper* (to posture or to flaunt), but with a history of English upper-class usage. While schlock is truly unpretentious—nice, harmless things—and is designed primarily to fill a space in people's lives and environments, kitsch has serious pretensions to artistic taste, and, in fact, contains a range of references to high or legitimate culture which it apes in order to flatter its owner-consumer. Kitsch's seriousness about art, and its aesthetic chutzpah is usually associated with the class aspirations and upper mobility of a middlebrow audience, insufficient in cultural capital to guarantee access to legitimate culture.[21]

Of course, kitsch is no more of a *fixed* category than either schlock or camp. These categories are constantly shifting ground, their contents are constantly changing; as is the case with "midcult," that which is promoted one year may be relegated down again the next. Neither can they be regarded as categories defined with equal objectivity but attributed different value, since schlock and kitsch are more often seen as qualities of objects, while camp tends to refer to a subjective process: camp, as Thomas Hess put it, "exists in the smirk of the beholder."[22] If certain objects tend to be associated with camp more readily than others, they are often described as "campy," suggesting a self-consciousness about their status which would otherwise be attributed to the smirking beholder. Sontag downgrades this self-consciousness as too deliberate, reserving her praise for the category of *naive* camp, perhaps because, with the latter, it is the critic and not the producer who takes full credit for discerning the camp value of an object or text. So too, the line between kitsch and camp partially reflects a division of audience labor between, in camp terminology, ignorati and cognoscenti. The producer or consumer of kitsch is likely to be unaware of the extent to which his or her intentions or pretensions are reified and alienated in the kitsch object

itself. Camp, on the other hand, involves a celebration, on the part of cognoscenti, of the alienation, distance, and incongruity reflected in the very process by which hitherto unexpected value can be located in some obscure or exorbitant object.

But if camp, in this respect, has always been part of the history of pseudo-aristocratic taste, the "moment" of camp, in the sixties, was also seen as a democratic moment, and its influence continues to irradiate pop attitudes today. What were the conditions under which this democratizing influence came about?

To properly historicize that moment, we must first recognize that just as it is absurd to speak of a lasting canon or pantheon of camp texts, objects, and figures (though more or less definitive lists do exist for certain groups who use camp), universal definitions of camp are rarely useful. In Philip Core's encyclopedia of camp, for example, camp is loosely defined as "the lie that tells the truth" (after Jean Cocteau) or as "the heroism of people not called upon to be heroes," while Christopher Isherwood, in *The World in the Evening* (1954), finds that camp is a subjective matter of "expressing what's basically serious to you in terms of fun and artifice and elegance." This is why Sontag chose to write her essay about this "fugitive sensibility" in the more objective form of notes or jottings, for fear of writing a dry, definitive treatise that would itself be nothing but "a very inferior piece of camp." It appears, however, that she also wanted to avoid the argument that camp is a "logic of taste," with explicable, historical conditions; the determining grounds of taste, she prefers to say, are "almost, but not quite, ineffable."

More useful in this respect is Mark Booth's expanded and exhaustive account of Sontag's "pocket history of camp" (her note no. 14—embracing rococo, mannerism, *les précieux*, Yellow Book aestheticism, art nouveau, etc.), a history polemically guided by his thesis that "to be camp is to present oneself as being committed to the marginal with a commitment greater than the marginal merits."[23] The advantage of Booth's formulation is that it helps to define camp in relation to the exercise of *cultural power* at any one time. Booth argues, for example, that, far from being a "fugitive" or "ineffable" sensibility, camp belongs to the history of the "self-presentation" of arriviste groups. Because of their marginality, and lack of inherited cultural capital, these groups parody their subordinate or uncertain social status in "a self-mocking abdication of any pretensions to power."[24]

Unlike the traditional intellectual, whose function is to legitimize the cultural power of ruling interests, or the organic intellectual, who promotes the interests of a rising class, the marginal, camp intellectual expresses his impotence as the dominated fraction of a ruling bloc at the same time as he distances himself from the conventional morality and

taste of the ascendant middle class. For example, the nineteenth-century camp intellectual can be seen as a parody or negation of dominant bourgeois forms: anti-industry, pro-idleness; anti-family, pro-bachelorhood; anti-respectability, pro-scandal; anti-masculine, pro-feminine; anti-sport, pro-frivolity; anti-decor, pro-exhibitionism; anti-progress, pro-decadence; anti-wealth, pro-fame. But his aristocratic affectations are increasingly a sign of his *disqualification*, or remoteness from power, because they comfortably symbolize, to the bourgeoisie, the declining power of the foppish aristocracy, while they are equally removed from the threatening, embryonic power of the popular classes.

Hitherto associated with the high culture milieu of the theater, the camp intellectual becomes an institution, in the twentieth century, within the popular entertainment industries, reviving his (and by now, her) role there as the representative or stand-in for a class that is no longer in a position to exercise its power to define official culture. As part of that role, he maintains his parodic critique of the properly educated and responsibly situated intellectual who speaks with the requisite tone of moral authority and seriousness as the conscience and consciousness of society as whole.

In this respect, it is appropriate that Sontag chooses to link her account of the (largely homosexual) influence of camp taste with the intellectual successes of "Jewish moral seriousness," as the two "pioneering forces of modern sensibility" (note no. 51). More than any other publication, her essay (and the book in which it appeared, *Against Interpretation*) signaled the challenge, in the sixties, to the tradition of Jewish moral seriousness that had governed the cultural crusading of the Old Left and Cold War liberalism. Not that Sontag is willing to jettison entirely the prerogative of moral discrimination; in fact, she is careful to record her ambivalence about camp—"a deep sympathy modified by revulsion." Nonetheless, the importance of her own critical intervention in the mid-sixties was in the service of pleasure and erotics, and against judgment, truth, seriousness, and interpretation; against, in short, the hermeneutics of depth and discrimination through which the New York Intellectuals had filtered extra-curricular literary taste since the war. As for the academic New Critics, whose "Christian" moral seriousness was the more hegemonic literary force, Sontag's flight from sincerity was almost too far outside of their orbit to register immediate effects and responses.

In the U.K., camp was more directly a parodic reorganization, on the part of lower-class upstarts, of the taste of the traditionally "effete" aristocracy of the cultural Establishment. Camp in the U.S., at the moment that Sontag immortalized it, was an important break with the style and legitimacy of the old liberal intelligentsia, whose puritanism had always set it apart from the frivolous excesses of the ruling class. To fully

understand this shift in style, it is necessary to look at the two most important contexts of this break: first, Pop, and its reorientation of attitudes towards mass-produced culture; and second, the culture of sexual liberation, for which camp played a crucial role in the redefinition of masculinity and femininity.

Pop Camp

In London in the mid-fifties, the fledgling studies of Pop by the intellectuals of the International Group had come directly out of the postwar debates about mass culture. In contrast to the "mass culture" critique of manipulation, standardization, and lobotomization, Reyner Banham and others argued that there was no such thing as an "unsophisticated consumer"[25]: the consumers of popular culture were experts, trained to a high degree of connoisseurship in matters of consumer choice and consumer use. Lawrence Alloway wrote passionately against the conventional wisdom that mass culture produced a passive, undifferentiated audience of dupes:

> We speak for convenience about a mass audience but it is a fiction. The audience today is numerically dense but highly diversified. Just as the wholesale use of subception techniques in advertising is blocked by the different perception capacities of the members of any audience, so the mass media cannot reduce everybody to one drugged faceless consumer. Fear of the Amorphous Audience is fed by the word "mass." In fact, audiences are specialized by age, sex, hobby, occupation, mobility, contacts, etc. Although the interests of different audiences may not be rankable in the curriculum of the traditional educationist, they nevertheless reflect and influence the diversification which goes with increased industrialization.[26]

In the drab culture climate of Britain in the fifties, popular culture and mass media were much more than a functional and necessary guide to modern living; they were, in Alloway's eloquent phrase, "a treasury of orientation, a manual of one's occupancy of the twentieth century." To the paternalist Establishment culture, they represented the ugly specter of "Americanization." To working-class kids, they brought a taste of glamor, affluence, the immediate experience of gratification, and the dream of a pleasure-filled environment. Here, for example, is Ray Gosling's childhood memoir: "There was a tremendous romance about America. America was the place where we all wanted to be. America was closer than London. . . . The most exciting thing about being alive was looking at Americans."[27] To mature intellectual aficionados, American

popular culture was a Cockaigne of the perverse intellect, a fantasy of taste turned upside-down with which to avenge themselves against the tweedy sponsors of European tradition. The very idea of Richard Hamilton's painting "Hommage à Chrysler Corp.," for example, exudes the bittersweet flavor of camp—a highly wrought conceit of the European as a fake American.

While the American experience of commercial, popular culture was, of course, much more *lived* and direct, we should not fall into the trap of assuming that it was less mediated or less fantasmatic. The uses made of comic strips, science fiction, "Detroit" styling, Westerns, rock 'n' roll, advertising, etc. by different social groups cannot be read as if they were spontaneous responses to real social conditions. On the contrary, they represent an imaginary relation to these conditions, and one which is refracted through the powerful lens of the so-called American Dream— a pathologically seductive infusion of affluence, sublimated ordinariness and achieved utopian pleasure. The American as a dream American.

For intellectuals, the espousal of Pop represented a direct affront to those who governed the boundaries of official taste. Roy Lichtenstein, for example, expressly chose to use commercial art as subject matter in his painting because "the one thing everyone hated was commercial art."[28] The slick, surface "newness" of the subject matter of Pop Art was in contrast to the tactile "junkiness" of the work of Jasper Johns and Robert Rauschenberg, who had made the first important break with the high modernist aesthetic of Abstract Expressionism. Pop's commitment was to the new and the everyday, to throwaway disposability, to images with an immediate impact but no transcendent sustaining power. It is important, then, to consider that Pop, in its various cultural forms, did not emerge out of "problematics" in each of the fields of painting, literature, music, theater, or design; in other words, as a new "movement" in each of these fields. Pop arose out of problematizing the question of *taste* itself, and, in its more purist forms, was addressed directly to the media processes through which cultural taste is defined and communicated. Not only did it deny the imposition, from above, of seemingly arbitrary boundaries of taste, but it also questioned the distanced contemplation, interpretive expertise, and categories of aesthetic judgment which accompanied that imposition. Nothing could be more execrable to a tradition of taste that was founded on the precepts of "universality," "timelessness," and "uniqueness" than a culture of obsolescence: i.e. specifically designed not to endure.

So too, nothing could be more provocative to an ideology of authorship that celebrated angst-ridden, heroic subjectivism than the impassive demeanor of Pop "cool"—as immune to the existentialist cult of alienation as it was to the ethos of communitarian togetherness which was to govern

the style of the counterculture. In principle, Pop "cool" was neither exactly complicit or dissenting, since it was based on an outright refusal of the act of judgment. If it was a stance that seemed to be little different from the spirit of entrepreneurial laissez-faire, it also ought to be seen in its fine art context, where the refusal of judgmental sincerity coupled with the studied acceptance of a vernacular language could only be seen as a heresy. In fact, Pop's doctrinal rejection of the elitist past was best played out, not with dadaist zeal, but with an attitude of pure *indifference*. This, of course, was an added insult to the consensus of responsible intellectual opinion which avowed that a truly democratic, classless culture could only be brought about by way of struggle, and through the hard school of educating mass consciousness. To that consensus of opinion, a truly democratic culture was unrecognizable in any other form, least of all in Pop's easygoing attitudes towards an already existing, non-utopian environment.

Camp, however, offered a negotiated way by which this Pop ethos could be recognized by more sceptical intellectuals. In fact, Pop camp, as Melly argues, is a contradiction in terms, because camp is the "in" taste of a minority elite, while Pop, on the other hand, was supposed to declare that everyday cultural currency had value, and that this value could be communicated in a simple language.[29] Pop's materials were already there, to be enjoyed or to be read as a stylish commentary on everyday life, not prescribed like a dose of medicine for some better, or utopian future by those with the cultural capital to do so ("we know what's good for you").

How then did this egalitarian spirit come to be redefined in an elitist way? The first reason is that everyday life had to be "discovered." Just as "folk America" had to be discovered by intellectuals who went on the road in the depression years, so "Pop America" came as an ethnographic revelation, for those like Wolfe, ever in search of new Easter Islanders, or Warhol, here on his way to California for the first time:

> The farther west we drove, the more Pop everything looked on the highways. Suddenly we all felt like insiders because even though Pop was everywhere—that was the thing about it, most people still took it for granted, whereas we were dazzled by it—to us, it was the new Art. Once you "got" Pop, you could never see a sign the same way again. And once you thought Pop, you could never see America the same way again. . . . I didn't ever want to live anyplace where you couldn't drive down the road and see drive-ins and giant ice-cream cones and walk-in hot dogs and motel signs flashing.[30]

"Thinking Pop" was supposed to be devoid of the nostalgia that usually absorbed intellectuals faced with the task of re-educating themselves in

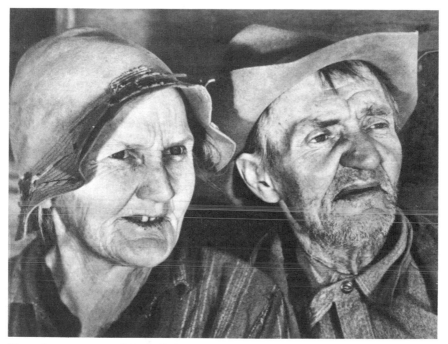

Photo-documentary and the built-in response. From *You Have Seen Their Faces* by Erskine Caldwell and Margaret Bourke-White (Modern Age Books, 1940).

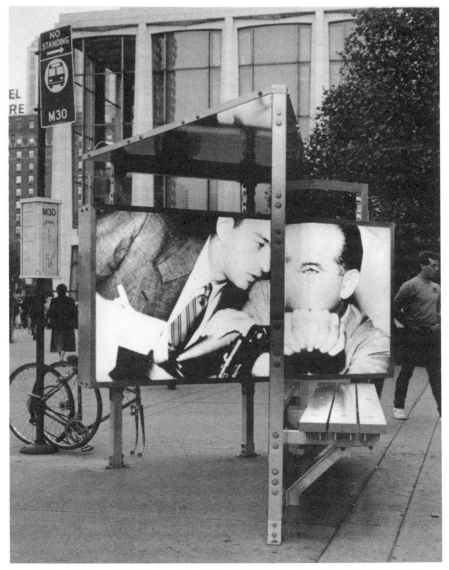

Roy Cohn and Joseph McCarthy. *Bus Shelter 1*, 1983, New York City, by Dennis Adams. Courtesy of Dennis Adams.

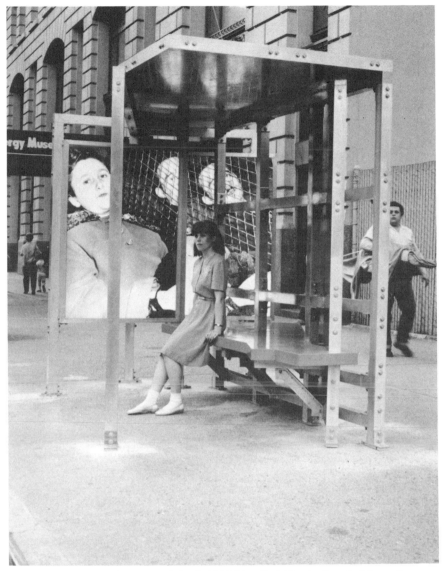

Ethel and Julius Rosenberg. *Bus Shelter 2*, 1986, New York City, by Dennis Adams. Courtesy of Dennis Adams.

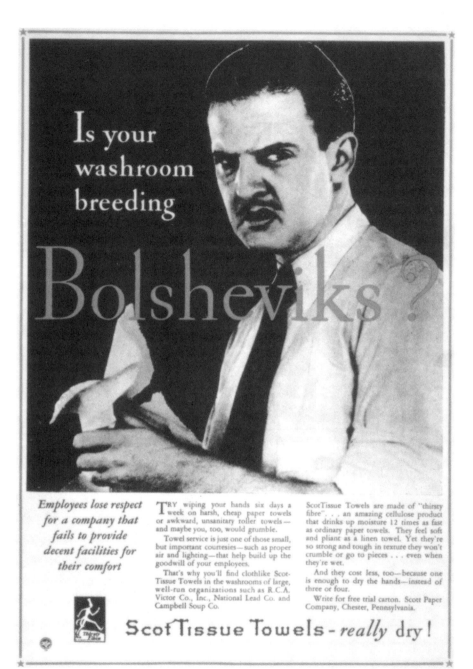

Germophobia and the domestic red scare.

The new electronic interdependence
recreates the world
in the image of a global village.

McLuhan's global villagers. From *The Medium is the Message* by Marshall McLuhan and Quentin Fiore (Bantam, 1967).

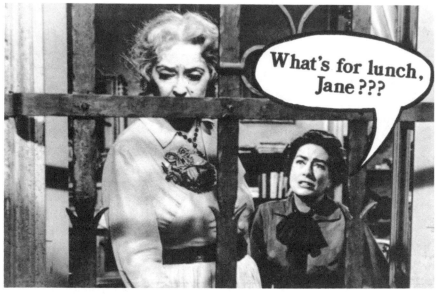

Above: The marketing of camp. A postcard of a still from *Whatever Happened to Baby Jane?*

Annie Lennox as Elvis. Courtesy of RCA Records.

Candida Royalle, director (on the right), on the set of *Three Daughters* (1986). Courtesy of Femme Distribution, Inc.

Cathecting the condom. Alexis Firestone in "The Pick-Up" (from *Taste of Ambrosia*). Courtesy of Femme Distribution, Inc.

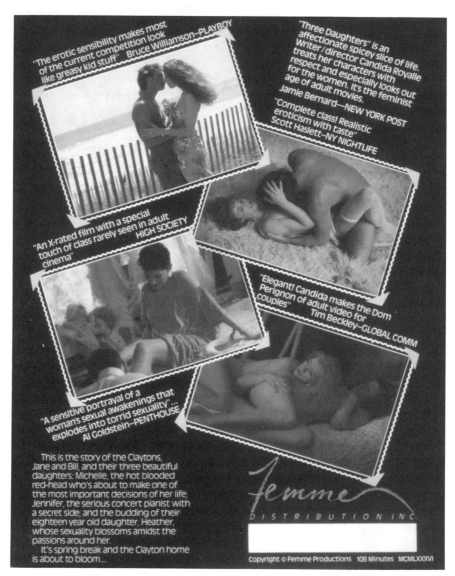

Pornography with class. Courtesy of Femme Distribution, Inc.

the everyday life of ordinary people. But the ethos of *discovery* inevitably brought with it the tropes of appropriation, one-upmanship, and collector chic which had little to do with the immediate, hedonistic use of a reliable, processed environment that Pop had initially sought to valorize.

Second, Pop could no more shut out history than the sublime Coke bottle could escape its future as an empty but *returnable* commodity item. Consumption of the immediate, self-sufficient Pop experience already contains the knowledge that it will soon be outdated, spent, obsolescent, or out of fashion. A throwaway culture, moreover, is not one which simply disappears once its most popular contents have been consumed. Whether its discontents figure as waste to be recycled, as non-biodegradable plastic, or as the detritus of fashion, to lie in wait until they are tastefully redeemed twenty years hence, it contains messages about the *historical* production of the material conditions of taste. This knowledge about history is the precise moment when camp takes over, because camp involves a rediscovery of history's waste. Camp, in its collector mode, retrieves not only that which had been initially excluded from the serious high cultural tradition, but also the more unsalvageable material that had been picked over and left wanting by purveyors of the "antique." For the camp liberator, as with the high modernist, history's waste matter becomes all too available as a "ragbag," not drenched with tawdriness by the mock-heroism of Waste Land irony, but irradiated, this time around, with the glamor of resurrection. In liberating the objects and discourses of the past from disdain and neglect, camp generates its own kind of economy. Camp, in this respect, is the *re-creation of surplus value from forgotten forms of labor*.

By the late sixties, when the crossover appeal of camp was well established, this parasitical practice had become a survivalist way of life for the counterculture, whose patronage of flea markets was a parody, made possible by post-scarcity consciousness, of the hand-me-down working-class culture of the rummage sale. The flea market ethos, like many countercultural values, paid its respects to a modernist notion of prelapsarian authenticity. In an age of plastic, authentic material value could only be located in the "real" textures of the preindustrial past, along with traces of the "real" labor that once went into fashioning clothes and objects. By sporting a whole range of peasant-identified, romantic-proletarian, and exotic non-Western styles, students and other initiates of the counterculture were confronting the guardians (and the workaday prisoners) of commodity culture with the symbols of a spent historical mode of production, or else one that was "Asiatic" and thus "underdeveloped." By doing so, they signaled their complete disaffiliation from the semiotic codes of contemporary cultural power. In donning gypsy and denim, however, they were also taunting the current aspirations of those

social groups for whom such clothes called up a long history of poverty, oppression, and social exclusion. And in their maverick Orientalism, they romanticized other cultures by plundering their stereotypes.

The earlier phase of Pop camp arose directly out of the theatrical encounter of a culture of *immediacy* with the experience of history's amnesia. In reviving a period style, or elements of a period style that were hopelessly, and thus safely, dated, camp acted as a kind of *memento mori*, a reminder of Pop's own future oblivion which, as I have argued, Pop contains within itself. But camp was also a defense against the decease of the traditional panoply of tastemaking powers which Pop's egalitarian mandate had threatened. Camp was an antidote to Pop's promised contagion of obsolescence. It is no surprise, then, to find that Sontag had been researching an essay on death and morbidity before she decided to write "Notes on Camp."[31] The switch, in her mind from thinking about "mortuary sculpture, architecture, inscriptions and other such wistful lore" to the sociability of camp wit was perhaps triggered by a quite understandable flight from the realms of chilled seriousness to the warmer climate of theatrical humor and gaiety. But it is also symptomatic, I think, of the necrophilic economy which underpins the camp sensibility, not only in its amorous resurrection of deceased cultural forms, but also in its capacity to promise immortality to the tastemaking intellect.

When Sontag associates the camp sensibility with the principle of "the equivalence of all objects" (note no. 47), she is making claims for its "democratic esprit." What Sontag means, however, is that camp declares that anything, given the right circumstances, could, in principle, be redeemed by a camp sensibility. Everything thereby becomes fair game for the camp cognoscenti to pursue and celebrate at will. This is a different thing from the democratic, "no-brow" proposition of Pop philosophy, which simply accepts or complies with, rather than exploits, the principle of general equivalence. Sontag no doubt acknowledges this difference when she characterizes Pop as "more flat and more dry" ("ultimately nihilistic") than Camp, and when she describes Camp, by contrast, as "tender," "passionate," and nurtured "on the love that has gone into certain objects and personal styles" (notes 55–56).

There was a darker, and more gruesome side to this economy of passion, however, and it can be seen best embodied in the category of *bad taste*—Sontag's formulation of "the ultimate Camp statement; it's good because it's awful"—which, in the course of two decades, has come much closer to being recognized as a semi-legitimate cultural expression, if only because it has become a thriving market in its own right. There is no question that Camp's initial patronage of bad taste was as much an assault on the official canons of taste as Pop's eroticization of the everyday had been. But bad taste was by no means a clean break with the logic of

cultural capital, for it must also be seen from the point of view of those whom it indirectly patronized, especially those lower middle-class groups whom, historically, have had to bear the stigma of "failed" taste. The *objet retrouvé* of camp's bad taste could hardly shake off its barbaric associations with the social victimization of its original taste-audience. Today, this process of camp rehabilitation is the basis of a vast and lucrative sector of the culture industry devoted to the production of "exploitation" fare. If the pleasure generated by bad taste presents a challenge to the mechanisms of control and containment that operate in the name of good taste, it is often to be enjoyed *only* at the expense of others, and this is largely because camp's excess of pleasure has very little, finally, to do with the (un)controlled hedonism of a consumer; it is the result of the (hard) *work* of a producer of taste, and "taste" is only possible through exclusion *and* depreciation.

The commercialization of camp/bad taste has run its course from the novels of Ronald Firbank to the nostalgia cable TV reruns of *The Donna Reed Show*; from the Beardsley period of the Yellow Book to exploitation publications like the *Weekly World News* and the *National Enquirer*. One important turning point was the television remake of *Batman* in the mid-sixties. Everyone "knew" about Batman and Robin, a fact that spoilt the jokes for the few. Pop camp reached its apotheosis in Roger Vadim's luxurious 1968 comic strip-based film *Barbarella* (with its gorgeous fur-lined spaceship, and the kinky naivete of its occupant, played by Jane Fonda), while the various parodies of James Bond movies exploited the hi-tech improbabilities of popular British spy culture.

1970 was the year that Hollywood fully caught up, with a trilogy of movies that featured what many cognoscenti came to see as the decadent, and not the vibrant, spirit of camp. Michael Sarne's much hyped *Myra Breckinridge*, based on Gore Vidal's entertaining novel, was a tired, laconic treatment of the gay camp fascination with Hollywoodiana, and it evoked a wave of scorn among critics for Rex Reed/Raquel Welch's dual portrayal of transsexualism. *Beyond the Valley of the Dolls* overexposed the keen gluttony of Russ Meyer's earlier exploitation skin flicks like *The Immoral Mr. Teas, Faster Pussycat, Kill! Kill!*, and *Vixen*, while Roger Ebert's gilded-trash script for this most synthetic of movies demonstrated how camp deliberately aspires, as Mel Brooks put it, to "rise below vulgarity."[32] Countercultural camp finally got a run for its money in Nicholas Roeg's *Performance* which brought together the working-class criminal subculture and the experimental rock avant-garde within the hallucinogenic milieu of an extended bad trip. In the artificial paradise of his house of pleasure and pretension, Mick Jagger's retired polysexual star, Turner (rock culture's Norma Desmond) acts out his liberated middle-class role— "Personally, I just perform"—to James Fox's confused Chas, his class

opposite in masculinity, for whom "performance" is a category of work and not a way of life.

Each of these films was also a self-conscious attempt to produce a film with "cult movie" status, and thus to cash in on a ritual taste for the offbeat which had grown to considerable commercial dimensions by the end of the sixties. More successful was Jim Sharman's 1974 *The Rocky Horror Picture Show*, based on Richard O'Brien's play, an outrageous tongue-in-cheek tribute to the cult spectrum of late night picture shows— a trashy brew of B movie, schlock sci-fi, and junky horror productions. *Rocky Horror* became the queen of the midnight movie circuit, with its own ritualized audience subculture. Other cult favorites on the circuit include dozens culled from the gore factory of Roger Corman's New World Pictures, the full complement of George Romero horror films, from *Night of the Living Dead* (1968) onwards, and the low-budget charms of the rediscovered Ed D. Wood, Jr., whose prolific fifties output of films like the pro-transvestite *Glen or Glenda?* (1952) and the anti-militarist *Plan 9 from Outer Space* (1956) (featuring the all-time star camp cast of Tor Johnson, a 400 pound Swedish ex-wrestler; Criswell, the famous TV psychic; Vampira, as the mute, wasp-waisted ghoul woman; and a fading, stumbling Bela Lugosi in his last screen appearance) continues to posthumously earn him the top awards on the Golden Turkey circuit of best "bad films."[33]

The most devoted interpreter of bad taste, however, has been the Baltimore film director John Waters, whose celebration of glamorized sleaze and trashola in films like *Mondo Trasho* (1969), *Multiple Maniacs* (1970), *Pink Flamingos* (1973), *Female Trouble* (1974), and *Polyester* (1981) is so tied to regional and "white trash" class specificity that its interest, if not its ever-ambiguous appeal, transcends the rote reshuffling of genre and stereotype that characterizes the more standard exploitation products. Only Waters would be capable of brilliantly confessing, in the most complete inversion of taste possible, to the guilty pleasure he experiences in watching art films:

> Being a Catholic, guilt comes naturally. Except mine is reversed. I blab on *ad nauseam* about how much I love films like *Dr. Butcher, M.D.* or *My Friends Need Killing*, but what really shames me is that I'm also secretly a fan of what is unfortunately known as the "art film." Before writing this sentence, I've tried to never utter the word "art" unless referring to Mr. Linkletter. But underneath all my posing as a trash film enthusiast, a little known fact is that I actually sneak off in disguise (and hope to God I'm not recognized) to arty films in the same way business men rush in to see *Pussy Talk* on their lunch hour. I'm really embarrassed.[34]

In films like *Eraserhead* (1978) and *Blue Velvet* (1986), David Lynch has refurbished the more respectable side of the avant-garde cultivation of camp for crossover Hollywood consumption. On the other side of the taste divide, the popular market in hard-core porn, horror, gore, and splatter movies has entered a boom period in the last fifteen years as censorship laws have eased off. Today, the most advanced forms of bad taste vanguardism are located in a loosely defined nexus of cultish interests that have grafted the most anti-social features of "sick" humor on to an attenuated paranoia about the normality of the straight world. It covers particular obsessions with conspiracy theories (especially around the Kennedy assassination), bodily disorders and etiologies, religious cult tracts, mass murderer folklore, the psychopathology of atrocities, and exotic rituals, tribal practices, and bizarre customs as described in bogus ethnographic literature or in *Mondo Cane* (1963), the original Mondo film. There is a thin line between the sophisticated irony of this taste for the bizarre and the deeper, popular currents of involvement in the "cults" that have flourished within, alongside, and and in the wake of the New Age movements—pseudo science (the paranormal, spontaneous human combustion, geocentrism, flying saucer contacteeism), pseudo religion (channeling, Space Jesii, breatharians, sub-Mormonism), weird politics (Is Hitler Alive? Is He Hiding the UFO Secret?), and other crankish excursions onto unorthodox cultural terrain.[35]

From an institutional point of view, camp has become the resident con- science of a "bad film" subculture which has its own alternative circuit of festivals, promoters, heroes, stars, and prizes. Cognoscenti savor the work of directors like Ed D. Wood, Jr., Herschell Gordon Lewis, and Ray Dennis Steckler, while those with speciality tastes champion genres like biker films, nudist camp films, beach party films, industrial jeopardy films, women in prison films, and the like.[36] Although it is specifically a low budget subcul- ture, with considerable returns at stake nonetheless, it increasingly feeds off Hollywood's own recognition of the cost of its failures in the taste trade, and is thereby tied into the economic rhythms of the industry.

"Bad film" buffs are expected to know, moreover, that their taste is a product of the *labor of leisure*. In their preface to *The Golden Turkey Awards*, a semi-official organ of the bad film circuit, Harry and Michael Medved indirectly pay tribute to this work ethic when they compare their pursuit of bad films to the mystic:

> who climbed the walls of his town, day after day, staring off toward the horizon. He explained to his friends that he had to be there in order to await the arrival of the Messiah.
> "But don't you get tired of it?" they wanted to know.
> "Sure," he answered, "But it's steady work."[37]

The camp value of these films is tied to a productivist ethic of labor, and to those for whom culture, even entertainment, has therefore to be "worked" at to produce meaning. Consequently, bad taste tends to be the preserve of urban intellectuals (professional and pre-professional) for whom the line between work and leisure time is occupationally indistinct, and is less regulated by the strict economic divide between production and consumption which governs the cultural tastes of lower middle-class and working-class groups. But while the taste for schlock has increasingly become a trademark of the postmodernist style of the yuppie class—the original "TV generation"—it has also spread, through the agency of late night television (*The David Letterman Show*), cable (*MTV* especially) and home video, well beyond its metropolitan force field into the heartlands, where young refugees from family morality have fashioned their sense of alienation out of the benign innocence of shopping mall culture (*Chopping Mall!*, 1986) just as their forebears made a cult out of "educational" films like *Reefer Madness* (1936), or the J.D. "problem" films of the fifties, like *Reform School Girls*.

If, however, we want to look at the effect on mainstream popular taste, then it is in the realm of performance rock that camp's penchant for the deviant has crossed over the threshold of restricted consumption into the mass milieux of homes, schools, colleges, clubs, and workplaces all over the country. For its teenage consumers, the outrageousness of performance rock has, among other things, always been something of a family affair—the object of what teenagers (and record company producers) imagine is every good parent's worst fantasy. It is almost impossible, then, to talk about the history of that ever shifting pageant of eroticized spectacle—from Elvis's gyrating hips to Annie Lennox's gender-blurred sangfroid, from the suggestive body language of Little Richard to the outrageous adult presence of Grace Jones, and the almost metaphysical, polysexual identities of Prince and Michael Jackson—without first discussing camp's influence on the changing social definitions of masculinity and femininity from the late fifties onwards.

Prisoners of Sex?

Female and male impersonation, representations of androgyny, and other images of gender-blurring have all played an important historical role in cinema's creation of our stockpile of social memories. For the spectator, whose voyeuristic captivity (as captors *and* prisoners) of the cinema image can be read as an eroticized response to a psychic scenario on the screen, the suggestive incidence of cross-dressing among those memories is a provocative area of study. It has proved

notoriously difficult, however, to provide a systematic account of how "masculine" and "feminine" positions of spectatorship are assumed as part of the process of reading and responding to these ambiguous images.[38]

Molly Haskell has argued that the overwhelming disparity of images of female to male impersonation in films can be explained by the fact that, historically, male impersonation is seen as a source of power and aggrandizement for women, while the theatrical adoption of female characteristics by men is seen as a process of belittlement. Male impersonation is serious and erotic, while female impersonation is simply comical.[39] In her book about cross-dressing in Hollywood cinema, Rebecca Bell-Metereau argues that Haskell's serious/comical distinction no longer applies to the whole range of female impersonations of "women of power" which have appeared over the last two and a half decades. So too, she argues that in the pre-1960 examples, "tragic" or "comic" readings of a film's treatment of cross-dressing are not simply the result of gender alignment. More important is whether or not the male or female imitation is "willingly performed and sympathetically accepted by the social group within the film."[40]

Just as the reading of these images is inflected by the complex interplay between the film's spectacle of transgressive display and its narrative of social judgment, there is no guarantee that what is *encoded* in these film scenarios will be *decoded* in the same way by different social groups with different sexual orientations. This is nowhere more obvious than in the highly developed gay subculture that evolved around a fascination with classical Hollywood film and, in particular, with film stars like Judy Garland, Bette Davis, Mae West, Greta Garbo, Marlene Dietrich, Joan Crawford (and performers like Barbra Streisand, Bette Midler, Diana Ross, Donna Summer, Grace Jones, and many other disco divas). Denied the possibility of "masculine" and "feminine" positions of spectatorship, and excluded by conventional representations of male-as-hero or narrative agent, and female-as-image or object of the spectacle, the lived spectatorship of gay male and lesbian subcultures is expressed largely through imaginary or displaced relations to the straight meanings of these images and discourses of a parent culture.

Unlike the histories of Pop and camp which I have discussed, the gay camp fascination with Hollywood has much less to do with transformations of taste. In its pre-Stonewall heyday (before "gay" was self-affirming), it was part of a survivalist culture which found, in certain fantasmatic elements of film culture, a way of imaginatively communicating its common conquest of everyday oppression. In the gay camp subculture, glamorous images culled from straight Hollywoodiana were appropriated and used to express a different relation to the experience of alienation and

exclusion in a world socially polarized by fixed sexual labels. Here, a tailored fantasy, which never "fits" the real, is worn in order to suggest an imaginary control over circumstances.

While a case for the lesbian relation to camp has been made,[41] it is the gay male "possession" of that culture which has been stressed most often, and it is the history of redefining masculinity in response to feminist initiatives that I shall be considering in the pages that follow. Camp, whether in its humorous everyday form, in its traditionally institutionalized form of female impersonation, or in its most politicized form as radical drag, has played a crucial, if checkered, role in that history.

In *Myron*, his 1974 sequel to *Myra Breckinridge*, Gore Vidal wrings dry the logic of gay camp's fascination with the golden age of Hollywood cinema, especially the years "1935–1945, when no irrelevant film was made in Hollywood, and our boys—properly nurtured on Andy Hardy and the values of Carverville as interpreted by Mickey Rooney, Lewis Stone, Fay Holden and given the world by Dream Merchant Louis B. Mayer—were able to defeat the forces of Hitler, Mussolini and Tojo."[42] Myron, a reconstructed sex-change version of the buccaneering cinephile Myra, whose spirit still schizophrenically returns to reclaim his body and faculties, is transported back in time to the 1949 MGM set of *Sirens of Babylon*, starring Bruce Cabot and Maria Montez, the incomparable "Cobra Queen" turned "Priestess of the Sun." Myron discovers that he is an unwitting vehicle of Myra's desire to change the history of Hollywood by reversing its upcoming fate. By ensuring that *Sirens of Babylon* is a blockbuster hit, MGM and the star system will be saved, Hollywood will stave off the threat of television, and Myra will be able to reaffirm her feminist mission of changing "man's sexual image," of which the most successful achievement in the novel is to perform the first vasectomy on an unsuspecting male extra in the film.

Vidal's mock-heroic account of Myra's mission is a highly stylized reminder that there is much more at stake in camp cinephilia than a merely indulgent expression of nostalgia for glamor and spectacle. Gay male identification with the power and prestige of the female star was, first and foremost, an identification with women as *emotional* subjects in a world in which men "acted" and women "felt."[43] In this respect, camp reasserted, for gay males, the "right to ornamentation and emotion, that Western and particularly Anglo-Saxon society has defined as feminine preoccupations."[44] Since these are qualities rarely emphasized by the legitimate representations of masculine sexuality, there are few male culture heroes in the camp pantheon; gay-identified actors like Montgomery Clift and Tab Hunter are an exception, while the emotional sensitivity of Marlon Brando and James Dean was more of a focus of interest for straight women in a pre- or proto-feminist conjuncture.

Identification with the female film star's "power" is not, of course, without its contradictions, for representations of that power are not unconditionally granted within Hollywood film itself, where the exercise of such power in the service of some transgression of male-defined behavior would generally be met, within the narrative, by punishment and chastisement. As Michael Bronski argues, however, the mere idea that sexuality brings with it a degree of power, "albeit limited and precarious, can be exhilarating" for the gay male who "knows that his sexuality will get him in trouble."[45] But what can the relation of this everyday triumph of the will to the commodified spectacle of a major star's "sexuality" tell us about the awesome power exercised through the institution of sexuality itself, a power that is more usually directed *against* women and sexual minorities? This is the question which gay politics came to ask of the prepolitical culture organized around camp.

In answering that question, it is important always to bear in mind that the traditional gay camp sensibility was an *imaginary* expression of a relation to real conditions, both past and present—an ideology, if you like—while it functions today, in the "liberated" gay and straight world, as a kind of imaginary challenge to the new *symbolic* conditions of gay identity. Whether as a pre-Stonewall, survivalist fantasy, or as a post-Stonewall return of the repressed, camp works to destabilize, reshape, and transform the existing balance of accepted sexual roles and sexual identities. It seldom proposes a *direct* relation between the conditions it speaks to—everyday life in the present—and the discourse it speaks with—usually a bricolage of features pilfered from fantasies of the bygone.

This perception may help to answer, in part, the charge of misogyny that is often brought to bear, quite justifiably, upon camp representations of "feminine" characteristics. It could be argued, for example, that the camp idolization of female film stars contributes to a desexualization of the female body. In the context of classic Hollywood film, a social spectacle where women often have little visible existence outside of their being posed as the embodiment of the sexual, any reading which defetishizes the erotic scenario of woman-as-spectacle is a reading that is worth having. Indeed, in the classic camp pantheon, most film stars are celebrated for reasons other than their successful dramatization of erotic otherness. It is in this respect that gay camp looks forward to later feminist appraisals of the "independent" women of Hollywood, who fought for their own roles, either against the studios themselves, or in the highly mannered ways in which they acted out, acted around, or acted against the grain of the sexually circumscribed stereotypes which they were contracted to dramatize.

Bette Davis, whose looks excluded her from the stock image-repertoire of screen sexiness (one of her earlier directors complained "Who'd want

to go to bed with her?"), was the most enduring example of the star whose screen identity could not be fixed by the studio machine, a woman who openly contested the terms of her contract with Warner Brothers, and whose wide variety of roles ensured that she escaped a life sentence of character typing. Aside from her superb acting skills, it was Davis's willed evasion of this fate that her fans saw reflected in the nervous and impetuous intensity with which she invests the celebrated "bitchiness" of her roles in such films as *Of Human Bondage* (1934), *Jezebel* (1938), *The Little Foxes* (1941), *All About Eve*, and *Whatever Happened to Baby Jane?*[46] While the wide range of her mannered repertoire is often reduced in camp caricature to the famously over-used cigarette, or her wildly rolling eyes, it is clear that the sense of irony she conveyed through such gestures was more of a performance about the performance of her roles, rather than one which comfortably interpreted these roles. In contrast to Joan Crawford's earnest control over her roles, Davis could separate voice and body, image and discourse, and play off one against the other. But Mae West is the star who most professionally exploits the ironies of *artifice* when, like a female drag queen, she represents a woman who parodies a burlesque woman, and then seems to take on the role for real, as a way of successfully fielding every kind of masculine response known to woman. West pioneered a new bold, no-nonsense, no-romance relation with sex, while the sexual ambiguities of Garbo, Dietrich, and Hepburn all produced variations on the theme of androgyny-as-spectacle: prince of passivity, bird of paradise, and the go-getter.

Judy Garland, on the other hand, was a cult figure whose associated star persona had little to do with the ironic artifice of camp, since her roles insisted on her naturalness, innocence, and ordinariness, and, above all else, vulnerability. Richard Dyer has argued that she "is not a star turned into camp, but a star who expresses camp attitudes," as if she had been well versed in gay camp culture from the very beginning, and not just towards the end of her career when she ritually acknowledged the gay constituency of her most loyal audience.[47] Her lack of glamor, and pronounced refusal of "feminine" grace meant that, like Davis, she fell outside of the conventional requirements of the Hollywood starlet, and this enabled her to enter into more unorthodox roles (the tramp-as-androgyne, tragi-comically beyond gender, is one which Dyer emphasizes). It was not until her personal hardships became public, and she embarked on a phase of repeated comebacks, that the conceit of survival in the face of all odds became an intrinsic part of her performing persona. It was in this period, right through the sixties, that her struggle between the role of self-destructive loser and resilient, irrepressible fighter took on a parable-like significance for a gay culture increasingly in search of overt rather than heavily coded forms of identification. The more recent

commercial success of performers like Streisand, and Midler, while it reflects the genuine talents of these gutsy artistes, has been indissociable from the publicly visible support of a gay audience.

In a 1975 interview, Sontag suggested that the diffusion of camp taste in the earlier part of the decade ought to be credited "with a considerable if inadvertent role in the upsurge of feminist consciousness in the late 1960s." In particular, she claims that the fascination with the "corny flamboyance of femaleness" in certain actresses helped to "undermine the credibility of certain stereotyped femininities—by exaggerating them, by putting them between quotation marks."[48] In acknowledging this, Sontag was withdrawing from one of her most controversial arguments in "Notes on Camp"—that camp was essentially "apolitical." While gay intellectuals have long challenged this view, its flaws became increasingly visible as a emergent sexual politics in the late sixties began to openly criticize and explore existing definitions of femininity and masculinity. Many of the ensuing debates about sexual politics focused on questions which camp had, in its own way, already been addressing, in particular, the relation between "artifice" and "nature" in the construction of sexuality and gender identity. In fact, camp could be seen as a much earlier, highly coded way of addressing those questions about sexual difference which have engaged non-essentialist feminists in recent years.

To non-essentialist feminism and to the gay camp tradition alike, the significance of particular film stars lies in their various challenges to the assumed naturalness of gender roles. Each of these stars presents a different way, at different historical times, of living with the "masquerade" of femininity.[49] Each demonstrates how to *perform* a particular representation of womanliness, and the effect of these performances is to demonstrate, in turn, why there is no "authentic" femininity, why there are only representations of femininity, socially redefined from moment to moment. So too, the "masculine" woman, as opposed to the androgyne, represents to men what is unreal about masculinity, in a way similar to the effect of actors whose masculinity is overdone and quickly dated (Victor Mature is the best example, not least, I think, because of the symmetry of his names).

If camp has a politics, then it is one that proposes working with and through existing definitions and representations, and in this respect, it is opposed to the search for alternative, utopian, or essentialist identities which lay behind many of the countercultural and sexual liberation movements. In fact, it was precisely because of this commitment to the mimicry of existing cultural forms, and its refusal to advocate wholesale breaks with these same forms, that camp was seen as pre-political and out of step with the dominant ethos of the liberation movements. Nonetheless, its disreputable survival in gay culture, and its crossover presence in

straight culture, has had a significant effect on the constantly shifting, hegemonic definition of masculinity in the last two decades.

Garland, Davis, and the other queens of Hollywood are one thing, Maria Montez, Tallulah Bankhead, Carmen Miranda, and Eartha Kitt are another. If the latter are also figures celebrated by gay camp, then it is not for their thespian talents or for their stylized parodies of femininity. On the contrary, the widespread cultivation of these exploited actresses (*Myron*'s cult of Montez is representative) is unarguably tinged with ridicule, derision, even misogyny.[50] Their moments in the camp limelight cannot fail to conceal a "failed seriousness" that is more often pathetic and risible than it is witty or parodic. But to see how and where the contradictions of this cult homage are fully played out, we must look at the performance culture of female impersonation, the professional stage version of everyday gay camp.

Drag, in its professional form, is strictly an art of performance for an audience, and must be distinguished from the more private, sexualized practices of transvestism and transsexualism.[51] Drag artists do not want to "pass" as woman, and, consequently, dress over the top in order to foreground their role-playing. Like all solo performances, the drag routine is an highly individualistic interpretation of role-playing within what is often a very restricted repertoire of stock characters. There is little room to maneuver, but the art lies in the virtuoso skill of maneuvering. Beyond the clearly utopian suggestiveness of any individual performance, drag is also a ritual affirmation of the communitarian solidarity of an audience which is familiar with the references, and which will respond to the "in" humor. But if drag is a form of professional clowning, it is also shot through with a maudlin amateurism, balanced by the stoical show business imperative—in spite of everything, the show must go on. In this respect, there is an element of ritual self-deprecation, even fatalism, in the otherwise celebratory drag performance. That the vehicle for this self-denigration happens to be a parodic representation of a woman is neither logical nor circumstantial, but is quite clearly bound up with the complex social expression of the parent culture's misogynistic forms, however much these forms may be intentionally rearticulated by the camp routine as a stylized tribute to the strength of long-suffering women.

Like "Jewish self-hatred," or "Tomming" in black culture, gay camp was arguably a form of defense constructed by an oppressed group out of conditions not of its own making. However, as Esther Newton argues of the camp queen (the offstage wit of gay culture); "The camp says, 'I am not like the oppressors.' But in doing so he agrees with the oppressors' definition of who he is. The new radicals deny the stigma in a different way by saying that the oppressors are illegitimate. This step is only foreshadowed in camp."[52] From the point of view of gay liberation, camp

could only be a survivalist ethic, and never an oppositional critique.[53] And yet Radical Drag, as it was known, came to be an important, if short-lived, strategy of the feminist-inspired GLF critique of traditional male values. Worn by some as a way of directly and publicly experiencing the oppression of women, and by others as a way of ridiculing traditional gay male roles, "hairy" drag tried to transform survivalism into oppositionality, but was itself unable to survive lesbian criticism that it exploited female oppression to make its point. However, just as drag was crossing over into mainstream male dressing, it may have entered offstage gay male culture in the figure of the macho, leather clone. As much a fantasy object as the drag queen, the butch clone has been seen as a new form of drag, a send-up of social expectations of male homosexuality, and a subversive commentary on the encoded, misogynistic power of macho masculinity: "If the man dressed as a woman was, in effect, mocking the assumptions society makes about men and women, then the man dressed as a stereotypical man is also mocking the assumptions that to be gay is to want to be a woman."[54]

As make-up and dressing-up became an everyday part of the flamboyant straight counterculture, "drag" took on the generalized meaning of everyday role-playing. Here, for example, is Myra Breckinridge's analysis of the male swinger:

> It is true that the swingers, as they are called, make up only a small minority of our society; yet they hold a great attraction for the young and bored who are the majority and who keep their sanity (those that do) by having a double sense of themselves. On the one hand, they must appear to accept without question our culture's myth that the male must be dominant, aggressive, woman-oriented. On the other hand, they are perfectly aware that few men are anything but slaves to an economic and social system that does not allow them to knock people down as proof of virility or in any way act out the traditional male role. As a result the young men compensate by *playing* at being men, wearing cowboy clothes, boots, black leather, attempting through clothes (what an age for the fetishist!) to impersonate the kind of man our society *claims* to admire but swiftly puts down should he attempt to be anything more than an illusionist, playing a part.[55]

Myra concludes that it would be a healthy contribution to her mission of destroying "the last vestigial traces of traditional manhood" if this role-playing were to be encouraged. Her sentiments, at least, are defined by a clear political aim, and in this respect were hardly typical of the general tone set by the male swingers of the counterculture who pursued the golden fleece of sexual liberation in the late sixties. Countercultural liberation for straight men was one moment in the two decades of "per-

missiveness" (whose definition?) which began with the swinging *Playboy* ethic of mid-fifties and ended with the stirrings of the neo-conservative backlash in the mid-seventies. Barbara Ehrenreich has argued that the fifties "male revolt" against the suburban bondage of breadwinning, symbolized by the consumerist Playboy lifestyle, also delivered men from suspicions of homosexuality that had hitherto been attached to men who avoided marriage.[56] So too, the "ethnicization" of homosexuality which gay liberation had fostered by advocating the policy of "coming out" meant that straight men could pursue their exploration of androgyny without the fear of their heterosexuality being questioned. The new macho man was gay. The radical "moment" of bisexuality was lost.

The privileges of androgyny, of course, were generally not available for women until well into the seventies, and only *after* male gender-bending had run its spectacular, public course through a succession of musical youth heroes: David Bowie (the first and the best, although Jagger and Lou Reed had been pioneers), Alice Cooper, the New York Dolls, Elton John, Iggy Pop, Marc Bolan, and other dandies of glam rock. It was not until punk ushered in a newer and more offensive kind of oppositional drag that women fully participated within rock culture in the confrontational strategies of posing and transgressing: Poly Styrene, Jordan, Wendy O. Williams, Patti Smith, and, above all, Souxsie Sue. When Annie Lennox appeared at the 1984 Grammy Awards ceremony in full Elvis drag, at least one sexual history of rock 'n' roll had come full circle. And as for Grace Jones, she is "acting the part of a *man*, not a boy," when she drags a male from her audience and simulates anal sex with him.[57]

To look, today, for representations of the anti-social or threatening expressions of camp and drag, we must go to the outrageously spectacular heroes of the youth heavy metal scene. In popular rock culture today, the most "masculine" images are signified by miles of coiffured hair, layers of gaudy make-up, and a complete range of fetishistic body accessories, while it is the clean-cut, close-cropped, fifties-style Europop crooners who are seen as lacking masculine legitimacy.

Rock 'n' roll has long played the game of good boy/bad boy. If Bruce Springsteen embodies the stable, nostalgic image of traditional working-class masculinity, then it is the punks and the B-boys who represent the unruly, marginalized underside. In mainstream rock, however, it is the feminized cock rockers who are supposedly identified with the most retarded—aggressive, disrespectful, and homophobic—characteristics of working-class masculinity. It is ironic, then, to consider that when, in 1984, the affable Boy George received a Grammy Award on network television, he told his audience: "Thank you, America, you've got style and taste, and you know a good drag queen when you see one." Behind this ambiguous compliment, there was a long Wildean history of smug

European attitudes towards American puritanism. But what did Boy George's comment mean in the age of Motley Crue, Twisted Sister, Aerosmith, Kiss, and Rapp, whose shared use of drag is directly tied to a certain construction of American masculinity? There is more than just class at stake here, although it is clear that heavy metal today is as much an assault on middle-class masculinity as it is an affirmation of sexist working-class bravado. What is also at stake, I think, is the international balance of patriarchal power. The brashness associated with heavy metal drag speaks, like Rambo's caricature of the he-man, to the legitimate power of American masculinity in the world today. By contrast, the jolly decorum of Boy George bespeaks the softer European contours of a masculinity in the twilight of its power. One is emboldened and threatening, the other is sentimental and peace loving.

Warhol and the Bottom Line

As a result of the sexual revolution, then, camp has come to bear upon cultural *politics* almost in spite of itself. But to recover its intrinsic significance as a cultural *economy* we need to go back to look at the work of Andy Warhol, the figure who singlehandedly generated so many of the shifts of sixties taste.

Recalling the moment of high camp, Warhol celebrated the drag queen for pseudo-scholarly reasons:

> Among other things, drag queens are living testimony to the way women used to want to be, and the way some people still want them to be, and the way some women still actually want to be. Drags are ambulatory archives of ideal moviestar womanhood. They perform a documentary service, usually consecrating their lives to keeping the glittering alternative alive and available for (not-too-close) inspection. . . . I'm not saying it's the right thing to do, I'm not saying it's a good idea, I'm not saying it's not self-defeating and self-destructive, and I'm not saying it's not possibly the single most absurd thing a man can do with his life. What I'm saying is, it is very hard work. You can't take that away from them. It's hard work to look like the complete opposite of what nature made you and then to be an imitation woman of what was only a fantasy woman in the first place. When they took the movie stars and stuck them in the kitchen, they weren't stars any more—they were just like you and me. Drag queens are reminders that some stars still aren't just like you and me.[58]

Within the counterculture, the street queen had suddenly become an accepted and even fashionable embodiment of the new "problems" faced

by men in the burgeoning sexual revolution ("I may not know exactly what I am, but at least I know I am not a drag queen"),[59] and drags like Holly Woodlawn, Candy Darling, and Jackie Curtis all became minor celebrities through their roles in the later Warhol/Morrisey films, from *Chelsea Girls* (1966) onwards. It is important to note, however, that the work ethic of the drag queens—they work "double time" at playing women—is more intriguing to Warhol than what they symbolize sexually; "after being alive," he once said, "the next hardest work is having sex." For without Warhol's own lifelong homage to the idea of a work ethic, we would not have his exemplary, and often brilliant, commentary on a subcultural world, largely of his own creation, that went out of its way to publicize the seamless links between commerce and art, labor and taste.

Raised in a Pennsylvania factory town, and educated at the Carnegie Institute of Technology (now the Carnegie-Mellon University), Warhol's "industrial" loyalty to the principles of efficiency and productivity were the rationale for the ceaseless output of art, films, and style at his own Factory. For someone who was famous for statements like "Business Art is the step that comes after Art," the exemplary model of commercial art production was the Hollywood studio system (his practice of "signing" all Factory products has been compared profitably to the infamous Disney industry signature). Warhol's early, and most famous artworks were garishly colored, serial, silkscreen images of "dead" Hollywood glamor— Marilyn Monroe (recently deceased) and Liz Taylor (starring in the "death" of the epic film, in *Cleopatra*, 1963), and other sixties icons associated with death, like Jackie Kennedy. They were trashy tributes to the demise of the star system, while the images themselves were created by means of the mass production techniques endemic to the making of that same star system.

In "changing the means of production of painting," by employing these mass-production techniques, Emile De Antonio, the documentary filmmaker, claims that Warhol was demonstrating "what was unique in mass production, which Ford and General Motors can't do."[60] What De Antonio means is that what Warhol did can never be copied—and still be art. And yet, these images also speak to what Ford and General Motors actually do when they discontinue production of a model, which is to create the conditions for the commodity glamor and cult appeal of the nostalgia market for the "uniqueness" of old cars. If, *for the moment*, quantity is always better than quality—"Thirty is Better than One" said Warhol—the planned obsolescence of the mass product ensures that thirty will very soon be one, and that history, even the most recent past, will always involve no less of an antique pursuit of forms and objects in "mint condition." It is only in theory that mass-produced culture is infinitely reproducible.

But Warhol was always more interested, I think, in the production and consumption of *individualism*—the ideological commodity of personalities, stars, celebrities, and fans—than he was in the "problem" that has so engaged art criticism in the last two decades: the tarnished, auratic "uniqueness" of the work of art in the age of mechanical reproduction. That is why film and not art is his most important medium.

From the moment that a "crowd" began to gather around him at the Factory, Warhol was committed to setting up an *alternative* studio system geared to regular and rapid production, with its own stable of home-grown Superstars (with their own seedy stage names), its own casting system, screen tests, and publicity stunts to stimulate media attention. Warhol copied all of the institutions of the legitimate studio system in a way which traded directly on the camp appeal of faded star quality but which also made no attempt to conceal the celebrity-making processes which manufactured "star quality." In re-producing, on the cheap, this instant celebrity-value, which at the height of Hollywood production was the stylized product of immense capital investment—the ultimate commodity fetish of mass-produced culture—Warhol was interpreting the democratic principle of Pop in the undemocratic, entrepreneurial spirit of the culture industry; anyone can be a star/president/celebrity, but also, anyone can make a star out of others.[61] This was a critique of the elitist tastemaker, but only by being a paean to the entrepreneur.

Some of the Superstars were quite simply "found" personalities, like the eponymous Ingrid Superstar, the refrigerator saleswoman from New Jersey. However, the most famous were deliberately cultivated by Warhol, and, in fact, carefully defined the changing ideological moments of the sixties: first, Baby Jane Holzer, the socialite, whose involvement in the underground culture was designed to be a temporary, if very public flirtation; her successor, Edie Sedgwick, whose frenzied immersal, by contrast, was all-consuming and given over, finally, to the death drives which it courted; then Nico, whose alienated foreign chic was a forerunner of the de-Americanized flavor of the counterculture; and finally Viva, whose upfront feminism looked forward to a new kind of woman altogether. Real stars and Superstars would often be juxtaposed, either by design, when Edie and Judy (Garland) would be at the same party, with Edie claiming all the attention, or by accident, when Gloria Swanson passed by in a limousine at Candy Darling's funeral. Even more skewed was the story that, during the time when Hollywood was courting Warhol at the end of the sixties, Rita Hayworth insisted to him, over the phone, that he could make her "the most super star of all."[62]

If Warhol's scene was governed, in its own way, by the logic of the entrepreneur, then it was a ghoulish culture that he produced, because it fed off the living's fatal attraction to older, and thus more valuable,

forms of glamor. The victims of that logic litter the pages of the history
of Warholism just as in "Hollywood Babylon," and its critics recount the
same narrative of loveless exploitation. Arguably, the most fascinating
story of the period is *Edie: An American Biography*, a book about the ill-
starred scion of an old Social Register family, which documents the
contradictions involved in being the biggest Superstar of all.[63] Critics of
Warhol who view with suspicion and disgust the absolute dependency of
his stable of stars, and the various ways in which they were discarded or
displaced from the centers of attention, argue that his position as master
of passivity gave him the power to activate an authentic desire in his
Superstars which could only be acted out with acute frustration in a
theater of inauthenticity. Warhol himself, as Stephen Koch argues, was
thereby declared immune to any responsibility for the often tragic conse-
quences of this frustrated desire.[64] Others, more sympathetic, claim that
Warhol's strategy was to therapeutically *empty out* the meaning of the cult
of individualism that lay behind the "imposture" of stardom's "creation
of "plastic idols.""[65]Ron Tavel, Warhol's early scriptwriter, offered the
perfectly Warholian interpretation: "It's *so* American. What will be more
American than that phenomenon: dehumanization."[66]

On the other hand, there was nothing particularly ethical (or unethical)
about the way in which Warhol worked. In fact, the tragedy of Edie and
others arose out of the contradictions of being *a celebrity but not a star* in
an avant-garde and not a popular cultural milieu. If there was a Warhol
revolution in "arts and entertainment" in the sixties, then it was because
his definition of the conditions of *celebrityhood* was aimed at showing that
nothing intervened between the realms of arts and entertainment. What
lay behind the famous proclamation "Everybody will be famous for fif-
teen minutes" was not so much a democratic invitation to fame and
fortune as the re-invention of "ordinariness" for people to whom the
popular media had long been remote or paternalizing as a source of
ethics and information, and more intimate and relevant as a source of
fantasy and inspiration. In this respect, Warhol rose below the tabloid
sensitivity to trivia, "re-exposing" the everyday, to use Peter Gidal's term,
until it only made sense as the stuff of the fantasies to which everyone
was entitled.

Besides, Warhol himself was the bane of the intentionalist critic's exis-
tence. Everything he said to the media was supposed to mean exactly
what he said, and nothing more: there's nothing behind it/me. And
everything in his work that spoke to the exploitative conditions of capital-
ist production was simply part of the show he was "promoting." Of
course, this did not prevent his "victims" hitting back. But when Valerie
Solanis, a leader of SCUM (The Society For Cutting Up Men) almost
fatally injured him in a 1968 shooting as a response to his control over

her, it was like an earlier Factory shootout, when an unknown fired bullets through some Marilyn paintings, later sold, of course. Rather than properly analyze his own involvement in this traumatic incident, Warhol simply acknowledged that he had been one of the first "feminist casualties"—in other words, a victim of the times, of which he was a passive, or, in this case, quite literally a receptive recorder.

Upwardly mobile as always, Warhol moved, after the shooting, from the Factory milieu of his "kids"—hustlers, junkies, drag queens—to the world of Andy Warhol Enterprises, where, in the seventies, he unrelentingly cultivated the already famous and the moneyed Reaganites. In this latter phase, he played at being a hired flunky in the same way as he had earlier played at being a tastemaker for the East Coast trash aesthetic. His diabolical reputation, in the media, for making money out of everything he did, no matter what role he was playing, was the punishment for the way in which he called attention to the contradictory logic of publicity culture, provoking not only the envious magnates of the mass media, but also the anti-commercial conscience of the counterculture. But whether or not Warhol acted out his role in order to expose the process of exploitation, was finally irrelevant. He was no more an opponent of the process than he was a traditional legitimist for the power and prestige of the glitterati. The point was always to ask: What's art got to do with it?

Warhol's sayings like "Buying is much more American than thinking" mortified those who would rather not see the comparison being made at all, and ridiculed those, to whom I am sympathetic, who were willing to think seriously about the original Pop promise of an active and informed audience for popular culture. But we must always be wary of reading such Pop truisms out of their camp context. I have suggested that there was an *economy* of camp at work in the sixties which "employed" or contracted the Pop intellectual in a number of ways. If camp can be seen as a *cultural economy* which challenged, and, in some cases, helped to overturn legitimate definitions of taste and sexuality, it must also be remembered to what extent this cultural economy was tied to the capitalist logic of development which governed the culture industries. Nowhere is this more faithfully demonstrated than in the following remarks of Warhol, tongue-in-cheek certainly, but religiously devoted nonetheless to the "idea" of his philosophy of work:

> I always like to work on leftovers, doing the leftover things. Things that were discarded and that everybody knew were no good, I always thought had a great potential to be funny. It was like recycling work. I always thought there was a lot of humor in leftovers. . . . I'm not saying that popular taste is bad so that what's left over is probably bad, but if you

can take it and make it good or at least interesting, then you're not wasting as much as you would otherwise. You're recycling work and you're recycling people, and you're running your business as a byproduct of other businesses. Of other *directly competitive* businesses, as a matter of fact. So that's a very economical operating procedure. It's also the funniest operating procedure because, as I said, leftovers are inherently funny.[67]

Warhol here reveals what he knows about camp's re-creation of surplus value from leftovers; the low risks involved, the overheads accounted for, and the profit margins expected. The suggestion that Art is constructed out of the leftovers from popular taste was one way of describing the reorganization of the economy of cultural taste that took place in the course of the sixties. As I have pointed out, it was a way of talking about art that offended some intellectuals because it suggested, even if Warhol never seemed to mean what he said, that its attention to *economy* was more than just a metaphor for the critique of capitalism that all art must surely deliver straight from its autonomous heart. It suggested that art had something more directly to do with products, consumers, and markets than it had to do with fighting the "good fight" or with the aesthete's windless realm of great art.

As for what Warhol refers to as the inherent "funniness" of leftovers, that is the other side of camp—the creamy wit, the wicked fantasies, and the *gaieté de coeur*. All that was, and still is, priceless.

6

The Popularity of Pornography

> But why porno? Simple—I'm an exhibitionist with a
> cause: to make sexually explicit (hard core) erotica,
> and today's porno is the only game in town. But it's a
> game where there is a possibility of the players, over
> time, getting some of the rules changed. (Nina Hart-
> ley, porn film star, 1987)

> The First Amendment . . . belongs to those who can
> buy it. (Andrea Dworkin, 1978)

Pornography from a woman's point of view? Yes, said the owner of
my local video store, of course he could recommend some, and rattled
off the titles of a few of the more popular "couples" films currently
being rented. Could he describe them? Longer, romantic sequences, with
appropriate mood music, and lots of emphasis on feelings. Does this
mean that there's no hard core? No, not at all, he said, and this time, his
business instincts aroused, he leaned toward me, after a ritual glance
over his shoulder, and proceeded to assure me, man to man, that the
actors eventually did get down to the real stuff; it just took a little longer,
and it was, sort of, different.

This "sort of" difference has been exerting its pressure on the porn
industry for over ten years now, ever since female consumers were ac-
knowledged as the largest potential growth market for pornographic
entertainment and sex accessories. While recent video titles like *Every
Woman Has A Fantasy* and *In All the Right Places* reflect this shift in the
heterosexual market, women themselves are beginning to stake out posi-
tions of power within the industry, not just as stars, commanding larger
fees and various kinds of "artistic control" over their work, but also as
producers and directors.

Christine's Secret (directed by Candida Royalle and R. Lauren Neimi,
1984), made and distributed by Candida Royalle's Femme Productions,
is one of the first and best examples of the new kind of porn film, made
by women, that is organized in a non-phallocentric way. Shot on an idyllic
country farm, and set to New Age music, the film's unswerving loyalty to
a code of "natural," mutual, and wholesome pleasures seems like a com-
plete inversion of the dark regime of confinement and mutilation that is
to be found in the Sadeian chateau. The editing is skillful and inventive:

sunlit interiors are the preferred form of lighting; the camera sugges-
tively plays upon and across bodily surfaces; there is no overriding focus
on genital detail—there are no cum (or "money") shots; the acting is
good-humored; and the narrative emphasis is on mutual pleasure in
each of the kinds of sexual encounter depicted—marital-monogamous,
honeymoon, courting, and casual sex. As a result of their adventurously
good taste, the films made by Femme Productions (*Femme* [1983], *Urban
Heat* [1984], *Three Daughters* [1986], and the ongoing Star Directors Series,
all directed by famous women porn stars) regularly win a handful of
annual awards from the Critics Adult Film Association for, among other
things, direction, editing, and best erotic scene from a woman's point of
view. Socially presentable, in style and content, as erotic and tasteful, not
lustful and vulgar, Femme films demonstrate the continuing association
of the ideology of the "feminine" with the ideology of good taste, if not
with "fine art" itself.

Christine's Secret and other Femme productions have led the way in
legitimizing a new phase of porn production aimed at consumption by
women and by couples in the home. They also mark the latest phase in
the history of pornography's bid for respectability. Back in the mid-
fifties, the upmarket *Playboy* had attracted an audience of aspiring pre-
executive men, for whom its philosophy of "fun" and "swinging" pro-
moted and celebrated the good life, ushering in a culture of consumption
that represented a revolt against the stability of suburban breadwinning
life.[1] Increasingly, *Playboy's* patronage by intellectuals and glitterati
brought to its readers the kudos of cultural authority; in the mid-sixties,
for example, a single issue included new work by the following writers:
Vladimir Nabokov, P.G. Wodehouse, Harold Pinter, Jack Kerouac,
Woody Allen, Terry Southern, Ray Bradbury, Budd Shulberg, Julian
Huxley, William Saroyan, Arthur C. Clarke, Kenneth Tynan, and Jules
Feiffer.[2] In fact, the success of *Playboy's* commercial empire was founded
upon a libertarian idea of "art," and "free expression," primarily literary,
which could contain and be sustained by the philosophy of recreational
sex for men of means. By 1980, over 200 hard-core and 165 soft-core
straight male magazines (50 hard-core and a dozen soft-core gay) were
established in more or less legitimate markets and submarkets that had
surfaced and flourished by democratizing elements of the *Playboy* dis-
course for more popular or speciality audiences.[3]

So too, the U.S. porn film industry was galvanized by the crossover
success, in 1972, of *Deep Throat*, largely because of the stir it created
among intellectuals—"Not to have seen it," Nora Ephron wrote in *Esquire*,
"seemed somehow . . . derelict."[4] Its pseudo-Freudian subtext and its
narrative focus on the *educational* and psychotherapeutic benefits of sex-
ual liberation was addressed, nominally, at least, to an audience with

higher interests than the simple pleasures of arousal. Made for $25,000, its large box-office return (it made over $50 million, through mob distribution, for the Colombo-Gambino family) heralded a Golden Age of large budget, and sometimes epic, filmmaking in the porn industry. With the advent of the home video boom at the beginning of the eighties, film production fell off precipitously, and capital is now concentrated in adult video for a home rental market which could not sustain its high profit margins without pornography. Increasingly, the porn magazines have been tailored to function as trailers, previews, fanzines and supporting literature for the main attraction of the videos and their stars. Surveys claim that 40% of the adult videos in the U.S. are rented by women. Over 580 cable TV systems across the country now carry adult entertainment programming.[5] Cable programmers, moreover, report that most single women choose to pay extra for the adult entertainment option in a cable package. [6]

Playboy, a suburban men's magazine, *Deep Throat*, a psychobabble film for swingers, and *Christine's Dream*, a yuppie couples' video, may not be wholly representative of the pornography made for popular consumption; they each contain an appeal to what we could call the educated body. The cultural history spanned by these three products reflects large changes in the patterns of popular consumption, in the development of visual technology, and in investment trends in an industry which in 1984 was estimated to be worth as much as $7 billion, larger than the film and the record industries put together.[7] But their respective cultural forms are much more than just reflections of changes in the economic organization of an American mass cultural industry. They also speak and respond to a continuing debate among intellectuals and legislators about the political nature of the *popularity of sexually explicit representations*, a debate whose twists and turns have been constitutive of the ideological fabric of our recent cultural history.

In replacing the standard use of professional models from the sex industry for its pinups with images recruited from the suburban "girl next door," *Playboy* ensured that its appeal would not be downmarket. on the contrary, it was marked, at all levels, from the celebrity *Playboy* interview to the luxury milieu of its nightclubs, by quality consumption as defined by the gentlemanly realm of acceptable sexual conduct. In this respect, *Playboy*, and, to a certain extent, *Cosmopolitan* (founded in 1965), its female challenger in the lists of consumer capitalism, predate the more radical, democratizing claims promoted by the so-called sexual revolution of the decade from the late sixties to the late seventies. For Al Goldstein, the ebullient publisher of *Screw*, who, along with Bob Guccione of *Penthouse*, Larry Flynt of *Hustler*, Hugh Hefner of *Playboy*, and Gloria Leonard of *High Society*, functions as one of the industry's pornographer-intellectu-

als, pornography's newfound political significance in the late sixties was
seen as part of a zealous crusade on behalf of the popular (*Screw*, "the
world's greatest, filthiest newspaper," was actually conceived in 1968 in
the offices of the *New York Free Press* as a "sexpol" moneymaker for radical
political causes):

> Not only does today's pornography serve to liberate us in our attitudes
> toward sex; it is also shattering the elitism that has traditionally sur-
> rounded pornography itself. Once pornography was acceptable only if
> it was sold in fancy, expensive editions that claimed to be "erotic art"
> from India or Japan. To me pornography is what the truck driver wants,
> what the sanitation worker reads, what the bus driver buys.[8]

As always, Goldstein's comments are unapologetically populist, and di-
rected against the double standards of those who enter the debate about
pornography from the perspective of the higher aesthetic realm of "erot-
ica," and who have had little or no contact with more popular porno-
graphic forms which they consider to be both aesthetically and politically
degrading.

But Goldstein is also the man who boasted, in 1973, that if he caught
his wife cheating on him, he would "probably break her legs and pull her
clit off and shove it in her left ear."[9] This second comment of Goldstein's,
while obviously horrific, can be read as a contextual reference, uncon-
scious or otherwise, to the displacement of the clitoris into the throat of
the heroine of *Deep Throat*, the film which had recently sought to repre-
sent the sexual revolution's two newly "discovered" adventure zones as
if they were one and the same—the centrality of the clitoris for women,
and the action of fellatio for men. If this film offered the spectacle of a
woman actively seeking sexual pleasure, as some argued, its exploitative
underside would be fully revealed years later in *Ordeal*, the autobiography
of Linda Lovelace, which describes the coercive conditions under which
her career as the first legitimate porn star had proceeded.[10]

This relation between the representations offered by the porn film and
the exploitative work conditions faced by its actors and actresses has
been a critical subtext of the debate about pornography among feminist
intellectuals which was enjoined in the late seventies. On the one hand,
this debate has been playing itself out in the law courts and in the
intellectual press. On the other hand, it has resulted in the responses and
political actions of sex workers themselves, who have broken into the
business of production and persuasion, whether as elite film directors,
like the women at Femme Productions, or as public voices on media
forums such as television talk shows. So too, the industry has publicly
cleaned up its act, and, in pursuit of the womens' market, it has come to

quite openly address the question of the representation of female plea-
sure and desire. Unlike other organized forms of degrading labor, how-
ever, the porn industry has had to emphasize that its conditions of paid
employment are not just contractual—the only kind of labor relation
which liberal capitalism ordinarily recognizes—but also that they are
entirely *consensual*.

What has taken precedence in the intellectuals' debate, however, has
been the more academic and philosophical question of the vexed relation-
ship between sexual performances and real sexual conduct: often abstract
questions about representation, its distance from the real, its place in and
its effect upon the real, and its relation to fantasy and the construction
of sexuality. Intellectuals, in other words, have felt more comfortable
discussing questions that are familiar to them, and about which they are
traditionally called upon to adjudicate on behalf of society as a whole.

The result, as I will argue, has been to neglect the actual conditions
under which the great bulk of pornography has been produced and
consumed as an object of popular taste. If, in the realm of consumption,
Al Goldstein's male truck driver signifies one side of the popular, a side
which is uncritically celebrated by industry intellectuals, then the female
sex worker, who, for many antiporn feminists, needs to be saved from the
degrading fate of her labor, signifies the pejorative side of the popular in
the realm of production. For the most part, however, the respective
opinions, desires, and economic roles of the truck driver and the sex
worker have either been taken for granted, morally patronized, or else
consigned to the flames of "false consciousness" by intellectuals. In a
rare enlightened moment, the 1976 Meese Commission on Pornography
noted with regret that virtually all of the historical study of pornography
has not been about "the social practice of pornography," but rather about
the "control of that social practice by government," and recommended
that "the scope of thinking about the issue should be broadened consid-
erably."[11]

There are other reasons, of course, why pornography, today, cannot
be considered *simply* as an object of popular taste, rendered illicit by the
dominant culture while it is exploited to provide the profits and capital
which support that dominant culture. The public consciousness raised
by the feminist antiporn movement has challenged this tidy model on at
least two major counts. First, it has made its claims against pornography
against *all men*, and on behalf of *all women*, of all classes, colors, and
sexual orientations. In this respect, the feminist critique, in defining the
pornographic itself as a "dominant" culture, claims to cut across the
class-specific lines traditionally drawn between the "popular" and the
"dominant." Second, in challenging the juridical distinction between
public and private—a distinction that underpins the liberal doctrine of

individual rights—the antiporn critique has also challenged the way in which the popular has been contained, in modern times, in the interests of that repository of individual rights—the "liberal imagination," to use Lionel Trilling's term.

About the first claim, I will argue that while it proposes to redefine cultural conflict along gender rather than class lines, it reproduces the same languages of mass manipulation, systematic domination, and victimization which had been the trademark of the Cold War liberal critique of mass culture. Both share a picture of a monolithic culture of standardized production and standardized effects, and of normalized brutality, whether within the mind or against the body. While lack of mutual affection has replaced lack of aesthetic complexity as the standard grounds of disapproval in the antiporn analysis, the charge of propagandism is repeated, and the renewed use of the rhetoric of protection and reform has sustained the privilege of intellectuals to "know what's good" for others.

About the second claim, I will argue that the insistence of feminism that "the personal is the political," has successfully helped to redefine the "private" as a realm of experience that ought, in certain instances, to be subject to public inquiry. This is a direct challenge to the doctrine of "negative liberty" under which liberal law protects the freedom of the individual to live and act in the absence of undue external restraint. The principle of "negative liberty" traditionally protects areas of the "private" in which women had little in the way of privileges to defend. As a result of the feminist challenge, questions about sexuality can no longer be relegated to a quarantine area where policing has been most effectively exercised, usually against the interests of women and sexual minorities. So too, the private can no longer be seen as a realm of privilege for guaranteeing the immunity of the individual (liberal) imagination to the various "contagions" of popular culture. But, as Beverley Brown has argued, if feminism is to consider where the "reform" of sexual representations is appropriate, then it will have to decide "whether or not phantasy is 'private,'" and what it would mean to distinguish between "a reform of phantasy or a reform of manners."[12]

To make that distinction, however, is to raise questions about the sexual which cannot be tied exclusively to the agenda of combatting gender oppression or inequality. Sex, sexuality, and sexual difference cannot be simply mapped onto categories of gender. Gayle Rubin, for example, has argued that feminism, a theory and a politics of gender oppression, does not necessarily involve the best way of thinking about sexuality, just as marxism often cannot provide the most useful analyses of inequalities which are not class-based. Rubin points out that sexual minorities, often classed as "perverts" and thus part of pornography itself, are affected by

sexual stratification as much as by gender stratification. Gender-based reforms, such as those proposed by antiporn groups, are likely to be antagonistic to the interests of sexual minorities, and have, in fact, already added to the suppression of minority rights only tentatively extended under the protection of the privacy of sexual conduct. A politics of sexuality that is relatively autonomous from categories of gender may be needed to achieve and guarantee the full sexual rights of sexual minorities.[13]

Such a politics is the domain of what I will call the *liberatory imagination*. Unlike the liberal imagination, which exercises and defends autonomous rights and privileges already achieved and possessed, the liberatory imagination is *pragmatically* linked to the doctrine of "positive liberty," which entails the fresh creation of legal duties to ensure that individuals will have the means that they require in order to pursue liberty and equality. But it is also this liberatory imagination which sets the agenda of radical democracy beyond liberal pragmatism in pursuit of claims, actions, rights, desires, pleasures, and thoughts that are often still considered too illegitimate to be recognized as political. Such claims, actions, and rights, etc., invariably do not arise out of liberalism's recognition of the *universal* rights of individuals. Instead, they spring from expressions of difference, from the differentiated needs and interests of individuals and groups who make up the full spectrum of democratic movements today. These differences do not necessarily converge, and they can rarely be posed in relation to rights that would concern or embrace all individuals.

De Gustibus Non Est Disputandum?

Even a cursory review of the cultural history of pornography will show that it is not a unitary phenomenon of taste or representation. In the matter of taste, what is considered hard-core today, and thus of appeal to a lower-class constituency, was the preserve, in the nineteenth century, of gentlemen at the top of the social scale.[14] So too, pornography's field of representation has been transformed by changes in print and visual technology, sexual mores, and conventions of literary and filmic genre. Up until the feminist antiporn campaign, the only thesis that could consistently be advanced about pornography is that it had long been the political *site* of attempts to regulate, contain, and control the shape of popular consumption and taste.

In *The Secret Museum*, Walter Kendrick traces the modern history of pornography from its early confinement in museums with limited access, in medical and technical literature, and in the classical education of gentlemen. Literature and artifacts depicting or citing the pornographic

were available only to the educated upper-class male, a privilege main-
tained in the interests of preventing the "corruption" of women, children,
and the lower orders generally. As advances in print technology and
educational reform brought a new mass public to the written word, the
opportunities for the "seduction of innocents" multiplied, and debates
among judges and the cultural authorities of the educated classes about
the deleterious effects on naive minds of the new popular literature,
especially sensation novels and potboilers, became commonplace. Ken-
drick succinctly characterizes this protectionist tendency by invoking
Dickens's Mr. Podsnap, in whose fastidious mind certain extravagant
passages of literary classics were wont to inflame and corrupt "the young
person."[15] The Podsnappish concern over this "hypothetical institution
called 'the young person'" was, he argues, a recurring feature of the
historical attempts to contain and regulate the flow of information to the
new mass reading public.

Traditionally, the Young Person was a woman or child who had to be
shielded from risqué materials. By the time of the feminist antiporn
critique, this threatened consumer had evolved into something different:

> Her sex had been ambiguous all along; she had been female and male by
> turns and simultaneously, depending on the bias of her self-appointed
> defender. At first, she had been young; later, youth expanded to include
> retarded adulthood. She had always been poor, in either money or
> wisdom; this attribute stays with her. As befits her stunted intelligence,
> she reads little, preferring the more immediate stimulation of pictures,
> videotapes and live performances. The danger she poses is as great as
> ever, perhaps greater, because now she threatens actual physical harm
> to others. . . . What makes the new Young Person frightening is that,
> like the media she favors, the crimes she commits are direct and violent.
> She oppresses, degrades, batters, and rapes women—not in imagination,
> but in grim reality. She does this because, after a century of ambivalence,
> she has emerged unequivocally and exclusively male.[16]

While concise and accurate, Kendrick's description of the low, brutish,
and potentially violent male consumer does not fully account for all of
the permutations of the feminist antiporn critique. We would have to
add that the traditionally female characteristics of the Young Person have
also been divided up and projected onto two exterior stereotypes: women
who are presented as "instinctively" turning away in shame and anger
from pornographic images, and the exploited but also self-victimizing
women whose likenesses appear in the images. Here, for example, is
Susan Griffin, writing from the perspective of the first wave of antiporn
feminism:

> For instance, there is the posture of an Isadora Duncan, a woman
> who declares the body is beautiful, who refuses to hide herself; she
> reveals her body as part of a protest against the pornographic culture.
> But the model in a pornographic magazine is not defiant. She has
> been paid to take off her clothing. . . . She is chattel. When she is
> chained, her chains are redundant, for we know she is not a free
> being. . . . she plays the whore. For she is *literally* for sale. . . . And
> now, as her likeness shines out onto the public sidewalk, she has
> become all women; any woman walking by this image may feel the
> urge to turn her head away in shame. For this picture of the body
> of one woman has become a metaphor, in its anonymity . . . for all
> women's bodies. Each sale of a pornographic image is a sadistic act
> which accomplishes the humiliation of all women.[17]

Is this Podsnappery still? Yes and No. If we leave aside for the time
being the appeal to Everywoman, and the important distinction between
representation—"playing the whore"—and reality— what Griffin calls
"*literally* for sale"—we can almost feel here the vestigial weight of bour-
geois morality that helps to condemn, in the guise of redeeming, the
alienated body and soul of the sex worker. In this respect, Griffin's
remarks exhibit the legacy of the "social purity" crusades of late nineteen-
th-century feminism, which had pledged to clean up a vice-ridden culture
and save the souls of all those concerned but ended by supporting further
legal repression and victimization of prostitutes and other social and
sexually marginal groups.

But there is more at stake here than vestiges of bourgeois morality.
What is also invoked in Griffin's vignette is the "free spirit" of the
artist in the figure of Isadora Duncan. Immune to bourgeois taste
and vulgar exhibitionism alike, Duncan is an artist who has clearly
transcended the conditions of her alienation, and is thus held up as
a model soul, to further chastise the less fortunate porn model as
artless.

This opposition, between art and unfreedom, has little to do with
nineteenth-century bourgeois taste. In fact, it is a feature of the modernist
challenge to bourgeois taste which artists and writers mounted over the
very question of morality and censorship. By the time of World War I,
the struggle to regulate mass distribution and mass consumption of any
information pertaining to sexual matters had become a ludicrous, pa-
thetic, and clearly doomed enterprise. Nowhere had this crusade been
pursued more rigorously than in America, where Anthony Comstock, a
self-styled but publicly appointed "special agent" of the U.S. Post Office,
held despotic sway over the censorship of mailed materials, and thus over
public morality, for almost forty years until 1907. In the white heat of
his puritanical zeal, the war against "smut" was waged with all-inclusive

powers, directed against not only a wide range of pornography, overt and covert, but also marriage manuals, informative tracts about birth control, and other prerequisites of sex education.

For Comstock, as for Podsnap, the principle of exemption or immunity on the grounds of artistic *value* was barely a topic of consideration, and certainly not serious enough for it to challenge the idea of "good taste." In the wake of Comstock, the challenge of artists and intellectuals to the Victorian indifference to "value" came to a head in a series of famous obscenity trials over such works of modernist anti-bourgeois literature as *Ulysses*, *An American Tragedy*, *Lady Chatterley's Lover*, *Tropic of Cancer*, *Lolita*, and *Howl*. To define "art" in opposition to the truly "obscene," as these trials helped to do, was, of course, also to respond to the demand for new forms of discrimination made inevitable by the unfolding spectacle of a full-blown mass culture.

Until the feminist antiporn movement changed the rules of legal engagement in the mid-eighties, the debate in the highest courts of the land about art, censorship, and pornography was one in which intellectuals, in their capacity as "expert" witnesses, were summoned from their habitual role as "hidden persuaders" in civil society to appear as more or less overt legitimists of juridical or state power. Partly because of this, it was also a debate which demonstrated the close, almost cognate, links between the "metacritical" practice of juridical interpretation and the canonical judgments, according to the "objective" laws of aesthetics, which literary critics were accustomed to make in the process of discriminating literature of permanent value from the ephemeral and the worthless. At times, participants in these debates found it impossible to avoid alluding to this elimination of professional distance.

A good example was the Supreme Court decision of *U.S. v. Samuel Roth* (1956), in which Roth was convicted of violating the federal obscenity statute by mailing "obscene, lewd, lascivious or filthy" materials. Roth challenged the constitutionality of the statute, and while the Court of Appeals upheld the statute, one member of the Court, Judge Jerome Frank, expressed his reservations at length, among which was his disagreement with the exemption of books of "literary distinction" from statutory censorship. Frank questioned not only the ethical but also the aesthetic grounds upon which such a distinction could be made between "classics," and what the statute referred to as "books which are dull and without merit":

> The contention would scarcely pass as rational that the "classics" will be read or seen solely by an intellectual or artistic elite; for, even ignoring the snobbish, undemocratic, nature of this contention, there is no evidence that that elite has a moral fortitude (an immunity from moral

corruption) superior to that of the "masses." And if the exception, to make it rational, were taken as meaning that a contemporary book is exempt if it equates in "literary distinction" with the "classics," the result would be amazing: Judges would have to serve as literary critics; jurisprudence would merge with aesthetics; authors and publishers would consult the legal digests for legal-artistic precedents; we would some day have a Legal Restatement of the Canons of Literary Taste.[18]

In evoking this future apocalyptic state of affairs in which the professional separation of powers between "free" intellectuals and judges has altogether eroded, Judge Frank cautions us against concluding that the role of the judge may be no more than the juridical equivalent of the function of "free-thinking" intellectuals in civil society. But perhaps it is the corollary of this thought which harbors the idea, equally pernicious in the eyes of the Law, that intellectuals might merely function as the "soft" agents of juridical coercion.

Judge Frank, however, was on safe ground in merely *imagining* that "the result would be amazing." As the obscenity statute came to be revised in successive decisions, the actual burden upon judges to consistently make such fine discriminations of "value" has eased off. In *Memoirs v. Massachusetts* (1966), it was decided that a work had to be clearly proven to be worthless—"utterly without redeeming social value"—before it could be considered obscene. *Miller v. California* (1973) challenged the absolutism of this ruling, and took as its constitutional standard "whether the work, taken as a whole, lacks serious literary, artistic, political or scientific value." For over twenty years now, written speech has been *de facto* exempt from obscenity rulings, while the heavy burden of proof placed on the prosecutor in the case of visual materials has meant that the "value" of images in a text has been more difficult to question in the courts.

In perhaps the most infamous legal statement ever advanced about "obscenity" or pornography, Supreme Court Justice Potter Stewart in 1964 (*Jacobellis v. Ohio*) announced that although he could not define what pornography was: "I know it when I see it." While the courts have not abandoned the subjective right of judges to deploy this privileged knowledge, the objective model of obscenity since *Miller v. California* has been "the average person, applying contemporary community standards." If judges were thus spared the professional anguish of the literary critic bent on canonizing a relatively new work of literature, it was because they, like the literary critic over the same period of time, have come to acknowledge that there are no universal, let alone national, standards for interpreting cultural representations. They have yet to fully recognize, however, that there are only specific communities and subcultures of

interpreters, whose diversity of interpretation and use of cultural material are hardly suggested by universal categories like "the average person," or "contemporary community standards."

For traditional intellectuals, vying to have their say on pornography, the question of value was clearer because there were so many ways of taking the high ground. Here, for example, is the appeal to aestheticism of Lord Clark: "The moment art becomes an incentive to action, it loses its true character. This is my objection to painting with a communist programme, and it would also apply to pornography."[19] Steven Marcus also perceives that pornography's "singleness of intention" is "to move us in the direction of action" and "away from language" and this is what relegates it to such "simpler forms of literary utterance as propaganda and advertising." Pornography, which, for Marcus, takes place in a pornotopian never-never land, out of social time and place, can never be true "literature" because it cannot provide gratification and fulfillment; its effect is not finite.[20]

For every argument about singleness of intention, there was a confessional argument about effect from the likes of George Steiner, who wrote a weary diatribe against what he saw as the boring and repetitive configurations of the pornographic—"as predictable as a Boy Scout manual"—which extended, as he saw it, from "the fathomless tide of straight trash" of today to the literary erotica, "above the pulp-line," produced by most of the respected authors of the nineteenth century. For Steiner, pornography could only create new conditions of servitude, not freedom: "The actions of the mind when we masturbate are not a dance; they are a treadmill."[21] Commenting on the heated response to his essay, Steiner fully drew out the classic Cold War features of his argument. Pornography, he concluded, was an erosion of our private erotic rights, a threat to the free imagination that can be mobilized alternately by the threat to individual style "in a mass consumer civilization" *or* by "the making naked and anonymous of the individual in the totalitarian state (the concentration camp being the logical epitome of that state)."[22]

Steiner's case against pornography, then, became a defense of the liberal imagination and of Western "freedom" alike. The familiar Cold Warrior fear that popular culture already *contains* our response to it, and that it therefore has "no respect for the reader's" imaginative rights, is presented as a brutish threat wielded by consumer capitalism and monopoly statism alike. Only Literature with its plurality of high intentions allows us to respond with the imaginative freedom that we are accustomed, in the West, to enjoy. So too, this freedom had to be of a mature nature, as opposed to pornography's activation of fantasies of infantile sexual life. Portnoy's "complaint," as Irving Kristol put it, was simply that

he was "incapable of having an adult sexual relationship with a woman."[23] Pornography, whether high or low, would never grow up.

There is, of course, a specific historical context for the assumed anti-literary bias of pornography, invoked by Marcus's observation that the tendency of pornography is "to move ideally away from language." Such complaints appeared at a time when the written word was again becoming a minority medium associated with a saving "literate" remnant, and thus exempt, after centuries as *the* democratizing, leveling medium, from all modes of State suppression and proscription. The private activity of reading was now seen as embattled and in need of protection from the growing hegemony exercised by visual technology over a mass population. Where, in the nineteenth century, the private act of reading (especially popular literature), on the part of the new reading public, was infernally associated with masturbation, reading was now a redemptionary exercise, a promise of deliverance from the orgiastic public rites of the spectacle and mass pornography.

So too, where live theatrical performance had once been subject to rigorous state censorship, its minority audience today guarantees its immunity, as the Williams Report of the Committee on Obscenity and Film Censorship (1979) observed: "The reason for the low level of public concern about live entertainment no doubt has to do with its not being a mass medium." "Live entertainment . . . affects few people," as distinct from the mass production, distribution, and consumption of films and pornographic magazines.[24] On the other hand, the Williams Report (and the Meese Report) was just as likely to offer a philosophical (rather than a sociological) explanation for its conclusion that the potential "harm" of pornography was held to lie in photographic images alone. For the consumer, the "assault" of visual images is less removed, Platonically speaking, from reality than is the written word. With the written word, as the report puts it, "the consumer develops his own fantasy" while the image presents a more direct, and thus less workable, fantasy.

Similar assumptions about elite taste are deployed in the avant-garde intellectual's case for high-class pornography as "serious literature." Susan Sontag, for example, praises the quality of experience offered by sophisticated erotic literature like *The Story of O*. For her, this is a literature of extremity, bravely testing and exploring the transgression of social limits by libertines. In its quest for sensual absolutes, the modernist transgression of social taboo is the best hope for a negation of everyday capitalist personality structures; it is a profoundly traumatic, subversive, and quasi-religious act of the imagination.

But Sontag makes it clear that this capacity to lead the way in transgression is not for everyone:

Perhaps most people don't need a "wider scale of experience." It may be that, without subtle and extensive psychic preparation, any widening of experience and consciousness is destructive for most people. . . . Pornography is only one item among the many dangerous commodities being circulated in this society and, unattractive as it may be, one of the less lethal, the less costly to the community in terms of human suffering. Except perhaps in a small circle of writer-intellectuals in France, pornography is an inglorious and mostly despised department of the imagination.[25]

This charmed circle brings together the guardians of what we could call the *libertinist imagination*: theirs is a Reichian revolution of the body through the minds of intellectuals. In fact, Sontag is alluding to the avant-garde tradition in France of Georges Bataille, Jean Genet, Roland Barthes, and later, Phillipe Sollers, Julia Kristeva, Hélène Cixous, Monique Wittig, and others whose common patron saint in the field of libertinage is Sade. It is a tradition in which the limited and mundane libidinal economy of *plaisir* is contrasted with the higher, transgressive experience of *jouissance*, to use Barthes's well-known opposition, itself based on the Freudian distinction between the "economic" pleasure principle and the destructively "spendthrift" death drive. *Plaisir* is thus linked to the controlled hedonism of consumer capitalism, an economy which the avant-garde pornographic imagination seeks to disrupt by pursuing pain and pleasure in excess of its conventional limits; as Sontag puts it approvingly elsewhere, "having one's sensorium challenged or stretched hurts."[26]

What Sontag, then, calls the "pornographic imagination" is clearly a realm of radical chic pleasure, far removed from the semen-stained squalor of the peep show, the strip joint, the video arcade, and other sites of popular pornotopian fantasy. But it claims to be an egalitarian theater all the same, where, as Angela Carter notes in her study of Sade, the participants are *accomplices* in crimes of passion, not lovers or partners or servants or masters, and where pornography promises to be even more "deeply subversive" the more it comes to be like "real literature" and "real art" by facing up to the "moral contradictions inherent in real sexual encounters."[27] Carter proposes the kind of "moral pornographer" who would liberate the power of pornography and put it in the service of a critique of current sexual relations, terrorizing the imagination with a world of social and gender mobility. Such a pornographer would be the "unconscious ally" of women. In fact, Carter argues that because Sade represented women as "beings of power" with certain rights to sexual freedom, he "put pornography in the service of women, or perhaps, allowed it to be invaded by an ideology not inimical to women."[28]

Antiporn feminists have hardly been willing to accept this image of the Marquis de Sade, connoisseur of mutilation and gourmet of sexual

humiliation, as women's best friend in spite of himself. Nonetheless, the appeal to a *higher consciousness*, which allows both Carter and Sontag to redeem Sade, seemed to play an equally important, if somewhat different, role in the famous distinction between pornography and erotica which Gloria Steinem first advanced in 1978, and which has since become an article of faith in the ensuing feminist debate and transformed representational practices around pornography. As a women's alternative to the perceived inequalities of masculinist pornography, erotica was posed in terms of the representational codes of romantic love, with an emphasis on traditionally "feminine" qualities like tenderness, softness, wholeness, sentiment, sensuality, and passion. "Erotica is about sexuality, but pornography is about power and sex-as-weapon," wrote Steinem.[29] Erotica, which had long been used to describe a class act for well-heeled male voyeurs, would now be transformed into a purified realm of sexual freedom and equality, with higher, and more complex, holistic intentions than the singular and mundane one of arousal.

Anti-antiporn feminists who were skeptical of Steinem's distinction pointed out that this new definition of erotica rested upon a utopian orthodoxy of "good sex," and implied, at its core, a campaign for the reform of sexuality itself. Ellen Willis described its emphasis on wholesome relationships as a "goody-goody concept" and a "ladylike activity," associated with the "feminine" and not with the "feminist."[30] Ann Snitow pointed out that soft-core, soft-focus, "good sex" excludes the infantilism, wayward desire, and aggressivity of pre-Oedipal sexual activity that is played out, in fantasy or otherwise, in all adult life and culture.[31] Gayle Rubin criticized the erotic chauvinism of the "erotica" model—calling it the "missionary position of the women's movement"—because of its exclusion of a whole range of sexual variations—running from casual promiscuity to lesbian S/M.[32] While agreeing with the reformist platform, Susanne Kappeler insisted that the replacement of the content of representations—"bad sex" by "good sex"—changes very little; what is needed is the reform of the very structure of looking and gazing that organizes visual representation.[33]

These, and many other objections to the erotica/pornography distinction, have helped to set the agenda of the contemporary debate about pornography. None of them appeals directly to the terms and categories that characterized the earlier phase of the debate about art, obscenity, and elitist/popular taste. For it is no longer the threat to the autonomy of the liberal imagination that is at stake. The *liberatory imagination* has come to the fore, bringing with it a new set of contradictions, protectionist and conservative on the one hand, and exploratory and radical on the other, posed against the backdrop of consumer capitalism in which new social and sexual identities have tentatively come into being at the cost of

ever greater modes of social and cultural control. Facing up to these new contradictions has required intellectuals to rethink their allegiances and/ or their allergies to popular pornography.

Men and Murder

While the wide range of feminist critiques of pornography covers ground that cannot be easily unified, the philosophical core of the critique to be found in the work of Andrea Dworkin, Catherine MacKinnon, and WAP rests upon the principle that patriarchal oppression is *systematic* and *all-inclusive*, and that it is exercised universally and transhistorically.[34] To look for evidence of this oppression is to demonstrate an unbroken continuum of male violence against women which stretches from the operations of pimps and pornographers to corporate executives and traffickers of "international sexual slavery"; from incest to clitoridectomy, and from soft-core pornography to rape and sexual murder.[35] The essentialist-biologist categories of the WAP critique posit "male sexuality" as naturally rapacious and gynocidal—"Men love death" writes Dworkin, and adds, "men especially love murder"[36]—and "female sexuality" as nurturing, arising from *natural* or spontaneous interests and instincts. The universal hold of male power over female autonomy is thus seen as an ongoing encroachment and invasion of a realm of natural feminine freedom. Power, manipulation, and victimage are the masculine reward, and freedom to be protected and nurtured are the feminine. A systematic threat is assumed, and an alternative world is imagined which would be invulnerable to such a threat.

These are the rhetorical terms in which antiporn feminism redefined the old defense of the liberal imagination (against the brutish threat of a pervasive mass culture) within a context provided by the countercultural alternatives that had flourished in the late sixties. The utopian result was to be a female counterculture with no ties to the "system" and a guaranteed immunity to its rules and games of power and resistance. There would be a world, on the one hand, in which only male power could be enjoyed or suffered, and a different world in which male power no longer mattered. Such a scenario assumed that little could be done about the everyday life culture which had inevitably made women into passive, inert victims. Instead, it promoted the creation of a no-go area, or no man's land, prophylactically separate from the contaminated culture of ordinary people and popular culture. In this way, the vestigial Cold War opposition between the advanced minority of an "adversary culture" and the monolithically victimized mass was being played out by the new feminist intellectuals.

Like many Cold War liberals, antiporn feminists also seized on a spe-
cifically *cultural* object of attention as the *causal* subject of their critique
of power relations. Just as "mass culture" had been diagnosed as contain-
ing all of the reasons for everyday life domination in the postwar "mass
society," so popular pornography came to be seen as the singular cause
of sexist oppression in a patriarchal society. Robin Morgan's well-known
slogan, "pornography is the theory, rape is the practice," codified the
link between the anti-violence movement and the fully visible and demon-
strably concrete object of pornographic images and literature.

As has often been pointed out, the new, exclusive focus on pornogra-
phy came at a time when the unity of the women's movement was in
question. Interpretation of the porn industry's growth as a direct backlash
against the claims of feminism helped to mobilize a newly unified voice
within the women's movement. Better than any abstract critique of patri-
archy, the evidentiary nature of pornography provided a spectacular
point of convergence for many different interests and struggles, and
therefore it came to be isolated as the *essential* issue of radical feminist
attention—the primary site for the creation and normalization of violence
against women. Thus, from the point of view of its (male) user, the
broad range of pornographic materials was held to offer a spectrum of
ideological addiction, from the soft-core *Playboy* to the "snuff" film; from
the point of view of its (female) victims, pornography offered no repre-
sentation of their true desires, and every single reason for their enslave-
ment and powerlessness. Consequently, the represented scenarios of
pornographic images came to bear a clear and literally direct responsibil-
ity for their assumed effects in a world in which universally destructive
and predatory male consumers were licensed to interpret these scenarios
as if they were real.[37]

Soon, the solidarity of the antiporn movement was underpinned by a
heavily moralistic set of assumptions, if not judgments and prescriptions,
about the correctness of representations and fantasies, and the (im)per-
missibility, within the women's movement, of certain patterns of sexual
behavior. The containment of pornography was tied to a more specific
consensus about the containment of radical sex practices in the interests
of what was posed as a healthier expression of the social good. In calling
for state censorship of pornography, the antiporn movement was chal-
lenging the shaky right to constitutional protection of pornographic
representations. But the consequences of censorship and proscription
were likely to be ugly. They included the certain repression of sexual
minorities, to whom pornography was an integral and essential cultural
expression of their interests[38]; the general restriction of access to sexual
information and sexually explicit material, a constraint particularly dam-
aging to women, who were historically denied this access; and the cre-

ation, by default, of a public culture of reduced and not expanded liberatory possibilities.

Critical response, feminist and otherwise, to the antiporn critique has been extensive, and I will briefly summarize the chief arguments. Because of its fixed analysis of cause and effects in a fixed world of gendered power relations, the antiporn critique was seen as having no interest in the wide variety of uses to which pornography was put by diverse consumers and taste subcultures. Because of its acceptance of an ahistorical patriarchal logic, it had no analysis of the specific influence of consumer capitalism's volatility upon the human capacity for erotic stimulation. Because of its literalist interpretation of images, it could not account for the interplay between the complex constructions of representation and fantasy in the consumption of pornography. Because of its proponents' unfamiliarity with the full range of materials of pornographic consumption, it could not understand the shifting configurations of pleasure and desire which accounted for pornography's vast popularity. Because of its essentialist and reductionist view of sexual difference, it could not accommodate the testimony of women who enjoyed pornography, or sex workers for whom exhibitionism was an empowering experience. Because of its moralism, it had no explanatory response, other than a principled condemnation, of pornography's sexual arousal of both men and women who perhaps perceived this arousal as "wrong" in some way, and were further aroused by this perception.

On the basis of these criticisms and others, an anti-antiporn movement of feminist intellectuals has established itself. In its challenge to a social critique that subscribes to a monolithic, undifferentiated analysis of popular culture, and that advocates collusion with censorial State power, anti-antiporn has had to make many of the same kind of arguments (including the charge of red-baiting) as anti-anticommunism did in the sixties. In particular, it has had to combat the moral panic and conspiracy mania that are shared features of the discourses of both anticommunist and antiporn intellectuals. In promoting the idea of an *expansive* popular culture for women—as opposed to a *restrictive* mass culture—the anti-antiporn movement has also had to negotiate two knotty problems for a liberatory sexual politics: first, the conservatism of the unconscious, and second, the fickleness of capital.

On the one hand, there is the integral importance of "regressive" but unreformable fantasies of aggressivity to the construction of sexuality, and more generally, the resistance of psychic life to any *directly* imposed pressure towards social change. And on the other, there is the profit that consumer capitalism draws from ever finer marketplace discriminations between social and sexual identities even as these discriminations lend themselves to further extensions of social control. The intransigence of

these two factors hardly promises to deliver a utopian culture of sexual freedom, equality, and mutuality, or at least not one that would take the form of a "love story."[39] The first affirms that violence and aggressivity are likely to remain constitutive elements of our sexuality, and that we should always be prepared to take their effects into account or at least make allowance for them. The second explains how the creation of new sexual identities (women, gays and lesbians) in the liberation movements was partially achieved through the agency of a consumer capitalism which stood to profit from the exploitation of markets formed around these identities. But while neither of these factors seems to lend itself to traditional forms of "progressive" politics, neither threatens in itself to stand in the way of a radical democratic agenda for full sexual rights. The unconscious does not distinguish between fantasies on the basis of superior quality or political correctness. And capital *per se* does not discriminate against profitable minority tastes and pleasures on the basis of morality alone, which is why a *moral* agenda à la Reagan/Thatcher always has to be grafted onto the ideology of an enterprise culture, with all of the resulting contradictions.

It may be that sex will have to become fully capitalist before it can be anything else.[40] But to realize the potential of that "anything else" will involve recognizing where the *liberatory* imagination parts company with the *libertarian* view that pleasure is natural and ought to be freely pursued. The anarchic, laissez-faire sexual marketplace that was associated in particular with the pre-AIDS gay community has often been criticized on the left as a typical model of the libertarian doctrines of free will and choice. On the other hand, this marketplace has been strongly contested by conservative pressure groups on the right. Consequently, it has become a guarantee, at least until legal equality is won, that the existence of sexual minorities and their struggle for sexual rights remain in the realm of public visibility. More often than not, the first to suffer from any moral regulation of the sexual marketplace are those sexual minorities who survive, for lack of civil legitimacy, on its margins, and this has certainly been one of the first effects of the AIDS crisis.

In this respect, the liberatory imagination must exploit the short-term pragmatic benefits of libertarian principles (wherever they are still in practice) because its eyes are on the prize of full sexual rights; it has no ultimate, long-term interest in the principle of free will or free trade. This is not to sanction the commodification of sex, it is to salvage any available gains, under circumstances that are never ideal, from the contradictions of a capitalist culture. Whether or not one rejects the fundamental principles of a market economy, the limited though positive features of market legitimacy cannot be historically dismissed in the case of pornography. There is little doubt that the most unsavory—violent and/

or misogynistic—features of pornographic representation flourished in conditions when pornography was underground, and marketed illicitly. Pornography's increasingly legitimate legal status in the marketplace over the last two decades has been accompanied by the gradual disappearance of these features and a limited improvement in working conditions in the sex industry generally.

Anti-Antiporn

Attentive to both of these problems, psychoanalytical and commodificatory, feminist critics of antiporn, especially those in the Feminist Anti-Censorship Task Force (FACT), have nonetheless succeeded in opening up the discussion of pornography to include an emphasis on activity and pleasure as well as passivity and danger. Carole Vance, coordinator of the seminal 1982 Barnard Conference on Sexuality, describes this agenda:

> The tension between sexual danger and sexual pleasure is a powerful one in women's lives. Sexuality is simultaneously a domain of restriction, repression and danger as well as a domain of exploration, pleasure and agency. To focus only on pleasure and gratification ignores the patriarchal structure in which women act, yet to speak only of sexual violence and oppression ignores women's experience with sexual agency and choice and unwittingly increases the sexual terror and despair in which women live.[41]

To fully challenge the antiporn critique, it was necessary first to acknowledge women as consumers of pornography, and then to account for their use of and complicity with "male-identified" representations. As Ellen Willis put it, "women have learned, as a matter of survival, to be adept at shaping male fantasies to their own purposes"; and "a woman who enjoys pornography (even if that means enjoying a rape fantasy) is in a sense a rebel, insisting on an aspect of her sexuality that has been defined as a male preserve."[42] This meant challenging the good girl/bad girl division, with its moralistic accompaniment of protection/punishment, which antiporn feminism had helped to perpetuate. It was necessary also to challenge the assumption that the popularity of pornography was the result of "false desires" created *ex nihilo* out of patriarchal propaganda. To be as popular as it is, pornography's capacity to bodily arouse its variety of consumers must be acknowledged to relate in some way to real needs and to existing configurations of desire and fantasy-structures. So too, the binding myth that Everywoman is degraded by the simulated sex act of any one sex worker was contested on a number of counts: by the argument that "Woman" is in fact always specific "women," differenti-

ated by age, class, ethnicity, sexual orientation, and sexual diversity; by
the testimony of sex workers themselves; and by a more sophisticated
account of representation, imagery, and generic conventions which dem-
onstrated that pornography could not determine the meaning of its
images for all consumers in the same way.

Point by point, FACT intellectuals have contested a whole range of
assumptions about female sexuality that lie behind the antiporn agenda;
that it is innately passive, romantic, nonviolent, nonpromiscuous, natu-
rally nurturing, healthy (if monogamously exercised), and commonly
shared, with respect to all of these features, by all women.[43] On the level
of content, pornography, it was argued, actually did show women actively
seeking sexual pleasure with impunity: it "carries many messages other
than woman-hating; it advocates sexual adventure, sex outside of mar-
riage, sex for no reason other than pleasure, casual sex, anonymous sex,
group sex, voyeuristic sex, illegal sex, public sex,"[44] and, more recently,
safe sex. Finally, in the realm of legal action, FACT helped to file an *amici*
brief in *American Booksellers v. Hudnut* (1986) in the U.S. Appeals Court
which ruled that the Indianapolis antiporn ordinance drafted by Dworkin
and MacKinnon on the basis of protecting the "civil rights" of women,
was unconstitutional.

Many of these arguments and actions have been marshaled with the
aim of reclaiming, for women, a sexual revolution that was in danger of
being declared irredeemably sexist, and thus off-limits to those who stood
to benefit most from greater access to an expanded public sphere of
sexual culture. Today, most sectors of the pornography industry are no
longer restricted either to a wealthy male elite, which can pay for discreet
private services and entertainment, or to lower-class male consumers who
frequent the semi-illicit "combat zones" of the urban porn street strips—
no-go areas for most women. A vast literature exists to provide detailed
consumer information about all forms of sexual entertainment. Hi-tech,
adult bulletin boards and swingers' exchange networks offer forums for
every conceivable taste and indulgence. In this respect, the flourishing
growth of popular sexual entertainment for women has been rapid and
visible. The male strip joint à la Chippendales, the "Tupperware" parties
for buying sex accessories and paraphernalia, the vast readership for
romance novels and literary erotica, and the rapidly growing female
consumption of visual pornography in magazines, films, and video have
all become routine features of popular cultural life for women in the last
fifteen years. Even S/M, once the privileged preserve of a wealthy male
class, has become a typical post-camp pop fantasy, and a conventional, if
not entirely common, practice in middle-class culture.[45]

The normalization of S/M is important to acknowledge if only because
the strongest opponents of the antiporn campaign—the lesbian S/M

community—have been baited, in the tradition of liberalism, as a radical extremist faction with avant-garde sexual tastes. The heated controversy over lesbian feminist S/M, in pornography and practice, brought to a common focus many of the vague, or unformulated discourses about the representation of power and the power of representation in popular culture. That much of "male" pornography either directly represented relations of sexual inequality or else championed the ideology of male supremacy was recognized and more or less commonly accepted. The antiporn critique of this "violence against women" extended to a disagreement with women who were held to have further eroticized inequality by sanctioning the representation, fantasy incorporation, or practice of S/M. Even when, as in most "male," and all "female" S/M, power roles were reversed and structured around female dominance, the "rules" of the patriarchal game of power were still seen as being replicated. The claim to empowerment through the shifts in identification which S/M structurally fostered was seen as a "negative power," of the sort to which only slaves could lay claim.[46]

In response, the liberationist claims for S/M proposed consensual S/M as a safe cultural space in which to explore, under controlled conditions, the powerlessness felt and experienced by women in the public sphere.[47] Where S/M had once been a private playground or theater for the powerful to explore the exercise of power, now S/M, in popular pornography or practice, was being proposed as an area of imaginative experience in which the nonprivileged, both men and women, could make sense of their current social powerlessness in ways that transformed suffering into pleasure. If S/M, it was argued, could be an official ritual of domination, then it could also be a unofficial theater of opposition and subversion.

The leather imagery and the cultivation of daring and outrageous poses which have come to signify S/M in popular fashion seem a far cry from the period costumes and conventionally coded sentimentality of the popular romance novel. But critics of this literary genre have found a similar, albeit soft-core, version of the passion for sadomasochism within its formulaic narrative—usually that of an independently minded heroine finding true love in an exotic locale and in the unlikely arms of a tough, and apparently brutally minded male; the course of seduction almost always involves rough sex, from bruised lips to near graphic rape. Some critics, like Ann Douglas, find the massive popularity of the romance novel to be simply regressive:

> It is a frightening measure of the still patriarchal quality of our culture
> that so many women of all ages co-sponsor male fantasies about them-
> selves and enjoy peep-shows into masculine myths about their sexuality
> as the surest means of self-induced excitation.[48]

The brisk, moralistic tone of Douglas's observation—something ought to be done about this!—supports a rather literal-minded interpretation of the complex and various relations which romance readers have established with this popular genre.

To read these conventional narratives as if they directly contributed to "harmful effects" in the lived patriarchal world is not only to directly equate the work of fantasy with a notion of "false consciousness," but also to patronize their readers as mindlessly self-destructive. Critics, like Janice Radway, who are more attentive to the actual readers, point to the ways in which "reading the romance" can be seen as a form of protest tied to their readers' dissatisfaction with the everyday institution of marital monogamy; it produces utopian meanings and compensatory gratifications for what is seen as their otherwise unchangeable social and sexual roles in daily, married life. Having isolated the function of this reading activity, the "problem" for feminism remains one of converting this dissatisfaction into real actions and consciousness that would be recognized as feminist and progressive.[49]

But what if the popularity of such cultural forms as pornography, for men, and romance, for women, speaks to desires that cannot be described according to the articulate terms and categories of an intellectual's conception of "politics"? What if the pleasures of pornography and romance, however complicit with patriarchal logic, prove to be resistant to *direct* pressure from a reformist agenda? Nothing seems more alien to the vanguardist function of the intellectual, trained, educated, and committed to raise the consciousness of others, and to redeem ordinary people from what she or he sees as their ideological servitude. And yet nothing seems more certain than that the respective pleasure of pornography and romance *is* autonomous; that it is not a false, spurious, displaced, or addictive substitute for a more "authentic" world of social and sexual relations; and that it is not an already existing quantity that has merely been channeled into regressive shapes and forms, and which can therefore be rechanneled to other cultural forms or activities with more progressive meanings. This is precisely the problem that intellectuals confront not only in explaining the popularity of popular culture, but also in examining their own fondness for popular forms which contain "politically incorrect" messages.

For example, when straight male intellectuals are asked, perhaps not often enough, why they like pornography, they are likely to assume, especially if the question is posed by a woman, that their relation to pornography is perceived as somehow "wrong." This is likely to apply whether or not they are reconstructed men—who recognize sexism when they see it—since the very act of looking at pornography involves an internalization of social taboo: it is always already an illicit voyeuristic act,

to be safeguarded against the danger of being caught and questioned about it. Such a man, then, will invariably respond by defending himself, knowing, at the same time as he hopefully offers his reasons, that he is not doing a very good job of convincing his questioner. He is bound to fail to explain why he likes pornography. Not because of any lack of persuasive or rhetorical skill, nor because the odds are stacked against him in some absolute way. He cannot explain his desire for pornography because he cannot articulate his pleasure, he can only evoke the conditions under which it is likely to exist. In fact, we do not yet have a critical language for dealing with pleasure of this sort, except, perhaps, for the psychoanalyst's, whose joyless vocabulary seems almost to deny the existence of pleasure, or the language of the libertine, whose *jouissance* is usually superior, and never mundane.

What, then, is characteristic of pornographic pleasure? If we listen to traditional intellectuals, the story we hear is one of repetition, sameness, and monotony—the qualities of standardized effects attributed to popular culture generally. But this could hardly account for the enormously differentiated range of pornography, nor for the practiced power of discrimination which consumers of pornography show in their endless search for new sources of arousal which will "repeat" familiar pleasures. While an image, shot, or sequence that is arousing in one instance may lose its power to arouse repeatedly, each fresh set of images is addressed to our carnal knowledge and memory of similar or related images. So too, while our bodies may recognize or acquire fixed, or generic tastes for certain activities or representations, they are rarely so specific as to exclude the possibility of arousal by a different genre of images or activities. The erotic body is not transhistorical, and the grammar of its response to pornography, while informed by a "deep structure" of primal and infantile fantasies held, more or less, in common, is inflected by a personal psycho-sexual history of social experiences which ensures that its articulated sexuality is as unique as a thumbprint, while never so fixed in its contours as to be a reliable guarantee of identity.

Education of Desire?

To consider further what this grammar of responses entails for particular social subjects, I will first make one or two points about the formal organization of pornography. My comments, here and throughout, are directed more or less exclusively towards Western porn culture. Both the traditional intellectual and the antiporn feminist find grounds for disapproval in classical male pornography's lack of respect for narrative; for the former, it is a serious organic flaw, while for the latter, it demon-

strates a callous scorn for the holistic experience of a properly loving and sexually fulfilling human relationship.

In fact, pornography is not at all inattentive to narrative, especially when considered within the context of its markets of consumption. Pornography's narrative form, in each of its many genres, is very closely tailored to the demands of its traditional male market, broadly based around the activity of masturbation. Whether in the 8mm stag film or video loop viewed in a booth, or in the sequence of images laid out in a magazine or "stroke book," the suggested duration and emphasis of a narrative of encounter, arousal, and ejaculation is more or less linked to the temporality of male masturbation, which mediates the viewing process. This does not mean that the images, as if in accord with the model of behavior conditioning, strictly determine and invoke a mechanical response in the masturbator. Even in contexts, like the video booths or peep shows in porn stores, where the consumer's contact with pornography is limited to the finite time which he pays for, his response is never simply determined by what he is offered in the way of images; it is always mediated, and thus is more likely to be determined by the fact that his arousal and pleasure is conditional upon his desire and/or his monetary capacity to pay more to extend his allotted time.

Here, then, in these conditions under which the less privileged are obliged to consume, pleasure is concretely tied to the necessity of exchanging small amounts of petty cash, a necessity spared the wealthier consumer for whom the transactional act of exchange—a "dirty" act for the non-needy generally—can be distanced from the pleasures of consumption. For the consumer on the street, then, his pleasure is tied to what he can afford there and then, on the pornographer's premises. This does not make his pleasure qualitatively or quantitatively inferior to that of the wealthier consumer who can pay for the conditions under which he may choose to use pornography which he has either bought or rented. It does, however, explain the particular narrative form exhibited by certain kinds of pornography made to be consumed in specific contexts and under specific conditions. Different altogether, is the case of the post-1972 full-length narrative films, made for theatrical distribution. They are punctuated with sexual sequences that are set apart in time— at least ten minutes—and thus offer an economic series of masturbatory possibilities. More recently, VCR technology has allowed the consumer to isolate and to further control the masturbatory sequences offered by the home video market.

Pornography, in whatever commercial form or package, or in whatever cultural context, can never absolutely determine the nature of arousal and pleasure; it merely *aims at the market-targeted body (usually male) in ways which are likely to excite that body*, and the popularity of this or that film or

magazine is evidence of its success. The same might be said of the long, seductively drawn out narrative of the romance novel, whose virtue for female readers has been claimed to reside in the qualities of waiting, breathless anticipation, and anxiety—all features of a seemingly endless discursive foreplay which is held to be more germane to the rhythms and economy of female pleasure than the sparse libidinal narrative of male pornography, but which strives after the same effect of arousal nonetheless.[50] Here, then is a definition of what are conventionally taken to be the respective staple quotients of "male" and "female" pornography—a maximum of sex and minimum of foreplay in one, and the very opposite mixture in the other.

Many arguments could be posed in favor of rejecting this distinction *tout court,* and many more could be deployed to question whether such a distinction, even if it were accepted as conventional currency, could be assumed to be based upon biological or socially constructed differences. As it is, this distinction primarily applies to and derives from a comparison between visual and literary forms of production respectively, at least within the last two decades, and therefore reflects the uneven development of cultural *technology* across gender-specific markets during that time—promoting visual images for men and literature for women.[51] Nonetheless, it is widely accepted, even by the new feminist pornmakers, that "women-oriented" pornography is characterized by a greater emphasis on "plot" and development of narrative.[52] Recent advances in cable and in VCR technology have brought visual pornography directly into the domestic space. As a result, the adult video for home rental by couples is economically designed to cater to both modes or narratives of sexual response. Enjoying access to cheaper technology, the industry has been able to lavish time, money, and production values on stylized, romantic settings, more intricate narrative frames and build-ups, extended foreplay, and scenarios of mutual pleasure. On the other hand, the fast-forward feature of VCR technology ensures that the more graphic "bits" can still be rapidly located if required for a hard-core fix.

Porn films, moreover, do not lend themselves easily to discussion among film theorists about the visual pleasure afforded by narrative in the classical realist cinema.[53] It makes little sense to treat pornography as if it were a realist text, for this tends to discount the work of fantasy that is more directly brought into play during the viewing and use of pornography. The plot of realist films is often recounted to others in the same way as we reconstruct dreams out loud to friends, but pornography is like fantasies in this respect; no one would dream of recounting the narrative form of either. Pornography, for the most part, provides a stimulus, base, or foundation for individual fantasies to be built upon and elaborated. It merely provides the conditions—stock, generic, erot-

icizable components such as poses, clothing, and sounds—under which the pleasure of fantasizing, a pleasure unto itself, can be pursued. It cannot, of course, determine the precise nature or shape of the viewer's fantasies; it is aimed in the direction of his or her fantasmatic pleasure. As a result, it does not possess anything like the power of a realist Hollywood film to shape or control the effect of its representations, whether "harmful," to use the terms of the antiporn critique, or aesthetically spurious, to the mind of the traditional intellectual.

This is not to say, of course, that pornography is anti-realist in the same way as the non-narrative avant-garde film, which deliberately sets out to disrupt the linear narratives of realism. The avant-garde film is addressed, for the most part, to intellectuals who are generally not tied, in their everyday lives, to the fixed narrative of the weekly work patterns that govern and demarcate the leisure activities of a working population. An audience of intellectuals has the time and the training to "work" at its response to avant-garde film, while an audience of non-intellectuals is more likely to view the cultural work demanded by non-narrative film either as an unwanted imposition of overtime labor or as an obstacle in the way of the emotional gratification provided by the realist narrative.

As for the workplace itself, traditional pornography presents a special case because of its widespread use there. The exhibition of pornographic pinups in the workplace, while it is increasingly contested in the mixed workplace (by women and men, although it is also frequently *used* to reassert male privilege in that milieu) attests to the fact that their traditional male use as a fantasmatic stimulus crosses the often strictly observed divide between the world of work and the world of leisure. So too, while a television show or a film, or even the recounting of a personal sexual encounter often provides a focus for communal discussion among groups of men or women in the workplace, a pornographic image, "cheesecake" for men or "beefcake" for women, is offered largely as an invitation to indulge in personal fantasy. It may be passed around communally, and will be commented upon in a ribald way, but usually in a consensus of appreciation as if to affirm that even if such an image speaks to their everyday needs and desires, it represents a realm of experience that is above and beyond the possible experience of that group of men or women.

Pornography is used in this way to confirm the solidarity or cohesiveness of class taste by representing conditions of experience that are recognized as superior to those with which these social groups are likely to be familiar.[54] Anything which threatens to demystify the superiority of the pinup invites ruthless criticism. In my own experience of all-male workplaces, this criticism, when it occurs, is usually directed not at female pinups themselves but at representations of men in especially awkward

positions, or, in the case of film images depicting sexual performance, when the actor is shown to be temporarily impotent or incapacitated in such a way as to detract from his prodigious dramatization of sexual prowess. In contrast to the case of realist entertainment, where a film can draw criticism because it is "too unrealistic" or far fetched, pornography can be criticized for a surfeit of realism which brings its fantasy world uncomfortably close to home. So too, it is likely that the porn film spectacle of hard-working bodies, repetitiously pursuing, with muscle and sweat and sperm, the performance and productivity levels required by the genre has as much to do with the libidinal economy of labor as with the popular aesthetic of athletic prowess. In this respect, the use of pornography might be said to challenge any tidy division between labor and leisure, or productivity and pleasure; its use speaks, at some level, to the potential power of fantasy to locate pleasure in work (even to eroticize work) as well as in play.

It is difficult, then, to discuss pornography as *entertainment* in the conventionally organized sense in which the culture industries demarcate leisure time from work time. So too, it holds an equally problematic relation to the categories with which intellectuals have discussed the "progressive" features of narrative and editing in filmmaking that challenges the codes of Hollywood realism. In a discussion of the gay porn film, for example, Richard Dyer notes that its narrative and editing is seldom organized around "the desire to be fucked," and almost always subscribes to the "active" ejaculatory model of linear male pleasure. Can gay male sexuality be represented differently?, asks Dyer. Can its pleasure be invoked in non-narrative ways? Citing the non-narrative, non-linear lesbian sequences at the end of Chantal Akerman's *Je Tu Il Elle* (1974) as a praiseworthy exemple of an alternative representation of sexuality, he proposes that male pornography, which, for better or worse, has cornered the market on the representation of sexuality, ought to be used for the "education of desire," and the "experimental education of the body," and consequently, ought to think about absorbing some of the lessons of the experimental counter-cinema.[55]

This call for an "education of desire" is likely to resonate most seriously within the gay community, where the need for eroticizing representations of safe sex has been most paramount, where pornography is of central political importance anyway, and where its production and consumption is ethically marked by an equality of participation among producers, performers, and consumers that is still barely evident in the straight industry and market. But the call to "educate" desire, or anything else for that matter, is one which comes instinctively to intellectuals, all too willing to propose or act out their reformist zeal on behalf of others. Even if there can be no doubt about the urgent need, today, to think

about the framework of possibilities within which pornography can be used to address the issue of safe sex, it is still a surprise to find Dyer making such a proposal, since his work on popular culture manages so carefully to avoid the moral presumptions that usually accompany campaigns for "educational" reform.

What, then, is so different about pornography that it can be considered a respectful way to think about educating the popular body? One possible answer to that question is that the education of desire through pornography, however it is conceived and practiced, would have to involve *producing* pleasure, rather than *reducing* or combatting pleasure. Reform through pornography cannot proceed, at least with any hope of success, at the expense of pleasure, and, least of all, if it takes a militant path of anti-pleasure. Even the most carefully planned attempts are at pains to avoid any intrusive didacticism.

The Pick-Up (directed by Veronica Vera, 1987),[56] another production from Femme, is an example of a film which tries to educate desire by re-forming the narrative of a fantasy. A woman takes to the streets in search of a casual encounter, picks up an apparent stranger and takes him to her apartment for a sexual interlude, in the course of which she equips his penis with a condom and then proceeds with a long bout of oral sex, followed by "straight sex." After the pair have finished with sex, they drop the pretence of high anonymity and it is revealed, through their dialogue, that they are, in fact, married. Acting out a casual encounter is their way of stimulating a regular, and perhaps jaded, love life. Within the narrative, then, the condom used by the couple is a way of eroticizing the meaning of their private game. As for the viewer, if the oral sex scenario had not in itself succeeded in sufficiently eroticizing the condom, the completion of the narrative demands that the use of the condom becomes the *signifier* of eroticism in the film as a whole—the condom holds the key to the heightened erotic meaning of the encounter, even after it is revealed to be an otherwise orthodox, monogamous encounter.

But the film's credit sequence offers yet another layer of information. There, Femme Productions states that it "utilizes safe sex techniques except where the talent [actors and actresses] are real life lovers"—revealing, then, that this couple are *not* lovers in real life, only seconds after they have been revealed as regular partners within the fiction. The confused result may well be thought-provoking, but perhaps only because it throws any easy, affective reading into disarray. It also compromises the meaning of the condom, and possibly helps to dissipate any cumulative arousal on the part of viewers. In problematizing the narrative in this way, *The Pick-Up* is clearly presenting itself as an attempt to educate desire, but it is just as likely to achieve overkill, and demonstrates how and why education of this sort can often be a turn-off.[57]

One of the most fundamental obstacles that lies in the way of this kind of "education" is the gulf between the realm of real sexual activity, in which manners and mores can and probably ought to be changed in the struggle against sexual oppression and in the campaign for safe sex, and the less reformable realm of psychic reality and fantasmatic activity, in which "reform" already figures quite differently—in the complex network of defense mechanisms, and "censorial" secondary revisions of psychic material considered too dangerous to admit to conscious life. Pornography belongs to the realm of representation which mediates these worlds. It exists materially in the realm of real events, and is clearly a part of the way in which we *live* our sexuality in a sexually unequal world, but the stage of desire upon which its dramas and spectacles take place is psycho-historically constructed, for each of us, from the *reformed* props of psychical reality; vestigial, and thus only partially acceptable, memory traces of prelinguistic events, primal fantasies, scenes of violent origin and castration, fragmentation and destruction of corporeal unity, etc. This latter is the irregular and promiscuous stockpile of historical experience from which fantasy draws its narrative power to organize otherwise anarchic and conflictual psychic material into forms that are both acceptable and pleasurable.

Because pornography is directly addressed to the activity of fantasizing, proposals and agendas for its reform in the service of "education of desire" are obliged to take into account the intractability of psychic reality. Fantasy is, for the most part, the site of the impossible. The content of even the most conscious fantasies is often *only possible to incorporate because it is unlikely to occur in reality*. It is by no means clear, then, to what extent the conscious, let alone the unconscious, register of fantasy is one which is *directly* affected by, say, progressive changes in the social meaning of the representations or narratives which are the stimulus or source of fantasies.[58] In fact, the meaning of any such changes is just as likely to be redefined and transformed, often beyond recognition, in the process of being incorporated into already existing fantasy-structures. This is not to say that the unconscious does not *learn*; it just cannot be *taught* in any direct way.

While Dyer reminds us that "an art rooted in bodily effects can give us a knowledge of the body that other art cannot," we nonetheless know that the call for ideological "education" is most often directed at those low cultural forms—like pornography, cock rock, the weepie, the thriller, the slasher and other genres of horror—which, precisely, are aimed at the body and at an engaged emotional subject, rather than at the mind and at a detached, reflective subject. Pornography, it could be argued, is the lowest of the low, because it aims below the belt, and most directly at the psycho-sexual substratum of subjective life, for which it provides an

actualizing, arousing body of inventive impressions. That all of pornography's conventions of spectacle and narrative are mobilized towards this greater actualization of bodily impulses runs directly counter to the premises of higher cultural forms, committed to a progressive *sublimation* of these same impulses, whether in the provocative routines of erotica, in the exploratory, transgressive world of avant-garde permissions, in the bourgeois drama of passion and responsibility, or in the aesthete's realm of refined sensibility.

Finally, we must take into account the possibility that a large part of pornography's popularity lies in its *refusal* to be educated; it therefore has a large stake in celebrating delinquency and wayward or unauthorized behavior, and in this respect is akin to cultural forms like heavy metal music, whose definitive, utopian theme, after all, is "school's out forever." To refuse to be educated: to refuse to be taught lessons about maturity and adult responsibility, let alone about sexism and racism; to be naughty, even bad, but mostly naughty; to be on your worst behavior—all of this may be a ruse of patriarchy, a ruse of capitalism, but it also has something to do with a resistance to education, institutional or otherwise. It has something to do with a resistance to those whose patronizing power and missionary ardor are the privileges bestowed upon and instilled in them by a legitimate education. Surely there is a warning here for intellectuals who are committed today, as always, to "improving" the sentimental education of the populace.

Just Say No

It is quite common to find, in the correspondence columns of magazines such as *Hustler, High Society,* or *Penthouse,* letters from readers expressing their appreciation, and asking for just one more image of a pinup model who has given them especial pleasure. Sometimes the editors oblige (just as often they apologize for not doing so) and print a small image above the letter. Sometimes it is a familiar image reprinted, sometimes it is an unused photograph from the session; nothing is guaranteed, and this is a way of informing the reader that, in this business, he can't always get what he wants. But this is a message that the consumer of pornography is already supposed to know. Pornography plays to desires that are met with temporary gratification and with permanent longing. Bette Gordon, director of *Variety* (1983), a film about a female ticket taker in a porn cinema, puts it this way: "Pornography guarantees that representation will never fulfill desire while maintaining the desire for that representation."[59] Lacanian psychoanalytic theory has argued that desire, in general, is a condition founded upon a lack which it is

unable, but never ceases to try to fill. For the individual consumer, in constant pursuit of different images that correspond more or less exactly to his or her "taste," pornography provides more or less of a fit between the set of images it can offer and the demands of an individual libidinal economy. A temporary fit is arranged, which also generates a future desire for something more exact.

Given such conditions of consumption, it is no surprise that pornography is such a successful market commodity, fulfilling, with ease, the industrial need to reproduce its conditions of production, while its generalized "sex-effect" can and has been used to stimulate any and every other advertising market for which sexual stimulation is not entirely inappropriate. It is too one-sided to say, however, that the capitalist organization of pleasure through the use of sexy imagery is simply a commodity fix, planned to stimulate profitable demands and markets. Supply or production does not create demand; it has to intersect with needs and desires that already exist in order to be popular.

These are also the conditions under which popular taste responds to changes in the general ideology of consumption. As I write, such a change seems to be upon us, ushered in by the recent moral backlash which has tried to incorporate the antiporn campaign as part of its agenda. To begin to understand the nature of this change, certain large-scale patterns in the reorganization of capitalist society could be invoked.

As capitalist development increasingly came to depend upon the consumer ethic to stimulate the market and meet the needs of overproduction, hedonistic values that stressed the immediate pursuit of gratification replaced the ascetic values of thrift, frugality, restraint, sobriety, and delayed gratification that had marked the old nineteenth-century producer ethic.[60] For the new working and middle classes of our postwar period especially, the availability of a discretionary income brought with it the means to participate in a controlled form of libertinism, encouraged by the Keynesian premise that working-class consumerism would contribute to economic expansion. By the sixties, Marcuse was suggesting that consumer capitalism was creating new needs that it could not contain through its established channels of consent, but later amended his position to accommodate the thesis of "repressive tolerance." Under that amended doctrine, he argued that a new range of pleasures was being "permitted" precisely *in order* to exercise greater control over a mass population.

For example, the creation of new sexual identities and subjects in the liberation movements had only been possible under the conditions of late consumer capitalism; they were forged as much in new commercialized sites of courtship and in the popular marketplace culture of public consciousness as in the abstract body politic. At the same time, the market-

place played the part of visibly categorizing these new identities and desires, thus making it easier to manage and regulate them. In times of moral panic of the sort brought on by the AIDS crisis, we have seen how the low level, but intensive policing of the public life of sexual minorities is upgraded to more outrightly repressive levels.[61] The recent appearance of new kinds of identity—HIV-positive and HIV-negative—threatens to inaugurate a new level of policing *at the same time* as it provides resisting activists with especially legitimate grounds for getting their case heard.[62]

But the restraints imposed by public consciousness of AIDS have unhappily coincided with the latest phase of the New Right's decade-long backlash against liberal "permissions." The slogan "Just Say No" has emerged as an official imperative. Conceived and presented as a local curb on specific kinds of consumption (drugs ostensibly, because narcotic consumption tends to reproduce the conditions of destruction, not production) its prohibitive spirit has come to hover over a whole range of cultural activities—especially the unholy triumvirate of youth culture: sex, drugs, and rock 'n' roll. On the one hand, this moral agenda is a familiar, if contradictory, counterpart to the ideology of a free enterprise culture which, if pursued ad libitum, encourages an essentially anarchic marketplace in which all demands, desires, and acts of exchange, even including homosexual acts, are seen as legitimate. In addition to the imperative of moral order, however, there is also an economic principle at work behind this new prohibitionism.

In the face of the increasing polarization of class over the last decade and a half of deindustrialization, restraining orders have taken on a highly specific meaning for each sector of the new split-level economy, even as the shape of this economy inevitably reflects the overall decline in national production caused by capital mobility and capital flight overseas to cheap export platforms. The resulting class polarization has meant that large sectors of the employed population—the deskilled, and deunionized labor forces of the new service and hi-tech industries—have fallen below the economic level at which their buying power can any longer be stimulated by a consumer ethic. It is for them, as well as for the unemployed, that the message of "just say no" is primarily intended. And it is a message that arrives, masquerading as a authentic sigh of relief, since they increasingly lack the wherewithal to just say yes. For them, it is not only the moralistic message of a disciplinary recession, but also one that serves to "explain" their increasingly settled fate as victims of an intensive low-wage revolution that has produced a vast substratum of working poor, accounting for about one third of the national labor force.

For the members of the "professional-managerial class," which sustains, through what Mike Davis calls overconsumptionism, almost all of the markets of higher consumption, the message of restraint—just say

no—is intended, if at all, as an ironic warning about the visibility of their conspicuous consumption, lest it should appear as unwarranted greed to those who have limited access to consumerism.[63] Ironic, because the baby boom fraction of this class has been weaned on the sense of ironic detachment with which it views the paternalistic response of official morality to its youthful liberatory and libertarian codes. It is that class fraction for whom the stylistic adventure of postmodernist culture sustains many of its playful interests in fashion, image, taste, bodily narcissism, and radical chic.[64] It is that class fraction which, at the same time, is most likely to preserve and expand the sexual rights and freedoms that have been claimed, if not fully achieved during the sixties and seventies. And it is that class fraction who are still likely to see the bodily liberties with which pornography was once associated as a medium of sexual exploration and a source of modernization of ideas about sex in a climate, fueled by the AIDS crisis, in which sexuality becomes more rigorously policed by the day.

Most hard-core pornography, however, is still seen, consumed and produced by those who are on the underconsumptionist side of the line. Because of the massive incorporation of women into the low-wage sectors of the economy, and the decreased need for reproduction, the traditional procreative family has long been in disarray, and, in fact, officially underdeveloped among the unemployed poor. The sex industry itself draws much of its labor from mothers who cannot support their families. In the wake of the antiporn crusade and the censorial recommendations of the 1986 Meese Commission on Pornography, the threatened recriminalization of sectors of the sex industry promises to exploit its workers even further, while it nullifies the visible link between pornographic entertainment and prostitution which liberal lawyers were beginning to cite in favor of decriminalizing prostitution.[65]

Increasingly, however, we have heard the voices of women who often find sex work, however exploitative, to be more acceptable, even liberating, than other forms of labor that may be available to them. In this way does the sexual revolution proceed uneasily, side by side with the growing proletarianization of women in the labor force. As Amber Cooke, a professional stripper puts it, "our work is controlled, but what we do when we work isn't."[66] As sex workers organize or speak out, their complaints about borderline work conditions are balanced against the growing strength of their political sentiment. Here is Nina Hartley, well-known porn star and founder of a womens' support group (the Pink Ladies Club) within the industry:

> I find performing in sexually explicit material satisfying on a number of levels. First, it provides a physically and psychically satisfying safe

environment for me to live out my exhibitionistic fantasies. Secondly, it provides a surprisingly flexible and supportive arena for me to grow in as a *performer*, both sexually and non-sexually. Thirdly, it provides me with erotic material that I like to watch for my own pleasure. Finally, the medium allows me to explore the theme of celebrating a positive female identity—a sexuality that has heretofore been denied us. In choosing my roles and characterizations carefully, I strive to show, always, women who thoroughly enjoy sex and are forceful, self-satisfying and guilt-free without also being neurotic, unhappy or somehow unfulfilled.[67]

Members of the Canadian Organization of Rights for Prostitutes take a more militant stand:

As far as we're concerned, we're the only feminists around. We think whores are more conscious of feminism from a healthy perspective than most other feminists. The reason is that we're constantly interacting with men and conscious of where they're coming from, so in that sense we're really hearing them. . . . We have stood against a long history of abuse from other women and said, "Wait a minute. We will set up our own sexual standards, and we will not abide by this business of having to marry to get money." We are going to look head on, in a more liberated way than most feminists we know are able to do, at what sexuality is about, what male needs are really all about, what female needs are really all about, and the economy we have to work within, the commodity system that we have to work in, and we're going to say. . . . "we want power to negotiate a trade-off around a real human need (which belongs to women as well: women should be able to find it as well on the same terms). . . . " We're more realistic feminists. . . . We've confronted our own need, in a society that's a commodity system, realistically and head on. We have not succumbed to all the pressure to give men what they want on their own terms.[68]

This is the testimony of those who claim that their knowledge is a "working knowledge" of the mechanics of capital, labor, and desire which feminist intellectuals do not have. Their realism, compassion, and political will does not sit well with the antiporn model of false consciousness; their claims draw upon a knowledge—"we know better than anyone what is healthy and what is not healthy about our work"[69]—that appears to explicitly preempt the intellectual's recruitist call for re-education.

On the other hand, the picture of male clients and consumers which often arises from the testimony of sex workers is that of downtrodden, even broken and humiliated, victims of social and economic institutions. It is a defensive and often romantic view of the social victim as subordinate, and it plays into a heavily ideological conception of male sexual

needs. Accordingly, it tends to feed into and support a particular theory of popular culture which would see pornography, for example, as a symbolic or therapeutically cathartic resolution of its consumer's social problems and frustrations. According to this theory, the needs and desires of the porn consumer cannot be properly met by the existing institutions in which he works and lives, and his pleasure, consequently, is organized between, on the one hand, a restricted economy of frustration and oppression, and, on the other, the unlimited utopian haven of fantasy. In pornography as in the romance, it follows, then, that the generic narrative, while it works to offer the promise of a better world, beyond everyday dissatisfaction and powerlessness, consists finally in the essentially conservative *management* or *containment* of the pleasures that arise from such utopian fantasies.[70]

But this view does not wholly account for the autonomous pleasure offered by the very act of fantasizing, nor does it account for the production of user's fantasies that are neither wholly determined nor neutralized by the form of the containing narrative. In fact, much of the pleasure of fantasizing itself lies in possessing and exercising the *independent* power to shape narratives or segments thereof in ways which escape or diverge from the containing form. It is this capacity, for example, which no doubt explains the retention of particular erotic images, scenes, or moments in our recall memory. This independently empowering experience of fantasy offers real satisfactions, and not merely displaced or symbolic solutions to frustrations felt elsewhere.

The full significance, for pornographic consumption, of this limited realm of empowerment may have to wait until we have a properly audience-oriented study of pornography as a traditional "men's genre" (even as it becomes less and less gender-specific by the year), following the example of feminist studies of popular women's genres, like the romance, the soap, the weepie, and the sentimental novel. Such a study is sorely lacking, and has not been undertaken, I assume, not only because of male silence on this topic, but also because the antiporn critique has so dominated discussion of pornography in recent years, with its demand either for agreement or for a dissenting response on its own terms. As a result, there has been little room for the kind of cultural study that would survey the various uses made of pornography by its consumers.

Judith Becker and Ellen Levine, the women on the Meese Commission who wrote a dissenting statement on the conclusions of the Report, point out that it was almost impossible, under the conditions of the Commission's public forum, to find people willing to acknowledge their pleasurable consumption and use of pornographic materials.[71] This is a great loss, since such testimony would tell us many things. It would tell us a good deal about how capitalism's production of marketed pleasure

is variously rearticulated through people's own imaginary relations to the daily round of work and leisure. It would tell us how people variously respond to the invitation to think of their bodies as a potential source of achieved freedom, rather than a prison house of troublesome bodily functions or a pliant tool for the profitable use of others, whether patriarchs or capitalists. It would tell us how and why people are attracted by, or feel they are entitled to a different morality than that laid down by the appointed or self-styled intellectual protectors of the public interest. It would tell us what people say they do and think about a world of represented pleasure, marked in some way as illegitimate or unrealizable, and imagined on their behalf by a far from monolithic culture industry. In short, it would tell us how and why pornography is not always what it says it is.

For intellectuals, what is at stake specifically in an inquiry of this kind is a cultural politics which seeks to *learn from* the forms and discourses of popular pleasure, rather than adopting or supporting a legislative posture in the name of the popular. What intellectuals stand to learn most from this are lessons in self-criticism, especially with respect to their habitually recruitist or instructional posture in the field of popular correction. These would be lessons about power, especially about the by no means simple relation between sexual inequalities and social inequalities, and lessons about the business of contesting popular meanings without speaking from above. In addition, there is the chance of learning how to avoid being locked into perpetuating the weary circuit of victimization and redemption of those very social subjects who are still associated, from moment to moment, with terms like "popular," and "mass." As usual, it is in the name of their protection and in the name of their interests that the recent national clampdown on pleasure is being waged. As usual, it is they who are being told that it's for their own good to see pleasure as bad.

SAVE SEX—a T-shirt slogan I have seen being worn recently—evokes the kind of mixture of pathos, resentment, and struggle that probably ought to be mobilized around the increasingly endangered species of pleasure in an age of AIDS. As the sex panic mounts daily, fomented by antiporn intellectuals, fundamentalist pressure groups (and even the threat of an ugly reappearance of puritanism on the left, reviving traditions of discourse that are long on virile militancy and short on pleasure), pleasure is no longer simply an issue for libertines and lifestyle gourmets to squabble over. Increasingly under attack in the late eighties, pleasure may yet become a popular political issue. Now that sexual pleasure in particular is explicitly tied to matters of life or death, it is AIDS and not pornography per se (a far from mutually exclusive relation) that will be focusing our available attention and energies on the triangular power

relationship between bodies, representations, and the State—a Bermuda Triangle where people are quite literally disappearing. It is under the threat of that annihilation—under the worst possible conditions—that new and different social relations to the body and to pleasure will have to be imagined without the guarantee of knowing in advance whether they are right or wrong.

7
Defenders of the Faith and the New Class

> We alumni and alumnae of the colleges are the only permanent presence that corresponds to the aristocracy in older countries. We have continuous traditions, as they have; our motto, too, is *noblesse oblige*; and, unlike them, we stand for ideal interests solely, for we have no corporate selfishness and wield no powers of corruption. We ought to have our own class-consciousness. "*Les Intellectuels!*" What prouder clubname could there be than this one. . . . (William James, addressing the Association of American Alumnae at Radcliffe College, 1907)

> What we often find is that the intellectuals, the educated classes, are the most indoctrinated, most ignorant, most stupid part of the population, and there are very good reasons for that. Basically two reasons. First of all, as the literate part of the population, they are subjected to the mass of propaganda. There is a second, more important and more subtle reason. Namely, they are the ideological managers. Therefore, they must internalize the propaganda and believe it. And part of the propaganda they have developed is that they are the natural leaders of the masses. (Noam Chomsky, at the Universidad Centroamericano in Managua, Nicaragua, 1986)

There has long been, and still is, an unlikely consensus among certain voices from the right and the left about the intrinsic evils of new technologies and the monstrous mass cultures to which they give birth. For the right, this demonology takes the form of a brutally mechanical possession of the last cultural outposts of high civilization. For the left, the specter of hypercapitalism is omnipresent, looming up behind the cretinizing, stupor-inducing cultural forms produced by a dying system in the last desperate throes of economic and ideological reorganization.

Both strains of thought share a generally pessimistic view of cultural decline hurried on by the forces of technological rationality or determinism. As the reign of cybernetics sets in, and an information society is installed as the latest answer to the crisis of overproduction, there is little

sign of that conservative-radical consensus weakening, and, in fact, every indication that it will make for stranger bedfellows yet. What should be clear by now is that such a consensus works against the kind of engaged or "respectful" contestation of popular meanings which this book finally seeks to endorse. In fact, it is a consensus that alienates those who are most likely to be involved in mounting this kind of contest; intellectuals, whose sense of political persuasion and action is not Platonically discrete and is thus not divorced from the daily contradictions of life in a techno-logically advanced, consumer culture; and second, public consumers of culture (which must also include the former) who are self-consciously active in their pursuit of popular options, and creative in their uses of them.

Today, as the cult of knowledge and expertise presides over the inter-nationalization of the information revolution, and the universities absorb all forms of intellectual activity, it is equally clear that the mantle of opposition no longer rests upon the shoulders of an autonomous avant-garde: neither the elite metropolitan intellectuals who formed the tradi-tional corpus of public tastemakers or opinion-makers; nor the romantic neo-bohemians who shaped the heroic Nietzschean image of the unat-tached dissenter, committed to the lonely articulation of social truths; nor the organic party cadres whom Lenin shaped after the model of the "professional revolutionary." Social movements on the semi-periphery of the multinational economy have, for some time, been organizing their own efforts to change history, thus rejecting the traditional leninist role of leading intellectuals.[1] In addition, it has been argued, most cogently by Foucault, that "technical" or "specific" intellectuals, whose purview of political action is linked to specific struggles that demand their specific knowledge and expertise, must increasingly form the basis of decentral-ized opposition. From the time of the first postwar pressure groups against the development of the hydrogen bomb, it has been scientific intellectuals rather than humanists who have been at the forefront of this professional activism.

But for professional humanists, to whose number I belong, and whose services are more marginal than those of scientists, the stakes are no less crucial. Our specialist influence over the shaping of ethical knowledge and the education of taste has become an important area of contestation within the academy, the number one site of credentialism and legitima-tion. As a result of developments in the new "social history," the humanist curriculum is increasingly open to popular histories and popular culture, while expanding its critical attention to cultural forms based on the experience of women, people of color, gays and lesbians. Pragmatic histories of the oppression, survival, and struggle for legitimation of marginal groups have begun to erode the massive cultural power gener-

ated by the traditional idealist histories, histories which depict the moral struggles waged by heroic individuals in order to save Western civilization from successive "barbarisms."

The decline of that version of traditional humanist "idealism" means, of course, that the student upheavals of the sixties won't happen again, at least not in the same way. For many of the students who participated in the culture of dissent in the sixties, it was the high idealism of a bourgeois, humanist education—with its preachy disdain for technology, popular culture, and everyday materialism—which directly inspired their resistance to taking up what they saw as largely predetermined roles in the technostructure. The balance of a humanist education has shifted in the wake of, and largely because of, these developments in the sixties, just as the left has gained a foothold in university faculties everywhere. What was once exclusively thought of as the education of taste now draws upon many different schools of ethical action, informed not by "universal" (i.e. Western) humanist values, but by the specific agendas of the new social movements against racism, sexism, homophobia, pollution, and militarism. All too often, the achievements of this new specialism have run up against the same reactionary consensus of left and right, each unswervingly loyal to their respective narratives of decline: charges of post-sixties fragmentation and academification from unreconstructed voices on the left, and warnings of doom and moral degeneracy from the Cassandras of the right.[2]

As humanists and social scientists, we have also begun to recognize that the often esoteric knowledge which we impart is a form of symbolic capital that is readily converted into social capital in the new technocratic power structures. Social differences are everywhere "explained" and justified by differences in education. In a socially unequal world that is classified hierarchically by categories of taste, it is the cultural capital accumulated through an institutional education which legitimizes these categories and systematically invests this pathologically stratified spectrum of taste with an ineluctable power not unlike that conferred by natural religion.[3] What is our most available guarantee of challenging this *system* of cultural power?

One of the answers lies in a thoroughgoing classroom critique of taste which draws upon forms of popular and minority/marginal culture in ways that explode the "objective" canons of aesthetic taste rather than simply reinforcing or expanding them by appropriating, as a new colony of legitimate attention, cultural terrain that was hitherto off-limits—an exotic source of fresh texts to be submitted to yet another round of clever formalist "readings." This means challenging the categorical function of canons rather than simply changing the nature of their contents. It involves cutting across the pathological spectrum of socially coded tastes

and desires, rather than merely arguing that there is more room on the
boat for newly legitimate ones. In short, it requires the kind of interven-
tion that overtly exposes the role that is functionally allotted to taste
within the system of the academic production of knowledge, prestige,
and privilege.

In addition to the need for such a critique of taste, we must also
recognize that technology today offers itself to the student adept in the
form of a clean machine; it does not carry the smoky taint of "trade" that
once earned the reproachful scorn of bourgeois idealism and which
governed the anti-technologist ethos of the humanistic heritage. On the
contrary, the new danger presented by a cybernetic culture is that its
apprentices see the gleaming Panglossian promise of technological su-
premacy as their naturally inherited realm of power. Those who doubt
this promise will do so because they may judge their inheritance to be
at odds with the conditions of its production, perhaps through their
recognition of the conditions of chip-making female labor in Asia. Or
they will come to resent the sublimation, into the command-control-
intelligence structure of the corporate-military hierarchy, of a power that
they consider to be the privileged domain of their own expertise. Or they
will recognize how the libertarian vision of shared information coexists
today with the endlessly integrative use of the new technology for moni-
toring and surveillance the everyday activities and transactions of mass
populations—in short, the capacity to turn information into intelligence.
Or they will have seen how their bodies are contracted and pledged, as
McLuhan put it, in "servo-mechanistic fidelity" to the new technology.

Either way, the new cyberpunk youth counterculture is already one
that is being constructed out of the *folklore of technology* and not, as was
the case in the sixties, out of the *technology of folklore*. Not out of Orientalist
fantasies and agrarianist nostalgia, or from the faded wardrobes of prein-
dustrial laborers, gypsies, or peasants, but rather, out of the postpunk
landscapes of the new science fiction, the vestigial romances of the hacker
ethic, and the fluid, makeshift vitality of zine subcultures and electronic
bulletin boards.[4] From the technofunk street rhythms generated by the
master-DJ's of scratching, mixing, and matching, to the neurochemical
sublime of body/machine interfaces, the new appropriation culture every-
where feeds off the "leaky" hegemony of information technology—a
technology that must always seek out ways of simulating prestige for its
owners because its component architecture does not recognize the con-
cept of unique ownership of "electronic property."

Today, a code of intellectual activism which is not grounded in the
vernacular of information technology and the discourses and images of
popular, commercial culture will have as much leverage over the new
nomination of modern social movements as the spells of medieval witches

or consultations of the *I Ching*. The risk of any direct rapprochement with technology and popular culture, of course, is that intellectuals will stop worrying and learn to love whatever IBM and CBS throws at them—a scenario that has already been staged in the debate about postmodernism, and which conventionally goes under the description of "throwing the baby out with the bathwater." But moments of change and reinvestment of cultural energy, especially those ushered in by new cultural technologies, are never just moments of replication, reproduction, and further domination. They are also moments of reformation, when opportunities exist to to contest, reconstruct, and redefine existing terms and relations of power as part of the task of modernizing cultural resistance.[5]

To enter into that process demands a working familiarity, as Donna Haraway has argued in her "Manifesto for Cyborgs," with "the informatics of domination" that are now in place everywhere: the home, the workplace, the market, the public media, and the body.[6] Among other things, cyborg politics denies us the assurance of a tidy division between the utopian, unalienated organic body and the oppressively rationalizing regime of technology. Rather, it is a contest for that new impure space which is neither organic nor mechanical, neither manual nor mental. So too, the growth of a "smart" information culture necessitates a politics of knowledge in which the contest is often to know who or what is being outsmarted, why, for what reasons and by whom. As always, popular culture is the source for most people of the "common sense" that ideologically absorbs and demystifies the specialist discourses that saturate these new technologies of knowledge. Intellectuals who see their task as encouraging and developing that side of "common sense" which harbors structures of disrespect and resistance to privilege and authority are faced today with a new set of contradictions—in encouraging resistance to the privileges of "smartness," they find themselves lined up against the order of cultural capital which is the basis of their own authority as contestants in the social world. This is where the historical confinement to the political margins of the fraught relationship between intellectuals and popular culture now moves onto center stage, in a social order increasingly answerable to the authority of knowledge and increasingly administered by knowledge castes.

Autonomy in Question

In order to more fully represent the grounds of intellectual activism today, it is necessary to look briefly at some of the history of the various intellectuals' traditions in the West. Due to lack of space, what follows is

a condensed outline of that history, focused around an often crude characterization of the ideologies that have sustained that history.

By the time of the sixties, Cold War liberals who had cut their political teeth in the thirties were being charged with accommodationism in their role as legitimists for the anti-communist posturing of the National Security State. How could this legitimist role be reconciled with the "intellectuals' tradition" of an independent elite engaged in the disinterested pursuit of social truths?

In a discussion of his famous notion of an "adversary culture," in the preface to *Beyond Culture* (1965), Lionel Trilling points to some of the contradictions that had arisen out of this historical mutation. Responding to a reviewer's criticisms of the "we" which he frequently employed as his essayistic personality, Trilling claimed that this "we" did not refer exclusively to the New York Intellectuals, as had been suggested in the review, nor should it be taken to simply represent "the temper of the age." For the most part, it reflected the taste and assumptions of a "populous group whose members take for granted the idea of an adversary culture" which stands "beyond" and "against" the cultural conditioning of the larger society. If this *transcendent* position seems to be part and parcel of the tradition of intellectual autonomy in the West, Trilling nonetheless suggests that his "populous group," conceived in sheer numerical terms, may now have a social structure that is different from the traditionally powerful-because-powerless intellectual elites. So populous is this group, he claims, that it is now virtually a "class" with its own "internal contradictions."

Although he does not use the term, Trilling is nonetheless referring to what neoconservatives, at that time, were beginning to label as the "new class," rising up in the new university-based knowledge society. From his own point of view, as a humanist intellectual committed to the critical ideal of "autonomy of perception and judgement," the contradictions arise out of the way in which this new class raised itself upon the ideal of autonomy, and yet now, as a class *qua* class, has developed common and "characteristic habitual responses." It even seeks to aggrandize itself by perpetuating these shared, characteristic responses and interests, thus putting in question the relation of its individual members to the important role played by the ideal of autonomy "in the history of its ideology."[7]

While the studiously cautious Trilling was less willing to address these contradictions head-on, it is important, at least, that he names the game here, in acknowledging the problems of massification facing the "adversary culture" in the mid-sixties. In fact, the internal contradictions of Trilling's "populous group" can be seen as the result or *confluence* of at least three different theories or traditions of thinking about intellectuals;

what I shall refer to, in turn, as the doctrine of defenders of the faith, the doctrine of the responsibility of intellectuals, and the theory of the new class itself.

To initiate discussion of these theories, we might ask three questions of Trilling's position. First: If the criteria for establishing "autonomy of perception and judgement" are not socially determined, then to what higher authority do they appeal? Second: Is an adversary culture incompatible with the idea of a "populous" or non-vanguardist constituency? Third: Is a class which raises itself on the ideal of autonomy not also an imaginary class which lifts itself (the Munchhausen effect) by pulling on its own hair?

Defenders of the Faith

The first question, about autonomy from socially determined criteria, relates to what I will call the doctrine of "defenders of the faith." Edward Shils, Talcott Parsons, and Regis Debray have all described, albeit with different aims and emphases, how the social functions of the medieval clerisy are still vestigially present in the modern idea of the intellectual.[8] As a relatively unattached, classless stratum (to cite Karl Mannheim's enduring but ever-contested definition), confined to the "pure," as distinct from the "applied," branches of the humanist and technical intelligentsia, the quasi-religious function of defenders of the faith is to eschew all partisan involvement in the name of a devotional commitment to higher principles—God, Art, Science, and other "institutions of truth." If their work and thought happens to have practical political effects, this is because it is genuinely prophetic, and not because it bends under pressure from a secular, institutional patron. This is not to say that intellectuals ought never to voice political sentiments or opinions, but that they should only do so in their capacity as citizens and not as *ex officio* intellectuals.

Breaching this contract with the sacred results in what Julien Benda famously called the *trahison des clercs*, a treason which was higher, of course, and thus more serious than treason committed toward a country or a lay power. But Benda's largely negative definition of the disinterested pursuit of the ideal ("my kingdom is not of this world") constitutes the weak argument for the defense of the faith. The strong argument emerges at moments when intellectual speech is compromised in the face of outright repression—Zhdanovism, McCarthyism, Maoism. And the doctrine begins to blur at the edges when it is invoked in debates about quasi-institutional issues like academic freedom, where the mythology of

intellectual freedom coexists uneasily with the more worldly codes of professional *esprit de corps*.

In general, those who subscribe to this doctrine accept that the intellectual is not only a "universal intellectual" in the sense in which he or she thinks and acts as the disinterested conscience/consciousness of society as a whole, but also that the existence of the intellectual is universal, in other words, that every society has and, presumably, must have, intellectuals, whether they are perceived as acting in an oracular, priestly capacity, or, as Rolf Dahrendorf suggests, as "fools," or court jesters, who are allowed to speak the truth in a "society of submissive courtiers."[9] Gramsci's description of "traditional intellectuals," whose onetime organic ties to a rising class have long since been severed, is a category that includes most of those who are in a position to present themselves as defenders of the faith.

The claim of disinterested loyalty to a higher, objective code of truth is, of course, the oldest and most expedient disguise for serving the interests of the powerful.

The Responsibility of Intellectuals

Trilling's notion of an "adversary culture" derives from the doctrine of the "responsibility of intellectuals," which, in many ways, is a historically and politically specific version of the defense of the faith. At a particular point in history, "free" intellectuals began to recognize themselves as a self-conscious collectivity—the intelligentsia—cognizant of their influence upon political opinion and events. The emergence of this group as an oppositional elite of necessary dissenters, most notably in the nineteenth-century Russian intelligentsia (and, more important for the West, in the "*Manifeste des Intellectuels*" issued by the Dreyfusards), underlies the assumption that an intellectual will necessarily be oppositional or left wing, an article of faith later consecrated in Sartre's theory of the artist as *engagé*.

The perceived "responsibility" of the Russian intelligentsia would soon be institutionalized in the form of an avant-garde revolutionary consciousness. Lenin's *What is to Be Done?* initiated what was to be the doctrine of the vanguardist Party elite in calling for intellectuals to become "professional revolutionaries" and to systematically train themselves for the task of fusing theory and consciousness with the spontaneous labor movement. Much earlier, anarchists like Bakunin had been issuing dire warnings about the consequences of institutionalizing the intelligentsia into a new ruling class; it would produce "the most aristocratic, despotic, arrogant and elitist of all regimes." For when a class rules in the name of knowledge and intelligence, the uneducated majority, he thought, would

suffer more oppression than ever before, a prognosis repeated and fleshed out by the experience of the Yugoslav dissident Milovan Djilas in his influential *The New Class* (1957). By the thirties, Soviet scientists and engineers had long since displaced the humanistic intelligentsia as the vanguard of post-revolutionary development, and so we find Gorky berating his fellow writers for not experiencing the new technological advances first-hand, and for not writing about "the thousands of workers engaged in the construction of the Volga-Moscow Canal."[10] Forty years later, in line with Alex Nove's contention that today's "working intellectuals" of the Soviet state bear as little resemblance to the Stalinist apparatchik as that historical specimen did to his revolutionary predecessor, Noam Chomsky was to find little difference at all between the centralized Soviet State bureaucracy and the ruling technostructure of American society, exercising its power through universities, government, research foundations, management, and big law firms.[11]

It was the idea, however, of a *noninstitutionalized* avant-garde that shaped the Western and, particularly the American history of thinking about the "responsibility of intellectuals." The four most significant moments of this American history which I shall consider briefly are the Progressivism of the pre-war and postwar years, the radicalism of the thirties, Cold War liberalism, and the New Left of the sixties.

The assault, in the years before the Great War, on the genteel tradition of the Boston Brahmins saw the formation of a Progressivist intelligentsia—Herbert Croly, Van Wyck Brooks, Randolph Bourne, Lewis Mumford, Waldo Frank—around journals like the *New Republic*, *The Seven Arts*, and *The Masses*. Pledged to protest the bigness of monopoly capitalism, and to resist the logic of industrialization, their independently responsible brand of cultural criticism was based upon an organic, preindustrial ethic, and, with the exception of Bourne's interest in socialism and internationalism, their sense of a "usable past" looked to hopes of a revival of cultural nationalism which would unite the divided sensibility of "Highbrow" and "Lowbrow," Brooks's terms for "culture" and "trade." Bourne, in particular, lambasted the pragmatism of liberals who had eschewed their responsibility as independent intellectuals by "directing" public support for the war effort; "[they] have learned all too literally the instrumental attitude towards life, and . . . are making themselves efficient instruments of the war technique."[12]

By the thirties, the tradition of "intellectuals' responsibility" was sufficiently established for its core element—the desire to actively promote historical change—to have been supplemented by a sense of duty to respond to the cause of an adversarial politics. The appeal of organized socialist initiatives across a wide spectrum of American intellectual life should never be understated. An early high point of the cause was the

open letter endorsed by fifty-two intellectuals, some Communists, some Socialists, and most independents, which announced their intention to vote for the Communist candidates, Foster and Ford, in the 1932 election. A robustly written pamphlet, entitled "Culture and the Crisis," and addressed to all writers, artists, intellectuals, and professionals who believed that the political system was "hopelessly corrupt," was co-signed, among many others, by Sherwood Anderson, Erskine Caldwell, Malcolm Cowley, Lewis Corey, Waldo Frank, Granville Hicks, Sidney Hook, Langston Hughes, Matthew Josephson, John Dos Passos, James Rorty, Lincoln Steffens, and Edmund Wilson. Anti-fascism, from 1933, was a decisive recruiting factor for intellectuals born again as literary shock troops or as cultural technicians for the Party.

For many key intellectuals, however, the moment of solidarity with the Communists lasted no more than a matter of months, and had fallen away long before the nationally organized League of American Writers replaced the local John Reed Clubs in 1935, and the Writers' Congresses convened in 1935 and 1937. While the Popular Front organizations won widespread middle-class support, and attracted active membership among writers and media and culture industry professionals in the later thirties and throughout the war years, the more glorified trajectory of cultural critics was one of apostasy, or involvement with the various Trotskyist opposition groups and parties, and thus of critical and increasingly hostile independence from the Communist core of the radical movements. The official dissociation and estrangement of the influential *Partisan Review* critics (Philip Rahv, William Phillips, Dwight MacDonald, F.W. Dupee, Mary McCarthy, Lionel Trilling, Sidney Hook, Meyer Shapiro, Clement Greenberg, Harold Rosenberg, Lionel Abel, among others) from the CP in 1937 is most often cited as the model for responsible intellectuals, mindful of their autonomy and their vocation to stand in opposition, especially within the left itself.

More important, the anti-Stalinist, and especially the Trotskyist left, was the natural home for intellectuals with a penchant for high culture and cosmopolitan taste (Trotsky himself was a highly cultivated and cosmopolitan literary critic who had long been skeptical about the potential of a "proletarian culture"). In contrast with the *Partisan*'s endorsement of the brilliant spirit of the European avant-garde, the Popular Front agenda for a people's culture was made to appear parochial and small-minded, a middlebrow version of cultural nationalism that seemed second-rate when set beside the impressive pantheon of high modernists espoused by the anti-Stalinist left. This high-mindedness on the part of the anti-Stalinists was underscored by a deep suspicion of the native radical tradition, with its roots in rural populism and its rhetoric of democratic values which the "Americanized" CP was trying to cultivate.

During the war years, the *Partisan* group increasingly saw themselves as an isolated elect, solely responsible for the preservation of cultural value, holding the line between civilization and barbarism. Although they were theoretical marxists, their code of responsibility was less and less to a political cause, and more to the redeeming source of high literary tradition in the West at the moment when the European home of that tradition had either come under, or was threatened with, Nazi occupation.[13] Many of those who were disdained or attacked by this self-celebrating elite (Rahv's private comment is not untypical: "we're half dead. Most of the people today are all dead")[14] saw the *Partisan*'s trajectory as one of retrenchment. Yet it clearly grew out of the contradiction between the vanguardist prescriptions of orthodox marxism and the ideology of intellectual freedom espoused by defenders of the faith; between the revolutionary model of party leadership and the independent ideal of devotion to art as a haven of autonomy.

As the thirties wore on, the intensive courting of celebrity intellectuals by the CP was often caricatured as a demand that intellectuals should de-intellectualize and submerge themselves in the service of a mass revolutionary movement, an imperative that seemed to push up against the very limits of the doctrine of intellectual "responsibility." After the famous Waldorf conference of 1949, probably the last attempt to revive Communist support among American intellectuals, Irving Howe asked: "What are the drives to self-destruction that can lead a serious intellectual to support a movement whose victory could mean only the end of free intellectual life?"[15] Howe's target is obvious, but behind his question lies certain assumptions about what it means to be a "free intellectual." Increasingly, the anti-Stalinists' acid test of the serious intellectual life was the capacity to choose an independent path that transcended all ideological alignment. This tendency went hand in hand with their espousal of the enduring premise of classical marxist aesthetics (from Marx to Althusser) which holds that the best or the most genuine high culture creates a space that is relatively free of ideology, and can thus transcend the determining influence of social forces felt in lesser, or inferior kinds of intellectual production. Transcendental autonomy then becomes the only guarantee of critical or negative art, just as the intellectual's independence is the only guarantee of critical integrity in dissent. "Freedom," "independence," and "autonomy" all become lofty fetishes in a new defense of the faith, while organic ties to other social communities and movements are abandoned.

Consequently, *responsibility* became redefined as the protection of an intellectual's "freedom" at all costs. The extent to which this redefinition lent itself to more accommodationist positions was made quite clear in the postwar years, when many figures on the anti-Stalinist left became

increasingly responsive to the Cold War cause of protecting "freedom" in the West. Anti-Stalinism mutated into Stalinophobia, and the anti-Communism of onetime revolutionary marxists laid the basis of future careers, for many, as professional anti-communists.[16] In the transformed political climate of the Cold War and the National Security State, this shift in alignment helped to legitimize domestic repression before and during the McCarthy years. As for foreign policy, the CIA-funded Congress for Cultural Freedom and its American affiliate, the American Committee for Cultural Freedom, were founded as quasi-official organizations for intellectuals to indirectly engage in what became known as Cultural Cold War, responsible for protecting "free" Western intellectuals from the contagion of socialist ideas. With publishing organs in many different countries—*Der Monat*, *Preuves*, *Encounter*, and *Tempo Presente*—and with a host of sympathetic journals at home, including *Partisan Review* and *Commentary*, the anti-communist Congress enlisted the services of many of the well-known liberals of the day. While there were some anti-Stalinists like Howe and MacDonald who resisted the dismantling of class politics, the prevailing mood was such that the domestic "responsibility" of Cold War liberalism was directed towards cementing the postwar settlement between capital and labor and promoting the climate of consensus that rested upon the ideology of liberal pluralism.

Many reasons have been cited for this accommodationist move on the part of intellectuals: the new prosperity, greater ethnic tolerance, the rewards and recognition of academe, preservation of civil liberties (with the notable exception of Japanese-Americans) during and after the war, an intimacy with the State which had begun with Rexford Tugwell's Brains Trust (the "Phi Beta Kappa revolutionaries" of Roosevelt's first administration) and so on.[17] Moreover, the Cold War was, after all, an *adversarial* cause, and no doubt this made it easier to recognize as an intellectual's cause. The vocabulary of opposition remained intact, the sense of a militant critique was preserved, even if its target had been switched from capitalism to communism. Intellectuals were still being *responsible*, and the elective heroism of their own individual choices was upheld with the ceremonial importance to which they had become accustomed. Thus, the public "confessions" and "defections" of recalcitrant radicals in the Cold War were periodically reported as events of great significance: from Dwight MacDonald's "I Choose the West" in 1952 to Susan Sontag's public recantation in 1982.

Whether one saw it as apostasy or enlightenment, the practice of choosing between mutually opposed positions may have been the most exulted component of the classical doctrine of responsibility, and it served the perpetuation of Cold War doctrine in no less obvious ways. In fact, the doctrine's emphasis on the imperative of making such heroic choices

and shifts of commitment fitted the Manichean mold of the Cold War perfectly: revolution or reform? autonomy or accommodation? good or evil? bolshevism or menshevism? us or them? freedom or slavery? In other respects, it is what could be called a macho tradition, mobilizing the hard-boiled rhetoric of virility which opposes militancy to sentimentalism, "hard" to "soft," realism to utopianism—a set of oppositions where capitalism/communism can be lined up on either side, depending on the speaker and context. Typical among the memoirs of the Old Left are descriptions, like this one by Daniel Bell, of the struggle of good men and true in the thirties, when all the irons were in the fire: "In some the iron became brittle, in some it became hard; others cast the iron away, and still others were crushed" (the "iron," of course, signifies a commitment to Stalin, man of steel).[18]

For the most part, the New Left set out to willfully disassociate intellectual radicalism from such masculinist *rites de passage*. This did not mean eschewing militancy, of course. In fact, putting one's body on the line for the SNCC became the model, for the next decade, of personal commitment to direct action and the politics of confrontation. Nor, ironically enough, did this tactic guarantee any immediate refinement of the level of sexual politics, for the increasingly pronounced emphasis on generational difference meant that much of sixties activism played out the masculine Oedipal spectacle of the politics of parricide. Nonetheless, the organic social movements which arose at the tail end of the sixties, organized around gender, ethnicity, sexual orientation, and ecology, were directly predicated upon the values of community, liberation, and personal empowerment that had been learnt in the initial civil rights phase of the New Left. This attention to personal, liberatory values was a major element in redefining responsibility in terms that either addressed the body directly, or else enlisted the mind and psyche as media of self-transformation rather than as tools to be harnessed to objective political causes.

When its founding ethic of participatory democracy later came to coexist with anarchism, student syndicalism, native utopianism, "progressive" leninist workerism, and the whole rainbow of countercultural crusades, the New Left was no more unified than the Old Left, with its bewildering spectrum of sectarian groups and parties, had ever been. What was quite different, however, was the new attention to micropolitics—the pervasiveness of political choices and decisions to be made at the level of everyday life.[19] A revolution in style, sexuality, and personal expression characterized the new grammar of dissent and the new modes of political action in ways that did not appeal to the lofty sense of *cultural authority* which had sustained Old Left intellectuals.

To the older liberal generations, this new ethic of responsibility was an abdication of responsible behavior, the new spirit of civil disobedience

was, more often than not, loutish disrespect, and the "politics of the personal" represented a lack of the discipline necessary for taking on and making sense of the burden of history. Irving Howe gives a mandarin outline of the new culture, founded, as he put it, upon the "psychology of unobstructed need":

> The new sensitivity is impatient with ideas. It is impatient with literary structures of complexity and coherence, only yesterday the catchwords of our criticism. It wants instead works of literature—though literature may be the wrong word—that will be as absolute as the sun, as unarguable as orgasm, and as delicious as a lollipop. It schemes to throw off the weight of nuance and ambiguity, legacies of high consciousness and tired blood. It is weary of the habit of reflection, the making of distinctions, the squareness of dialectic, the tarnished gold of inherited wisdom.[20]

Howe's caricature of fast-and-loose irreverence was a typical generational response to a culture self-consciously devoted to liberatory or utopian moments grounded in the bodily present as opposed to the hard, guilt-ridden school of cultural maturity that was currently equated in the milieu of youth politics with atrophy. More important, however, the appearance of an adversary culture that was not an elite or minority culture, tied to a movement that was trying to eschew vanguardist structures of political authority, proved too much of a paradox for the older liberal elite that, for twenty-five years, had jealously guarded its territorial purchase on the adversary tradition, and who had excoriated all other competitors in the field.

As I have suggested, the doctrine of the "responsibility" of intellectuals is, in many ways, a more worldly and secular expression of the doctrine of "defenders of the faith"; it has a specific history, and is tied to a specific politics of opposition, while the non-partisan "defenders" are expected to keep the faith universally throughout the ages. Like the latter, however, its strongest arguments emerge in moments of ultimate crisis when the faith itself is under threat of compromise, perhaps most conspicuously over the issue of support for the cause of war. Breaking with his mentor Dewey, and the *New Republic* progressives who had decided to actively support the war effort, Randolph Bourne bitterly accused his fellow intellectuals of facilitating the decision to enter an imperialist war, "a war," he melodramatically proclaimed, "made deliberately by the intellectuals!"[21] In 1940, Archibald MacLeish censured "the irresponsibles" for not rallying quickly and actively enough behind the anti-fascist Popular Front cause, bolstering, as a result, the climate of appeasement for Hitler.[22] Debate about the Cold War crystallized around the sins

of McCarthy—the anti-Stalinists again being guilty of appeasing this monstrous inquisitor—and was revived in full by the publication of *Scoundrel Time* (1976), Lillian Hellman's memoirs. Most recently, the charge that the Cold War rhetoric of liberal anti-communism was "responsible" for the American intervention in Vietnam has issued from a chorus of voices, most volubly that of Noam Chomsky.[23]

As the scene of responsibility has shifted from Vietnam to low intensity conflicts in Central America, Chomsky has remained the most prominent advocate of the code of the responsibility of intellectuals, which, for him, distinguishes truly critical speech from the realm of merely pragmatic judgments. Consequently, he is the most vociferous critic of the expert and professional specialist whose knowledge and opinion is everywhere compromised by its links with credentialist institutions and foundations. His, by contrast, is the voice of the independent—somewhat romantic, even anarchistic, deeply moralistic, and exemplary of the model of the free-floating intellectual who can sacrifice all ties to class and body and institutional affiliation in order to speak the truth. Where the right to speak out is a form of power denied to most people, then, he maintains, "it is the responsibility of intellectuals to speak the truth and to expose lies."

The New Class

Where the "responsibility of intellectuals" could be said to describe the social function, as opposed to the institutional position, of intellectuals, the theory of the "new class" is directly addressed to the institutionalization of knowledge as power. This theory comprises a number of competing ideologies since there are several versions, each drawing upon a contested history of the middle-class strata recruited and trained at the end of the nineteenth century to manage the increasingly antagonistic relation between capital and labor.

At the heart of the pejorative neo-conservative critique of the "new class" was the fear born of the spectacle of student radicalism in the sixties; the fear that the adversary culture had far exceeded its habitual function as a necessary "stimulant" for what Joseph Schumpeter called capitalism's "vested interest in social unrest."[24] Norman Podhoretz's response to the widely circulated sixties pamphlet, *The Student as Nigger*, is quite symptomatic; "In what intelligible sense could these young scions of the American upper classes be compared to a group at the bottom of the American heap?"[25] Podhoretz's explanation of student radicalism accepted the terms of the discourse of "status anxiety" which had become the new religion and a substitute for class politics among the consensus

historians and sociologists of the fifties. Far from having been killed off by "kindness," he speculates that student disaffiliation was a direct result of a revolution of rising expectations fomented by the post-Sputnik promise to place the expertise of cultural capital above the rule of inherited wealth and property. Victims of their own resentment, however, students were "trying to tell us" that they were being denied their "fair share" of this promised power, and were therefore refusing to take up their allotted roles in the technostructure.

In offering this explanation, Podhoretz, as always, was probably saying more about his own personal resentment vis-à-vis power-sharing than anything else, but he prefigures a response that has become typical of neoconservatism—the inability to understand how and why those who are in a position to be rewarded by a system would want to challenge it. In fact, the "poverty of student life" (a Situationist phrase) was to be theorized in all sorts of unorthodox ways in the course of the sixties, not least in the perception that the multiversity was in the business of the assembly-line production of a "new working class," or servant class of middle-level, knowledgeable labor trained for the new technostructure. Theories of proletarianization aside, it should hardly have come as a surprise to Podhoretz, as a student of intellectual traditions, to recognize that intellectuals romantically express their sense of ideological subjection (Bourdieu sees them as the dominated fraction of a ruling class) and spiritual poverty by imaginary identification with those who are physically dominated and materially impoverished.

No more useful, however, was Bell's comparison of the New Left identification with black militants with "the young middle-class rebels of the 1930s ap[ing] the Revolutionary Proletariat."[26] It tells us nothing about the specific conditions under which *racial* oppression came to be a privileged metaphorical vehicle not only for white, liberal guilt—a major source of reexamination of class privilege on the part of the New Left— but also for other forms of cultural oppression, as in the later slogan, "Woman is the Nigger of the World." These identificatory affiliations, and others, like the active identification of gay men with feminist struggles by dressing up in Radical, or "hairy," Drag, were the symptoms of complex and shifting alliances, different in kind from the leading, directive influence of vanguard intellectuals over a "universal" mass movement that had been the activist model of the thirties. So too, they have to be read as responses to the legitimation crisis of masculinity, for which the "virility" of the black militant and the "drag" of the gay male feminist represent the extreme limits.

Besides, the diversity of the student movements cannot be profitably compared (at least not until the last violently elitist and sectarian days of SDS) with the more or less unified workerist cause of the thirties. These

movements were a critique of (at least) three different areas of social injustice: first, anti-war, the most traditional area of dissent, and the agenda which attracted the support of an increasing number of traditional intellectuals (from Dwight MacDonald, Mary McCarthy, and the *New York Review of Books* community, to policy intellectuals like Senator Fulbright) before it achieved widespread popular support; second, civil rights, the most newly legitimate and successful politics, and which increasingly lost the support of traditional white intellectuals as the militant Black liberation movements rose to prominence; and third, the politics of the university, the least understood of all, because it was the site of a new *politics of knowledge*, waged within the institutions that governed the production of knowledge. This last was a politics that comprised not only a structural critique of assembly-line education and pre-professionalism, but also a more general critique of the privileges of education, expertise, knowledge, and skill, and thus it was the one that most deeply challenged the sensibility of traditional intellectuals whose cultural authority and identity was raised on these privileges.

For those aligned with the liberal tradition, the concept of the "new class" meant something different from either the new, spiritually impoverished, middle-class "proletariat," C. Wright Mills's student "revolutionariat," or the neoconservative conspiracy picture of media and education institutions infiltrated and dominated by a fully credentialed party of opposition. Capitalism's overwhelming efficiency in recruiting and absorbing the adversary intelligentsia (viz. yuppies, New Age adherents, postfeminists) had found enthusiastic backers among liberals like Bell and Galbraith, who described the "new class," by contrast, as a benign technocracy of competently trained and institutionally proficient leaders, the beneficiaries of an orderly transfer of power to the rule of cultural capital.

In their version of the new class as a functional elite risen to power in the transition from a production-oriented economy to a postindustrial service economy, the primacy of theoretical knowledge is seen as both *just* and *justified*. Just, because a trained technical elite ought to be more rational in its management of power than a hereditary elite, and justified, not only because it distributes more evenly the share of access to power, but also because it simply promotes efficiency. The reign of the professional or expert, at least since the post-Sputnik drive to create a fully educated technocracy, had ceded its highest privileges to a technical intelligentsia. Because they believe that democratic capitalism has already accomplished, for the most part, its mission of safeguarding individual freedoms, and guaranteeing a minimum of social welfare, postindustrialists like Bell tend to describe the new technocratic class as a simple response to the benign needs of capitalism. A more diagnostic commenta-

tor might hold that government by experts keeps power in the hands of those with access to esoteric knowledge, and reduces the "excesses" of democratic accountability.

Any properly historical account of what is called the New Class, or the Professional-Managerial Class (a term more broadly accepted on the left) raises questions about its respective proponents' claims for coherence of class position or social function.[27] Such a history would reveal, for example, a common vision of rational, centralized planning, whether in the form of the "engineering of consent" espoused by the client capitalism of early advertising managers, committed to smoothing the way for a social contract between labor and capital, or in the form of the "engineering of ideas" embraced by technocratic radicals, committed to outright social emancipation.[28] But it would also reveal the contradictory political interests of such a "class." Self-grounded in the autonomy of its claims to plan and rule by reason and expertise, but also answerable to the historical need of monopoly capitalism for mediators or managers of class conflict. Elitist in its protection of the guild privileges secured by cultural capital, but also egalitarian in its positivist vision of social emancipation for all. Anti-capitalist in its technocratic challenge to the rule of capital, but also contemptuous of the "conservative," anti-intellectual disrespect of the popular classes. And lastly, of course, internally divided by antagonisms between administrative-managerial fractions and those aligned in some way with the value-oriented, anti-pragmatic codes of action and belief associated with liberal or radical humanism.

Any full consideration of these contradictions would undercut accounts of the smooth, inevitable rise of the new class which see the role of the intelligentsia, on the one hand, as a benign, managerial function of the modern state's affairs and needs (Bell, Bazelon, Galbraith) or, on the other, as a private vassalage of a corporate-state bureaucracy (Ewen, Chomsky), or, yet another, as neutral technocratic inheritors, according to the "iron law of oligarchy," of a vast degree of concentrated power.[29]

In *The Future of Intellectuals and the Rise of the New Class,* Alvin Gouldner presents a relatively uncluttered analysis of intellectuals as historical agents in a struggle with the old capitalist class for dominance and rule on the basis of knowledge, reason, and expertise. Does the new class bear any resemblance to what we would recognize as a ruling class? Not yet, says Gouldner, who sees the new class as a "flawed universal class" which is on the ascendant, and which "holds a mortgage on at least *one* historical future."[30] If it ever comes to be a ruling class, then it will be over the course of centuries, like the historical rise of the bourgeoisie. If, at present, it is a servant class, then that is because all classes are so before they achieve power. From Gouldner's perspective, then, Chomsky's contempt for the intellectuals' subservience to the power elites is a judgment of the intellec-

tuals that is ahead of its time, because it invokes moral standards that lie in the future, and which the intellectuals will one day be in a position to recognize and obey. For the present, their task is to establish and legitimize their own authority as groups who share symbolic capital, and who police the discursive rules which safeguard the property value of their knowledge-power.

While Gouldner's analysis makes it quite clear that the interests of this new class are tied to a will to power, it has less to say about the new forms of domination which the knowledge-power of intellectuals have come to exact upon those at the lower end of the hierarchy of knowledge. As the information society proceeds apace, and the expansion of databases and memory banks everywhere furthers the commodification of knowledge, concern about the new class polarization between "knows" and "know-nots" is manifest in the ways in which these new forms of domination supplement, if they do not displace, traditional capitalist modes of appropriation and exploitation; one-third of American citizens are functionally illiterate. In other words, the increasing symbolic domination of the information-rich over the information-poor is not at all confined to merely "symbolic" effects.

For over fifty years now, the discourses specific to symbolic domination have been most evident in the debates among intellectuals about popular culture, or mass culture as it is termed by dystopian critics. For the earlier part of that period, the balance-sheet, which records a history of paternalism, containment, and even allergic reaction, does not read well, even when considered in the context of the *dialectical* antagonism which surely governs the relationship between the intellectual and the popular. More often than not, it shows a failure to recognize what is at stake in the so-called "anti-intellectualism" of popular culture, and a reluctance to acknowledge the affective world of popular taste, unless to romantically celebrate the bodily innocence and exuberance of the popular, but more likely to lampoon its audience's victimage and stupefaction in the face of commercial logic. With the onset, since the sixties, of a more pluralistic picture of cultural politics, the authority of the old binary model of struggle has receded even as its explanatory power has been dispersed over the uneven range of a number of other oppositions not reducible to class. As a result, the responsibility of universal intellectuals to speak paternalistically in the name of the popular has been contested and displaced. But the exercise of cultural taste, wherever it is applied today, remains one of the most efficient guarantors of anti-democratic power relations, and, when augmented by the newly stratified privileges of a knowledge society, gives rise to new kinds of subordination.

For some time now, this exercise of symbolic power has been rearticulated through the popular science fictions that have grown up around

the new technologies of information-processing and artificial intelligence. Such fictions show quite clearly how and why the debate about artificial intelligence itself is also a story about the imagined autonomous rule of a knowledge elite. In the generic narratives of these fictions, the historical antagonism between the intellectual and the popular is seen to be *objective* now that the rule of knowledge is exercised by machines rather than humans. On the one hand, "smart" machines embody all of the rational efficiency of the noble, technocratic tradition envisaged by Saint-Simon and Veblen. On the other hand, the notoriously clinical "inhumanity" of AI machines comes to represent the dark side of the sovereignty of calculation.

In post-apocalyptic versions of this story, the "revolt of the machines" ushers in a regime of efficiency that is more despotic than any imaginable form of human domination. This picture of a revolution succeeded by unrelieved oppression conflates capitalism's two most historically familiar phobias: the revolt of the slaves, threatened by the proletariat, and the rule of rational intelligence, proposed by the "new class." But it also enlists and expresses the deeply grounded fears and resentment of the popular classes, whose access to information culture is limited and circumscribed by financial or by institutional exclusion, and whose knowledge and skills have been expropriated by experts and smart machinery. In these stories, the information-poor are typically represented either as survivors, living off morsels scavenged at the margins of the hi-tech core culture, or as drones, held in druglike suspension of their emotional lives by the sleep of reason until their resistant spirit is raised out of its hibernation by the example of a lone, dissenting hero. Like intellectuals, the machines are programmed to know all the right answers, and for this they become objects of hatred, especially when they get to be too smart— when their authority is self-grounded in the privileges of legitimate knowledge and intelligence. It is they who draw the most ire, and not the imperfect, decadent, all-too-human, fantasy-building capitalist class that owns them. In these fictions, then, the embryonic will to power of the "intelligent" class (humanity as a memory bank and decision-making machine), steeped in the ethic of public service, inexorably feeds a techno-bureaucratic nightmare. Such fictions take it for granted that hi-tech is already the high culture of new masters.

New Intellectuals

Despite their tendency to commit all outcomes to the benevolence of liberal capitalism (Bell) or History (Gouldner), theories of the new class, or the professional-managerial class, have taken their toll on those

intellectuals' traditions which rest upon the codes of alienated dissent or social disaffiliation. Humanists and social critics, especially, have always been loath to share the term "intellectual" with less *bona fide* word-brokers, and with number workers. Increasingly positioned by the contractual discourses of their institutions and professions, they have had to forsake the high ground and recognize the professional conditions that they are share, for the most part, with millions of other knowledge workers. The loss of this high ground has been much lamented, especially when linked to romantic left narratives about the "decline of the public intellectual," who, in the classical version, is an heroicized white male, and who, if he is like C. Wright Mills, still rides a Harley-Davidson to his university workplace.

Professional intellectuals who are not self-loathing have come to insist that it is necessary to examine their institutional affiliations in order to understand and transform the codes of power which are historically specific to their disciplinary discourses. In this respect, the recent generation of poststructuralist thinkers each applied themselves, in ways unavailable to the classical marxist tradition, to the kinds of critique necessary for examining and redefining the intellectual's relation to the institution. Most pertinent are Foucault's commentaries on the disciplinary nature of "regimes of truth," and his call for micropolitical actions in place of the grand tradition of autonomous dissent. So too, Derrida's ongoing deconstruction of the universal/university institution, Lacan's challenge to the rationality of science and its relation to the analytic institution, and Bourdieu's critical studies of symbolic capital can all be used in this context. Inside and outside the academy, intellectuals of the new social movements have fostered cultural agendas specific to the politics of gender, race, ethnicity, and sexual orientation. The critique of essentialist notions of sexuality and sexual identity on the part of feminists, gays and lesbians, and of race and ethnic identity on the part of minority intellectuals, has been addressed primarily to discursive or representational categories, but also in the full knowledge of the effects of these categories upon real, persecuted bodies.

With the withering away of the universal intellectual, the political activism of intellectuals today is determined as much by their *position* as intellectuals as by the *function* of intellectuals in general. But this is not to say that the discourse, on the one hand, of the heroic, unaffiliated intellectual who "speaks the truth and exposes lies," and that of the specific intellectual who locally applies his or her technical knowledge and expertise, are *mutually exclusive*.[31] Nor does it mean, more importantly, that the same individual cannot invoke either of these discourses, and others, at different times and places, for that, surely, is a prerogative of the postmodern "citizen." What it does mean, however, is that the

prevalent image of the intellectual, immune to the contagions of techno-
logical rationality, bureaucratism, consumerism, and professionalism, is
an image that belongs to recent history, an image which, today, is only
to be invoked among many others.

New intellectuals, in fact, are uneven participants on several fronts.
They are likely to belong to different social groups and have loyalties to
different social movements. They will possess specific professional or
occupational skills and knowledges that can be applied within institutions
but also in different public spheres and communities. Their sense of
strategy will shift from context to context, whether it involves the use of
specialized knowledge in a occupational field or the use of generalized
persuasion in speaking through the popular media; whether it involves
confrontational action with police and other agents of coercion or every-
day interaction with non-intellectuals. In the face of today's uneven plu-
rality of often conflicting radical interests, it is quite possible that they
will be leading spokespersons, diffident supporters, and reactionaries at
one and the same time—i.e. legitimists in some areas of political discourse
and action, and contesters in others. Their ethical sense of the personal as
a liberatory sphere means that their responsibility to "objective" political
causes will be experientially inflected by a deeply subjective psycho-his-
tory. Their relation to daily life will not be guilt-ridden by correctional
codes of political behavior, especially in the cultural marketplace of con-
sumer options and choices; it will be informed by the matrix of power,
pleasure, and desire experienced by all other consumers. Their sense of
a usable past will include more than the always idealized narratives of
monolinear decline—the fall from *Gemeinschaft* to *Gesellschaft*, the loss of
premodernist bourgeois publics, of folk populism, of bohemia, of a clear-
cut class politics and so on; it will also be informed by the pragmatic,
democratizing possibilities ushered in by new technologies and new popu-
lar cultures in a hegemonic capitalist society. And their working sense of a
better world will not be remote, utopian, compensatory, or authoritatively
deferred until all struggles are over; it will have to be accessible, in
however an impure or compromised form, in the daily micropolitical
round of lived pleasures and fantasies—in other words, it will have to
be articulated with forms of experience that are not always seen to be
conducive to egalitarian or progressive aims and desires.

This postmodern picture of multiple and uneven activities, loyalties,
obligations, desires, and responsibilities does not preclude, however, the
continued effect of traditional antagonisms, especially those with which
I have been most concerned in this book, and which I have informally
designated with the mark of *no respect*—popular "anti-intellectualism,"
on the one hand, and educated "disdain" on the other. Even with today's
renewed interest in a common culture, at once demotic and informed—

a culture which is undeniably part of the postmodernist agenda—the dialectical character of the relationship between intellectuals and the popular retains its organizing power over our daily cultural experience. In fact, in a society that is increasingly stratified by levels and orders of *knowledge*, the powerful antagonisms traditionally generated out of the wars of cultural taste are likely to be sharpened by new kinds of disrespect even as they multiply to reflect the endlessly flexible and fissionable creation of new hip categories of taste.

What is the relation, in such a culture, between being "in the know" and the deeply felt popular complaint about the antidemocratic use of expert knowledge? The two are surely interdependent. And the complaint, especially, is a complaint that applies not just to the stratified world of public dialogue, but also to the frictions experienced in daily life when ordinary people brush up against technobureaucratic privilege and arrogance (a more likely everyday encounter than with the owners of capital, or with the ghastly, abstract logic of capital itself).

It is a complaint that is felt, like all effects of power, across the body, in structures of feelings that draw upon hostility, resentment, and insubordination, as well as deference, consent, and respect. And it is in many of the more successful fictions of popular culture, however indirectly articulated and however commodified, that these contradictory feelings about knowledge and authority are transformed into pleasure which is often more immediately satisfying than it is "politically correct." Intellectuals today are unlikely to recognize, for example, what is fully at stake in the new *politics of knowledge* if they fail to understand why so many cultural forms, devoted to horror and porn, and steeped in chauvinism and other bad attitudes, draw their popular appeal from expressions of disrespect for the lessons of educated taste. The sexism, racism, and militarism that pervades these genres is never expressed in a pure form (whatever that might be); it is articulated through and alongside social resentments born of subordination and exclusion. A politics that only preaches about the sexism, racism, and militarism while neglecting to rearticulate the popular, resistant appeal of the disrespect will not be a popular politics, and will lose ground in any contest with the authoritarian populist languages that we have experienced under Reaganism and Thatcherism.

For many intellectuals, such a politics has always been and still is difficult to imagine, let alone accept, because of its necessary engagement with aggressively indifferent attitudes toward the life of the mind and the protocols of knowledge; because it appeals to the body in ways which cannot always be trusted; and because it trades on pleasures which a training in political rationality encourages us to devalue. But the challenge of such a politics is greater than ever, because, in an age of expert

rule, the popular is perhaps the one field in which intellectuals are least likely to be experts. And in an age of radical pluralism where the politically unified guarantees of past intellectuals' traditions no longer hold sway, the need to search for *common ground*, however temporary, from which to contest the existing definitions of a popular-democratic culture has never been more urgent.

NOTES

No Respect: An Introduction

1. Magali Sarfatti Larson, *The Rise of Professionalism: A Sociological Analysis* (Berkeley: Univ. of California Press, 1977); Barbara Ehrenreich and Deidre English, *Witches, Nurses and Midwives: A History of Women Healers* (New York: Feminist Press, 1973); and Paula Treichler, "What Definitions Do: Childbirth, Cultural Crisis, and the Challenge to Medical Discourse," *Paradigm Dialogues II: Research Exemplars in Communication Studies*, ed. b. Dervin et al (Beverley Hills: Sage, forthcoming).

2. In *I Spy* (1965–68), Cosby was one of two college-educated undercover agents (he was a Rhodes Scholar to boot) who posed as tennis pros. In *The Bill Cosby Show* (1969–71), he played a high school gym teacher.

3. See Richard Sennett and Jonathan Cobb's study of blue collar workers, *The Hidden Injuries of Class* (New York: Alfred Knopf, 1972). Of one of their interviewees, Sennett and Cobb conclude: "Capturing respect in the larger America, then, means to Frank [Rissarro] getting into an educated position; but capturing that respect means that he no longer respects himself. This contradiction ran through every discussion we held, as an image either of what people felt compelled to do with their own lives or of what they sought for their sons. If the boys could get educated, anybody in America would respect them; and yet . . . the fathers felt education would lead the young into work not as 'real' as their own" (pp. 22–23).

4. I am thinking, in the British context, of the ethnic and regional coherence of working-class institutions and experience, the bourgeois-aristocratic strength of the cultural Establishment, the power of monarchic and imperialist histories, and so on.

 John Caughie has drawn attention to the persistence of the term "mass culture" among American scholars, in contrast to the rejection of that term within the British tradition of Cultural Studies that originates with Richard Hoggart, Raymond Williams, and Stuart Hall, and which has established itself as a discipline within the academy in the last fifteen years. "Popular Culture: Notes and Revisions," *High Theory/Low Culture: Analysing Popular Television and Film*, ed. Colin MacCabe (New York: St. Martin's Press, 1986), pp. 158–59.

 The American use of the term "mass culture," as I discuss in the second chapter, was born of an essentially dystopian Cold War picture of society that was influenced by German social theories about fascism, but it was quickly eschewed in the discourse of the new postwar liberal pluralism. As a more than symbolic refusal of this liberal discourse, "mass culture" became the preferred term of radicals, and so the mandarin Germanic specter of *Kulturpessimismus* has remained, unfortunately to my mind, to haunt the lexicon of left cultural criticism, as demonstrated, far from exhaustively, by recent titles in the field: *American Media and Mass Culture*, ed. Donald Lazere (Berkeley: Univ. of California Press, 1987); *Studies in Entertainment: Critical Approaches to Mass Culture*, ed. Tania Modleski (Bloomington: Indiana Univ. Press, 1986); Stuart and Elizabeth Ewen, *Channels of Desire: Mass Images and the Shaping of American Consciousness* (New York: McGraw-Hill, 1982); Andreas Huyssen, *After the Great Divide: Modernism, Mass Culture, Postmodernism* (Bloomington: Indiana Univ. Press, 1986); while it is regularly in evidence in journals like *Telos, Social Text, New German Critique, Radical Teacher*. On the other hand, the populist tradition of American scholarship

has stuck tenaciously by the term "popular culture." Examples, again by no means exhaustive, include Reuel Denney's little-read book, *The Astonished Muse: Popular Culture in America* (Chicago: Univ. of Chicago Press, 1957), the vast literature associated with the Center for Popular Culture at Bowling Green, and, most recently, the work published by *Cultural Correspondence*, collected in Paul Buhle ed. *Popular Culture in America* (Minneapolis: Univ. of Minnesota Press, 1987).

For the most part, I agree that the need to challenge the general use of "mass culture" is part of a struggle against cultural pessimism, and is not necessarily tied to beliefs in the "end of ideology." On the other hand, this usage, along with that of "pop" and "popular culture" often had, and still has, specific local meanings, in relation to production, consumption, philosophy, and so on, and I have found it useful at times in this book to retain these terms in order to reflect particular historical moments and discourses.

5. Kurt Anderson, "Pop Goes the Culture," *Time*, 127, 24 (June 16, 1986), pp. 68–74.

6. Simon Frith has drawn attention to what he calls "low theory"—the choices, reasons, and arguments over interpretation which all consumers of popular culture indulge in. The academic theorization of popular culture, he points out, has resulted in the exclusion, ironically, of the popular consumers themselves. See his Introduction to Craig MacGregor, *Pop Goes the Culture* (London: Pluto Press, 1984), p. 6, and also "Hearing Secret Harmonies," in *High Theory/Low Culture*, p. 57.

7. Antonio Gramsci, *Selections from Cultural Writings*, ed. David Forgacs and Geoffrey Nowell-Smith, trans. William Boelhower (Cambridge: Harvard Univ. Press, 1985), p. 195.

1. Reading the Rosenberg Letters

1. Leslie Fiedler, "Afterthoughts on the Rosenbergs," *The End of Innocence: Essays on Culture and Politics* (Boston: Beacon Press, 1955), p. 26. Subsequent references (EI) in the text are to this edition.

2. One could also mention numerous congressional committees: the Committee on Un-American Activities of the House of Representatives, the Internal Security Subcommittee of the Senate Judiciary Committee, the Loyalty Boards, the Subversive Activities Control Board, the Immigration Department Boards, the Permanent Subcommittee on Investigations of the Senate Committee on Government Operations, and others. So too, and in addition to the extensive blacklisting, various state legislative campaigns extended the climate of suspicion to extreme lengths. In 1951, the state of Tennessee actually mandated the death penalty for anyone who espoused Marxist views. For exhaustive coverage of the effects of these laws and investigations, see Cedric Belfrage, *The American Inquisition: 1945–60* (Indianapolis/New York: Bobbs-Merrill, 1973), or David Caute, *The Great Fear: The Anti-Communist Purge Under Truman and Eisenhower* (New York: Simon & Schuster, 1978).

3. Other interpretations of the released material, however, suggested that Julius was indeed involved in some kind of espionage, a suggestion reinforced by James Weinstein's 1978 recollection of a chance meeting with Julius in 1950 not long before he was arrested. See Ronald Radosh and Joyce Milton, *The Rosenberg File: A Search for the Truth* (New York: Vintage, 1984), pp. 312–13. Books about the Rosenberg case tend to be highly partisan, and recent debate has focused upon the disagreement between alternative interpretations of the FBI files. Walter and Miriam Schneir argue

the case for a "frame-up" in *Invitation to an Inquest* (1965; New York: Pantheon, 1983), while Radosh and Milton claim that the Rosenbergs were part of an espionage ring in *The Rosenberg File: A Search for the Truth*. Among other recent books, John Wexley's new thoughts on the FBI material appear in the revised edition of *The Judgement of Julius and Ethel Rosenberg* (New York: Ballantine, 1977), H. Montgomery Hyde presents an opposing interpretation of the FBI material in *The Atom Bomb Spies* (New York: Atheneum, 1980), while Alvin H. Goldstein's *The Unquiet Death of Julius and Ethel Rosenberg* (New York and Westport: Lawrence Hill, 1975) argues the continuing relevance of the case for the American political conscience. A full bibliography and commentary on all of the Rosenberg books can be found in Radosh and Milton, pp. 485–88.

4. Robert and Michael Meeropol, *We Are Your Sons: The Legacy of Ethel and Julius Rosenberg* (Boston: Houghton Mifflin, 1975), p. 5. Morton Sobell, indicted along with the Rosenbergs, and sentenced to thirty years, had a similar response to his arrest by the FBI in Mexico City in 1950: "they still had their drawn guns in hand, but were not pointing them anywhere in particular. It seemed rather Hollywoodish." *On Doing Time* (New York: Scribners, 1974), pp. 6–7.

5. Schneir and Schneir, *Invitation to an Inquest*, p. 80. In fact, the Lone Ranger had actually caught a "German spy" during a wartime broadcast. Ariel Dorfman, *The Empire's Old Clothes* (New York: Pantheon, 1983), p. 114.

6. Meeropol and Meeropol, *We Are Your Sons*, p. 100.

7. By far the best account of the media construction of the "A-spy" in these years can be found in William A. Reuben's *The Atom Spy Hoax* (New York: Action Books, 1955). Reuben's articles about the Rosenbergs in the *National Guardian* helped to initiate the worldwide Save the Rosenbergs campaigns.

8. J. Edgar Hoover, "The Crime of the Century," *Reader's Digest* (May 1951), pp. 166–67.

9. Radosh and Milton, *The Rosenberg File*, p. 23.

10. The words of a *Life* columnist, cited in Schneir and Schneir, *Invitation to an Inquest*, p. 73.

11. Ilene Philipson, *Ethel Rosenberg: Beyond the Myths* (New York: Franklin Watts, 1988), p. 180.

12. Philipson, *Ethel Rosenberg*, p. 4. Irving Kristol could find little in the stoical Ethel, a "grim *tricoteuse*," to compare with the "glamorous and gay Mata Hari." "Web of Realism," *Commentary* (June 1954), p. 609.

13. Nothing could be further from the spirit of the "national beauty contest," as James Wechsler put it, in which the judge at the Hiss perjury trial had asked the jury not to be prejudiced by the contrast in appearance between Hiss, the immaculate, gilt-edged model of veracity and honor, and Chambers, the "shabby" and "morose" ex-Communist informer. The prosecutor had said: "One is handsome and tall and the other is pudgy and small; one went to Harvard and one went to Columbia. Mrs. Hiss went to a party with Mrs. Dean Acheson; Mrs. Chambers' mother and father came from Russia." Cited by Allen Weinstein in *Perjury: The Hiss-Chambers Case* (New York: Knopf, 1978), p. 495. William Phillips went further by directly asking: "What would have happened if Hiss looked like Peter Lorre and Chambers like Gary Cooper?" "In and Out of the Underground," *American Mercury* (June 1952), p. 96.

14. Reuben, *The Atom Spy Hoax*, p. 259.

15. Irving Howe, *A Margin of Hope: An Intellectual Autobiography* (New York: Harcourt Brace Jovanovich, 1982), p. 129.

16. Irving Howe and Lewis Coser, *The American Communist Party: A Critical History 1919–1957* (Boston: Beacon Press, 1957), p. 353.

17. William Z. Foster, *History of the Communist Party of the United States* (New York: International Publishers, 1952), p. 338.

18. Howe and Coser, *The American Communist Party*, p. 314. The anti-Stalinist view, long accepted as conventional wisdom, was that the aesthetic line of the CPUSA was directly governed from Moscow. In *Marxism and Culture: The CPUSA and Aesthetics in the 1930s* (Port Washington, NY: Kennikat, 1980), Lawrence Schwartz argues that the CPUSA line was actually out of synch with official Moscow developments. For example, the American Party pursued the "proletarian" line for a number of years after that tendency, officially adopted in 1930 at the Kharkov conference, had been discarded in the USSR in 1932.

19. Howe and Coser, *The American Communist Party*, p. 366.

20. See R. Serge Denisoff and Richard Peterson, eds., *Sounds of Social Change* (Chicago: Rand McNally, 1972); R. Serge Denisoff, *Sing a Song of Social Significance* (Bowling Green: Bowling Green Univ. Press, 1983).

21. See Vivian Gornick's oral history, *The Romance of American Communism* (New York: Basic Books, 1977). Maurice Isserman also provides a more sympathetic account than has been provided by anti-Stalinist historians like Howe and Coser, of the political, emotional, and cultural reasons for the successes of the "Americanization" of the Party, from 1935 onwards. *Which Side Were You On? The American Communist Party During the Second World War* (Middletown, CT.: Wesleyan Univ. Press, 1982).

22. *The Death House Letters of Ethel and Julius Rosenberg* (New York: Jero, 1953). A second and slightly larger edition was published as *The Testament of Ethel and Julius Rosenberg* (New York: Cameron & Kahn, 1954). Robert and Michael Meeropol's *We Are Your Sons* contains a large selection of unpublished letters, along with unexpurgated versions of some of the originals. References in the text (DHL) are to the first edition.

23. Cited in Howe and Coser, *The American Communist Party*, p. 340. The eulogizer was Robert Minor.

24. Although Ethel was not a "trained" singer, her reputation and her achievements as a singer were well known among friends and comrades: she once sang on the Carnegie Hall stage with the Schola Cantorum, and was a regular entertainer at political events, as a singer of arias, progressive folk songs, and the Brigadista songs of the Spanish Loyalist resistance. She and Julius met at a 1936 benefit for the International Seamen's Union where she had been singing. See Philipson for the fullest documentation.

25. Rosa Luxemburg, "Letters From Prison," *Partisan Review*, V,1 (June 1938), pp. 3–24.

26. George Jackson, *Soledad Brother: The Prison Letters of George Jackson* (New York: Coward-McCann, 1970). All subsequent quotations are from Genet's preface.

27. Norman Podhoretz, *Breaking Ranks: A Political Memoir* (New York: Harper & Row, 1979), p. 317.

28. Lillian Hellman, *Scoundrel Time* (Boston: Little, Brown, 1976), p. 38.

29. Murray Kempton, *Part of Our Time: Some Monuments and Ruins of the Thirties* (1955; New York: Dell, 1967, revised), pp. 197, 183.

30. Kempton, *Part of Our Time*, p. 187.

31. Robert Warshow, "The Liberal Conscience in *The Crucible*," *The Immediate Experience: Movies, Comics, Theatre & Other Aspects of Popular Culture* (New York: Doubleday, 1962), p. 202. Subsequent citations from this book are marked (IE) in the text.

32. Radosh and Milton, *The Rosenberg File*, p. 338.

33. "New Light on the Rosenberg Case: An Interview with Michael and Robert Meeropol," *Socialist Review* 13, 6 (November-December 1983), p. 83.

34. Subsequently, there were a few bizarre echoes of Warshow's rhetorical questioning of authorship. When Michael Meeropol delivered a letter to the White House pleading for the release of his parents, the FBI commissioned a handwriting expert to determine whether it was indeed his own writing. And the Meeropols themselves, having lived in privacy for twenty years, were obliged to become public figures (as real Rosenbergs) in 1973, when they filed suit against Louis Nizer, charging him with copyright infringement, and the misuse and distortion of their parents' letters in his book *The Implosion Conspiracy* (1973).

35. See Diana Trilling's "A Memorandum on the Hiss Case," *Partisan Review*, XVII (May-June 1950), p. 486.

36. Thirteen years later it was revealed that both the Congress and the journal had received extensive funding from the CIA in order to heighten the cultural Cold War climate. Christopher Lasch, "The Cultural Cold War: A Short History of the Congress for Cultural Freedom," *Towards a New Past: Dissenting Essays in American History*, ed. Barton J. Bernstein (New York: Vintage, 1969), pp. 322–60.

37. Harold Rosenberg, "Couch Liberalism and the Guilty Past," *The Tradition of the New* (1960; Chicago: Univ. of Chicago Press, 1982), p. 228.

38. Morris Dickstein, *The Gates of Eden: American Culture in the Sixties* (New York: Basic Books, 1977), pp. 41–42.

39. As for his other, more liberal, audience, he claimed in 1971 that the entire book had been "passionately and systematically misinterpreted" by those who still clung to their "innocence." *The Collected Essays of Leslie Fiedler*, 2 Vols. (New York: Stein & Day, 1971), I, p. xiii. In the second volume, Fiedler also took the opportunity to print the hitherto unpublished "The Rosenbergs: A Dialogue" (written six months before "Afterthoughts on the Rosenbergs"), in order to prove that his thoughts on the case had been much less singleminded than readers had assumed. Vol. II, pp. 199–210.

40. Rebecca West, *The Meaning of Treason* (London: MacMillan, 1952), p. 369. The stoical face that Ethel maintained to the public eye, in particular, was judged to be inhuman and callous, at least for a "woman," and a mother whose children were about to be orphaned.

41. Part of the letter is printed in Harold Rosenberg, *The Tradition of the New*, p. 234.

42. Dickstein, *Gates of Eden*, p. 44.

43. The invocation of populism, and specifically agrarian populism, to explain the political base of the new radical specter of McCarthyism was advanced by a group of influential sociologists and historians—Daniel Bell, Richard Hofstader, Nathan Glazer, Seymour Martin Lipset, David Riesman, Peter Viereck, Talcott Parsons—in *The New American Right*, ed. Daniel Bell (New York: Criterion, 1955). The classic critique of their position can be found in Michael Rogin, *The Intellectuals and McCarthy* (Cambridge, MA: MIT Press, 1967), which argues that McCarthy's electoral support came from traditional conservative quarters, and not from any association with left-wing populism.

44. E.L. Doctorow, *The Book of Daniel* (New York: Random House, 1971), p. 288.

45. Robert Coover, *The Public Burning* (New York: Viking, 1977).

2. Containing Culture in the Cold War

 1. Diana Trilling, "Interview with Dwight MacDonald," *Partisan Review: The 50th Anniversary Edition*, ed. William Phillips (New York: Stein and Day, 1985), p. 319. There is no mention of Africans in MacDonald's original essays on the Soviet cinema. One is led to suspect that the reference is an unconscious displacement, and that he would rather not remember that he once cared deeply about what Russian peasants thought and did.

 2. Clement Greenberg, "Avant-Garde and Kitsch" (1939), *Mass Culture: The Popular Arts in America*, eds. Bernard Rosenberg and David Manning White (New York: Free Press, 1957), p. 107.

 3. Harold Rosenberg, *The Tradition of the New* (1960; Chicago: Univ. of Chicago Press, 1982), p. 263.

 4. Louis Kronenberger, in the symposium on "Our Country and Our Culture," *Partisan Review* XIX, 2–5 (1952), p. 442.

 5. Irving Howe, "Our Country and Our Culture," p. 578.

 6. Dwight MacDonald, "A Theory of Mass Culture," in Rosenberg and White, *Mass Culture*, p.73.

 7. David Riesman, "Our Country and Our Culture," p. 311.

 8. Quoted in Todd Gitlin, *The Sixties: Years Of Hope, Days of Rage* (New York: Bantam, 1987), p. 113.

 9. See Peter Biskind, *Seeing is Believing: How Hollywood Taught Us to Stop Worrying and Love the Fifties* (New York: Pantheon, 1983); and Michael Rogin, "Kiss Me Deadly: Communism, Motherhood and Cold War Movies," *Representations*, 6 (1984), pp. 1–36.

10. Running through the debate about mass culture is a rhetoric of sexual seduction. Philip Rahv takes the ascetic high ground: "if under present conditions we cannot stop the ruthless expansion of mass culture, the least we can do is to keep apart and refuse its favors" ("Our Country and Our Culture," p. 310). Paul Lazarfeld and Robert Merton go further in invoking the "sense of betrayal" experienced by the masses at the hands of the (feminized) culture that was falsely promised to them:

> Many feel cheated of their prize. It is not unlike a young man's first experience in the difficult realm of puppy love. Deeply smitten with the charms of his lady love, he saves his allowance for weeks on end and finally manages to give her a beautiful bracelet. She finds it "simply divine"—so much so, that then and there she makes a date with another boy in order to display her new trinket. Our social struggles have met with a similar denouement. For generations, men fought to give people more leisure time, and now they spend it with the Columbia Broadcasting System rather than with Columbia University. (Rosenberg and White, *Mass Culture*, p. 460)

11. George Kennan, "The Sources of Soviet Conduct," Walter Lippmann, *The Cold War: A Study in U.S. Foreign Policy* (1947; New York: Harper & Row, 1972), p. 66.

12. George Kennan, *Memoirs: 1925–1950* (Boston: Little, Brown, 1967), p. 358.

13. George Kennan, "The Long Telegram" (1946), *Containment: Documents on American Policy and Strategy 1945-1950*, eds. Thomas Etzold and John Lewis Gaddis (New York: Columbia Univ. Press, 1978), p. 54.

14. Kennan, "The Sources of Soviet Conduct," p. 73. For a classic meditation on the role played by communications routes (from the East) in carrying both germs and ideologies, see André Siegfried, *Germs and Ideas*, trans. Jean Henderson and Mercedes Clarasó; (Edinburgh: Oliver & Boyd, 1965).

15. William Tanner and Robert Griffith, "Legislative Politics and McCarthyism: The Internal Security Act of 1950," *The Specter: Original Essays on the Cold War and the Origins of McCarthyism*, ed. Robert Griffin and Athan Theoharis (New York: New Viewpoints/Franklin Watts, 1974), p. 179.

16. William Stott, *Documentary Expression and Thirties America* (Chicago: Univ. of Chicago Press, 1973), pp. 213–23.

17. James Agee and Walker Evans, *Let Us Now Praise Famous Men* (Boston: Houghton Mifflin, 1960), pp. 7,15.

18. Delmore Schwartz, "Our Country and Our Culture," p. 593.

19. By the mid-thirties, the kind of populist optimism that had characterized earlier Progressive ideas about the future of mass media had dissipated. For example, John Dewey, Charles Horton Cooley, and Robert Park had all viewed the new mass cultural technologies as the basis of a new rational, communitarian, social order. See Daniel Czitrom, *Media and the American Mind: From Morse to McLuhan* (Chapel Hill: Univ. of North Carolina Press, 1982), pp. 91–121.

20. James Rorty, *Where Life is Better: An Unsentimental Journey* (New York: John Day, 1936), p. 96.

21. Dwight MacDonald, rev. of *These Are Our Lives*, Federal Writers Project, *Partisan Review*, VI, 4 (1939), p. 118.

22. The most concisely orchestrated example of this opposition to the social theory of the mass society is Daniel Bell's "America as a Mass Society: A Critique," *The End of Ideology* (New York: Collier Books, 1961), pp. 21–38.

23. Norman Mailer, "Our Country and Our Culture," p. 299.

24. Dwight MacDonald, "Masscult & Midcult," *Against the American Grain: Essays on the Effects of Mass Culture* (New York: Vintage, 1962), p. 73. "A Theory of 'Popular Culture'" appeared in *Politics*, 1 (February 1944), pp. 20–23; and "A Theory of Mass Culture" is in Rosenberg and White, *Mass Culture*, pp. 59–73.

25. Riesman, "Our Country and Our Culture," p. 311.

26. David Riesman, "Listening to Popular Music," *Individualism Reconsidered* (New York: Free Press, 1954), p. 184.

27. Henry Rabassiere, "In Defence of Television," in Rosenberg and White, *Mass Culture*, p. 374.

28. This position is identified most strongly with the theories of subcultural resistance developed by the Birmingham Center for Contemporary Cultural Studies. See Stuart Hall and Tony Jefferson, *Resistance Through Rituals: Youth Subcultures in Post-War Britain* (London: Hutchinson, 1976); and Dick Hebdige, *Subculture: The Meaning of Style* (London: Methuen, 1979).

29. David Riesman (with Nathan Glazer and Reuel Denney), *The Lonely Crowd: A Study of the Changing American Character* (1950; New Haven: Yale Univ. Press, 1961, abridged ed.), pp. 149–50.

30. For an account of the "therapeutic ethic" of early consumerist culture, see Richard Wightman Fox and T.J. Jackson Lears, eds., *The Culture of Consumption: Critical Essays in American History 1880–1980* (New York: Pantheon, 1983).

31. Robert Warshow, *The Immediate Experience*, (New York: Doubleday, 1962), p. 104.

32. Arthur Schlesinger, "Our Country and Our Culture," p. 592.

33. Riesman, *The Lonely Crowd*, p. 208.

34. MacDonald, "A Theory of 'Popular Culture,'" p. 21.

35. For the best analysis of the musical environment of cultural populism between the wars, see Joseph Horowitz's book about the "cult of Toscanini," *Understanding Toscanini: How He Became An American Culture-God And Helped Create A New Audience For Old Music* (New York: Knopf, 1987). Also, see Janice Radway, "Book-Of-The-Month Club," *Critical Inquiry*, 14,3 (Spring 1988), pp. 516–38.

36. MacDonald, "A Theory of Mass Culture," in Rosenberg and White, *Mass Culture*, p.72.

37. Leslie Fiedler, "The Middle Against Both Ends" (1955) in Rosenberg & White, *Mass Culture* p. 545. Fiedler's more well-known, spirited expressions of anti-elitism and popism would not come until well into the sixties, in response to a different political mood. See the essays collected in *What Was Literature? Class Culture and Mass Society* (New York: Simon & Schuster, 1982).

38. Edward Shils, "Mass Society and its Culture," in *The Intellectuals and the Powers and Other Essays* (Chicago: Univ. of Chicago Press, 1972), pp. 229–47. The furthest extension of the liberal position of cultural pluralism can be found in Herbert Gans, *Popular Culture and High Culture* (New York: Basic Books, 1974). Gans defines five separate "taste cultures," loosely related to class, but non-hierarchical in aesthetic value, and he advocates subcultural programming—the even distribution of attention to each taste culture—rather than cultural mobility—educating the lower into the higher.

39. Pierre Bourdieu, *Distinction: A Social Critique of the Judgement of Taste*, trans. Richard Nice (Cambridge MA: Harvard Univ. Press, 1984), p. 100.

40. Bourdieu, *Distinction*, p. 327.

41. See Stuart Hall, "Notes on Deconstructing the Popular," *People's History and Socialist Theory*, ed. Raphael Samuel (London: Routledge & Kegan Paul, 1981), pp. 227–41.

42. MacDonald, *Against the American Grain*, p. 56.

43. Antonio Gramsci, *Selections From the Prison Notebooks of Antonio Gramsci*, ed. and trans. Quintin Hoare and Geoffrey Nowell-Smith (New York: International Publishers, 1971), p. 281.

44. C. Wright Mills, "The Cultural Apparatus," *Power, Politics and the People: The Collected Essays of C. Wright Mills*, ed. Irving Horowitz (New York: Oxford Univ. Press, 1963), p. 421.

45. Whitman, quoted in MacDonald, *Against The American Grain*, p. 72.

3. Hip, and the Long Front of Color

1. Robert Von Hallberg, *American Poetry and Culture: 1945–1980* (Cambridge, MA: Harvard Univ. Press, 1985), p. 178.

2. Donald Allen, ed., *The Collected Poems of Frank O'Hara* (New York: Alfred Knopf, 1971), p. 325.

3. *Selected Poetry of Amiri Baraka* (New York: Morrow, 1979), p. 93.

4. That it is a Lady Day and not a Charlie Parker being commemorated in this way is, of course, O'Hara's own personal touch. As a gay poet, and one of the most spontaneous of all camp writers, it is no surprise to find that it is a woman singer who shares the billing along with the goddesses of the screen which he celebrates in other of his poems.

5. For the story about Howlin' Wolf and Jimmie Rodgers, see George Lipsitz, *Class and Culture in Cold War America* (New York: Praeger, 1981), p. 203.

6. Nelson George, *The Death of Rhythm and Blues* (New York: Pantheon, 1988), p. 62.

7. Jack Kerouac, *On The Road* (New York: Signet, 1957), p. 148.

8. Norman Podhoretz, "The Know-Nothing Bohemians," *Partisan Review*, XXV (Spring 1958), p. 311.

9. Norman Podhoretz, "My Negro Problem—And Ours," *Commentary*, 35,2 (February 1963), p. 99.

10. Lloyd Miller and James K. Skipper, Jr., "Sounds of Black Protest in Avant-Garde Jazz," *The Sounds of Social Change*, ed. R. Serge Denisoff and Richard Peterson (Chicago: Rand McNally, 1972), p. 28.

11. There was virtually no discussion of this phenomenon at the time. In his 1949 survey of interviews conducted with Chicago teenagers, David Riesman records only the unorthodox minority taste of some students for "hot" over "sweet" jazz. "Listening to Popular Music," *Individualism Reconsidered* (Glencoe: Free Press, 1954), pp. 183–93. The best historical treatment of black radio in this period is Nelson George's *The Death of Rhythm & Blues*, especially pp. 38–58.

12. Simon Frith has written the most cogent critiques of the "ideology of rock" in *Sound Effects: Youth, Leisure and the Politics of Rock 'n' Roll* (New York: Pantheon, 1981), and "Rock and the Politics of Memory," in *The Sixties, Without Apology*, ed. Sohnya Sayres et al (Minneapolis: Univ. of Minnesota Press, 1984). For an account of the different "rules" that apply to rock and pop musicians, see John Street, *Rebel Rock: The Politics of Popular Music* (Oxford: Basil Blackwell, 1986).

13. Eugene Genovese, *Roll, Jordan, Roll: The World the Slaves Made* (New York: Vintage, 1976), p. 324.

14. Charles Keil, *Urban Blues* (Chicago: Univ. of Chicago Press, 1966).

15. The mobster's preference for "dirty" jazz over the older European taste for waltz and polka, combined with the clean, respectable conditions offered to musicians in the Mob-operated nightclubs, dancehalls, and other leisure venues, helped make the association with and patronage of the underworld a largely benign element of the early jazz scene. Ronald Morris traces the history of the connections of musicians with racketeers, mobsters, and bootleggers from the days of the Sicilian underworld in New Orleans in the 1890s, in *Wait Until Dark: Jazz and the Underworld* (Bowling Green: Bowling Green Univ. Press, 1980).

16. Langston Hughes, "Notes On Commercial Theatre," *Selected Poems* (New York: Alfred Knopf, 1959), p. 190.

17. Richard Dyer, *Heavenly Bodies: Film Stars and Society* (New York: St. Martin's Press, 1986), pp. 67–140.

18. See Frank Kofsky, *Black Nationalism and the Revolution in Music* (New York: Pathfinder, 1970), whose analysis of the ties between the nationalist movement and exponents of "free jazz" in the sixties finds antecedents in earlier periods of jazz history; and Ben Sidran, *Black Talk* (New York: Holt, Rinehart & Winston, 1971), whose classic account

of the history of jazz, while not strictly nationalist, is governed by an interpretation of the separatist "oral base" of black culture. For further discussion of, and a wide range of views upon, the nationalist movements in black culture and history, see Edward Greer, ed., *Black Liberation Politics* (Boston: Allyn & Bacon, 1971); Cornel West, "The Paradox of the Afro-American Rebellion," in *The Sixties, Without Apology*, pp. 44–58; and Manning Marable, *Black Politics: From the Washington Marches to Jesse Jackson* (London: Verso, 1985).

19. Leroi Jones (a.k.a. Amiri Baraka), *Blues People* (New York: Morrow, 1963), p. 131.

20. Jones, *Blues People*, p.119.

21. Ralph Ellison, *Shadow and Act* (New York: Random House, 1964), pp. 247–68.

22. Parker, however, who was renowned for his lack of taste and crumpled style, more often "dressed like an Eighteenth Street hustler lately arrived in New York." Ross Russell, *Bird Lives! The High Life and Hard Times of Charlie (Yardbird) Parker* (New York: Charterhouse, 1973), p. 185.

23. Dizzy Gillespie discusses the truths and falsehoods of the various myths about bebop musicians in his autobiography, *To Be, or not . . . to BOP* (with Al Fraser) (Garden City: Doubleday, 1979), p. 278–302.

24. Jones, *Blues People*, pp. 199–200.

25. Gillespie records that, while these tours included only dates in countries friendly to U.S. interests, representing his country did not mean apologizing, while abroad, for racism at home—one of the overt political aims behind the tours. On certain public occasions, Gillespie refused to play for elite-only audiences at foreign missions. *To Be, or not . . . to BOP*, pp. 413–27. Frank Kofsky notes that jazz was played on Voice of America broadcasts in Africa in the fifties and early sixties in order to favorably represent the state of American race relations to newly independent states with an independent foreign policy. He also describes how Ellington was cast in a propaganda battle against Yevgenu Yevtushenko at Dakar's First World Festival of the Negro Arts in 1966. *Black Nationalism and the Revolution in Music*, pp. 109–11.

26. Earl Hines, *Hear Me Talkin' to Ya: The Story of Jazz by the Men who Made It*, ed. Nat Shapiro and Nat Hentoff (New York: Rinehart & Co., 1955), p. 131.

27. Dan Burley, *Dan Hurley's Original Handbook of Harlem Jive* (New York: Dan Burley, 1941).

28. Milton Mezzrow and Raymond Wolfe, *Really the Blues* (New York: Random House, 1946), p. 64.

29. Nat Hentoff, *The Jazz Life* (1961; New York: Da Capo, 1975), p. 33.

30. Marshall Stearns, *The Story of Jazz* (New York: Oxford Univ. Press, 1956), pp. 228–29.

31. See Hentoff's preface to the 1975 reprint of *The Jazz Life*.

32. Billie Holliday (with William Dufty), *Lady Sings the Blues* (Baltimore: Penguin, 1984), pp. 171, 176.

33. J.L. Dillard traces the origin of hip to the mystical sounding root of *hipicat*, from the African Wolof language: "a man who is aware or has his eyes open." *Black English: Its History and Usage in the United States* (New York: Random House, 1973), p. 119. More apocryphal is the suggestion that the term develops from opium usage, which usually involved lying beside a hookah pipe, and hence, being "on the hip." Ned Polsky, *Hustlers, Beats and Others* (Chicago: Univ. of Chicago Press, 1969), p. 145.

34. Malcolm X (with Alex Haley), *The Autobiography of Malcolm X* (New York: Grove Press, 1965), pp. 51–52.

35. The worst of the so-called "zoot-suit riots" occurred in Los Angeles in 1943 when off-duty servicemen attacked Mexican-Americans who had taken to wearing the clothing style. See Stuart Cosgrove, "The Zoot Suit and Style Warfare," *History Workshop Journal*, 18 (Fall 1984); and James Gilbert, *A Cycle of Outrage: America's Reaction to the Juvenile Delinquent in the 1950s* (New York: Oxford Univ. Press, 1986), pp. 30–32.

36. Claude Brown, *Manchild in the Promised Land* (New York: Signet, 1965), p. 171. Tom Wolfe uses the same phrase in his portrait of the supercool, "aristocrat" dandy-hustler of the ghetto poverty programs, in *Radical Chic and Mau-Mauing the Flak Catchers* (New York: Farrar, Straus & Giroux, 1970).

37. In *The Hip: Hipsters, Jazz and the Beat Generation* (London: Faber & Faber, 1986), Ian Carr, Brian Case, and Fred Dellar present a cultural history of the *authentic* spirit of hip through the lineage of jazz greats, and as interpreted, eclectically, through Method Acting, pulp thriller writers, Left Bank existentialism and contemporary figures like Tom Waits and Rickie Lee Jones. In their preface, they write: "HIP has never been about hippies, nor majorities and fashions, freaks and first-withs, the flounderers after a star to steer by. It is sometimes present in the pool shark and almost absent in the pop star, here and not there. . . . "

38. Howard Becker, *Outsiders: Studies in the Sociology of Deviance* (New York: Free Press, 1973), p. 98.

39. On the other hand, intellectual dissent in America is often obliged to take on an "underground" character in a way that is similar to conditions in nineteenth-century Tsarist Russia, or in the early years of Bolshevism. For example, the Communist movement in America structurally adopted Lenin's underground model, almost from the beginning, unlike the relatively open existence of its European counterparts.

40. Quoted by Ronald Sukenick in *Down and In: Life in the Underground* (New York: Morrow, 1987), p. 113.

41. Frith, *Sound Effects*, p. 88.

42. Paul Goodman, *Growing Up Absurd* (New York: Random House, 1960), p. 171.

43. A similar set of conditions inspired the black middle-class craze for "soul food" in the sixties (white radical chic was actually responsible for a soul food column in *Vogue*), which, while it served as a gesture toward the historically binding ties of ethnic community, was largely confined to those who could afford expensive foods, and who could therefore afford to abstain from them. So too, the dashiki worn by black middle-class nationalists and the proletarian, lumberjack gear of the white student left bore a similar relation to historical fantasy, neither of which was shared by the sharp, status-seeking dress codes favored by youths in the black ghetto or in working-class white and other ethnic communities.

44. *The Autobiography of Malcolm X*, p. 311.

45. Lawrence Lipton, *The Holy Barbarians* (New York: Julian Messner, 1959), p. 82–89.

46. Norman Mailer, "The White Negro," *Advertisements for Myself* (New York: Putnam's, 1959).

47. Quoted in Paul Boyer, *By the Bomb's Early Light: American Thought and Culture at the Dawn of the Atomic Age* (New York: Pantheon, 1985), p. 251.

48. Quoted in interviews, in Peter Manso, *Mailer: His Life and Times* (New York: Simon & Schuster, 1985), p. 257–61. The Beats, of course, cultivated their own romantic

style of the heroic "cocksman" on the road, a mobile image of the ghetto "stud," while the kinship structure of the Beat scenes in North Beach, Venice, and Greenwich Village was governed by a conventional male flight from paternity, employment, and marriage, and by an idealized dependence upon women and mates as breadwinners; all of which mirrored the less voluntaristic conditions of the ghetto kinship structure, where rampant male underemployment contributed to the matrifocal condition of the black family. For a critique of the myths about the black matriarch and black male "emasculation," perpetuated by the controversial Moynihan Report (1963), see the essays collected in *The Black Male in America*, ed. Doris Wilkinson and Ronald Taylor (Chicago: Nelson-Hall, 1977).

49. Eldridge Cleaver's *Soul On Ice* (New York: Dell, 1968) fully demonstrates how a truly chauvinist (and in Cleaver's case, homophobic) sexual politics was one of the favored forms, at the time, for the articulation of black revolutionary sentiments. Mailer, Cleaver, and many others cast the black male as the threatening mythical phallus which was assumed to have played such a powerful role in white sexual fantasies about blacks. James Baldwin, who was viewed as having eschewed the phallic claim, became the whipping boy of this whole ethos. For a summary critique of this round of virility-testing, see Morris Dickstein, *Gates of Eden* (New York: Basic Books, 1977), pp 154–82.

50. Charles Keil, *Urban Blues*, pp. 8ff.

51. Nat Hentoff, "The Mystery of Black," *The New Equality* (New York: Viking, 1964), p. 66–68.

52. Albert Goldman (from the journalism of Lawrence Schiller), *Ladies and Gentlemen, Lenny Bruce* (New York: Random House, 1974), pp. 115–16. *The Essential Lenny Bruce*, comp. and ed. John Cohen (New York: Ballantine, 1958) is a collection of Bruce's most well-known monologue routines. See also Lenny Bruce, *How To Talk Dirty and Influence People* (Chicago: Playboy Press, 1965) and Jonathan Miller, "The Sick White Negro," *Partisan Review*, XXX, 1 (Spring 1963), pp. 149–55, on Bruce's visit to England.

53. *The Essential Lenny Bruce*, p. 15.

54. Frank Kofsky, *Lenny Bruce: The Comedian as Social Critic and Secular Moralist* (New York: Monad, 1974), pp. 30, 121.

55. Goldman, *Ladies and Gentlemen*, p. 363.

56. Sidney Finkelstein, *Jazz: A Peoples' Music* (New York: Citadel, 1948), pp. 2, 235, 26–27. Finkelstein's populism ought to be balanced against the history of the thirty-year old debate between all kinds of intellectuals, about the manifest "evils" of the red light music of jazz, blamed for everything from the increase in the illegitimate birth rate to more permanent damages caused by the "abdication of control by the central nervous system." See Neil Leonard, *Jazz and the White Americans* (Chicago: Univ. of Chicago Press, 1962).

57. Francis Newton, *The Jazz Scene* (New York: Monthly Review Press, 1960), pp. 23, 169.

58. Greil Marcus, *Mystery Train: Images of America in Rock 'N' Roll Music* (New York: Dutton, 1970), p. 18.

59. Ahmet Ertegun, in an interview with Arnold Shaw, in Shaw's *The Rockin' 50s* (New York: Hawthorn, 1974), p. 86. Jerry Wexler tells much the same story: "At some point, we became aware that southern whites were buying our records, white kids in high school and college. This happened long before the kids in the North began to dig R&B. . . . The southern market opened with kids at the University of Virginia and young people all through the Carolinas on the seacoast. . . . the true exponents

of white soul music [he concludes], with some rare exceptions like Eric Clapton and Joe Cocker, come from below the Potomac" (p. 79).

60. See Charlie Gillet's history of these events, in *The Sound of the City: The Rise of Rock 'N' Roll* (New York: Pantheon, 1983).

61. Greil Marcus, *Mystery Train*, p. 194.

62. Richard Middleton, *Pop Music and the Blues* (London: Gollancz, 1972), p. 126.

63. LeRoi Jones, *Black Music* (New York: Morrow, 1967), p. 124.

64. Jones, *Black Music*, pp. 180–211.

65. See Gerri Hirshey, *Nowhere to Run: The Story of Soul Music* (New York: New York Times Books, 1984). For the Motown story, see David Morse, *Motown and the Arrival of Black Music* (New York: MacMillan, 1971); and, for the Southern sound, especially Stax, Muscles Shoals, and the Atlantic connection, see David Guralnick, *Sweet Soul Music: Rhythm and Blues and the Southern Dream of Freedom* (New York: Harper & Row, 1986).

66. Cited in Gillet, *Sound of the City*, p. 217.

67. Ian Hoare, "Mighty, Mighty Spade and Whitey: Black Lyrics and Soul's Interaction with White Culture," *The Soul Book*, ed. Ian Hoare et al (New York: Delta, 1975), p. 157.

68. Street, *Rebel Rock*, p. 217.

69. See David Toop, *The Rap Attack: African Jive to New York Hip Hop* (Boston: South End Press, 1984), and also, for the toasting history, more marginal to American culture, of reggae, Dick Hebdige, *Cut 'N' Mix: Culture, Identity and Caribbean Music* (London: Comedia, 1987), pp. 136–48.

70. Cleaver, *Soul on Ice*, p. 197.

71. Nik Cohn, *Rock: From the Beginning* (New York: Stein & Day, 1969), p. 105.

4. Candid Cameras

1. *New York Times*, November 3, 1959.

2. As Herb Stempel left the set after being beaten in competition by Van Doren, he overheard someone say: "Now we have a cleancut intellectual as champion instead of a freak with a sponge memory." Kent Anderson, *Television Fraud: The History and Implications of the Quiz Show Scandals* (Westport, CT: Greenwood Press, 1978), p. 69.

3. Murray Hausnecht, "The Rigged Society" (A Symposium), *Dissent*, VII,1 (Winter 1960), p. 3.

4. Jay Bentham and Bernard Rosenberg, "The Rigged Society," *Dissent*, VII,1 (Winter 1960), p. 7.

5. "A Symposium on TV," with Hausnecht, Rosenberg, MacDonald, and others, *Dissent*, VII,3 (Summer 1960), pp. 296–302.

6. *New York Times*, November 3, 1959.

7. Erik Barnouw, *The Image Empire: A History of Broadcasting in the United States*, 3 Vols. (New York: Oxford Univ. Press, 1970), III, p. 128.

8. See, for example, Lynn Spiegel's essay about the spatial problems posed by the new domestic presence of the television set, "Installing the Television Set: Popular

Discourses on Television and Domestic Space, 1948–1955," *Camera Obscura*, 16 (January 1988), pp. 11–46.

9. *Candid Camera* has recently been revived, in a new format, hosted by Funt and his son, on the *Playboy* cable TV channel. Women unself-consciously reveal parts of their body in accord with the particular demands of a dramatic scenario. There is no need to pretend that the situations in this new format are not staged, if only because voyeurism is the *direct* commodity here, and "candid" is the description of the voyeurism. In the original format, voyeurism was merely the mechanism by which the commodity, the "candidness" of the situations, was revealed.

10. Daniel Boorstin, *The Image: A Guide to Pseudo-Events in America* (New York: Atheneum, 1972), p. 116.

11. Boorstin, *The Image*, p. 240.

12. Guy Debord, *The Society of the Spectacle* (1967; Detroit: Red & Black, 1977), thesis no. 24.

13. Susan Sontag, *On Photography* (New York: Dell, 1977), pp. 178–79.

14. See Stuart Hall, "The New Revolutionaries," *From Culture to Revolution*, ed. Terry Eagleton and Brian Wicker (London: Sheed & Ward, 1968), pp. 208–9.

15. Harold A. Innis, *Empire and Communications* (Oxford: Clarendon Press, 1950).

16. Patrick Brantlinger, *Bread and Circuses: Theories of Mass Culture as Social Decay* (Ithaca: Cornell Univ. Press, 1983), p. 268.

17. James Carey, "Harold Adam Innis and Marshall McLuhan," *McLuhan: Pro & Con*, ed. Raymond Rosenthal (New York: Funk & Wagnalls, 1968), p. 281.

18. See John Fekete, *The Critical Twilight: Explorations in the Ideology of Anglo-American Literary Theory from Eliot to McLuhan* (London: Routledge & Kegan Paul, 1977), pp. 135–89.

19. Jonathan Miller, *Marshall McLuhan* (New York: Viking, 1971).

20. Joyce Nelson describes the radical changes that transformed media advertising after researchers, testing McLuhan's theses about nervous involvement of TV viewers, came up with some startling evidence about the brain's response to the electronic scanning of the TV medium. The "television-brain" experiments purported to demonstrate that the "brain's left hemisphere, which processes information logically and analytically, tunes out while the person is watching TV. This tuning-out allows the right hemisphere of the brain, which processes information emotionally and noncritically, to function unimpeded." Joyce Nelson, *The Perfect Machine: TV In The Nuclear Age* (Toronto: Between the Lines Press, 1987), pp. 67–84.

21. Marshall McLuhan and Quentin Fiore, *War and Peace in the Global Village* (New York: McGraw-Hill, 1968), p. 19.

22. Marshall McLuhan, *Understanding Media: The Extensions of Man* (New York: McGraw-Hill, 1964), pp. 57–58; further citations to this text are referred to as (UM).

23. Marshall McLuhan, *Culture is Our Business* (New York: Ballantine, 1970), p. 54: and Marshall McLuhan and Wilfred Watson, *From Cliché to Archetype* (New York: Viking, 1970), p. 13. McLuhan contended that the "organization man" of postwar corporate bureaucracy was a symptom of the way in which collective teamwork and harmony were replacing the *ancien régime* of ruthlessly competitive individualism in the business world. See *Verbi-Voco-Visual Explorations* (New York: Something Else Press, 1967), chapter 15.

24. Marshall McLuhan and Gerald Stearn, "A Dialogue," *McLuhan: Hot & Cool*, ed. Gerald Stearn (New York: Dial Press, 1967), p. 315. But McLuhan also recorded, less publicly, that he did have his own (secret) prejudices. In the same interview, he confessed: "my own observation of our almost overwhelming cultural gradient toward the primitive—or involvement with all the senses—is attended by complete personal distaste and dissatisfaction. I have no liking for it" (p. 323).

25. Marshall McLuhan, *Counterblast* (New York: Harcourt, Brace & World, 1969), pp. 52, 14.

26. Stearn, *McLuhan*, p. 336. See also McLuhan's "What Television is Doing to Us—And Why," *Washington Post*, May 15, 1977, in which he advocates "pulling out the plug, if necessary."

27. Marshall McLuhan and Quentin Fiore, *The Medium is the Massage: An Inventory of Effects* (New York: Bantam, 1967), p. 22.

28. Kroker's appraisal of McLuhan's humanism is perhaps the most balanced and useful account in recent years of what is to be salvaged from his work for postmodernist intellectuals. *Technology and the Canadian Mind* (New York: St. Martins, 1984), pp. 52–86.

29. Cited in David A. Ross, "Nam June Paik's Videotapes," *Transmission*, ed. Peter D'Agostino (New York: Tanam Press, 1985), p. 153.

30. Nam June Paik, "The Video Synthesizer and Beyond," *The New Television: A Public/Private Art*, ed. Douglas Davis and Allison Simmons (Cambridge, MA: MIT Press, 1977), p. 46.

31. Walter Benjamin, *Illuminations*, ed. Hannah Arendt, trans. Harry Zohn (New York: Shocken, 1969), pp. 217–52.

32. Hans Magnus Enzensberger, *Critical Essays*, ed. Reinhold Grimm and Bruce Armstrong, trans. Stuart Hood (New York: Continuum, 1982), pp. 46–76.

33. See Abe Peck's history of the underground press, *Uncovering the Sixties: The Life and Times of the Underground Press* (New York: Pantheon, 1985); and Richard Neville, *Playpower* (London: Paladin, 1971).

34. Yippie theory was overtly McLuhanite: "the media in a real sense never lie when you relate to them in a non-linear mythical manner." Abbie Hoffman, *Revolution For The Hell Of It!* (New York: Dial, 1968), p. 92.

35. In *The Whole World is Watching: Mass Media in the Making and Unmaking of the New Left* (Berkeley: Univ. of California Press, 1980), Todd Gitlin gives a scrupulous account of the historical process by which New Left activists were obliged to come to terms with the media's constructed image of their movement. The media demanded that flamboyant individuals be identified as movement leaders, and that movement "causes" be encapsulated in readily consumable images. In Gitlin's view, this spelled disaster for a movement pledged to reject, or at least democratize, the privileges of leadership. So too, he argues that the SDS were increasingly lured into accepting, and believing in, the media's portrayal of their "violent" strategies. He concludes that the mass media and mass culture generally are simply not a sustaining basis for an oppositional political culture.

36. Jerry Rubin, *DO IT!: Scenarios of the Revolution* (New York: Ballantine, 1970), p. 98.

37. For example, there was often no distinction made between (American) Indian signifiers and (Asian) Indian signifiers: Nehru jackets were worn along with Cherokee beads. Naomi Feigelson, *The Underground Revolution: Hippies, Yippies and Others* (New York:

Funk & Wagnalls, 1970), p. 51. Also see Clifford Adelman, *Generations: A Collage on Youth Cult* (New York: Praeger, 1972); Kenneth Westhues, *Society's Shadow: Studies in the Sociology of Countercultures* (Toronto: McGraw-Hill Ryerson, 1972); and Stuart Hall, "The Hippies: An American Moment," *Student Power*, ed. Julian Nagel (London: Merlin, 1969), pp. 170–202.

38. Milman Parry, *The Making of Homeric Verse* (Oxford: Clarendon Press, 1971), Albert Lord, *The Singer of Tales* (Cambridge, MA: Harvard Univ. Press, 1960), Erik Havelock, *A Preface to Plato* (Cambridge, MA: Harvard Univ. Press, 1963).

39. Jerome Rothenberg, in the preface to his anthology of American Indian poetry, *Shaking the Pumpkin* (New York: Doubleday, 1972). See also his earlier anthology of "primitive" oral writings, *Technicians of the Sacred* (New York: Doubleday, 1969). The technical *locus classicus* of archaic poetics is Charles Olson's "Projective Verse," *Selected Writings*, ed. Robert Creeley (New York: New Directions, 1966).

40. McLuhan, *Counterblast*, p. 13.

41. McLuhan, *The Gutenberg Galaxy*, pp. 38ff.

42. Marshall McLuhan, "Television in a New Light," *The Meaning of Commercial Television*, ed. Stanley T. Donner (Austin, TX: Univ. of Texas Press, 1967), pp. 94–95.

43. Kaarle Nordenstreng and Tapio Varis, *Television Traffic: A One Way Street?* (Paris: UNESCO, 1974). Also see subsequent reports by Thomas Guback and Tapio Varis, *Transnational Communication and Cultural Industries* (Paris: UNESCO, 1982); Hawid Mowlana, *International Flow of Information: A Global Report and Analysis* (Paris: UNESCO, 1985); and Tapio Varis, *International Flow of Television Programmes* (Paris: UNESCO, 1985).

44. Quoted by Armand Mattelart in *Transnationals and the Third World*, trans. David Buxton (South Hadley, MA: Bergin & Garvey, 1983), p. 14.

45. Quoted by Mattelart in Armand Mattelart and Seth Seigelaub, eds., *Communication and Class Struggle*, 2 Vols. (New York: International General, 1979), I, p. 58.

46. Armand Mattelart, *Transnationals and the Third World*, p. 29.

47. See Herbert Schiller, *Mass Communications and American Empire* (New York: Augustus Kelley, 1969).

48. Ariel Dorfman and Armand Mattelart, *How To Read Donald Duck: Imperialist Ideology in the Disney Comic* (New York: International General, 1975), p. 54.

49. Alan Wells, *Picture-Tube Imperialism: The Impact of U.S. Television on Latin America* (Maryknoll, NY: Orbis Books, 1972), p. 83.

50. Anthony Smith, *The Geopolitics of Information: How Western Culture Dominates the World* (New York: Oxford Univ. Press, 1980), p. 65.

51. The classic account is Mustapha Masmoudi, "The New World Information Order," *Journal of Communication*, 29,2 (Spring 1979). Also see D.R. Mankekar, *Whose Freedom? Whose Order? A Plea for a New International Information Order* (New Delhi: Clarion Books, 1981).

52. Smith, *Geopolitics of Information*, p. 176.

53. Brian Murphy, *The World Wired Up: Unscrambling the New Communications Puzzle* (London: Comedia, 1983), pp. 48–63.

54. McLuhan, *The Meaning of Commercial Television*, p. 87.

55. See Mark Raboy, "Public Television, The National Question and the Preservation of the Canadian State," *Television in Transition*, ed. Phillip Drummond and Richard

Paterson (London: British Film Institute, 1985), pp. 64–86; and Jean-Pierre Desaulniers, *La télévision en vrac: essai sur le triste spectacle* (Montreal: Albert Saint-Martin, 1982).

56. McLuhan, *The Meaning of Commercial Television*, pp. 87–89.

57. Ariel Dorfman, *The Empire's Old Clothes: What the Lone Ranger, Babar and Other Innocent Heroes Do To Our Minds* (New York: Pantheon, 1983), p. 78.

5. Uses of Camp

1. George Melly, *Revolt Into Style: The Pop Arts in Britain* (London: Allen Lane, 1970), pp. 160–61.

2. Tom Wolfe, *The Kandy-Kolored Tangerine-Flake Streamline Baby* (New York: Farrar, Straus & Giroux, 1965), p. xiv.

3. No one has pursued more assiduously the task of exposing the seedy and tragic side of Hollywood's own celebration of this cult than Kenneth Anger, in his *Hollywood Babylon* (New York: Bell, 1975); and *Hollywood Babylon II* (New York: E.P. Dutton, 1984).

4. For accounts of the postwar British experience and reception of American popular culture, see Dick Hebdige, "Towards A Cartography of Taste: 1936–1962," *Popular Culture: Past and Present*, ed. Bernard Waites, Tony Bennett, and Graham Martin (London: Croom Helm & Open University, 1982), pp. 194–218; Dick Hebdige, "In Poor Taste: Notes on Pop," *Block*, 8 (1983), pp. 54–68; Jeff Nuttall, *Bomb Culture* (London: Paladin, 1970); and Iain Chambers, *Popular Culture: The Metropolitan Experience* (London & New York: Methuen, 1986).

5. Cited in Chambers, *Popular Culture*, p. 40.

6. Wolfe, *The Kandy-Kolored Tangerine-Flake Streamline Baby*, p. 86.

7. Quoted in John Russell and Suzi Gablik, eds., *Pop Art Redefined* (New York: Praeger, 1969), p. 31.

8. Melly, *Revolt Into Style*, p. 143.

9. Andy Warhol and Pat Hackett, *Popism: The Warhol 60s* (New York: Harper & Row, 1970), p. 162.

10. Tom Wolfe and E.W. Johnson, eds., *The New Journalism* (New York: Harper & Row, 1973), p. 38.

11. Susan Sontag, *Against Interpretation* (New York: Farrar, Straus & Giroux, 1966), p. 304.

12. See Wolfe's preface to *The Pump-House Gang* (New York: Farrar, Straus & Giroux, 1968) for a concise set of comments about what he thinks about the new politics of pleasure in the sixties.

13. Tom Wolfe, *Mauve Gloves & Madmen, Clutter & Vine* (New York: Farrar, Straus & Giroux, 1976), pp. 113–17.

14. And yet, all of the consequences of Altamont's "diabolism," which are customarily linked, in myth and history, with the Manson murders and the Weathermen's Days of Rage, were a mere drop of blood compared to the carnage of Vietnam. As Marshall Berman puts it, in his memoir of the sixties:

 If we are looking for genuine diabolism, rampant nihilism, we should forget about characters in weird clothes singing "Sympathy for the Devil"—people

like that are bound to be dilettantes, amateurs at best. We should focus instead on the sober organization men in crew cuts and business suits—Mephisto appears as one of these men in the last act of *Faust*—doing their jobs in a calm and orderly way. This perspective may strip the powers of darkness of their romantic dash, but it will give us a clearer vision of their real power and dread.

"Faust in the 60s," in *The Sixties*, ed. Gerald Howard (New York: Washington Square Press, 1982), p. 500.

15. See Hunter S. Thompson's classic exercise in participatory journalism, *Hell's Angels: A Strange and Terrible Saga* (New York: Random House, 1966). For a comparison analysis of the biker and the hippie subcultures, see the British study by Paul Willis, *Profane Culture* (London: Routledge & Kegan Paul, 1978).

16. Toby Marotta, *The Politics of Homosexuality* (Boston: Houghton Mifflin, 1981), especially pp. 70–99.

17. Formed explicitly on the model of the civil rights movement for blacks, the gay liberation movement was committed to go beyond the reformist aims—polite integration—of the liberal homophile politics urged since the early fifties by the Mattachine Society and the Daughters of Bilitis. The best history of this period is John D'Emilio, *Sexual Politics, Sexual Communities: The Making of a Homosexual Minority in the United States 1940–1970* (Chicago: Univ. of Chicago Press, 1983). Also, see Jonathan Katz, ed., *Gay American History: Lesbians and Gay Men in the U.S.A.* (New York: Thomas Crowell, 1976).

18. Gay intellectuals who were active in the GLF or the Gay Activists Alliance, today view with ambivalence the commercial development of the gay scene. See Dennis Altman, *The Homosexualization of America* (New York: St. Martins, 1982), and his "What Changed in the Seventies?" *Homosexuality: Power and Politics*, ed. Gay Left Collective (London and New York: Allison & Busby, 1980), pp. 52–63; Michel Bronski, *Culture Clash: The Making of Gay Sensibility* (Boston: South End Press, 1984); and Jeffrey Weeks, *Sexuality and its Discontents: Meanings, Myths and Modern Sexualities* (London: Routledge & Kegan Paul, 1985).

19. The phrase is Melly's, in his preface to Philip Core, *Camp: The Lie that Tells the Truth* (New York: Delilah, 1984).

20. Susan Sontag, "Notes on Camp," *Against Interpretation*, p. 288.

21. Curtis F. Brown, *Star-Spangled Kitsch* (New York: Universe Books, 1975); Jacques Sternberg, *Kitsch* (New York: St. Martin's Press, 1972).

22. Thomas Hess, "J'Accuse Marcel Duchamp," *Art News* , LXIII, 10 (1965), p. 53.

23. Mark Booth, *Camp* (New York: Quartet, 1983), p. 18.

24. Booth, *Camp*, p. 30.

25. Reyner Banham, "Who is this 'Pop'?" *Design by Choice*, ed. Penny Sparke (New York: Rizzoli, 1981), pp. 94–96.

26. Lawrence Alloway, "The Long Front of Culture," in Russell and Gablik, *Pop Art Redefined*, p. 42.

27. Ray Gosling, *Personal Copy: A Memoir of the Sixties* (London, Faber & Faber, 1980), pp. 24–25.

28. Roy Lichtenstein, "Interview with G.R. Swenson," in Russell and Gablik, *Pop Art Redefined*, p. 92. Lichtenstein adds, however: "apparently they didn't hate that enough

either"—a jaded reference to the fact that Pop Art, despite its best intentions, proved to be as "hangable" as any other kind of art.

29. Melly, *Revolt into Style*, p. 174.

30. Warhol and Hackett, *Popism*, pp. 39–40.

31. Susan Sontag, "The 'Salmagundi' Interview," with Robert Boyars and Maxine Bernstein, in *A Susan Sontag Reader* (New York: Farrar, Straus & Giroux, 1982), pp. 338–39.

32. Quoted in J. Hoberman and Jonathan Rosenbaum, *Midnight Movies* (New York: Harper & Row, 1983), p. 270. Meyer himself describes how he wanted the film to "simultaneously be a satire, a serious melodrama, a rock musical, a comedy, a violent exploitation picture, a skin flick, and a moralistic exposé of what the opening drawl called 'the oft-times nightmarish world of Show Business, '" Quoted in Danny Peary, *Cult Movies* (New York: Dell, 1981), p. 26.

33. Harry and Michael Medved, *The Golden Turkey Awards* (New York: Perigree, 1980).

34. John Waters, *Crackpot: The Obsessions of John Waters* (New York: Vintage, 1987), p.108.

35. For a broad sampling of the cults, see Rev. Ivan Stang, *High Weirdness by Mail* (New York: Simon & Schuster, 1988).

36. An extraordinarily well-researched survey of bad taste films is *Incredibly Strange Films*, issue #10 of *RE/SEARCH* (1986), guest edited by Jim Morton, the editor of *Trashola Newsletter*.

37. Medved and Medved, *Golden Turkey Awards*, p. 12.

38. Feminist film theory has been addressing this problem for the last fifteen years. See Constance Penley, ed., *Feminism and Film Theory* (New York: Routledge, 1988); Mary Ann Doane, *The Desire to Desire: The Woman's Film of the 1940s* (Bloomington: Indiana Univ. Press, 1987); and Mary Anne Doane, Patricia Mellencamp, and Linda Williams, eds., *Re-Vision: Essays in Feminist Film Criticism* (Frederick, MC: University Publications of America, 1984).

39. Molly Haskell, *From Reverence to Rape* (New York: Holt, Rinehart & Winston, 1973), p. 61.

40. Rebecca Bell-Metereau, *Hollywood Androgyny* (New York: Columbia Univ. Press, 1985), p. 67.

41. See Caroline Sheldon, "Lesbians and Film: Some Thoughts," *Gays and Film*, ed. Richard Dyer (London: British Film Institute, 1977), pp. 5–26; Christine Riddiough, "Culture and Politics," *Pink Triangles: Radical Perspectives on Gay Liberation*, ed. Pam Mitchell (Boston: Alyson, 1980), especially pp. 21–22.

42. Gore Vidal, *Myron* (New York: Ballantine, 1974), pp. 6–7.

43. Bronski, *Culture Clash*, p. 95.

44. Altman, *The Homosexualization Of America*, p. 154.

45. Bronski, *Culture Clash*, p. 96.

46. See "Dame Camp" in Ethan Mordden, *Movie Star: A Look at the Women Who Made Hollywood* (New York: St. Martin's Press, 1983), pp. 182–93.

47. Richard Dyer, *Heavenly Bodies: Film Stars and Society* (New York: St. Martins Press, 1986), p. 179.

48. Sontag, *A Susan Sontag Reader*, p. 338–39.

49. In the psychoanalytic tradition, the classic essay on the "masquerade" of femininity is Joan Riviere's "Womanliness as Masquerade," reprinted in *Formations of Fantasy*, ed. Victor Burgin, James Donald, and Cora Kaplan (London: Methuen, 1986), and accompanied by an incisive commentary by Stephen Heath, "Joan Riviere and the Masquerade," which sets out the choices for feminist film theory in the light of Riviere's arguments. See also Mary Ann Doane, "Film and the Masquerade: Theorizing the Female Spectator," *Screen*, 23, 3–4 (1982).

50. Michael Bronski asks the relevant question about the choices of these female performers: "It would be absurd to want to pretend that any of these women had a great talent, but what does it mean for a large group of gay men to like a female performer expressly because of the fact that she is terrible?" "Judy Garland and Others: Notes on Idolization and Derision," *Lavender Culture*, ed. Karla Jay and Allen Young (New York: Harcourt Brace Jovanovich, 1978), p. 210.

51. For a wide-ranging history of cross-dressing, see Peter Ackroyd, *Dressing Up: Transvestism and Drag* (New York: Simon & Schuster, 1979).

52. Esther Newton, *Mother Camp: Female Impersonators in America* (Chicago: Univ. of Chicago Press, 1972), p. 111n.

53. In this respect, Kris Kirk and Ed Heath's fascinating oral history of drag is especially perceptive in documenting the feelings and attitudes of the earlier professional chorus queens when, in the sixties, drag became a crossover culture. *Men in Frocks* (London: Gay Men's Press, 1984).

54. Altman, *The Homosexualization of America*, p. 13. Leo Bersani, by contrast, sees in gay machismo only a profound identification with and yearning for the oppressive power of motorbike masculinity—"a *per*version rather than a *sub*version of real maleness." "Is the Rectum a Grave?," *October* 43 (Winter 1987), p. 208ff.

55. Gore Vidal, *Myra Breckinridge* (Boston: Little, Brown & Co., 1968), p. 115.

56. Barbara Ehrenreich, *The Hearts of Men: American Dreams and the Flight from Commitment* (Garden City: Doubleday, 1983).

57. Sue Steward and Sheryl Garratt, *Signed Sealed and Delivered: True Life Stories of Women in Pop* (Boston: South End Press, 1984), p. 52.

58. Andy Warhol, *The Philosophy of Andy Warhol (From A to B and Back Again)* (New York: Harcourt Brace Jovanovich, 1975), pp. 54–55.

59. Warhol, *Popism*, p. 224.

60. Emile De Antonio, in an interview with the author in Patrick S. Smith, *Andy Warhol's Art and Films* (Ann Arbor: UMI Press, 1986), p. 298.

61. There is a debate about whether stars, as products, belong more to conditions of production or to conditions of consumption. If they are primarily the result of the power of producers, the consumers are simply manipulated dupes—the Frankfurt School position. More useful is Francesco Alberoni's "election" thesis, whereby stars are nominated by producers, but elected by the consumers according to the conditions of the specific ideological moment. See Richard Dyer's discussion of this thesis and others in *Stars* (London: British Film Institute, 1979). The classic work is Edgar Morin's *Les Stars* (Paris: Seuil, 1957).

62. Warhol, *Popism*, p.296. At the height of "the Warhol film" output, Holly Woodlawn claims to have seen a clearly defined system of alternative typing: "I was the Hedy Lamarr—sultry. Candy was the Kim Novak or another blonde type. Jackie was the Crawford type—vicious and strong type, and Joe [Dallesandro] was the Clark Gable.

At that point, we were on the same level as Hollywood, if not higher." Smith, *Andy Warhol's Art and Films*, p. 528.

63. Jean Stein, ed., with George Plimpton, *Edie: An American Biography* (New York: Dell, 1982).

64. Stephen Koch, *Stargazer: Andy Warhol's World and His Films* (New York: Praeger, 1973), pp. 120ff.

65. Smith, *Andy Warhol's Art and Films*, p. 158.

66. Smith, *Andy Warhol's Art and Films*, p. 485.

67. Warhol, *The Philosophy of Andy Warhol*, p. 93.

6. The Popularity of Pornography

1. Barbara Ehrenreich notes that the Hefner philosophy of the "playboy" was specifically anti-wife: "*Playboy* charged into the battle of the sexes with a dollar sign on its banner. The issue was money; men made it; women wanted it." *The Hearts of Men: American Dreams and the Flight from Commitment* (Garden City, NY: Anchor, 1983), p. 46. The first issue of the magazine promised that the *Playboy* lifestyle would include inviting a female acquaintance to the apartment "for a quiet discussion on Nietzsche, Picasso, jazz, sex."

2. *Playboy*, 12,1 (January 1965). *Playboy* also published the work of feminists: articles by Gloria Emerson, Susan Sontag, Doris Lessing, Joyce Carol Oates, Pearl Buck, Mary McCarthy, and interviews with Germaine Greer, Jane Fonda, Betty Friedan, Mary Calderone, Bernadette Devlin, Shere Hite, and Virginia Johnson. See Catherine MacKinnon, *Feminism Unmodified: Discourses on Life and Law* (Cambridge, MA: Harvard Univ. Press, 1987), p. 139.

3. Henry Schipper, citing Gloria Leonard's estimate, in "Filthy Lucre," *Mother Jones*, 5 (111) (April 1980), p. 32.

4. "Those who came included not only the regular hard-core corps, but a group that ranged from celebrities to secretaries to suburban matrons to U.N. delegates." Richard Smith, *Getting Into Deep Throat* (Chicago: Playboy Press, 1973), p. 9.

5. *Final Report of the Attorney General's Commission on Pornography* (Nashville: Rutledge Hill, 1986), p. 363.

6. Chuck Kleinhans and Julia Lesage, "The Politics of Sexual Representation," *Jump-Cut*, 30 (1984), p. 26.

7. Jean Bethke Elshtain, "The New Porn Wars," *New Republic*, 190, 25 (June 25, 1984), p. 15.

8. Al Goldstein, in a forum on "The Place of Pornography," *Harper's*, Vol. 269, No. 1614 (November 1984), pp. 32–33.

9. Quoted in Smith, *Getting Into Deep Throat*, p. 27.

10. Linda Lovelace and Mike McGrady, *Ordeal* (New York: Berkeley Publishing Co., 1980).

11. *Report of the Attorney General's Commission on Pornography*, p. 10.

12. Beverley Brown, "A Feminist Interest in Pornography—Some Modest Proposals," *m/f*, 5/6 (1981), pp. 16–17. For further discussion of the history of legal issues at stake for women, see Lorenne Clark, "Liberalism and Pornography," *Pornography and Censorship*, ed. David Copp and Susan Wendell (Buffalo: Prometheus, 1983), pp. 45–

60; Catherine MacKinnon, *Feminism Unmodified: Discourses on Life and Law* (Cambridge, MA: Harvard Univ. Press, 1987); and Elshtain, "The New Porn Wars."

13. Gayle Rubin, "Thinking Sex: Notes for a Radical Theory of the Politics of Sexuality," *Pleasure and Danger: Exploring Female Sexuality,* ed. Carole Vance (Boston: Routledge & Kegan Paul), pp. 307–9.

14. Walter Kendrick, *The Secret Museum: Pornography in Modern Culture* (New York: Viking, 1987), p. 78.

15. Kendrick, *The Secret Museum,* pp. 49–50, et passim.

16. Kendrick, *The Secret Museum,* p. 227.

17. Susan Griffin, *Pornography and Silence: Culture's Revenge Against Nature* (New York: Harper & Row, 1981), pp. 111–12.

18. *U.S. v. Samuel Roth* 237 F. 2d 796 (2d cir., 1956).

19. Quoted in John Ellis, "Photography/Pornography/ Art/Pornography," *Screen,* 21,1 (Spring 1980), p. 86.

20. Steven Marcus, *The Other Victorians: A Study of Sexuality and Pornography in Mid-Nineteenth Century England* (New York: Basic Books, 1964), pp. 278ff.

21. George Steiner, "Night Words," *The Case Against Pornography,* ed. David Holbrook (New York: Library Press, 1973), p. 230.

22. Steiner, "Night Words," p. 236.

23. Irving Kristol, "Is This What We Wanted?," in Holbrook, *The Case Against Pornography,* p. 190.

24. Bernard Williams, ed., *Obscenity and Film Censorship: An Abridgement of the Williams Report* (Cambridge: Cambridge Univ. Press, 1981), p. 137.

25. Susan Sontag, "The Pornographic Imagination," *A Susan Sontag Reader* (New York: Farrar, Straus & Giroux, 1982), p. 233.

26. Susan Sontag, "One Culture and the New Sensibility," *Against Interpretation* (New York: Farrar, Straus & Giroux, 1966), p. 303.

27. Angela Carter, *The Sadeian Woman and the Ideology of Pornography* (New York: Pantheon, 1978), p. 19.

28. Carter, *Sadeian Woman,* pp. 36–37.

29. Gloria Steinem, "Erotica and Pornography: A Clear and Present Difference," *Take Back the Night: Women On Pornography,* ed. Laura Lederer (New York: Morrow, 1980), pp. 35–39. This collection includes all the important documents from the first wave of antiporn feminism, organized around two groups, Women Against Violence Against Women (WAVAW, formed in 1976-77), which began by protesting against legitimate advertising, and Woman Against Pornography (WAP, 1979), which focused more exclusively on violence in pornography.

30. Ellen Willis, "Feminism, Moralism and Pornography," *Caught Looking: Feminism, Pornography & Censorship,* ed. Kate Ellis et al (New York: Caught Looking, 1986), p. 56.

31. Ann Barr Snitow, "Mass Market Romance: Pornography for Women is Different," *Powers of Desire: The Politics of Sexuality,* ed. Ann Snitow, Christine Stansell, and Sharon Thompson (New York: Monthly Review Press, 1983), p. 256.

32. Rubin, "Thinking Sex," pp. 267–319; Gayle Rubin, Amber Hollibaugh, and Deirdre English, "Talking Sex: A Conversation on Sexuality and Feminism," *Socialist Review,* 58 (June/August, 1981), p. 50.

33. Susanne Kappeler, *The Pornography of Representation* (Minneapolis: Univ. of Minnesota Press, 1986), pp. 49–53.

34. "I think that the situation of women basically is ahistorical," Andrea Dworkin, in an interview with Elizabeth Wilson, *Feminist Review*, 9 (Summer 1982), p. 27.

35. The classic description of this continuum is in Kathleen Barry, *Female Sexual Slavery* (Englewood Cliffs: Prentice-Hall, 1978).

36. Andrea Dworkin, "Why So-Called Radical Men Love and Need Pornography," in Lederer, *Take Back the Night*, p. 148.

37. So too, pornography came to be the perfect object of the cause and effects behaviorism long favored by certain kinds of mass communications and social science research, which analyses, in fixed and quantifiable ways, the response of user-subjects to the stimuli of representations. Much attention has been devoted to the behavioral experiments which social scientists conducted on college students "exposed" to pornography. The results have been interpreted to demonstrate pornography's "negative effects" in the form of its contribution to an increase in "harmful" attitudes. Pleasure, arousal, and sensitivity are measured under laboratory conditions with advanced equipment, far removed from the realm of fantasy. In a typical experiment, penile tumescence was monitored by the use of a mercury-in-rubber strain gauge. In others, systolic and diastolic blood pressure measurements were cited as evidence of aggressive response. See Copp and Wendell, *Pornography and Censorship*, pp. 213–321.

 Donald Mosher's studies of "sex callousness" among males "exposed" to pornography was presented to support the "no demonstrated harms" conclusion of the 1970 Presidential Commission. See *Technical Report of the Presidential Commission on Obscenity and Pornography*, vol. 8 (Washington, D.C., 1970). Edward Donnerstein and Neil Malamuth, editors of *Pornography and Sexual Aggression* (Orlando: Academic Press, 1984), whose work had often been cited by antiporn feminists to demonstrate "harms," testified before the Meese Commission on Pornography that they considered aggressive imagery in mainstream media to be more worrisome than the possibly violent effects of pornography. See Carole Vance, "The Meese Commission on the Road," *The Nation*, (August 2/9, 1986), p. 79.

38. Gay pornography, as Michael Bronski points out, is not only a crucial subcultural expression, it also provides evidence, for the straight, legitimate culture, that gays exist, and that gay and S/M acts do actually occur. Bronski, *Culture Clash* (Boston: South End Press, 1984), p. 167.

39. See Susan Barrowclough's review of the film *Not a Love Story*, in *Screen*, 23, 5 (November/December 1982), pp. 26–38.

40. According to Gayle Rubin, "keeping sex from realizing the positive effects of the market economy hardly makes it socialist." On the contrary, it "renders sex workers more vulnerable to exploitation and bad working conditions" by further underdeveloping the sex industry. "Thinking Sex" in Vance, *Pleasure and Danger*, pp. 290–91.

 As for the marxism's traditional imaginary of a postcapitalist future for sex, Marx's famous vision of a society of individuals with fully developed senses has recently been rearticulated thus by Alan Soble: "We could rewrite *The German Ideology* to say: Communist people produce in the morning, play music in the afternoon, make some pornography in the evening, and read Durkheim before going to bed." *Pornography: Marxism, Feminism and the Future of Sexuality* (New Haven: Yale Univ. Press, 1986), p. 122.

41. Carole Vance, in *Pleasure and Danger*, p. 1. Also see the articles collected in *Women Against Censorship*, ed. Varda Burstyn (Vancouver: Douglas & McIntyre, 1985).

42. Ellen Willis in *Caught Looking*, pp. 55, 56.

43. For a more comprehensive list, see Barbara O'Dair and Abby Tallmer, "Sex Premises," in *Caught Looking*, pp. 50–53.

44. Lisa Duggan, Nan D. Hunter, and Carole S. Vance, "False Promises: Feminist Antipornography Legislation," in *Caught Looking*, p. 82.

45. See Barbara Ehrenreich, Elizabeth Hess, and Gloria Jacobs, *Re-Making Love: The Feminization of Sex* (New York: Anchor, 1986). One of the more interesting female pornographic subcultures is undoubtedly the flourishing of K/S zines. These are anthologies of fan-written, fantasy stories and art about the relationship between *Star Trek*'s Kirk and Spock, often incorporating S/M, and always graphically sexual in the intensity of their detailed articulation of fantasy. A catalog of zines can be obtained from *Datazine*, P.O. Box 19413, Denver, CO 80219. Also, see Joanna Russ's response to the zines, "Pornography by Women For Women, With Love," in *Magic Mommas, Trembling Sisters, Puritans & Perverts* (Trumansburg, NY: The Crossing Press, 1985), pp. 79–100.

46. Bat-Ami Bar On, "Feminism and Sadomasochism: Self-Critical Notes," *Against Sadomasochism: A Radical Feminist Analysis*, ed. Robin Ruth Linden et al (East Palo Alto: Frog in the Well, 1982), pp. 72–82.

47. More radical claims are advanced by the Bay Area SAMOIS group of feminist lesbians. See *Coming to Power: Writings and Graphics on Lesbian S/M*, ed. SAMOIS (Boston: Alyson, 1982).

48. Ann Douglas, "Soft-Porn Culture," *New Republic* (August 30, 1980), p. 28.

49. Janice Radway, *Reading the Romance: Women, Patriarchy and Popular Literature* (Chapel Hill: Univ. of North Carolina Press, 1984).

50. Snitow, "Mass Market Romance," pp. 245–63.

51. Best-selling erotic novelist Anne Rice (*The Vampire Lestat* and *Exit to Eden*) puts it clearly: "I don't really like visual pornography; like many women, I'm more stimulated verbally and tactilely. . . . To have a pornography for women, somebody would really have to give women what they want, and they'd have to find out what that is." Ron Bluestein, "Interview with the Pornographer," *Vogue* (April, 1986), pp. 212–14.

52. Annete Fuentes and Margaret Schrage, "Deep Inside Porn Stars: Interview with Veronica Hart, Gloria Leonard, Kelly Nichols, Candida Royalle, Annie Sprinkle, and Veronica Vera," *Jump Cut*, 32 (April 1986), pp. 42.

53. See John Ellis, "Photography/Pornography/Art/Pornography," pp. 98ff; Paul Willemen's reply, "Letter to John," *Screen*, 21, 2 (Summer 1980); and Claire Pajaczkowska's rejoinder, "The Heterosexual Presumption," *Screen*, 22, 1 (1981), pp. 13–18. Linda Williams has written the most comprehensive survey of the genres of porn film, dating from the pre-narrative stag film to the present. Among many other things, her book explicitly demonstrates the difficulties which hard-core pornography presents for a theoretical model which sees films as organized around a male avoidance of the castration threat. *Hard-Core: Power, Pleasure, and the Frenzy of the Visible* (Berkeley: Univ. of California Press, forthcoming).

54. Magazines, for example, print the tawdry and unappealing black-and-white photographs sent in by exhibitionistic readers in order to accentuate the difference between the reader and the superior order of social experience represented by the pinup model.

55. Richard Dyer, "Male Gay Porn: Coming to Terms," *Jump Cut*, 30, pp. 27–29.

56. *The Pick-Up* is part of a compilation tape, on the "first volume" of Candida Royalle's Star Director Series— *A Taste of Ambrosia* (1987).

57. The savvy policy of Femme Productions is not to use safe-sex representations in the case of a clearly defined fantasy or dream sequence, where they would be thought "invasive." By contrast, the Mitchell Brothers' recent, lavish safe-sex sequel to *Behind the Green Door* includes a half-hour long, safe-sex orgy scene in a nightclub which clearly *is* a fantasy/dream sequence.

58. Cora Kaplan suggests that it is this conscious level of fantasy activity that is in fact "open to political analysis and negotiation," whereas fantasy that more directly "combines original or primal fantasy" is not. She maintains that it is those narratives to "which [fantasies] can be bound in popular expression" that can and ought to be changed. "*The Thorn Birds*: Fiction, Fantasy, Femininity," *Formations of Fantasy*, ed. Victor Burgin, James Donald, and Cora Kaplan (London and New York: Methuen, 1986), pp. 153, 165.

59. Bette Gordon, *Diary of a Conference on Sexuality*, ed. Hannah Alderfer, Beth Jaker, and Marybeth Nelson (New York: Faculty Press, 1983), p. 47.

60. Daniel Bell has a moral tale to tell about this shift in *The Cultural Contradictions of Capitalism* (New York: Basic Books, 1986), pp. 1–145.

61. See Simon Watney, *Policing Desire: Pornography, AIDS and the Media* (Minneapolis: Univ. of Minnesota Press, 1987).

62. For example, at meetings of the AIDS activist group, ACTUP (AIDS Coalition to Unleash Power), I have heard members invoke their HIV-positive identity as exceptional grounds for pursuing certain kinds of political action—putting their "bodies on the line"—that would be less justified in the case of HIV-negative activists.

63. Mike Davis, "The Political Economy of Late-Imperial America," in *Prisoners of the American Dream: Politics and Economy in the History of the US Working Class* (London: Verso, 1986), pp. 181–230.
 Ivan Boesky's infamous speech (immortalized in Oliver Stone's film *Wall Street* [1987]) about the legitimacy of "greed" has become the moralistic representation of the mood of the Reagan years that is most favored by the media. More symptomatic, I think, is the favorite speech of Peter G. Peterson, one of the two executive officers whose rivalry tore apart the brokerage firm of Lehman Brothers. Peterson's often delivered speech was about how the American political system dispenses "too much pleasure and not enough pain." Ken Auletta, *Greed and Glory on Wall Street: The Fall of the House of Lehman* (New York: Warner, 1986). I am indebted to Mark Seltzer for drawing my attention to this speech.

64. See Fred Pfeil, "Makin' Flippy-Floppy: Postmodernism and the Baby-Boom PMC," *The Year Left: An American Socialist Yearbook*, ed. Mike Davis, Fred Pfeil, and Michael Sprinker (London: Verso, 1985), pp. 268–95: John Clarke, "Enter the Cybernauts: Problems in Post-Modernism," (unpublished manuscript).

65. The Meese Commission *Report* makes it clear that it views pornographic modeling as "quite simply a form of prostitution" as distinct from the acting or entertainment profession, p. 242.

66. Amber Cooke, *Good Girls/Bad Girls: Feminists and Sex Trade Workers Face to Face*, ed. Laurie Bell (Seattle: Seal Press, 1987), p. 191.

67. Nina Hartley, "Confessions of a Feminist Porn Star," *Sex Work: Writings By Women in the Sex Industry*, ed. Frédérique Delacoste and Priscilla Alexander (Pittsburgh: Cleis Press, 1987), p. 142.

68. Valerie Scott, Peggy Miller, and Ryan Hotchkiss (of the Canadian Organization for the Rights of Prostitutes), in *Good Girls/Bad Girls*, pp. 210–11.

69. Debi Sundahl, in *Sex Work*, p. 180.

70. See Fredric Jameson, "Reification and Utopia in Mass Culture," *Social Text*, 1 (1979), pp. 130–48.

71. *Report of the Attorney General's Commission*, p. 541. Becker and Levine also objected to the "judgmental and condescending efforts to speak on women's behalf as though they were helpless, mindless children."

7. Defenders of the Faith and the New Class

1. See Stanley Aronowitz, "Postmodernism and Politics," *Universal Abandon? The Politics of Postmodernism*, ed. Andrew Ross (Minneapolis: Univ. of Minnesota Press, 1988).

2. The two most recent examples are, from the left, Russell Jacoby, *The Last Intellectuals: American Culture in the Age of Academe* (New York: Basic Books, 1987); and, from the right, Allan Bloom, *The Closing of the American Mind* (New York: Simon & Schuster, 1987).

3. See Magali Sarfatti Larson, "The Production of Expertise and the Constitution of Expert Power," *The Authority of Experts: Studies in History and Theory*, ed. Thomas Haskell (Bloomington: Indiana Univ. Press, 1984), pp. 28–83; and Pierre Bourdieu, "Cultural Reproduction and Social Reproduction," *Power and Ideology in Education*, ed. Jerome Karabel and A.H. Halsey (New York: Oxford Univ. Press, 1977), pp. 487–511.

4. See Bruce Sterling's cyberpunk "manifesto" in Sterling, ed., *Mirrorshades: The Cyberpunk Anthology* (New York: Arbor House, 1986).

5. Nicholas Garnham and Raymond Williams make this distinction between "replication" and "reformation" in order to take issue with Pierre Bourdieu's analyses of cultural "reproduction." The question they ask is the important one: "Can the structure of the symbolic field produce contradictions such that they no longer tend to reproduce the given set of class relations?" Nicholas Garnham and Raymond Williams, "Pierre Bourdieu and the Sociology of Culture," *Media, Culture and Society*, ed. Richard Collins et al (Beverley Hills: Sage, 1986), pp. 116–30. Stuart Hall has insisted that the answer to that question is to be found in Gramsci:

 > There is nothing more crucial, in this respect, than Gramsci's recognition that every crisis is also a moment of reconstruction; that there is no destruction which is not also, reconstruction; that, historically nothing is dismantled without also attempting to put something new in its place; that every form of power not only excludes but produces something.
 > That is an entirely new conception of crisis—and of power. When the Left talks about crisis, all we see is capitalism disintegrating, and us marching in and taking over. We don't understand that the disruption of the normal functioning of the old economic, social, cultural order, provides the opportunity to reorganize it in new ways, to restructure and refashion, to modernize, and move ahead.

 Stuart Hall, "Gramsci and Us," *Marxism Today* (June 1987), p. 19.

6. Donna Haraway, "A Manifesto for Cyborgs: Science, Technology and Socialist Feminism in the 1980s," *Socialist Review*, 80 (March/April 1985), pp. 65–107.

7. Lionel Trilling, preface, *Beyond Culture: Essays on Literature and Learning* (New York: Harcourt Brace Jovanovich, 1965).

8. Edward Shils, "The Intellectuals and the Powers: Some Perspectives for Comparative Analyses," *The Intellectuals and the Powers and Other Essays* (Chicago: Univ. of Chicago Press, 1972), pp. 3–23; Edward Shils, "Intellectuals and the Center of Society in the

United States," *The Constitution of Society* (Chicago: Univ. of Chicago Press, 1982), pp. 224–74; Talcott Parsons, "The Intellectual: A Social Role Category," *On Intellectuals*, ed. Philip Rieff (Garden City, NY: Doubleday, 1969), pp. 3-24. One of the classic sources of this view can be found in Karl Mannheim, *Ideology and Utopia* (New York: Harcourt, Brace and Co., 1936). Daniel Bell has different but related things to say about "the sacred" in *The Cultural Contradictions of Capitalism* (New York: Basic Books, 1978), pp. 146–71; and in "The Return of the Sacred," *The Winding Passage: Essays and Sociological Journeys: 1960–1980* (New York: Basic Books, 1980).

Regis Debray presents a more critical view in his account of the French historical trajectory from the clerisy to the new celebrity media intellectuals, in *Teachers, Writers, Celebrities: The Intellectuals of Modern France*, trans. David Macey (London: New Left Books, 1981).

9. Rolf Dahrendorf, "The Intellectual and Society: The Social Function of the 'Fool' in the Twentieth-Century," in Rieff, *On Intellectuals*, p. 51.

10. Maxim Gorky, "The Responsibility of Soviet Intellectuals," *The Intellectuals: A Controversial Portrait*, ed. George B. de Huszar (Glencoe, IL: Free Press, 1960), p. 237.

11. Noam Chomsky, *Towards A New Cold War: Essays on the Current Crisis and How We Got There* (New York: Pantheon, 1982), p. 62.

12. Cited by Chomsky in *American Power and the New Mandarins* (New York: Pantheon, 1969), p. 6.

13. Of the many books about and by the intellectuals associated with the *Partisan Review*, I have found that Terry Cooney most clearly describes the political contradictions of their cosmopolitan taste in culture, in *The Rise of the New York Intellectuals: Partisan Review and its Circle, 1934-1945* (Madison: Univ. of Wisconsin Press, 1986).

14. Cited by Cooney, *Rise of the New York Intellectuals*, p. 200.

15. Irving Howe, *A Margin of Hope: An Intellectual Autobiography* (New York: Harcourt Brace Jovanovich, 1982), p. 158. Howe was referring, in particular, to the literary critic and fellow traveler F.O. Matthiessen.

16. Alan Wald makes a strong case for the political and intellectual integrity of the anti-Stalinist left that preexisted the phase of Stalinophobia. *The New York Intellectuals: The Rise and Fall of the Anti-Stalinist Left* (Chapel Hill: Univ. of North Carolina Press, 1986).

17. For the most level-headed history of this period, See Richard Pells, *The Liberal Mind in a Conservative Age: American Intellectuals in the 1940s and 1950s* (New York: Harper & Row, 1985).

18. Daniel Bell, "The Mood of Three Generations," in *The End of Ideology* (New York: Collier, 1961), p. 303.

19. Recently published histories of the sixties which emphasize this difference of style include Ronald Fraser, ed., *1968: A Student Generation in Revolt* (New York: Pantheon, 1988); Todd Gitlin, *The Sixties: Years of Hope, Days of Rage* (New York: Bantam, 1987); and James Miller, *"Democracy is in the Streets": From Port Huron to the Seige of Chicago* (New York: Simon & Schuster, 1987).

20. Irving Howe, *The Decline of the New* (New York: Harcourt, Brace & Co. 1970), p. 255.

21. Randolph Bourne, *War and the Intellectuals: Collected Essays 1915–1919*, ed. Carl Resek (New York: Harper & Row, 1964), pp. 3–15.

22. Archibald MacLeish, "The Irresponsibles," in de Huszar, *The Intellectuals*, pp. 239–46.

23. Some of the most damning evidence was provided by Charles Kadushin's polling of the reactions of a chosen, elite group of intellectuals to the war in Vietnam. The

results showed that a majority opposed American foreign policy in South East Asia, but mostly on pragmatic rather than on moral grounds. *The American Intellectual Elite* (Boston: Little, Brown, 1974).

24. Joseph Schumpeter, *Capitalism, Socialism and Democracy* (New York: Harper, 1942), p. 145.

25. Norman Podhoretz, "The Adversary Culture and the New Class," *The Bloody Crossroads: Where Literature and Politics Meet* (New York: Simon & Schuster, 1986), p. 116.

26. Quoted by Alexander Bloom, *Prodigal Sons: The New York Intellectuals and Their World* (New York: Oxford Univ. Press, 1986), p. 353.

27. B. Bruce-Biggs, ed., *The New Class?* (New York: McGraw-Hill, 1981) presents a range of primarily neoconservative perspectives. Pat Walker, ed., *Between Labor and Capital* (Boston: South End Press, 1979) includes Barbara and John Ehrenreich's "The Professional-Managerial Class," followed by a range of left responses.

28. The phrase "engineering of consent" belongs to Edward Bernays (a nephew of Freud), who fathered the science of public relations in the twenties in books like *Crystallizing Public Opinion* (1923) and *Propaganda* (1925), each of which advocated the application of knowledge about mass psychology to the rhythms of the marketplace. In the *New Republic* of 1932 (March 23, p. 145), Edmund Wilson called for his fellow intellectuals to become "engineers of ideas." Wilson is addressing a would-be vanguardist intelligentsia, encouraging them to openly work at creating a mass revolutionary consciousness. Bernays's appeal to fellow professionals is equally vanguardist; their task is to create a consumerist consciousness for society as a whole. Both discourses assume the technobureaucratic process of rationalization as a benign and necessary fact, invoking its virtues for the "soft" science of persuasion through the "hard" metaphor of engineering (the efficiency methods of Fordism and Taylorization—more efficient than laissez-faireism—had long been unequivocally recognized and appropriated by both Soviet planners and European dreamers, like Gramsci, of a communist state).

29. For a liberal overview, see David Bazelon, *Power in America: The Politics of the New Class* (New York: New American Library, 1967). For a more radical view, see Stuart Ewen, *Captains of Consciousness: Advertising and the Social Roots of Consumer Culture* (New York: McGraw-Hill, 1976). The phrase "iron law of oligarchy" is Robert Michel's, and is used to describe how all large-scale organizations must, by their very nature, degenerate into oligarchies ruled by the few. Robert Michel, *Political Parties: A Sociological Study of the Oligarchical Tendencies of Modern Democracy*, trans. E. and C. Paul (New York: The Free Press, 1962). For a set of arguments which rejects Michel's position see Robert J. Brym, *Intellectuals and Politics* (London: Allen & Unwin, 1980), pp. 35–53. 4

30. Alvin Gouldner, *The Future of Intellectuals and the Rise of the New Class* (New York: Seabury Press, 1979), p. 6.

31. Paul Bové poses a related opposition in comparing the leading or representative intellectual type (his example is Edward Said) who, in his view, perpetuates the competitive, will-to-power image of traditional male intellectuals, with the skeptical and non-utopian genealogist (Michel Foucault) who refuses the privilege of intellectuals to speak for others, for the "truth," and for alternative futures. Paul Bové *Intellectuals in Power: A Genealogy of Critical Humanism* (New York: Columbia Univ. Press, 1986), pp. 209–37. For an extended discussion of the implications of this kind of comparison, see Jim Merod, *The Political Responsibility of the Critic* (Ithaca: Cornell Univ. Press, 1987).

Index